QUEEN

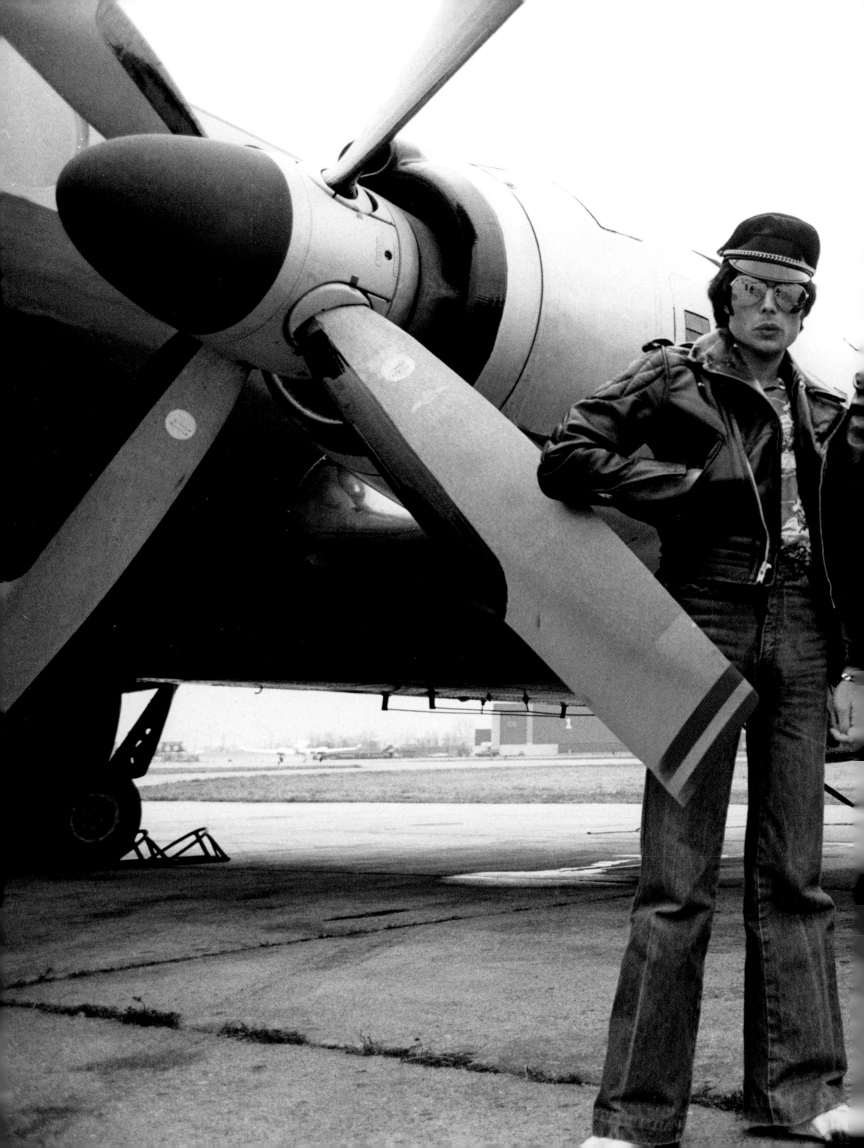

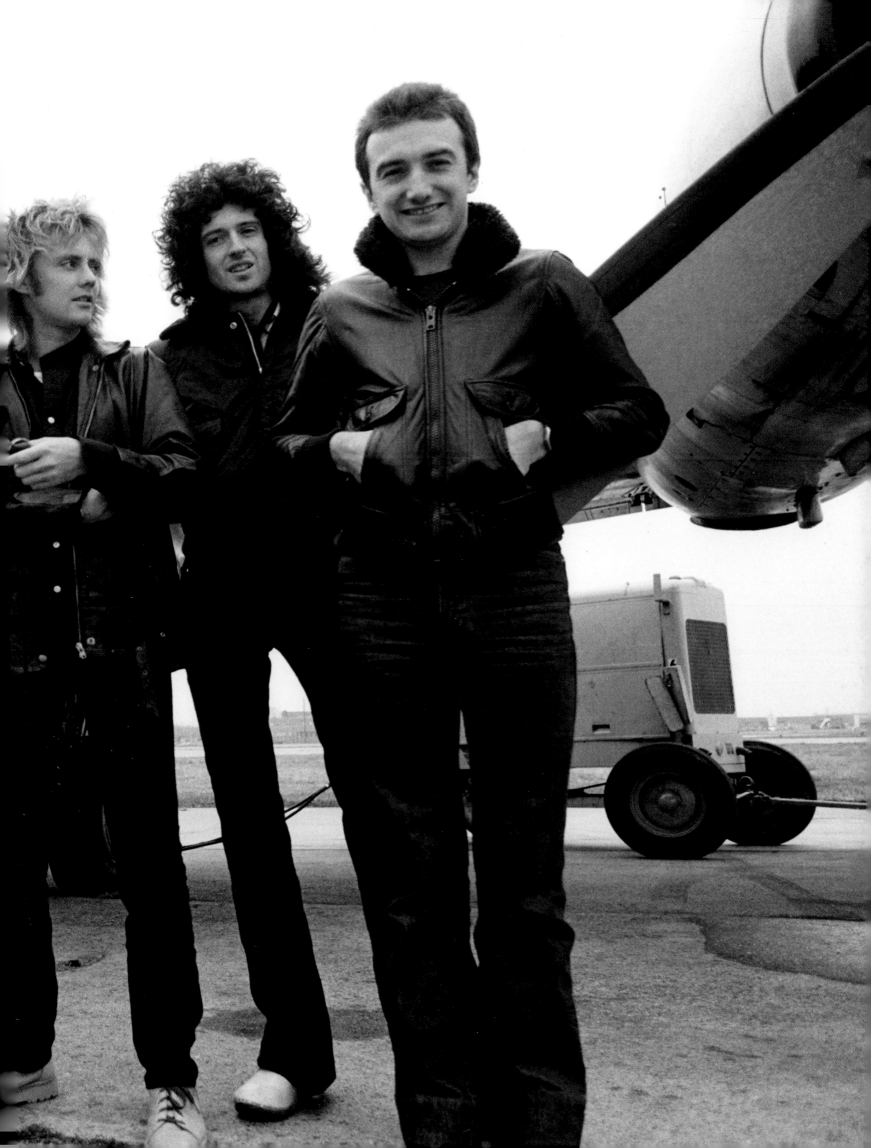

QUEEN

THE NEAL PRESTON PHOTOGRAPHS

REEL ART PRESS

So many memories from so many corners of the world.

A young, fresh faced, curly haired Neal Preston—seemingly everywhere with his big lens—providing us with so many great shots and capturing the moments. Of course not all of these moments really need to be aired all these years later. This is the reason I'm writing this note. Gotta keep Neal's mouth shut somehow!

In actual fact Neal's omnipresence on Queen's rampaging around the world was an absolute joy as he was such a fun and positive person to have around.

These are great pictures, every one tells some kind of story— I hope you enjoy them.

Roger Taylor
Surrey, July 2020

Neal is one of my oldest and greatest friends. Some of the stuff we have been through you wouldn't believe!

It can be difficult to have a photographer on the road with you all the time. If they're around too much they can get in the way but if they're not in the right place at the right time they can miss the good stuff. Neal just has the knack, or the skill, to always be in position at the right moments. He became part of the life of the band.

As a bonus, Neal had on other occasions been part of the life of other bands—notably Led Zeppelin. So after a few beverages of a night, we enjoyed hearing Neal's yarns about his adventures in similar situations to our own but with our heroes. Neal became a very trusted companion.

Many of my favourite Queen pictures are in this book, many of which haven't previously been published. Some of them are incredibly evocative, summoning up memories of those fleeting moments; things were moving too fast at the time for us to really take them in.

There's that amazing shot of Freddie and myself, apparently connected by an invisible force, explosions all around—didn't we use that on an album cover? Then the one of the four of us from behind stage at the end of the show thanking the audience. That's been widely emulated since. Before, during and after many amazing shows, all around the world, Neal captured the essence of Queen, live and dangerous, while we quietly and unexpectedly got on with becoming, perhaps momentarily, the biggest band in the world.

Brian May
London, June 2020

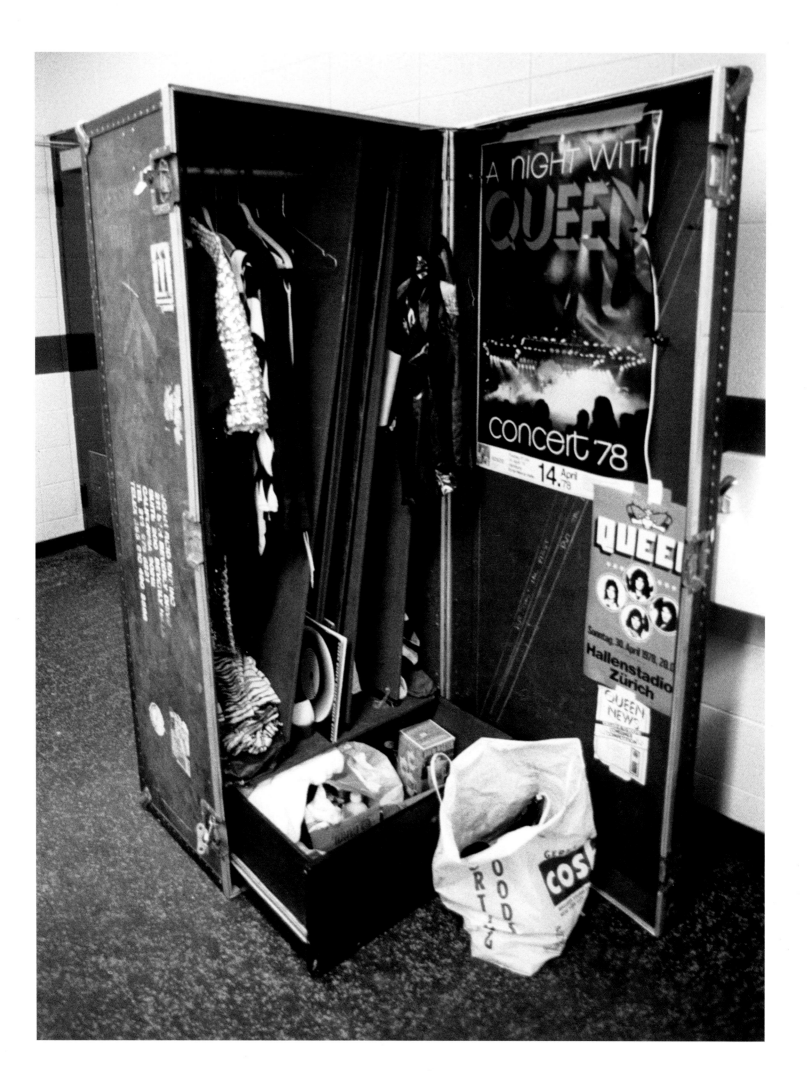

Contents

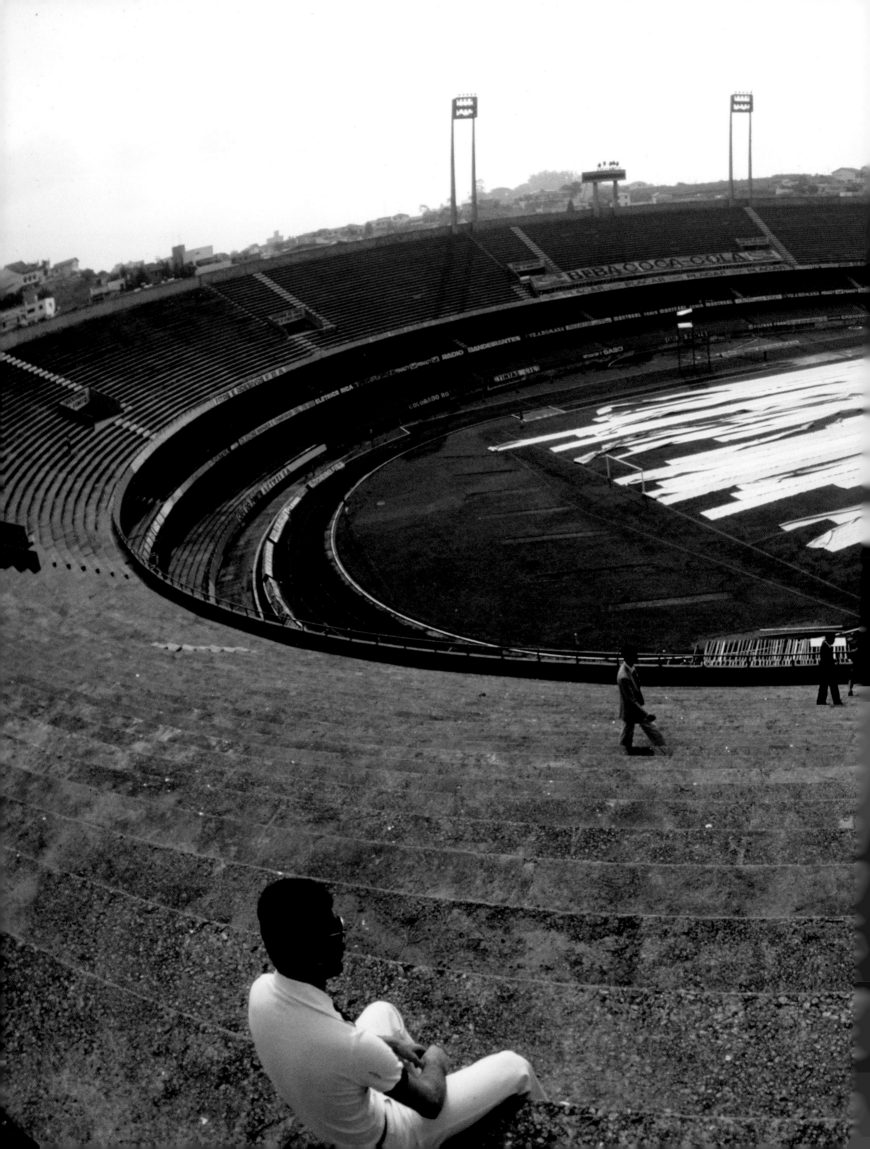

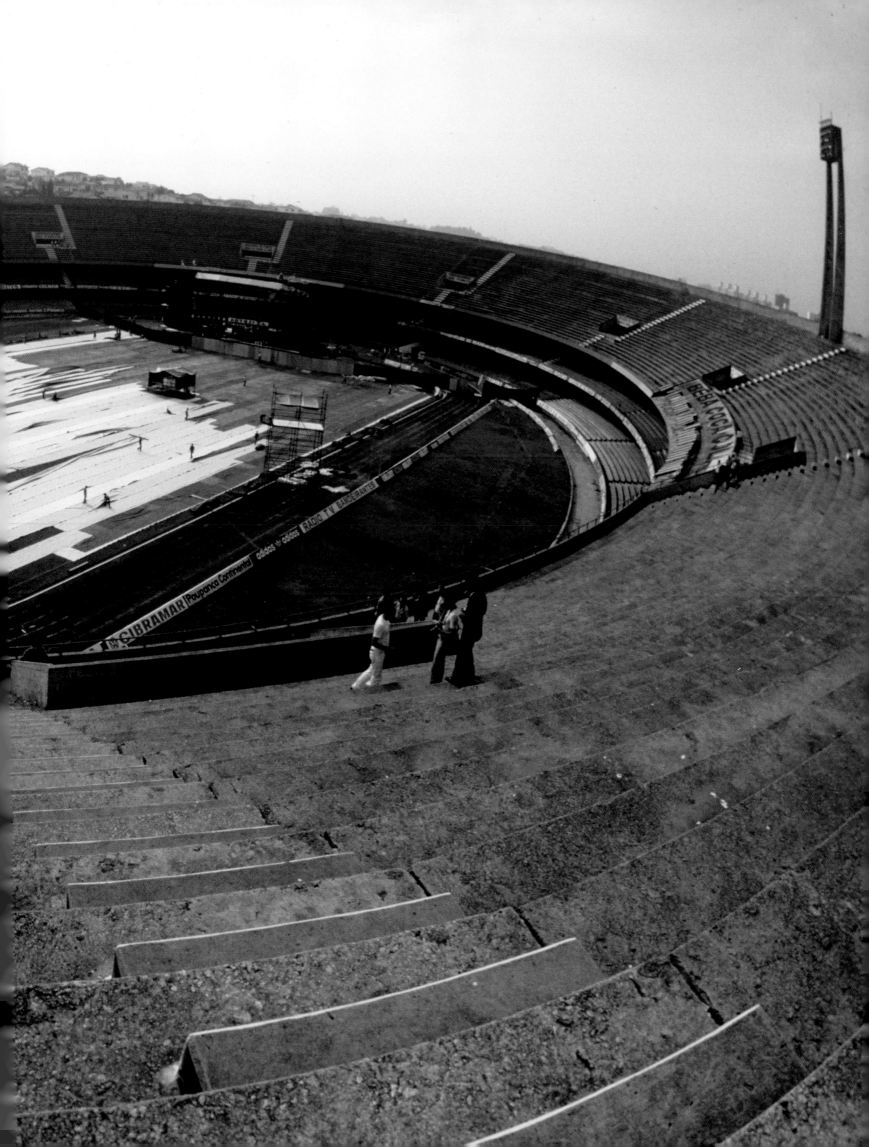

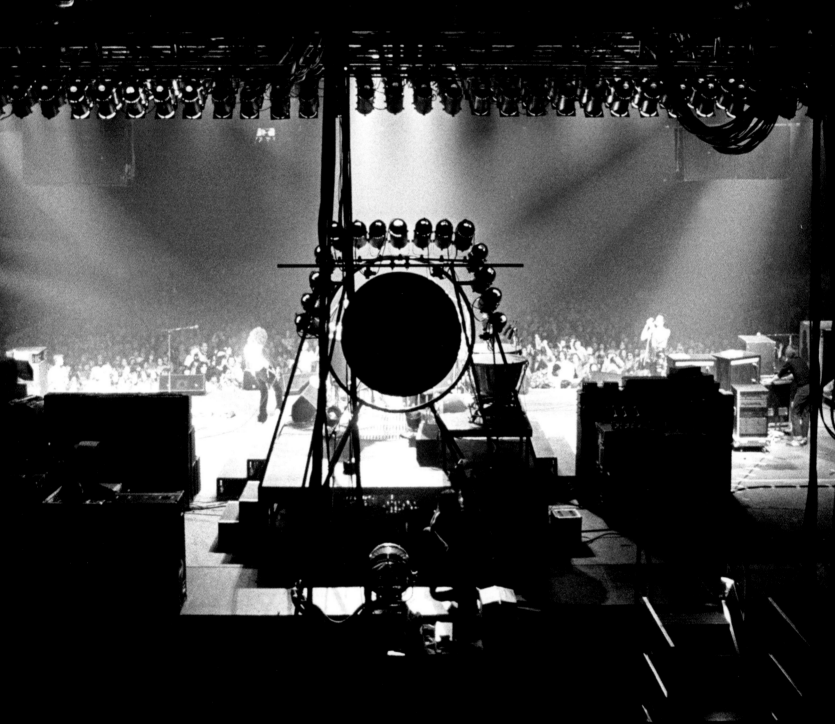

Introduction

When I was 16 years old I started my career as a professional photographer. At that time I immediately gravitated towards working with musicians. To me it seemed to be a perfect marriage, and I've been fortunate to have had some measure of success in my chosen profession.

Within a few years I found myself being hired to photograph rock musicians on tour. Needless to say these gigs were heady experiences for me. I began to realize that touring with any big rock band, despite the implied perks, is grueling. As much as I loved music, there were other aspects of touring that weren't much fun. Stress and fatigue became my constant companions. Those camera bags can get awful heavy after a couple of shows. There have been plenty of times on tour I did not want to get out of bed. I'd have paid any amount of money for another hour of sleep. But at 22, 23 years old, youth and resilience take over like the afterburners on a jet fighter.

But working with Queen was different. I was welcomed with open arms and encouraged to *go for broke* . . . and I did. Both the band and the crew seemed happy to have a photographer along who could blend in seamlessly with all concerned and not only get the job done but roll with the punches. The more time I spent with them, the more I realized this was a dream job for me. And that job continued on and off for many years.

Photographically I couldn't have asked for more. The scale of each production, from the '77 tour through the '86 tour, grew almost exponentially. The productions were full of thunder and lightning and bigger was definitely better. Year after year, bigger lighting rigs and bigger stages were the norm. For me it was like being a kid in the ultimate candy store, and many of the photographs in this book bear that out.

I'm not a music critic and I certainly don't regard myself as an expert in the field of rock music. I'm just a photographer (first) and a fan (second) but I've seen and heard enough in my life to know what I like and why I like it. I also know that spending as much time as I did around Queen taught me something extremely important: good is only good enough, great is only great, but there is always room to excel.

I know how hard every single member of Queen worked every night. They always strove for pure excellence and when the pressure was on they were at their best, crushing everything in their path. Going on tour was serious business for them. Every aspect of each show had to be perfect.

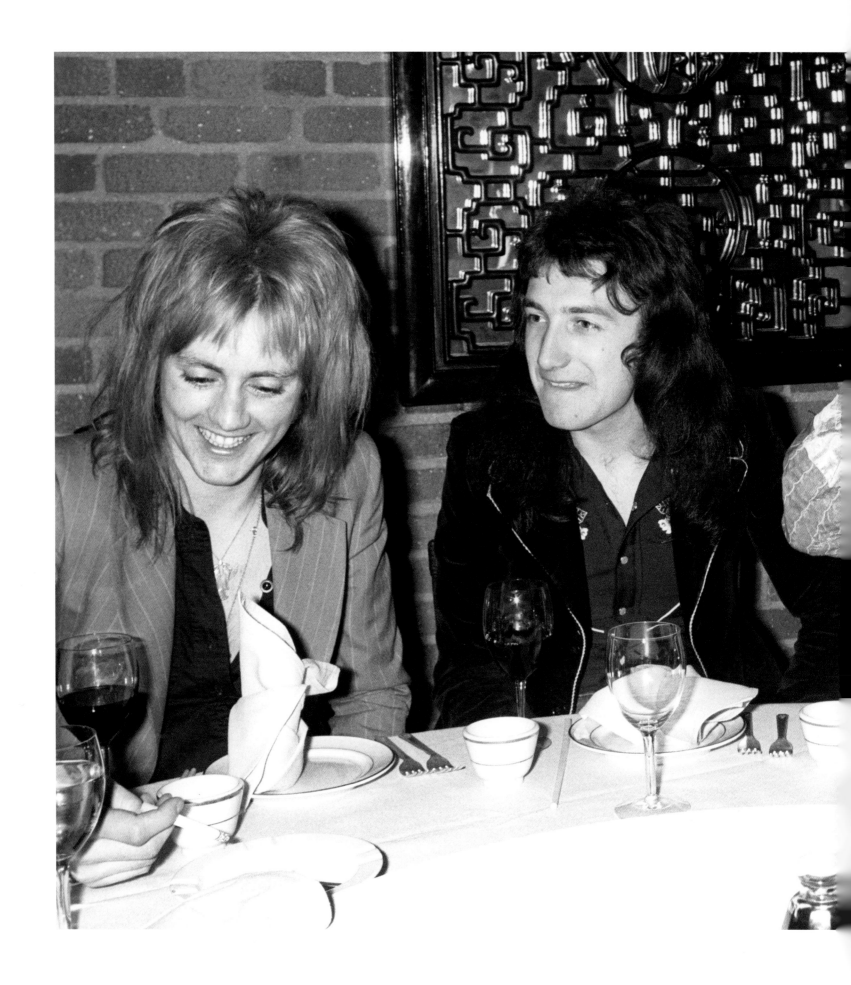

Roger Taylor **John Deacon**

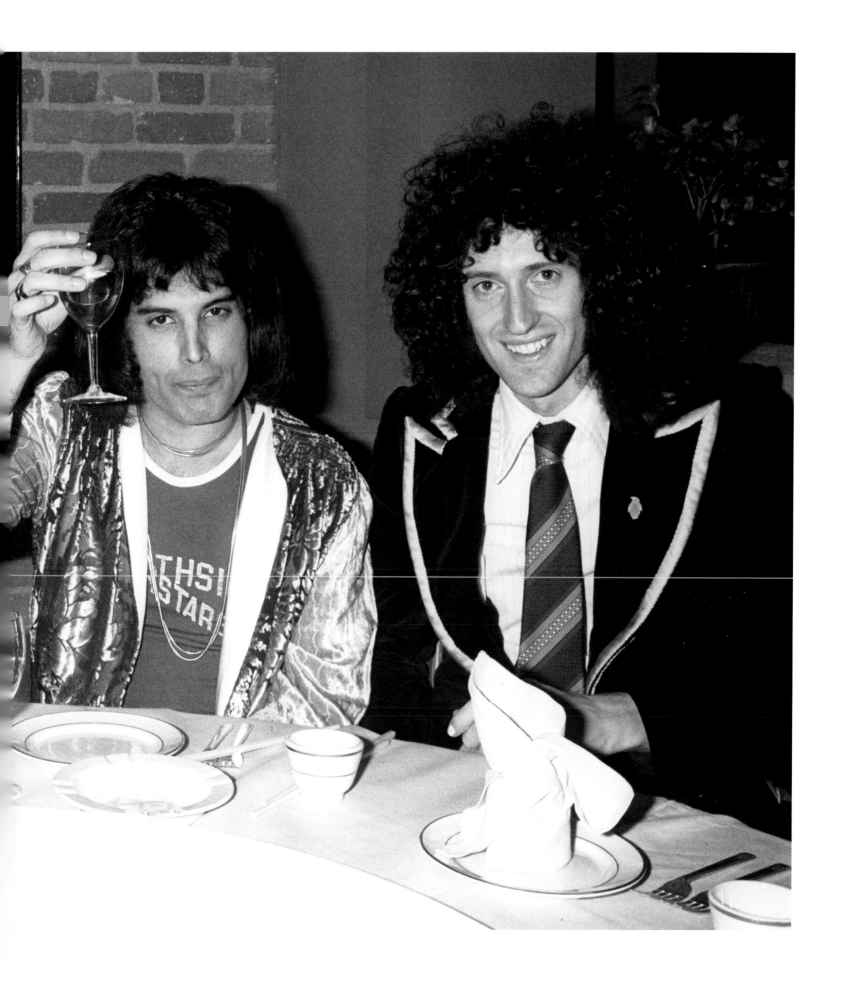

Freddie Mercury **Brian May**

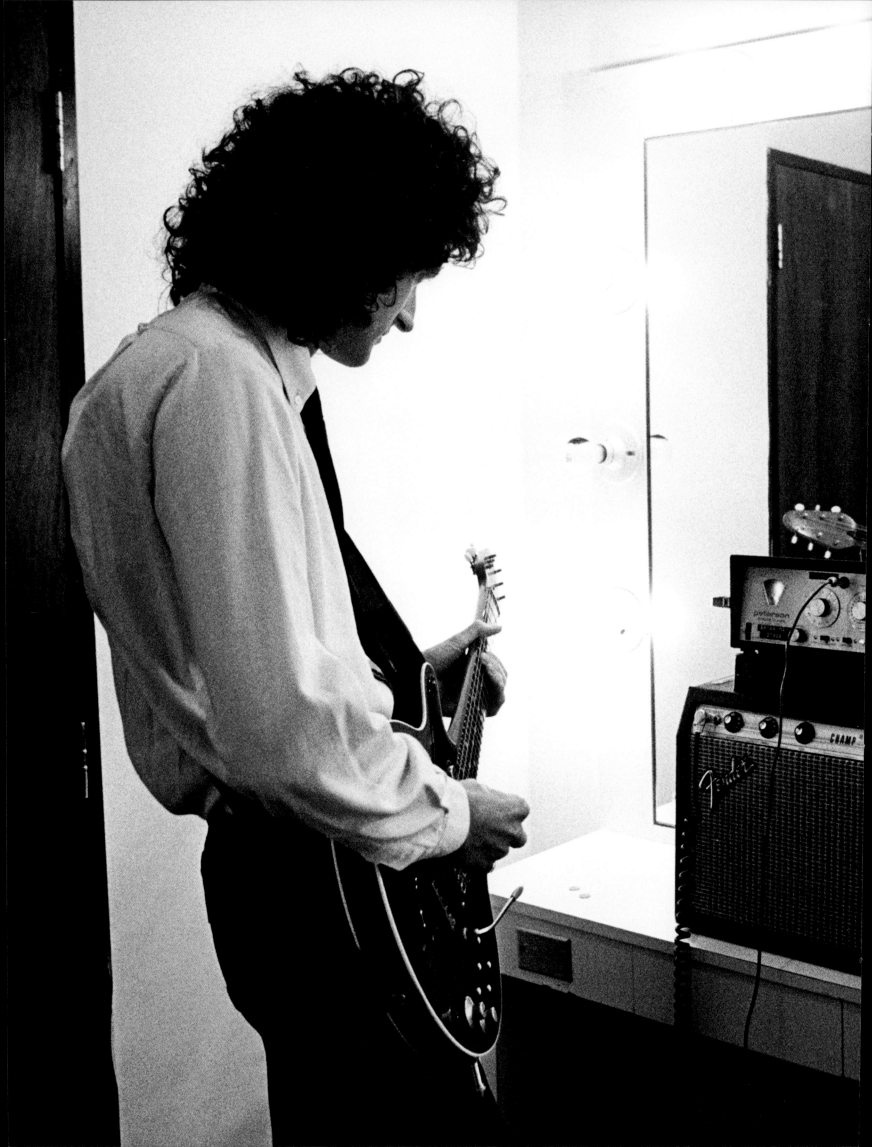

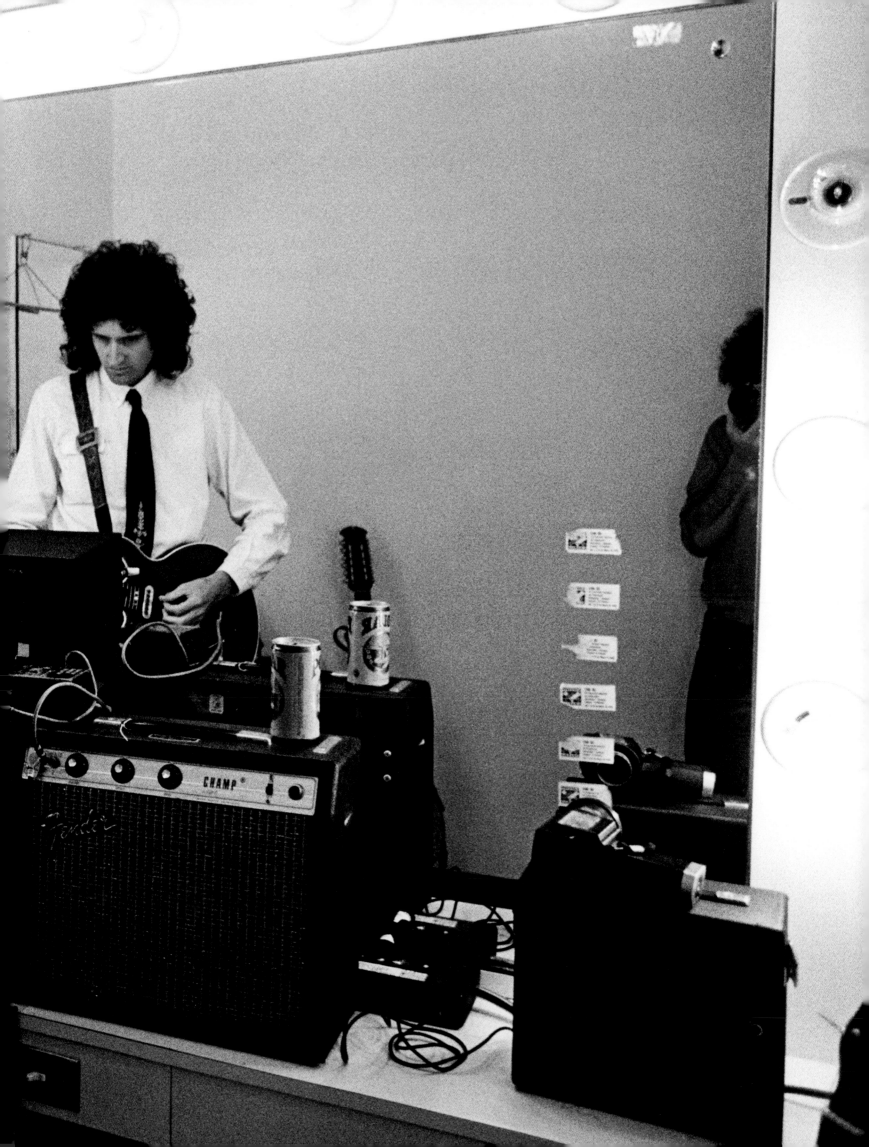

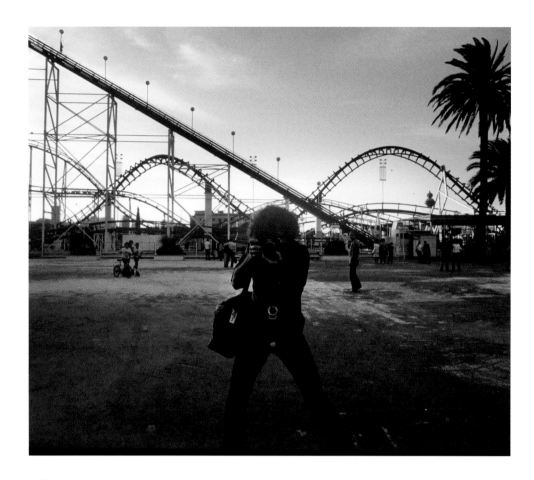

All bands I've worked with have one thing in common: they're never quite happy with a gig when it's over. Ask any member of a big rock band after they come off stage what they thought of the gig and you'll rarely get anything close to a positive response. I recall one particular gig in 1978 that I thought was truly amazing. When I asked Brian afterwards what he thought of it he said, "It was shit, the sound was crap." . . . After that I asked Roger the same question and his answer was the same but his language was far more colorful. I didn't have to ask Freddie—I heard him express himself at the top of his lungs from the next room. And John had a look on his face that said, "Don't even think of talking to me." I couldn't believe it because I knew how good the show had been. But I came to understand that what I was really hearing from each guy was, "It could have been better." I was dealing with four world-class perfectionists. Night after night they reinforced the idea to me that you should never settle for anything less than your best and never take your job for granted.

Before I started writing the text for this book I decided to watch a tape of the band's performance at Live Aid. I hadn't seen it in years and I'd never really watched it as a fan would watch it because I was too close to it, having been on that stage with them. I played the tape three times in a row and I've *never* heard Brian, Roger and John play like that. Freddie was, of course, beyond amazing but something much bigger was happening during those 30-odd minutes that I never hear anyone talk about. They were simply possessed.

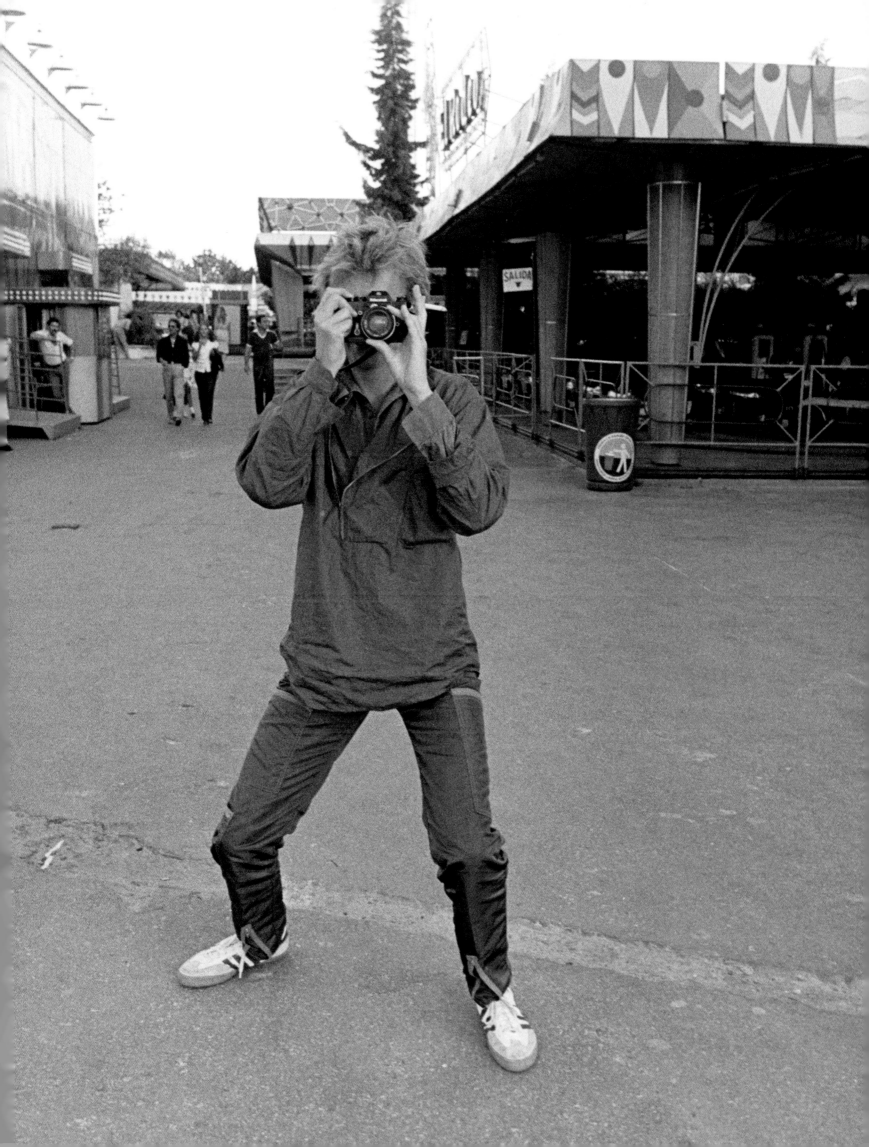

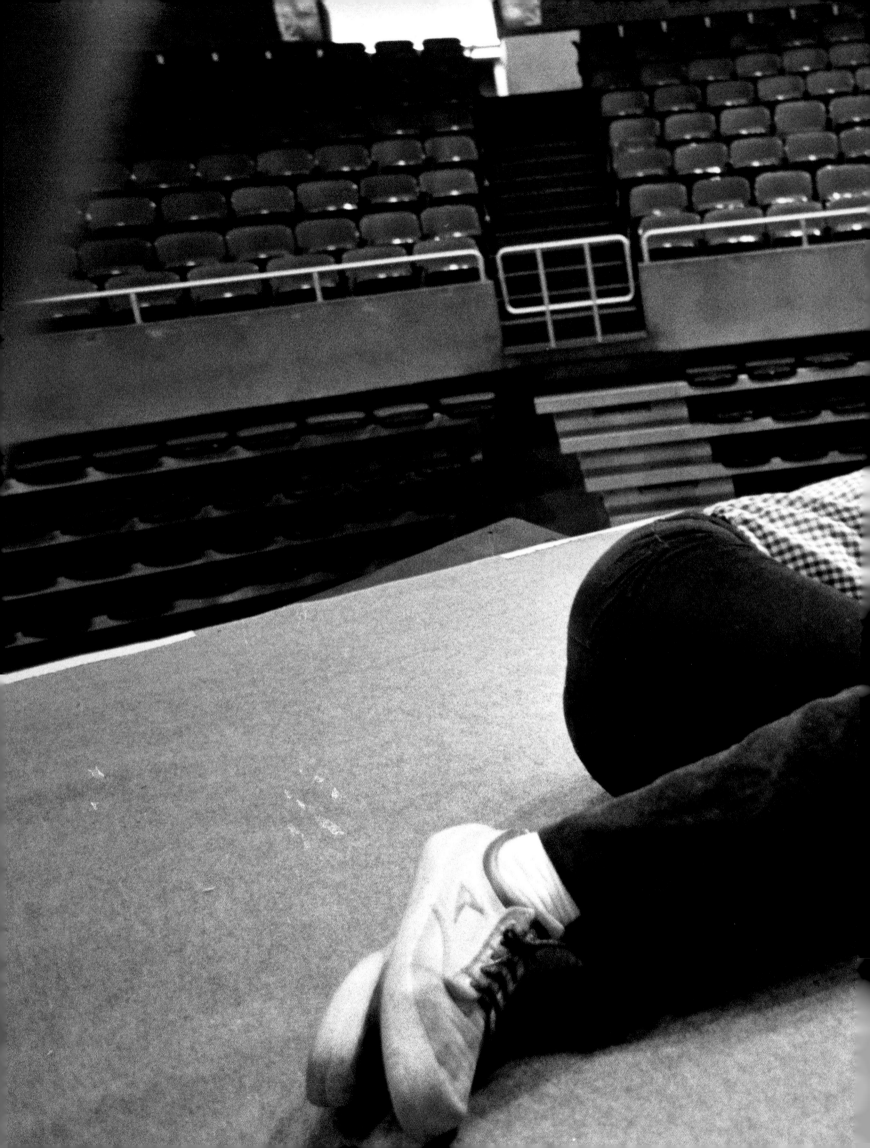

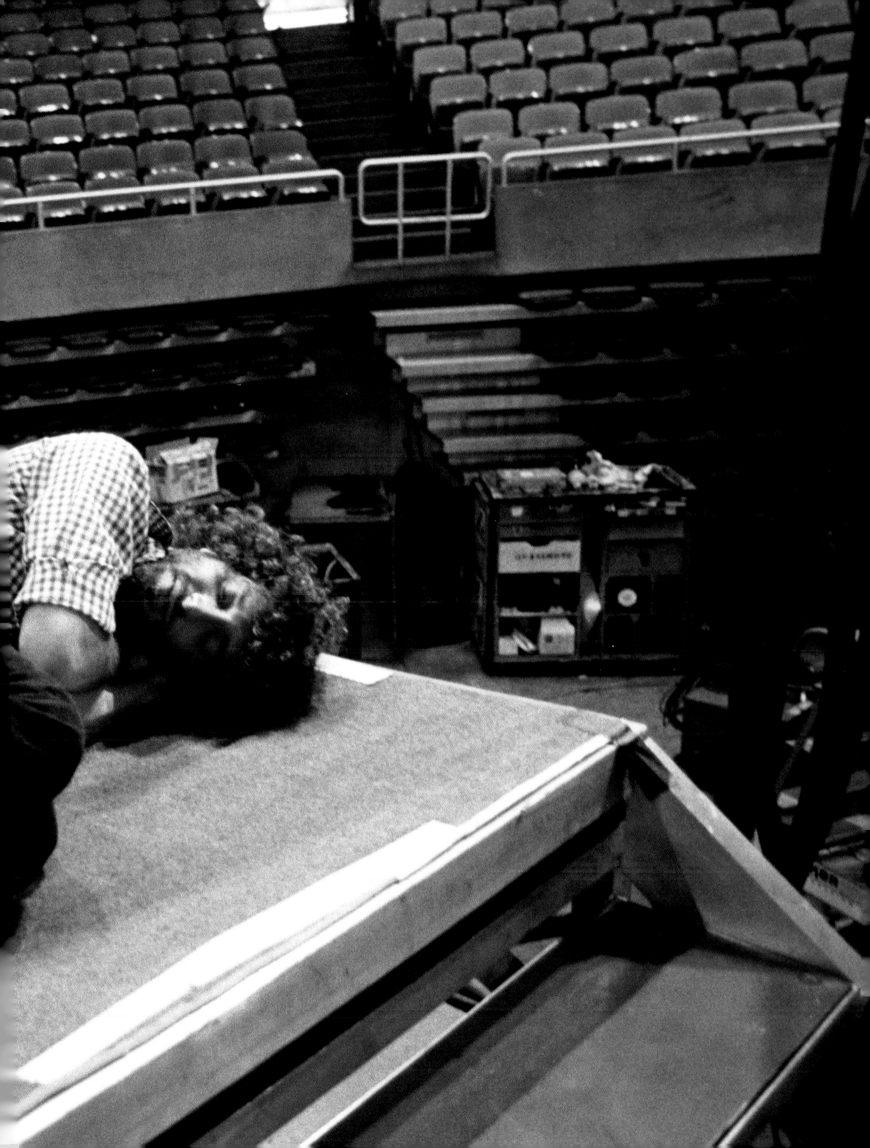

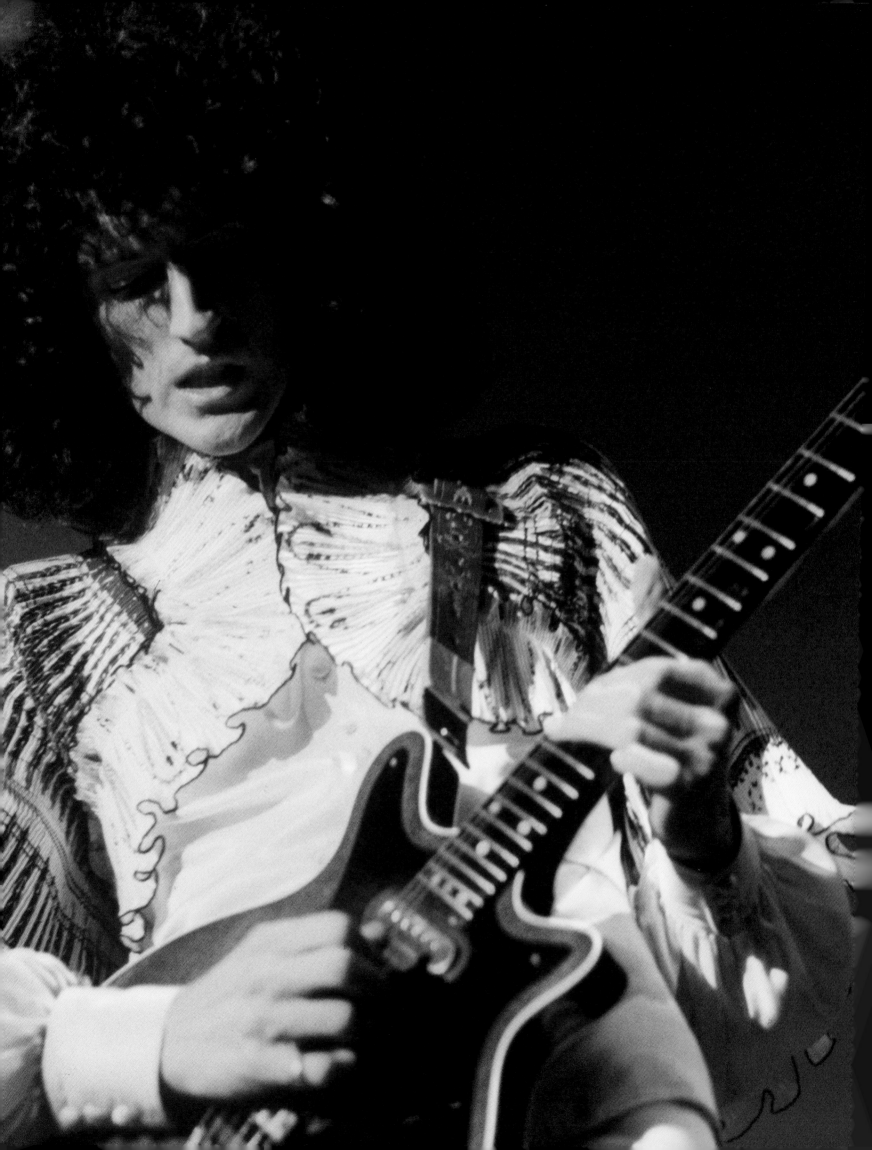

News of the World Tour, North America 1977

11 November – Cumberland County Civic Center, Portland, ME, USA
12 November – Boston Garden, Boston, MA, USA
13 November – Civic Center, Springfield, MA, USA
15 November – Civic Center, Providence, RI, USA
16 November – Veterans Memorial Coliseum, New Haven, CT, USA
18 November – Cobo Arena, Detroit, MI, USA
19 November – Cobo Arena, Detroit, MI, USA
21 November – Maple Leaf Gardens, Toronto, ON, Canada
23 November – The Spectrum, Philadelphia, PA, USA
24 November – The Spectrum, Philadelphia, PA, USA
25 November – Scope Arena, Norfolk, VA, USA
27 November – Coliseum, Richfield, OH, USA
29 November – Capital Center, Landover, MD, USA
01 December – Madison Square Garden, New York, NY, USA
02 December – Madison Square Garden, New York, NY, USA
04 December – University Arena, Dayton, OH, USA
05 December – Chicago Stadium, Chicago, IL, USA
08 December – Omni, Atlanta, GA, USA
10 December – Convention Center, Fort Worth, TX, USA
11 December – Summit, Houston, TX, USA
15 December – Aladdin Theater, Las Vegas, NV, USA
16 December – Sports Arena, San Diego, CA, USA
17 December – Oakland-Alameda County Coliseum, Oakland, CA, USA
20 December – Long Beach Arena, Long Beach, CA, USA
21 December – Long Beach Arena, Long Beach, CA, USA
22 December – The Forum, Inglewood, CA, USA

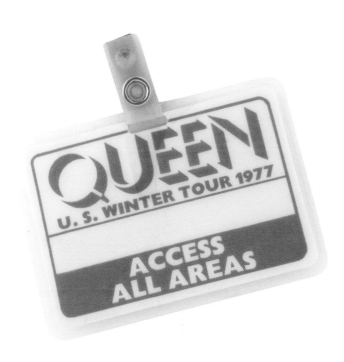

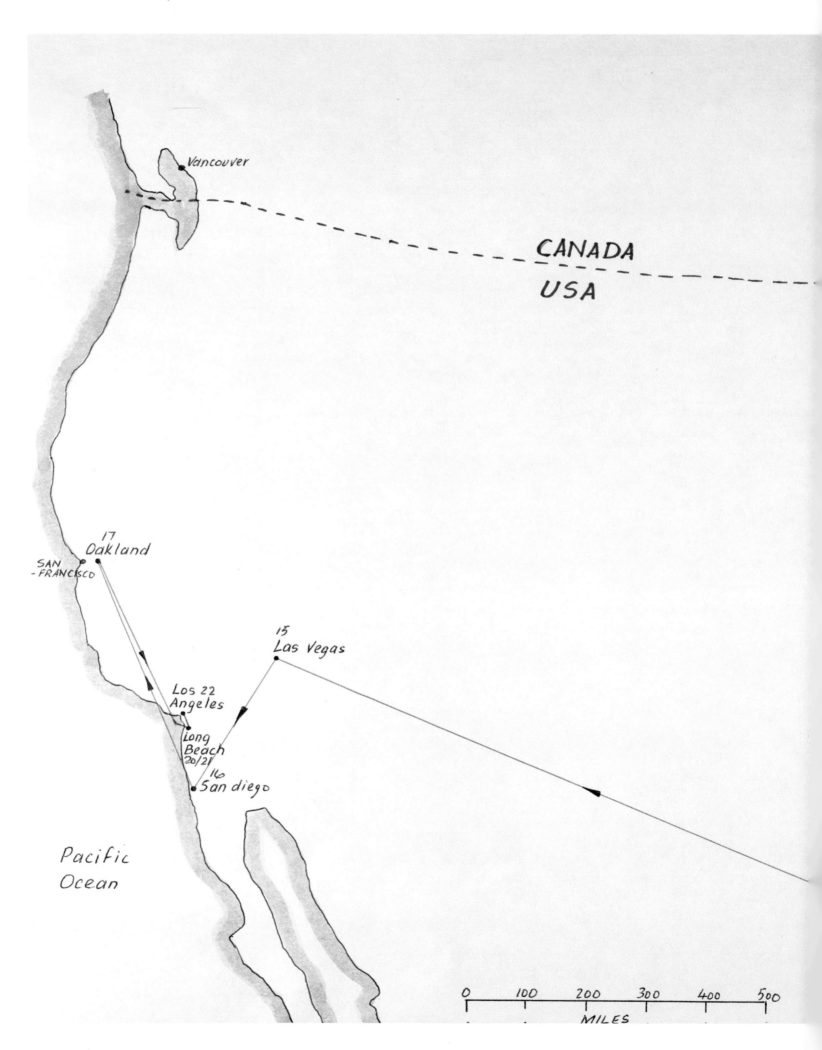

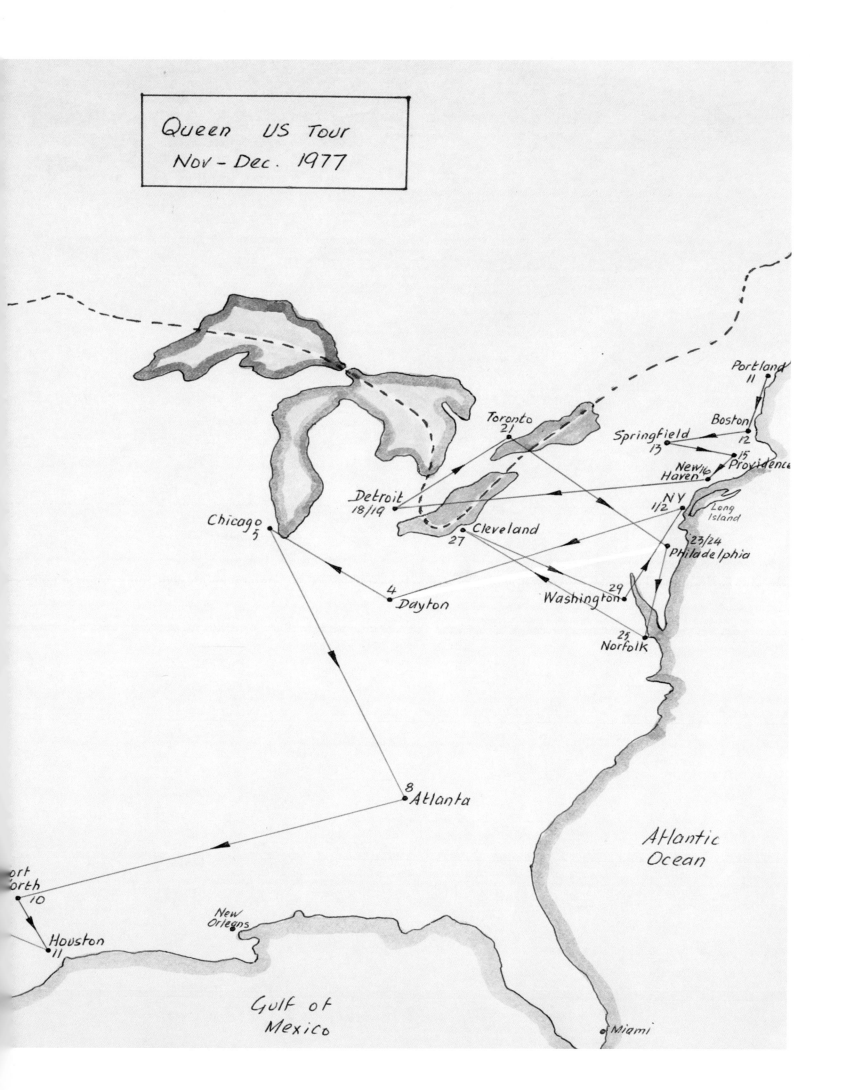

Queen US Tour
Nov - Dec. 1977

Portland 11
Boston 12
Springfield 13
Toronto 21
New Haven 16
Providence 15
NY 1/2
Long Island
Detroit 18/19
Chicago 5
Cleveland 27
Philadelphia 23/24
4 Dayton
Washington 29
25 Norfolk
8 Atlanta
Atlantic Ocean
ort orth 10
New Orleans
Houston 11
Gulf of Mexico
Miami

My time with Queen goes way back to 1977 or so. At that point in my life my work with Led Zeppelin had preceded me, and it seemed like every band I worked with had that same look in their eyes: sooner or later Preston's gonna bust out some killer Zeppelin stories. When I first hooked up with Queen it was no different. But it wasn't typical fan-boy type stuff they asked me . . . it was more about how the Zeppelin organization worked, and lots of questions about Peter Grant.

Certainly, Brian, Roger and John were all ears; Freddie, not so much. I explained how, as a photographer, I fit into the Zeppelin jigsaw puzzle. I wanted to work with Queen the same way—let me do what I do, let me go where I need to go, and just allow me to be invisible. That's the way we're going to get the best photos, I told them. And by that point in my career I had come to the realization that the best way to be invisible was to be completely visible at all times. That's the irony of how I work, I become part of the fabric of the tour. Nobody blinks an eye if a roadie walks in the dressing room. Nobody notices the agent, the promoter or the bus driver. And nobody should notice me . . .

From the beginning, all four of the guys were quite genial and seemed genuinely pleased to have me around. I was given a very long leash, which was what I needed.

Over my first few days on the road with Queen, I naturally came away with some initial impressions (not knowing that I'd become part of the band's family for the next 10 years and beyond). First off, they all took their jobs very seriously. Each soundcheck seemed to be a quasi band meeting so I'd sneak around, shoot a few frames, and just generally take the room's temperature.

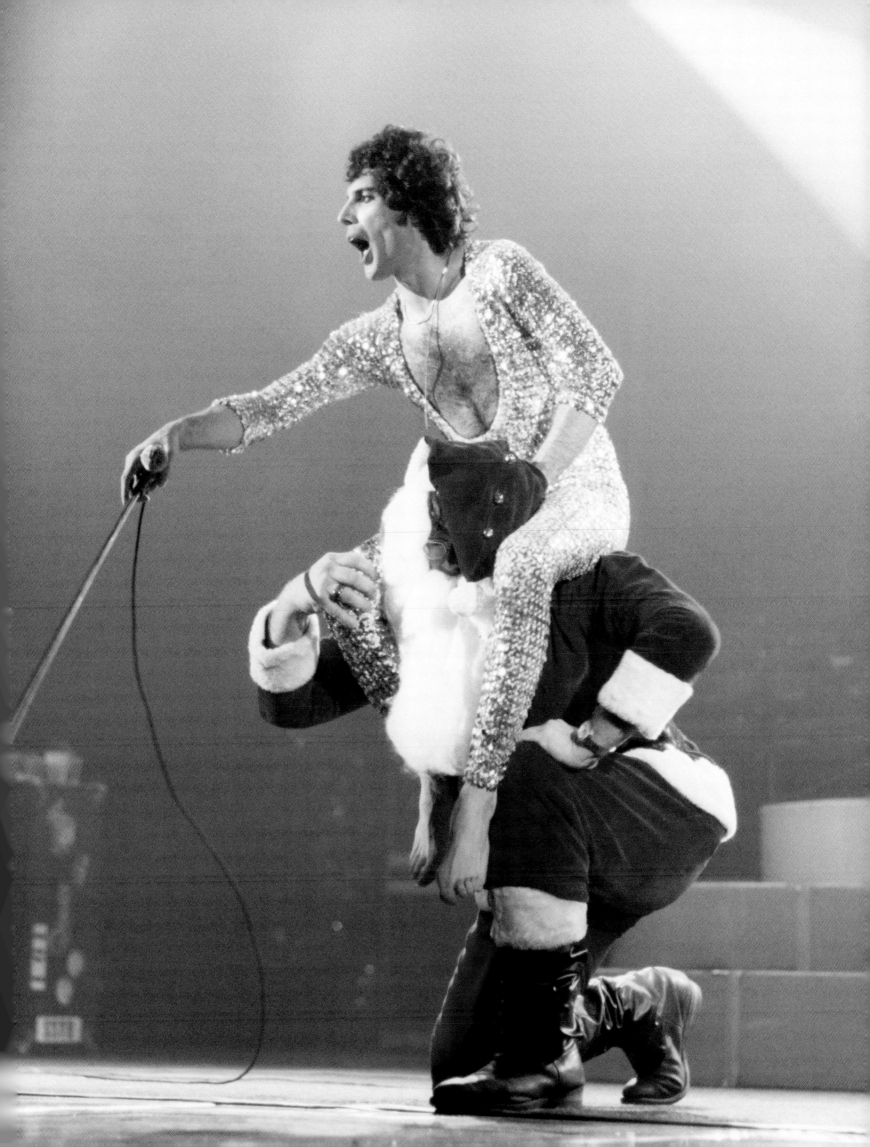

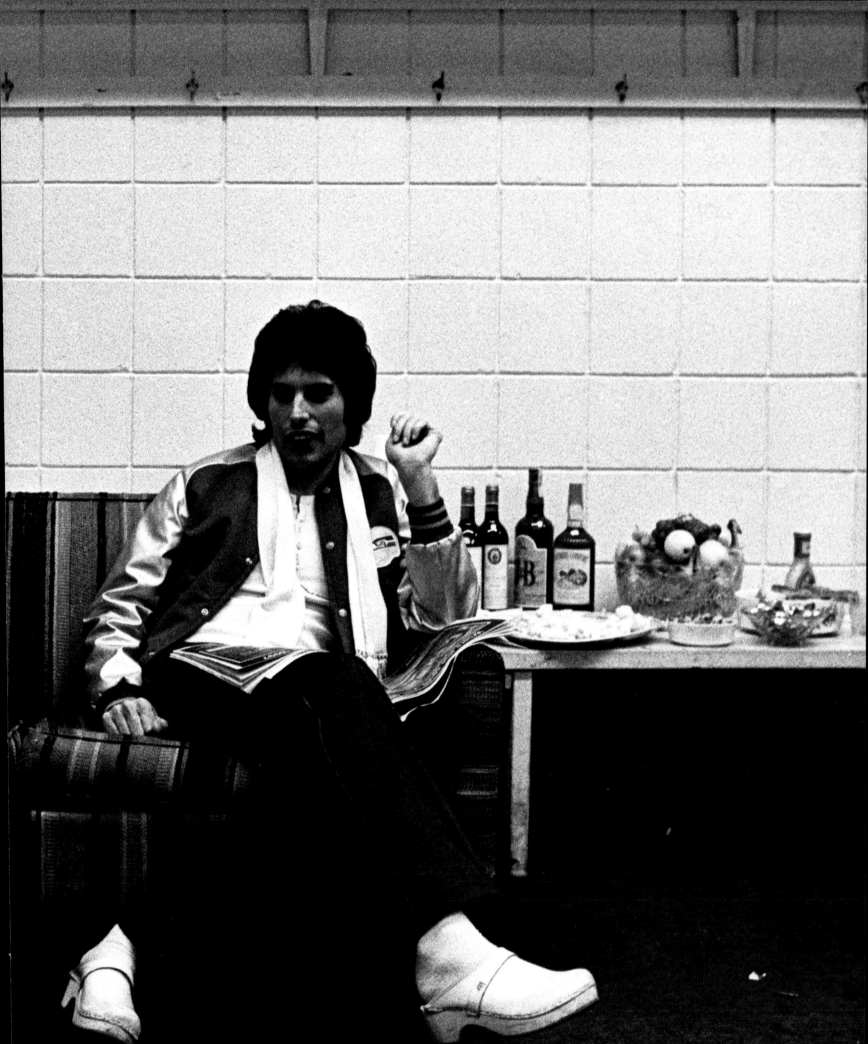

Freddie was the obvious visual focus of the band for me. He was always happy to have me around and I came to realize that his favorite thing in life was to be Freddie Mercury. Even when he was "off" he was "on". He never told me to put a camera down, on the contrary he seemed to revel in the fact that I was always around to document everything that went on. As a badge of honor and acceptance I was immediately given a very Queen-esque nickname by Freddie, dubbed "Linda Lens".

John was also so gracious and accepting of me. He seemed quite bright (they all did) with a vague air of independence. He would sort of listen to people's conversations and evaluate what was said, reacting with a sly grin or perhaps nothing at all.

Roger, of course, was the initial band member I gravitated to. A real rock star from top to bottom, he looked like one, dressed like one and generally always carried himself like one. He also seemed to be the one most concerned with how he looked in photos, so I knew that getting close to his drum roadie Crystal was gonna be imperative for me.

Brian May at first seemed a bit aloof but I came to realize that was just his normal day-to-day mode. On stage, he seemed to have a bit of a look on his face that said, "Where am I? Who are all these people?" We bonded over a mutual love of photography, and I had no idea that he was considered an expert in the field of stereoscopic photography. Sometimes he'd throw me one of his stereo cameras and say, "Just shoot whatever you want with this," which I happily did. He also knows a strong image when he sees one and never minded when I'd sneak up behind him with a Nikon or two.

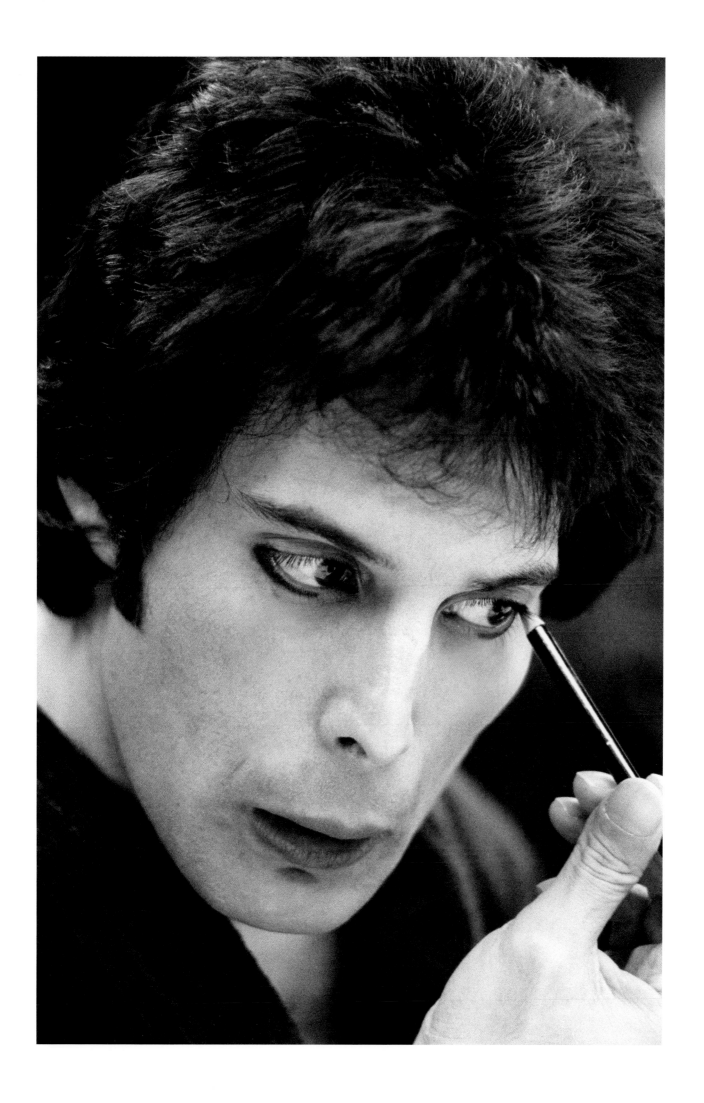

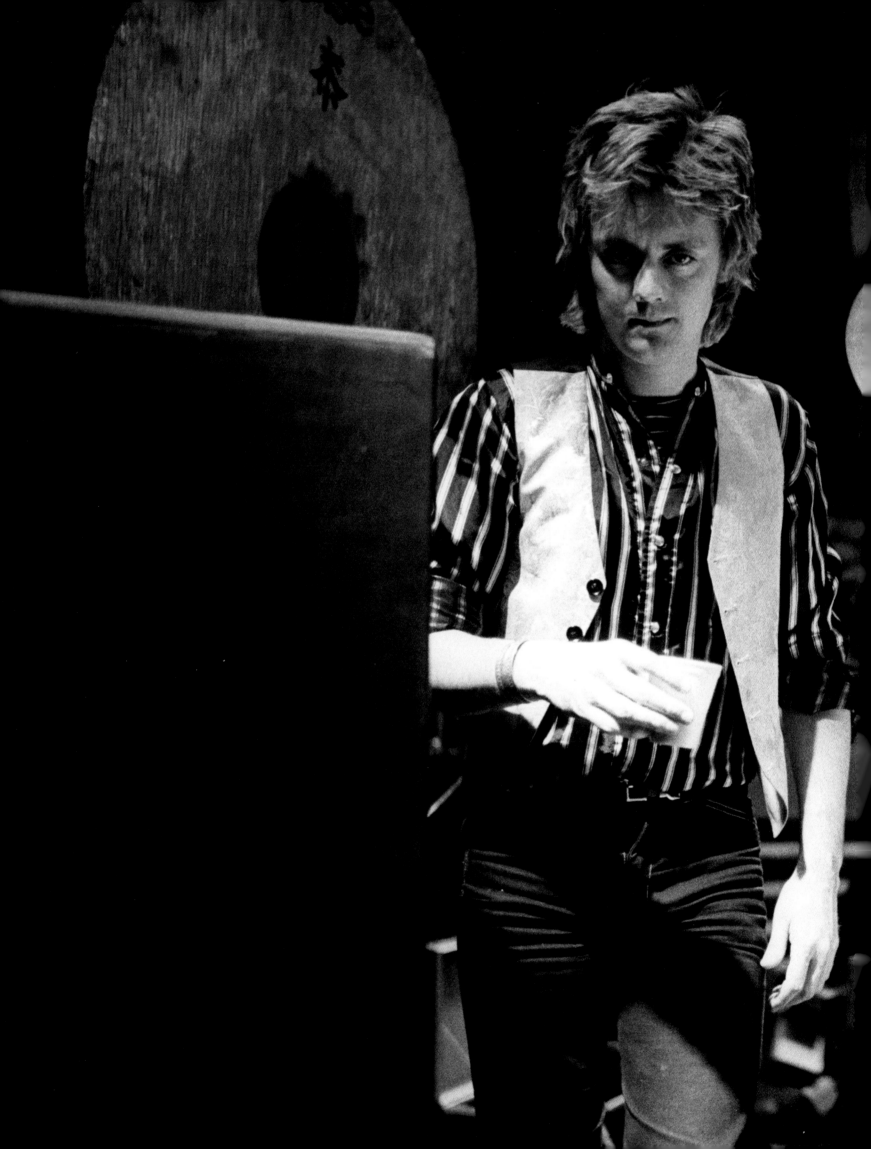

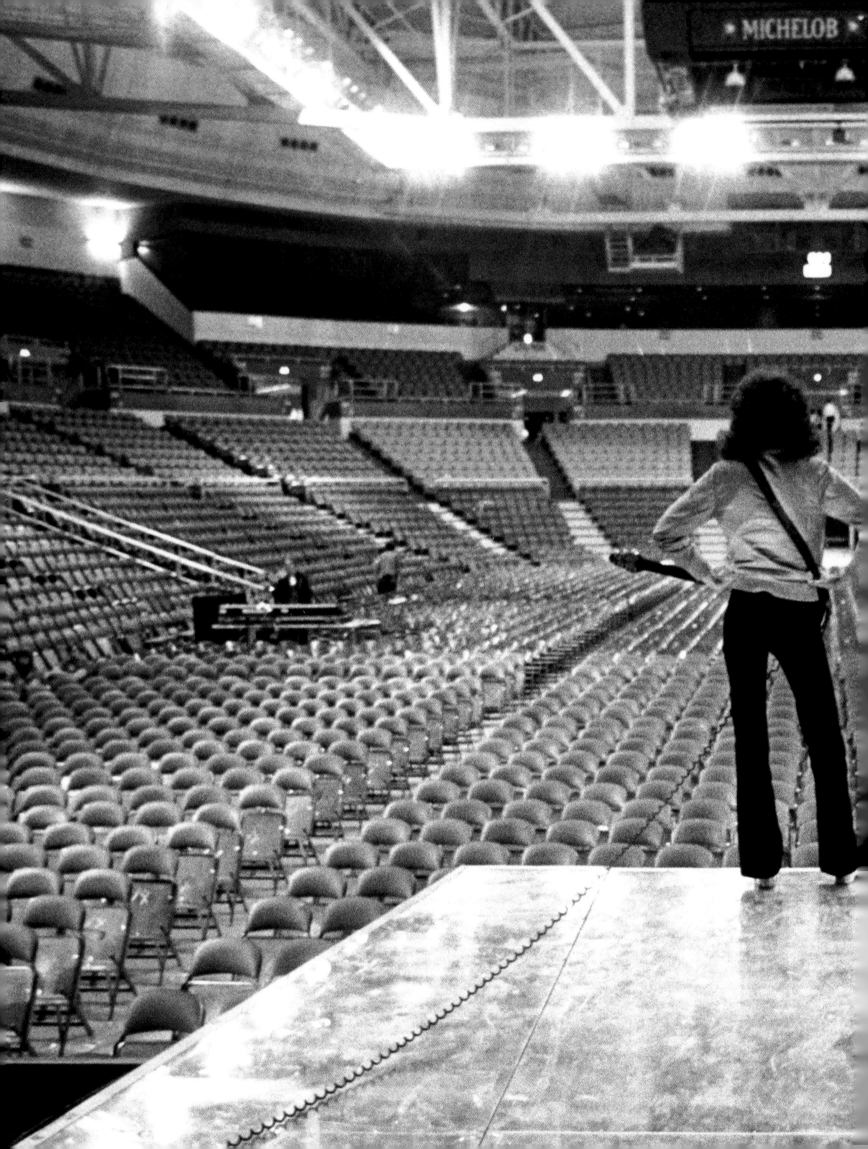

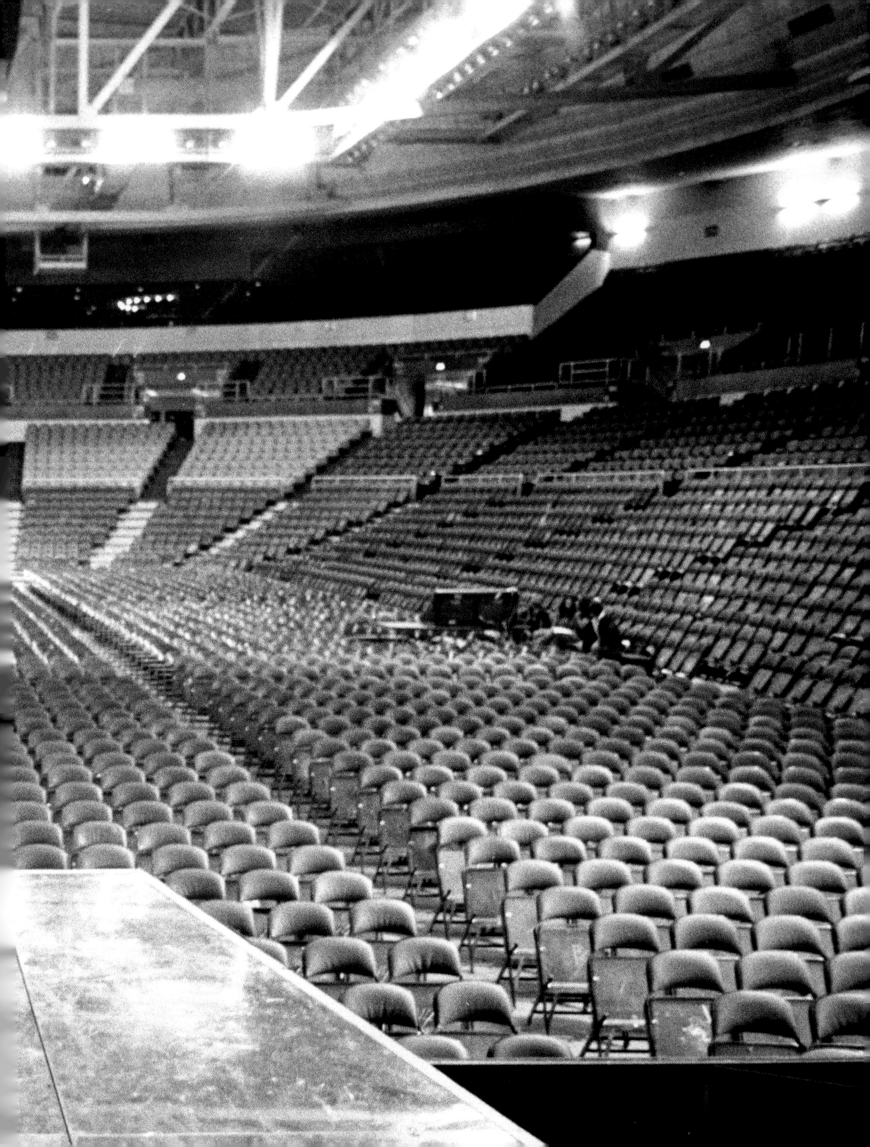

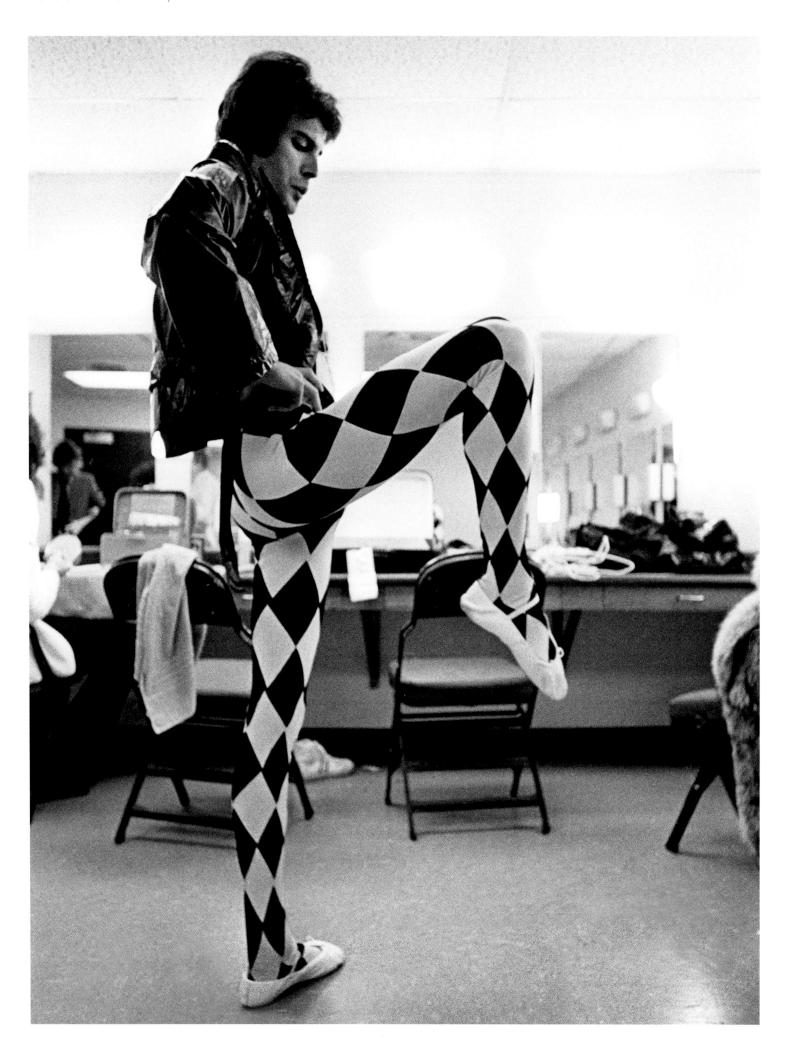

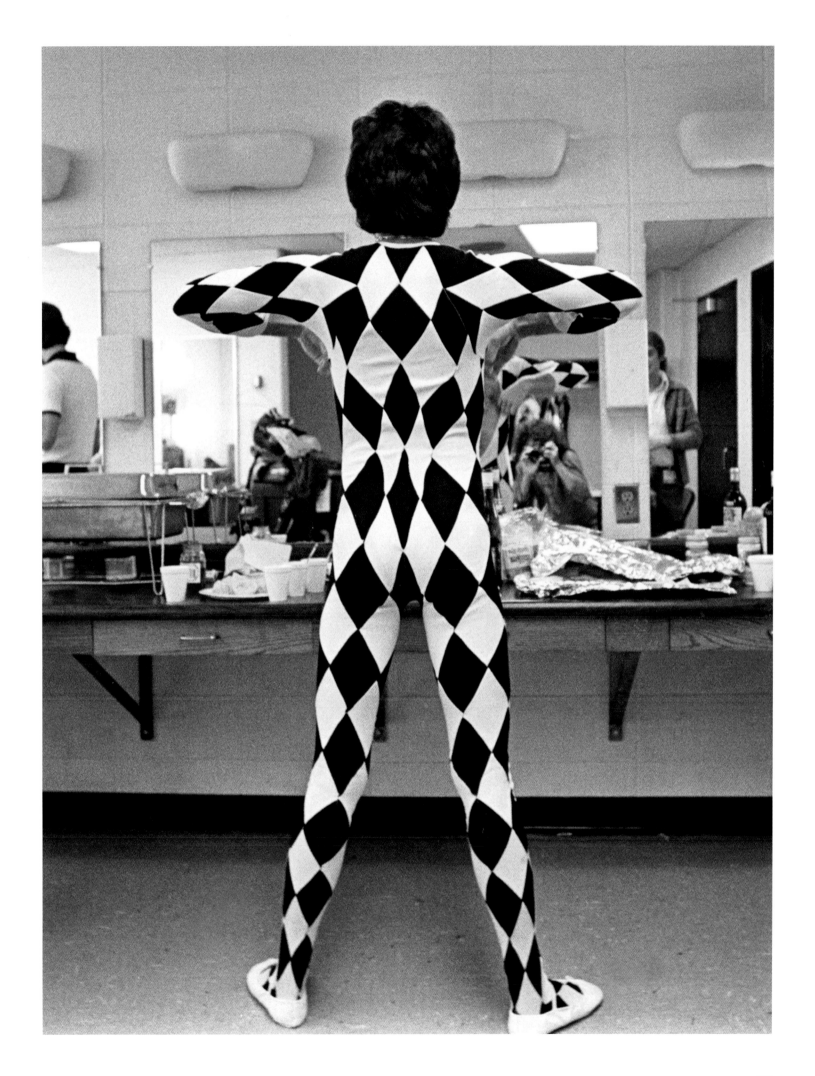

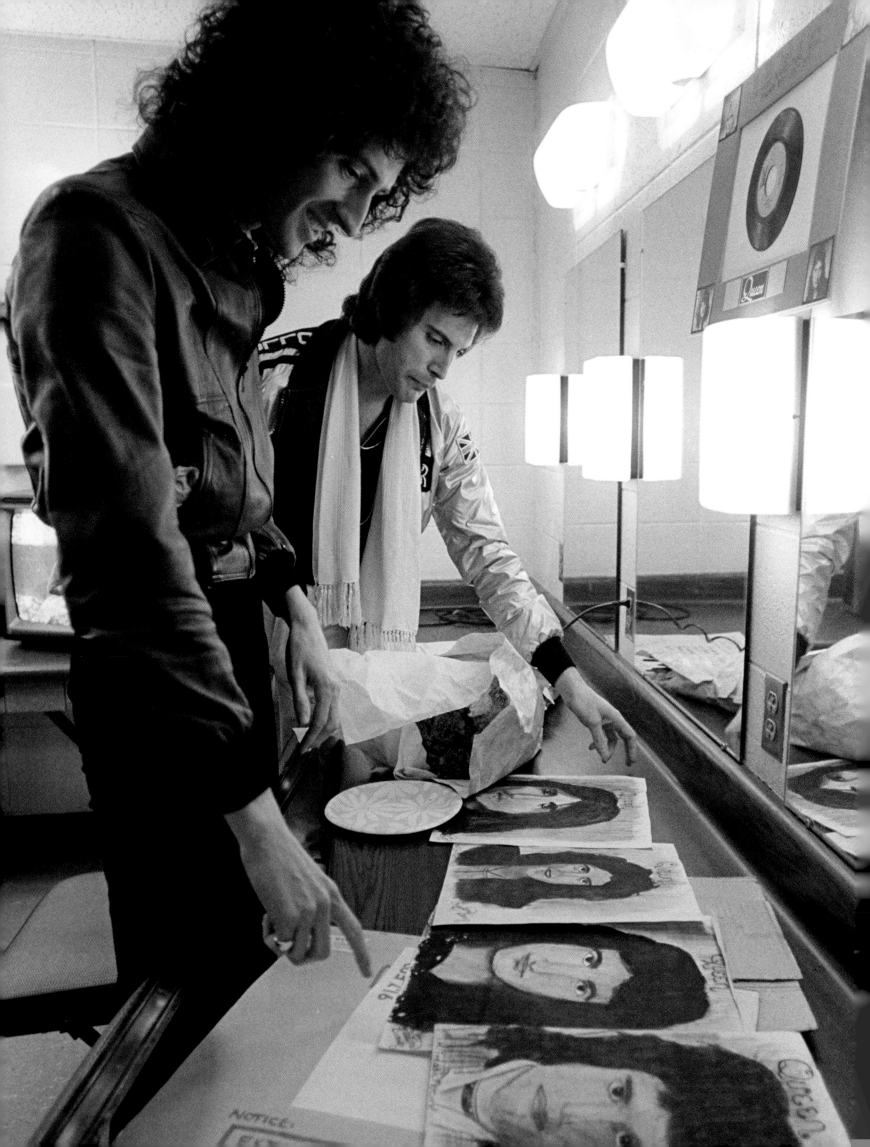

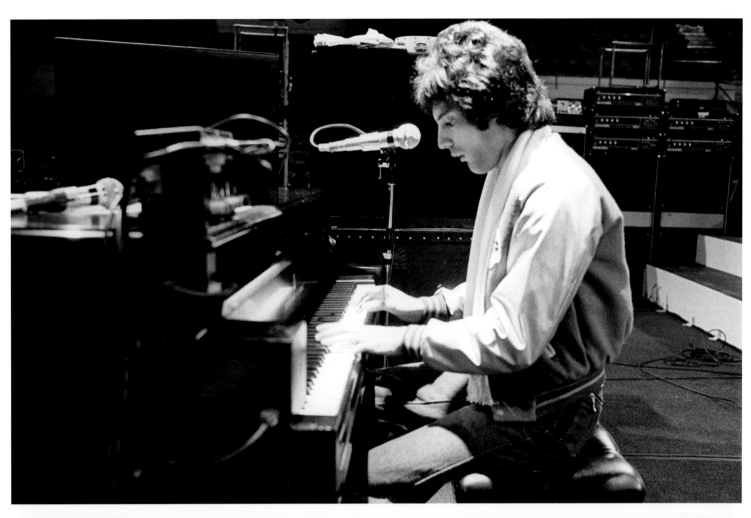

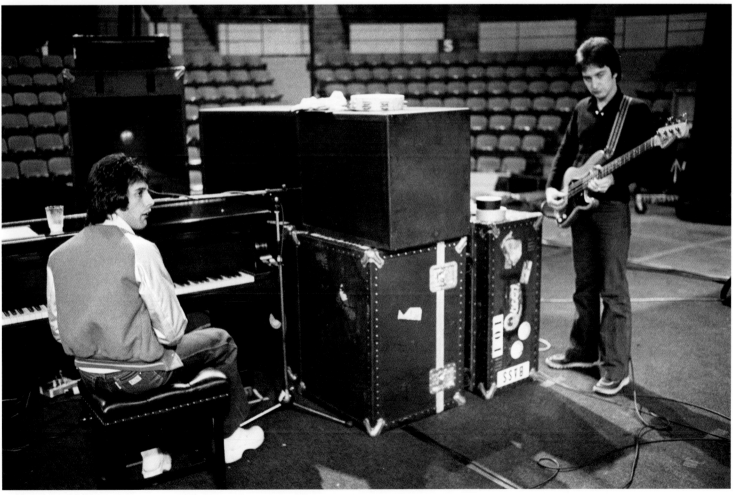

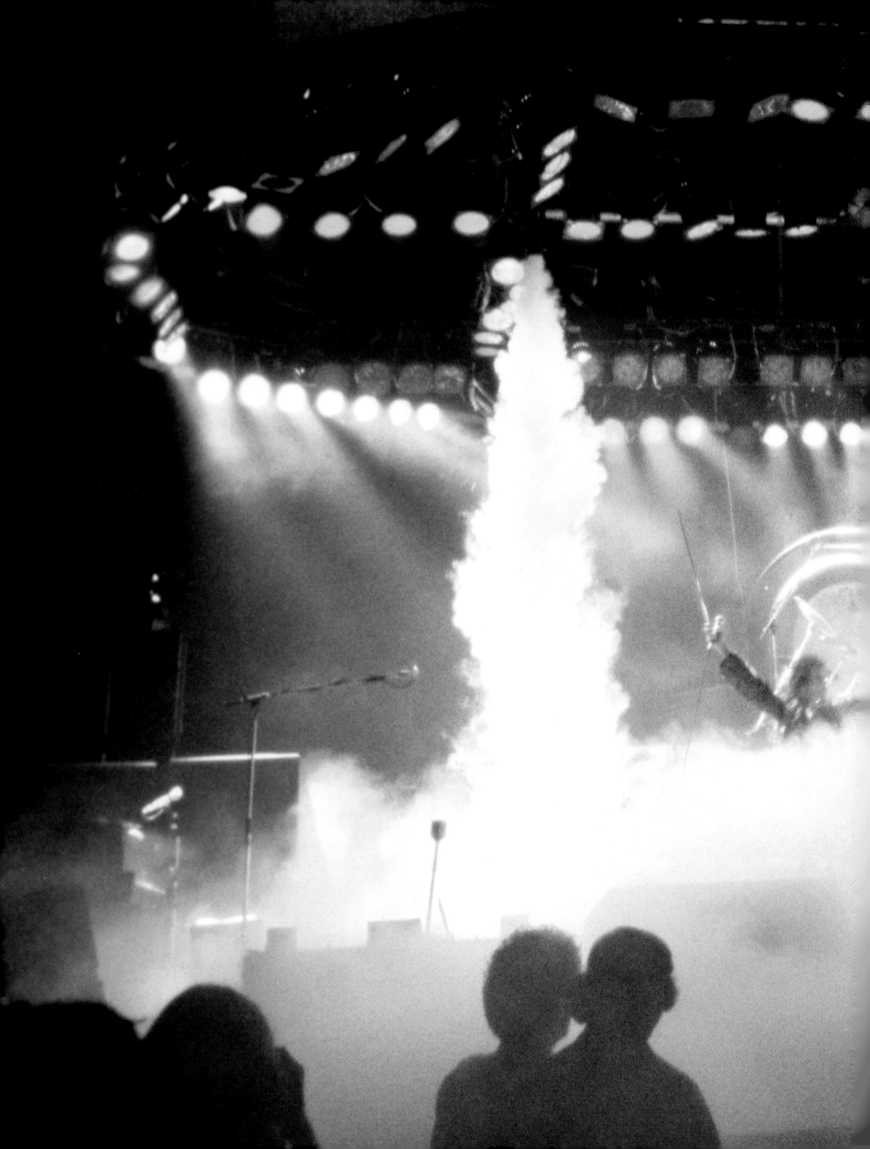

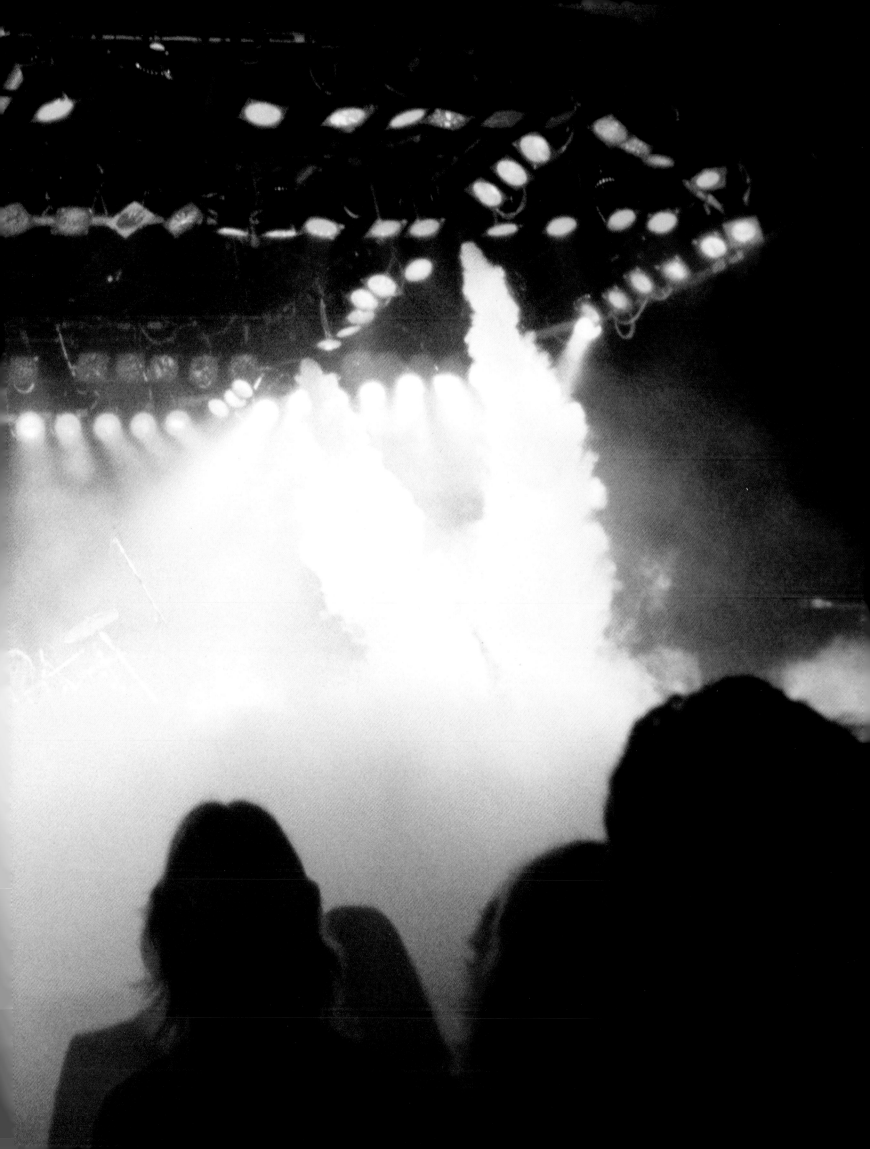

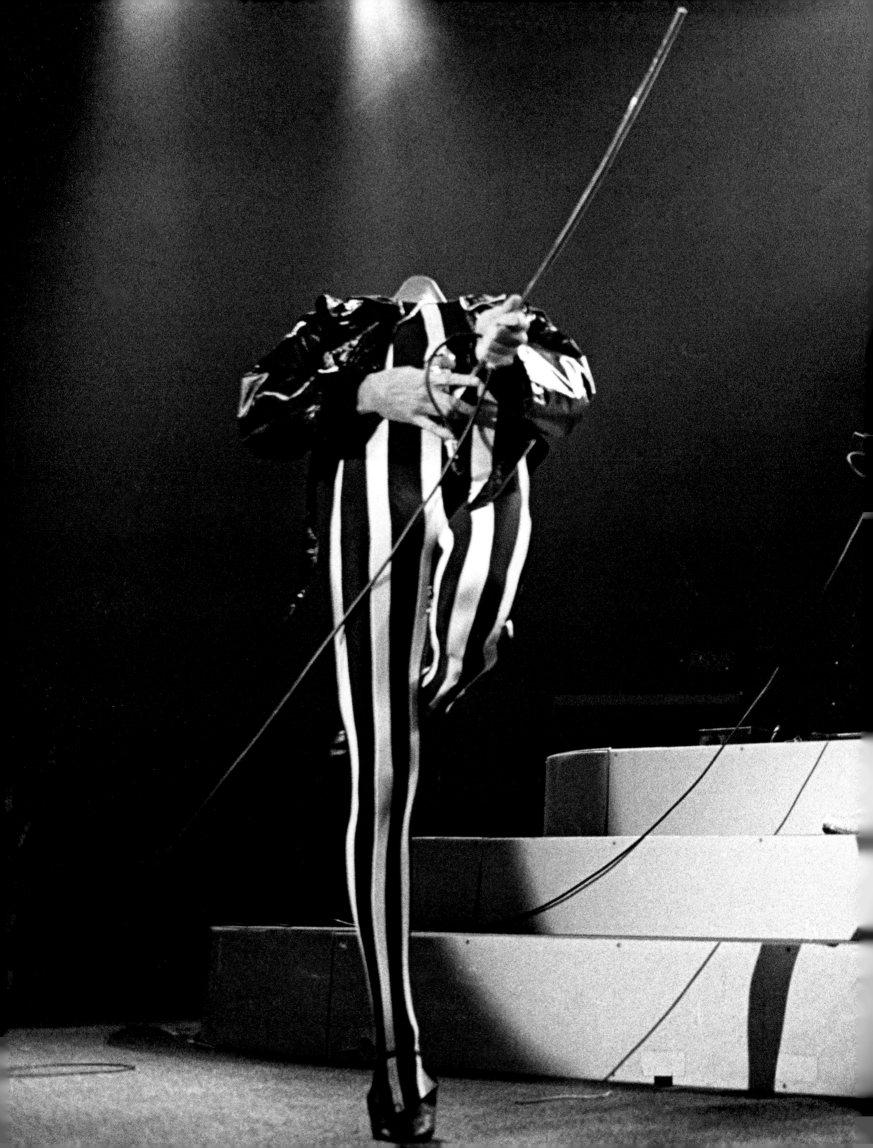

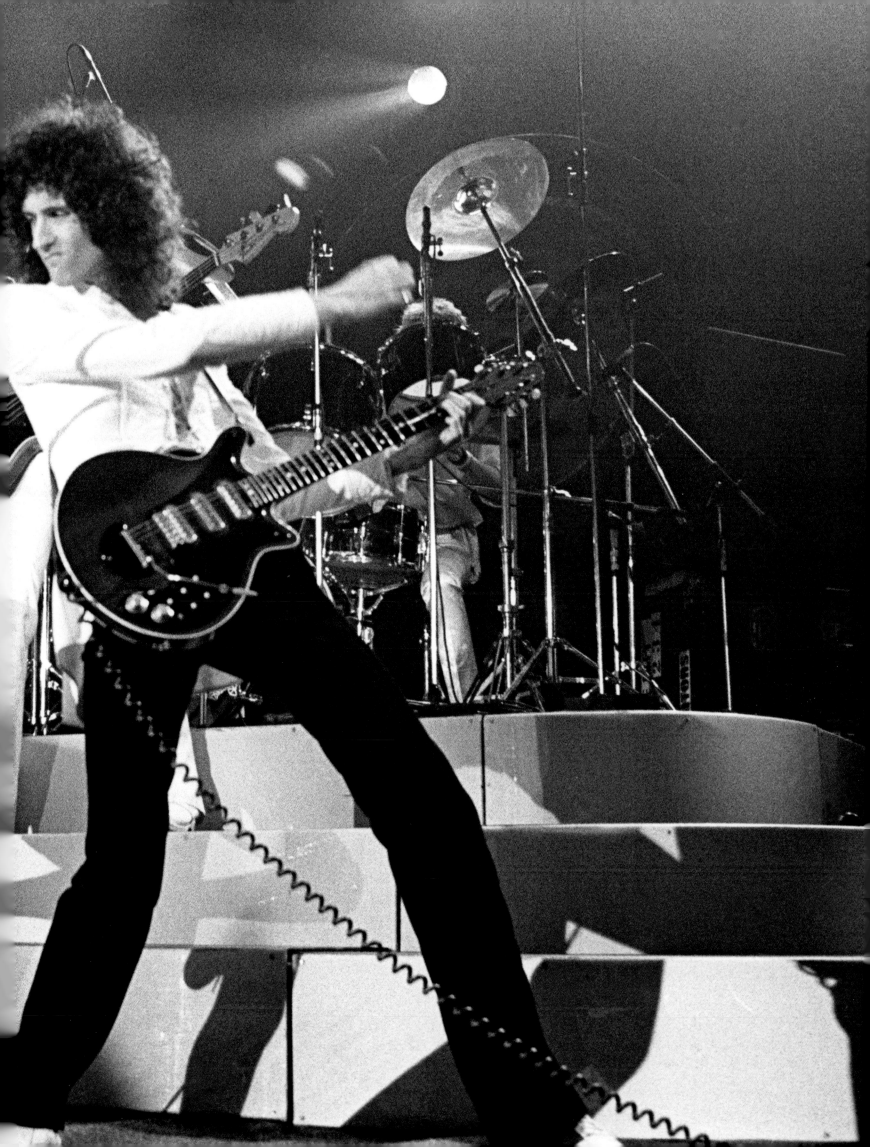

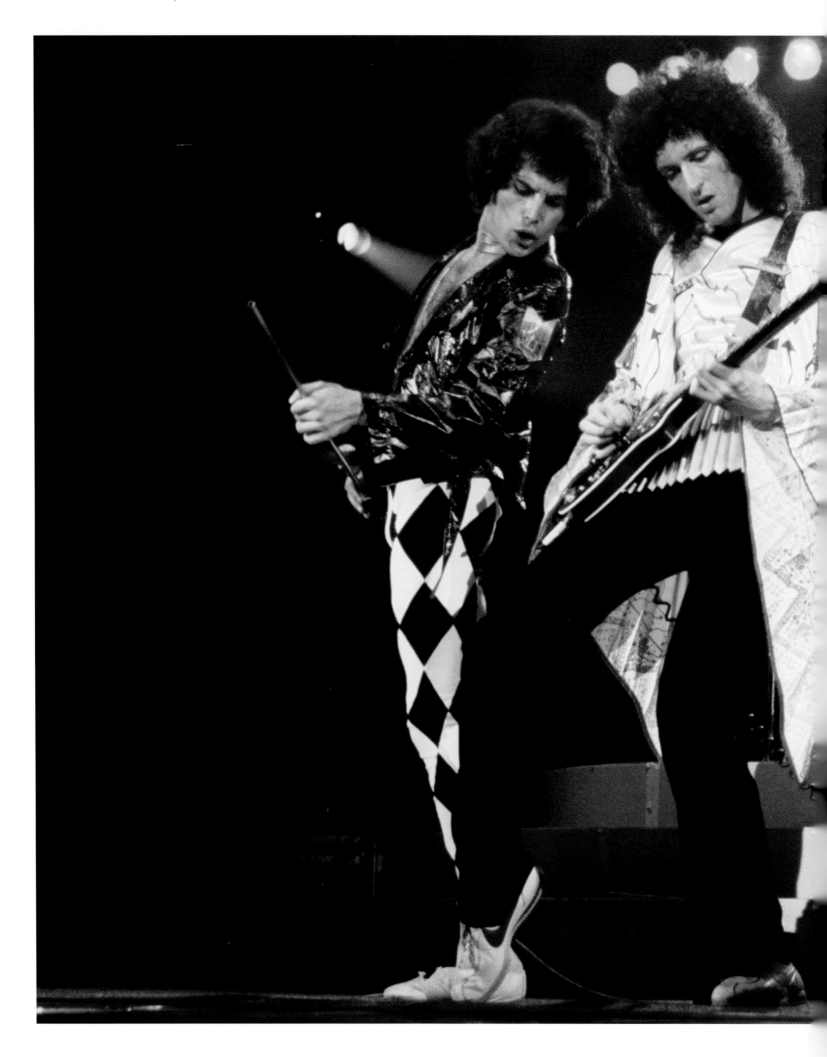

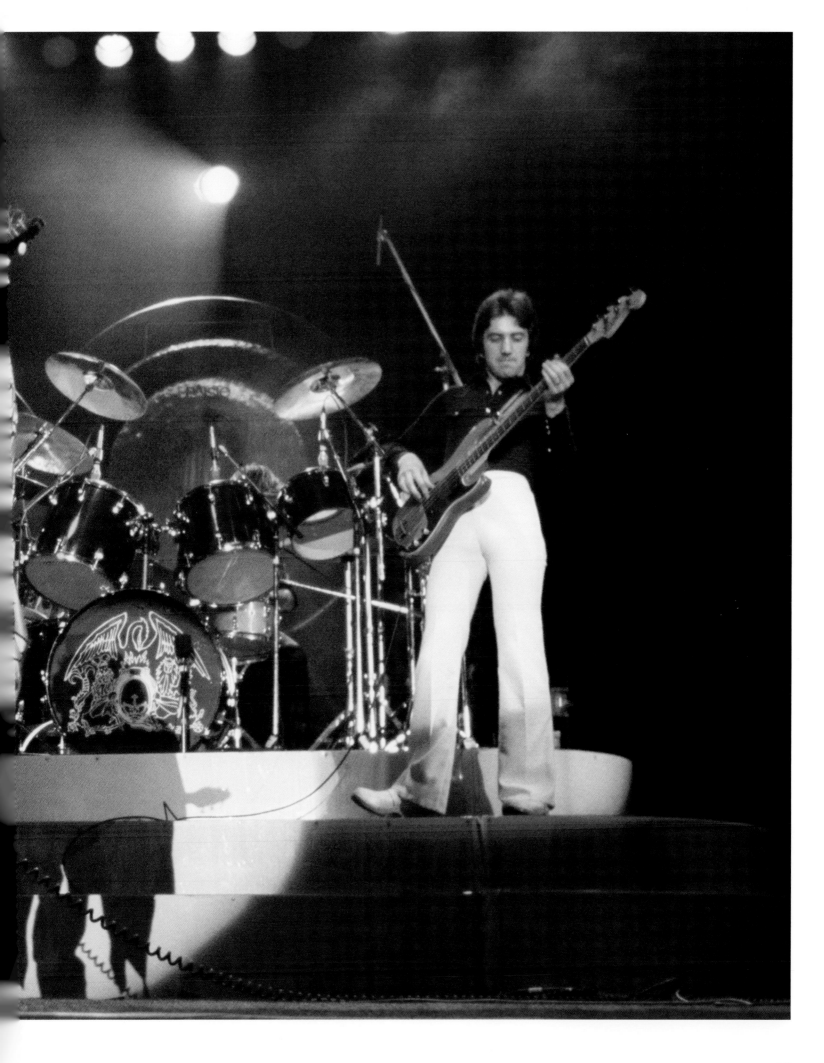

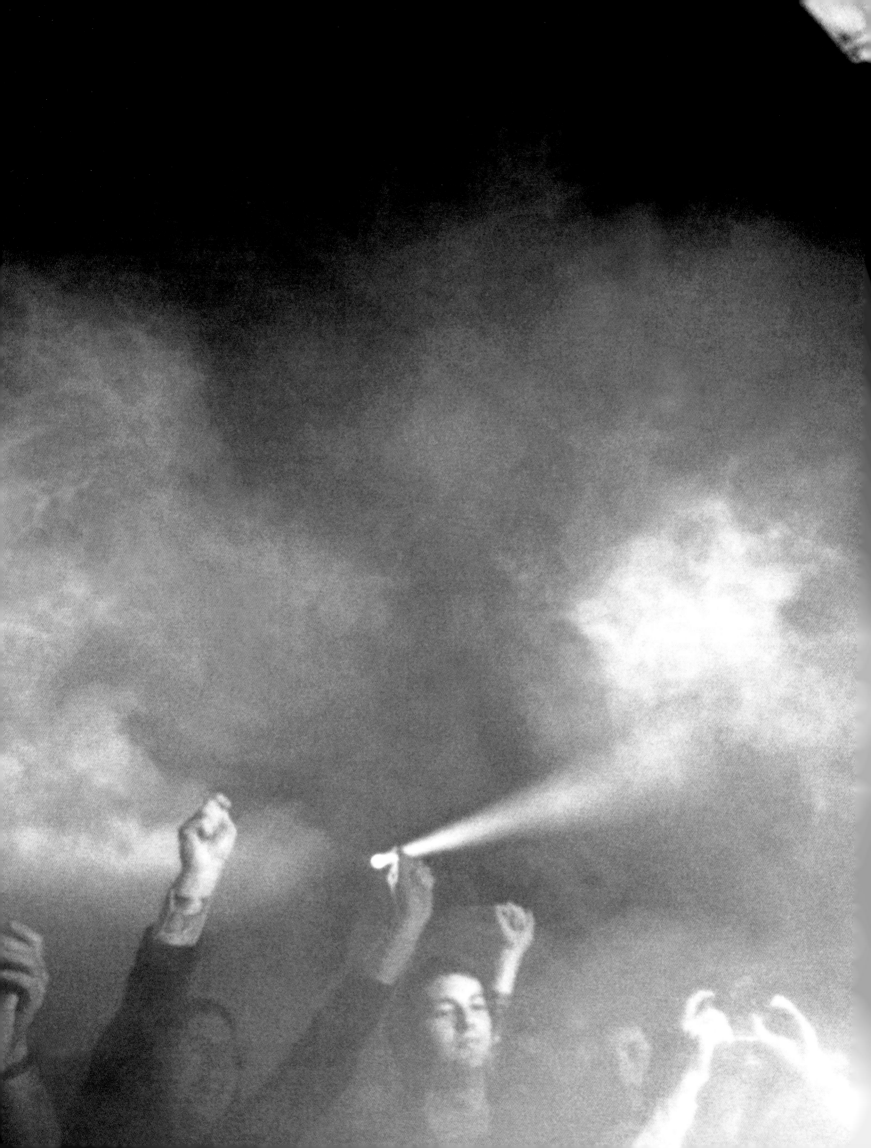

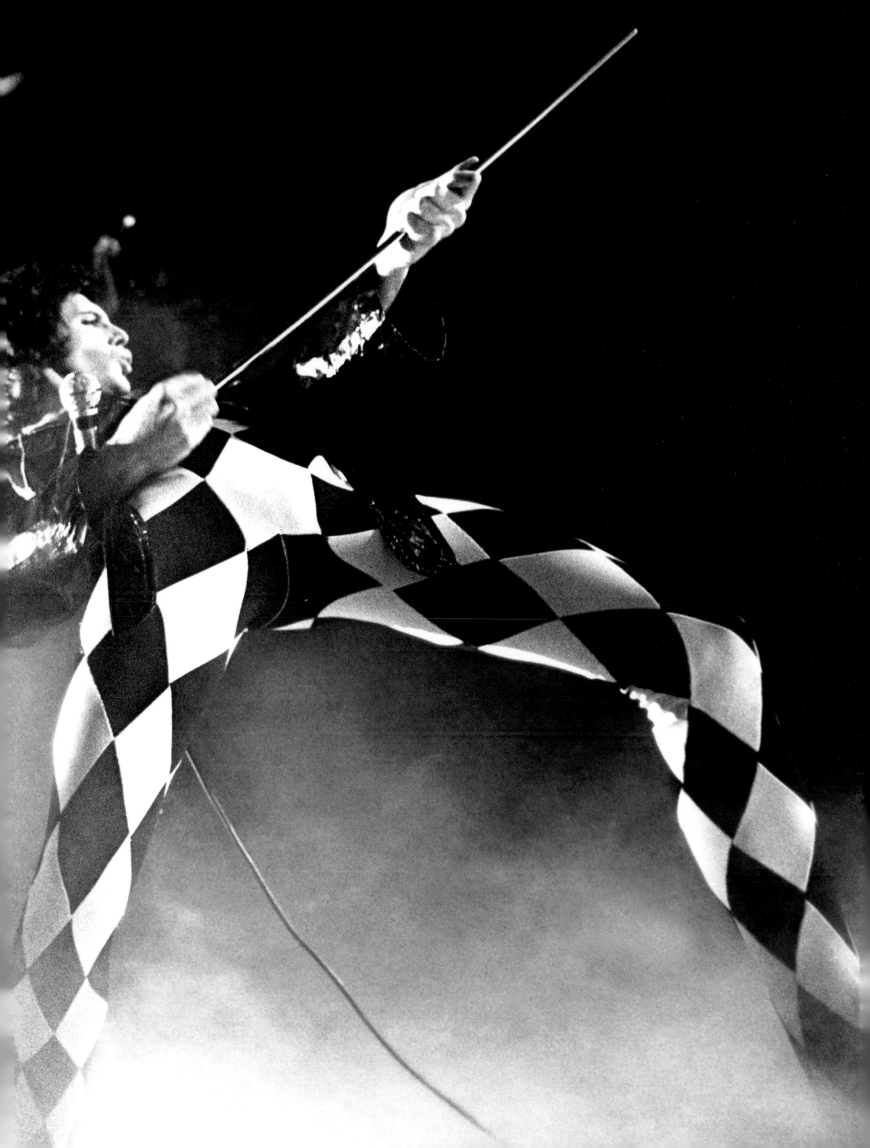

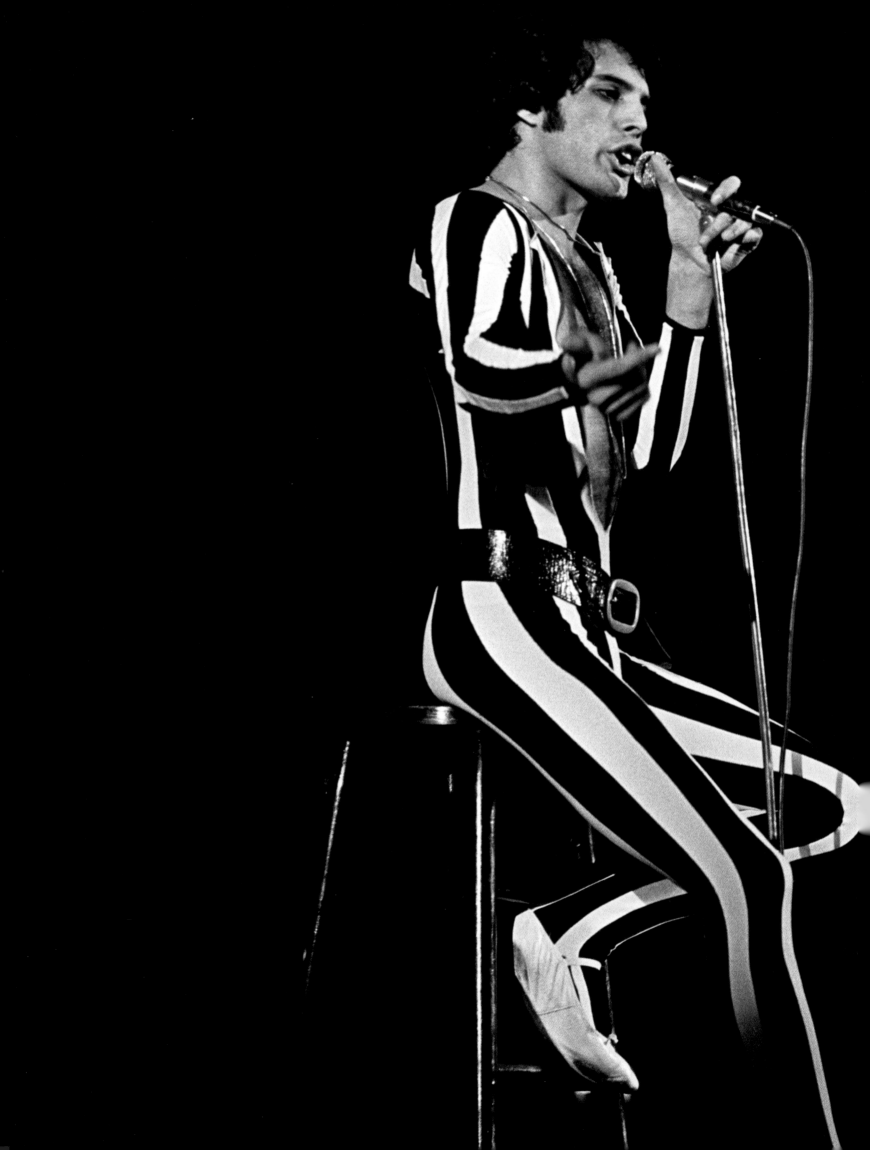

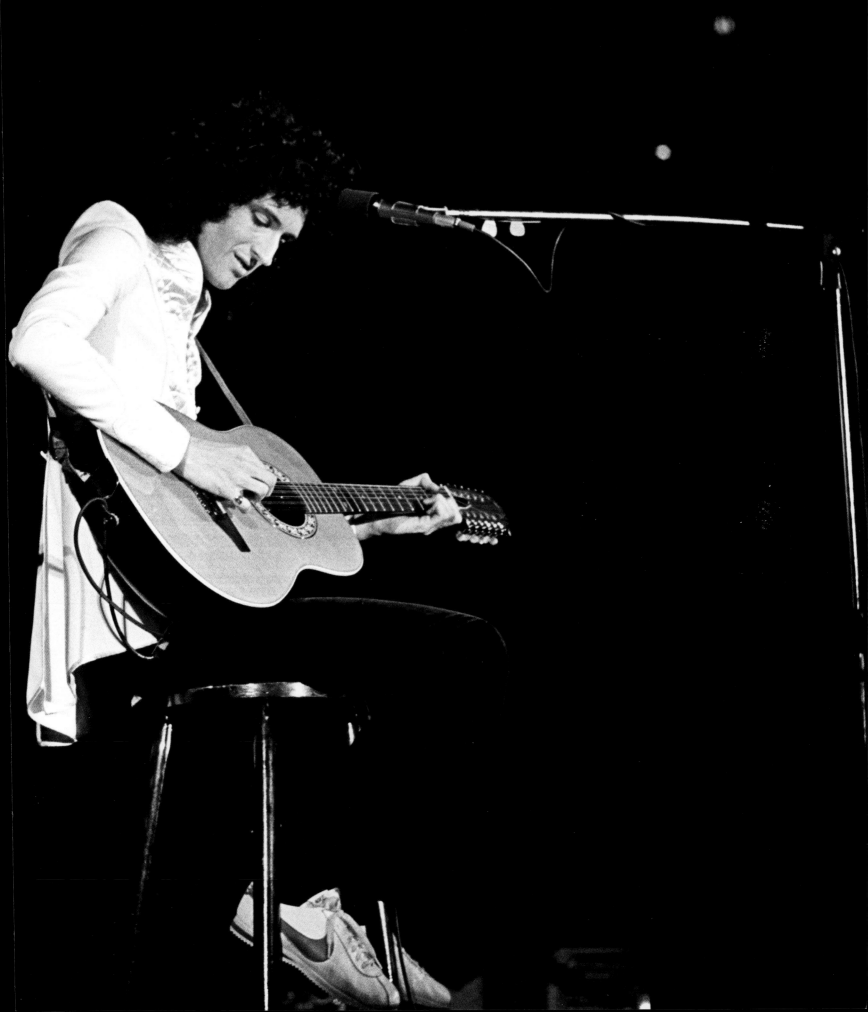

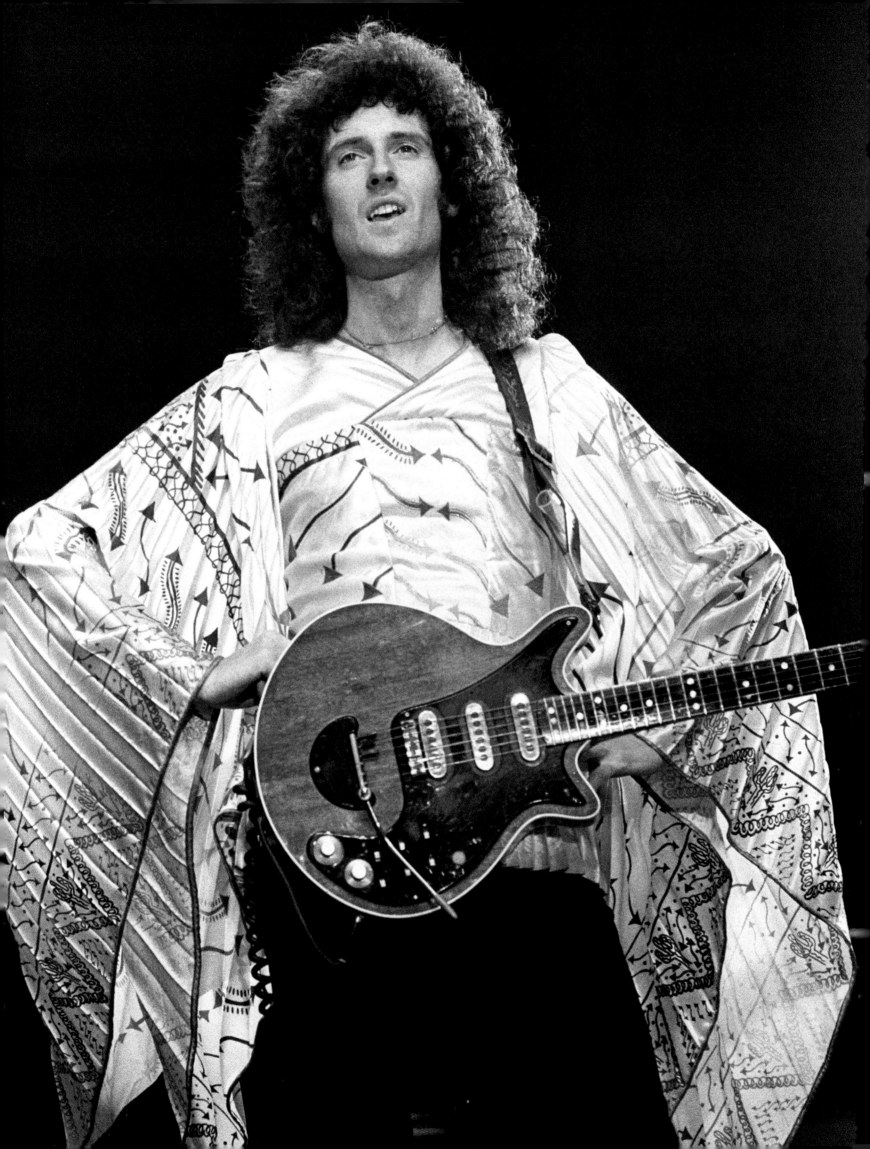

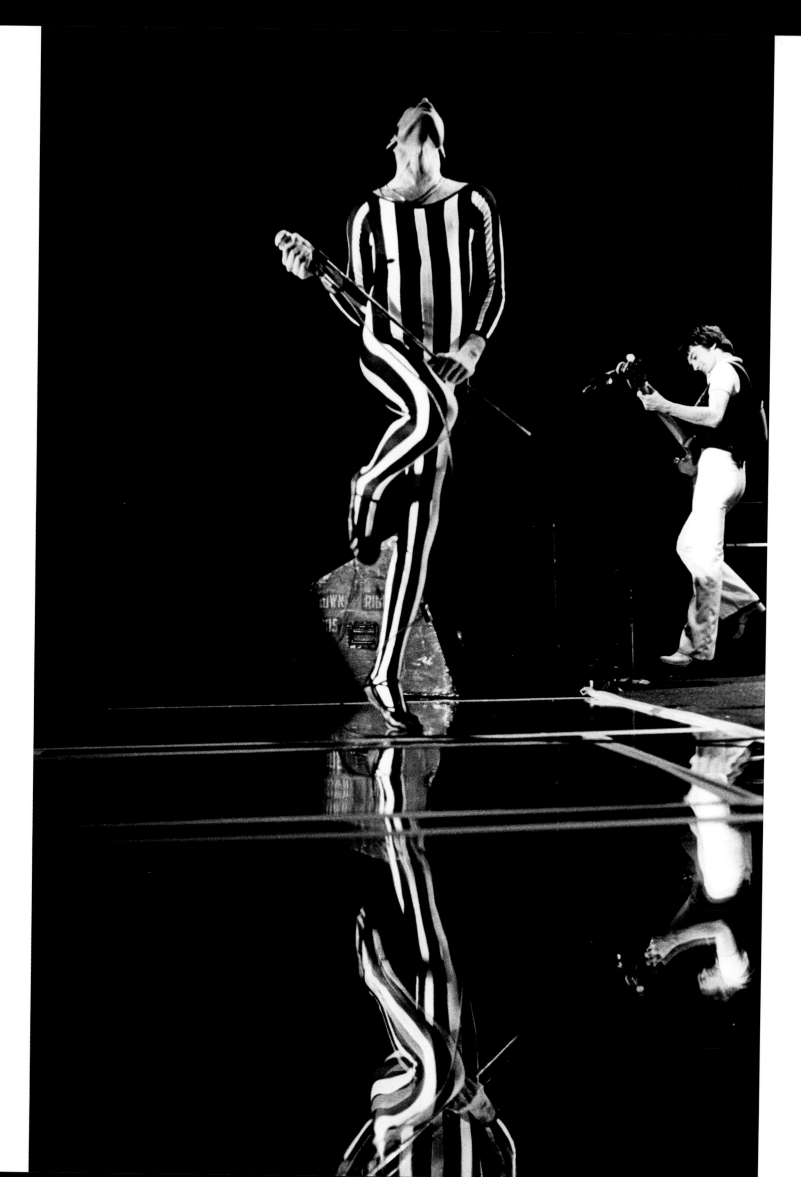

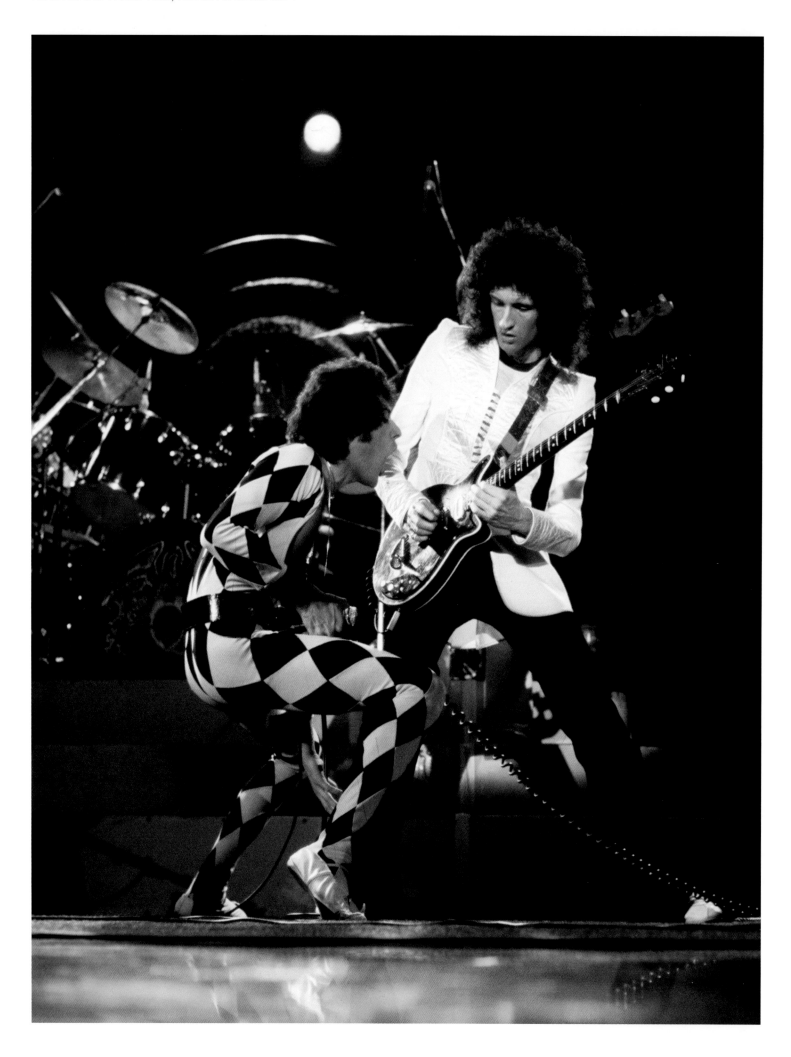

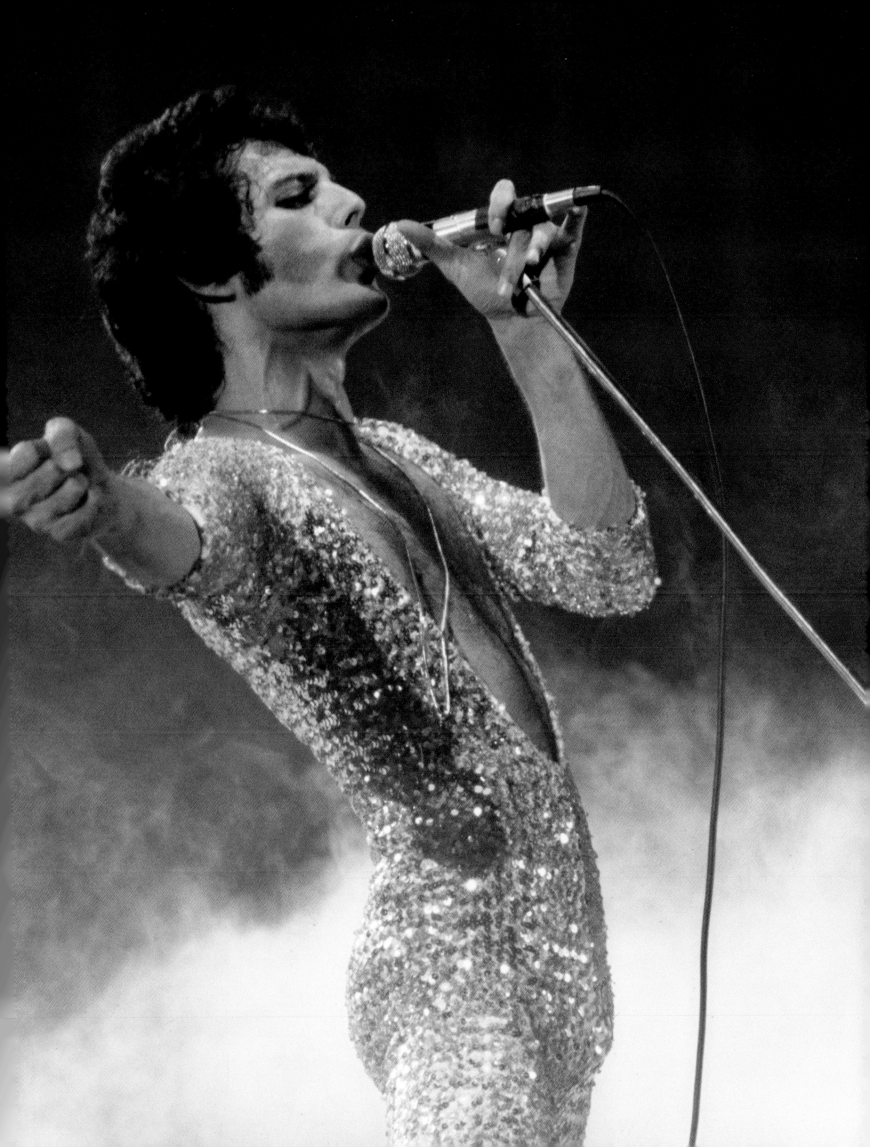

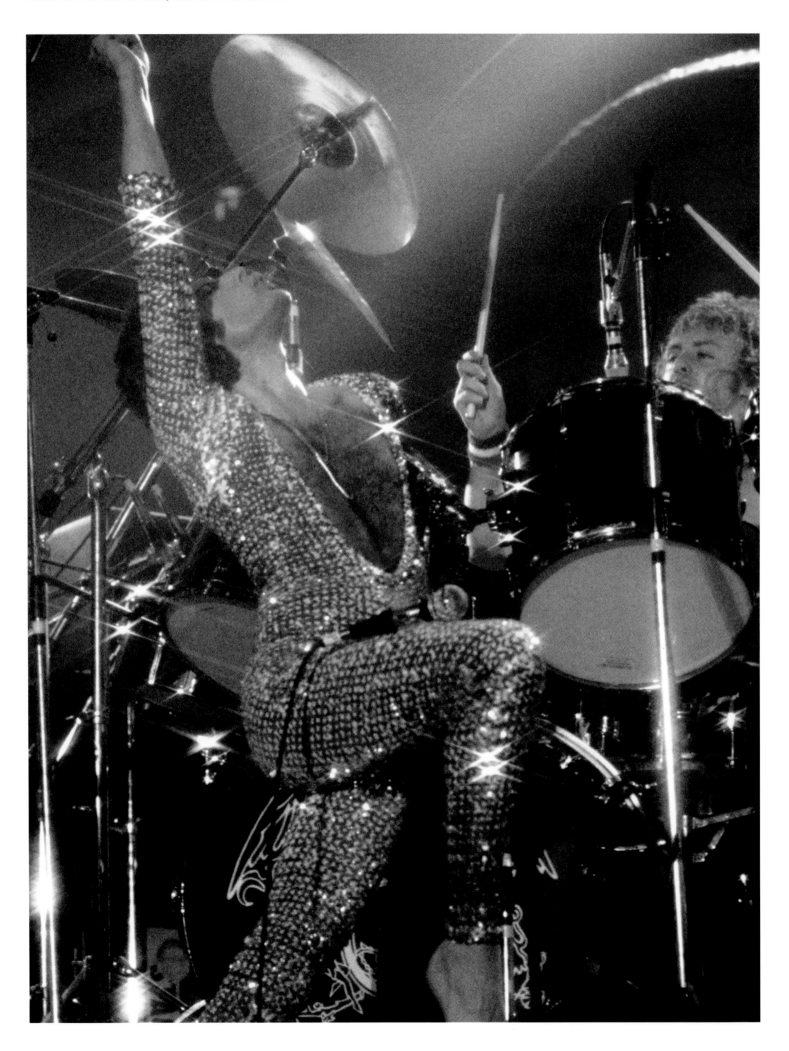

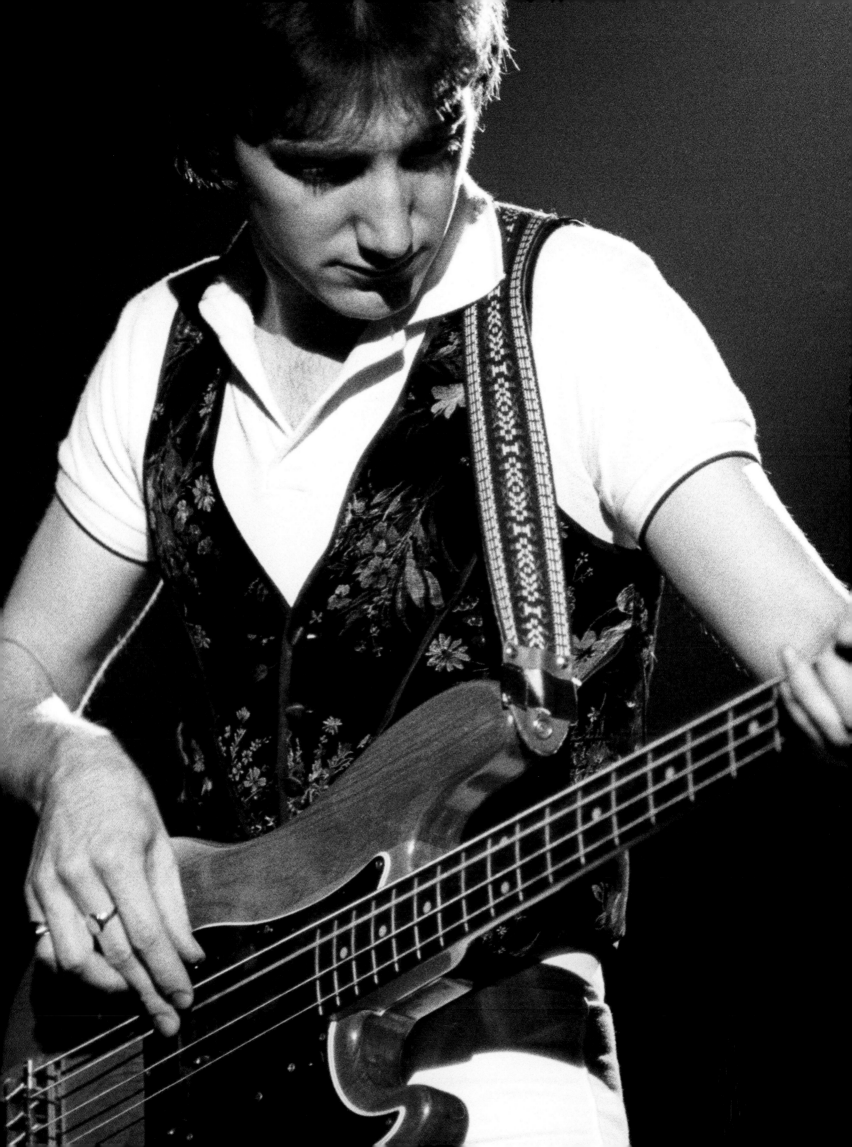

The Jazz Tour, North America 1978

28 October – Convention Center, Dallas, TX, USA
29 October – Mid-South Coliseum, Memphis, TN, USA
31 October – Municipal Auditorium, New Orleans, LA, USA
03 November – Sportatorium, Miami, FL, USA
04 November – Civic Center, Lakeland, FL, USA
06 November – Capital Center, Landover, MD, USA
07 November – Veterans Memorial Coliseum, New Haven, CT, USA
09 November – Cobo Arena, Detroit, MI, USA
10 November – Cobo Arena, Detroit, MI, USA
11 November – Wings Stadium, Kalamazoo, MI, USA
13 November – Boston Garden, Boston, MA, USA
14 November – Civic Center, Providence, RI, USA
16 November – Madison Square Garden, New York, NY, USA
17 November – Madison Square Garden, New York, NY, USA
19 November – Nassau Coliseum, Uniondale, Long Island, NY, USA
20 November – The Spectrum, Philadelphia, PA, USA
22 November – Municipal Auditorium, Nashville, TN, USA
23 November – Checkerdome, St. Louis, MO, USA
25 November – Coliseum, Richfield, OH, USA
26 November – Riverfront Coliseum, Cincinnati, OH, USA
28 November – War Memorial Auditorium, Buffalo, NY, USA
30 November – Civic Center, Ottawa, ON, Canada
01 December – Forum, Montreal, QC, Canada
03 December – Maple Leaf Gardens, Toronto, ON, Canada
04 December – Maple Leaf Gardens, Toronto, ON, Canada
06 December – Dane County Coliseum, Madison, WI, USA
07 December – Chicago Stadium, Chicago, IL, USA
08 December – Kemper Arena, Kansas City, MO, USA
12 December – Seattle Center Coliseum, Seattle, WA, USA
13 December – Memorial Coliseum, Portland, OR, USA
14 December – Pacific Coliseum, Vancouver, BC, Canada
16 December – Oakland-Alameda County Coliseum, Oakland, CA, USA
18 December – The Forum, Inglewood, CA, USA
19 December – The Forum, Inglewood, CA, USA
20 December – The Forum, Inglewood, CA, USA

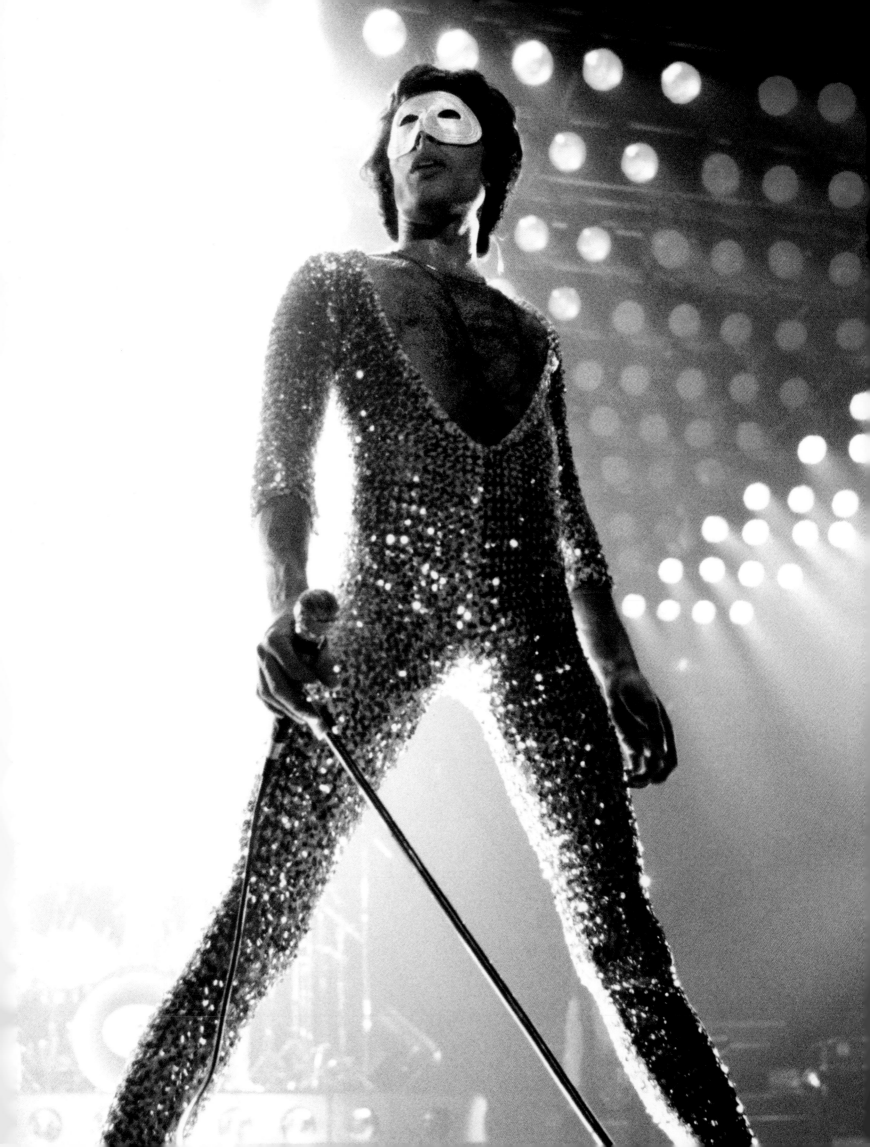

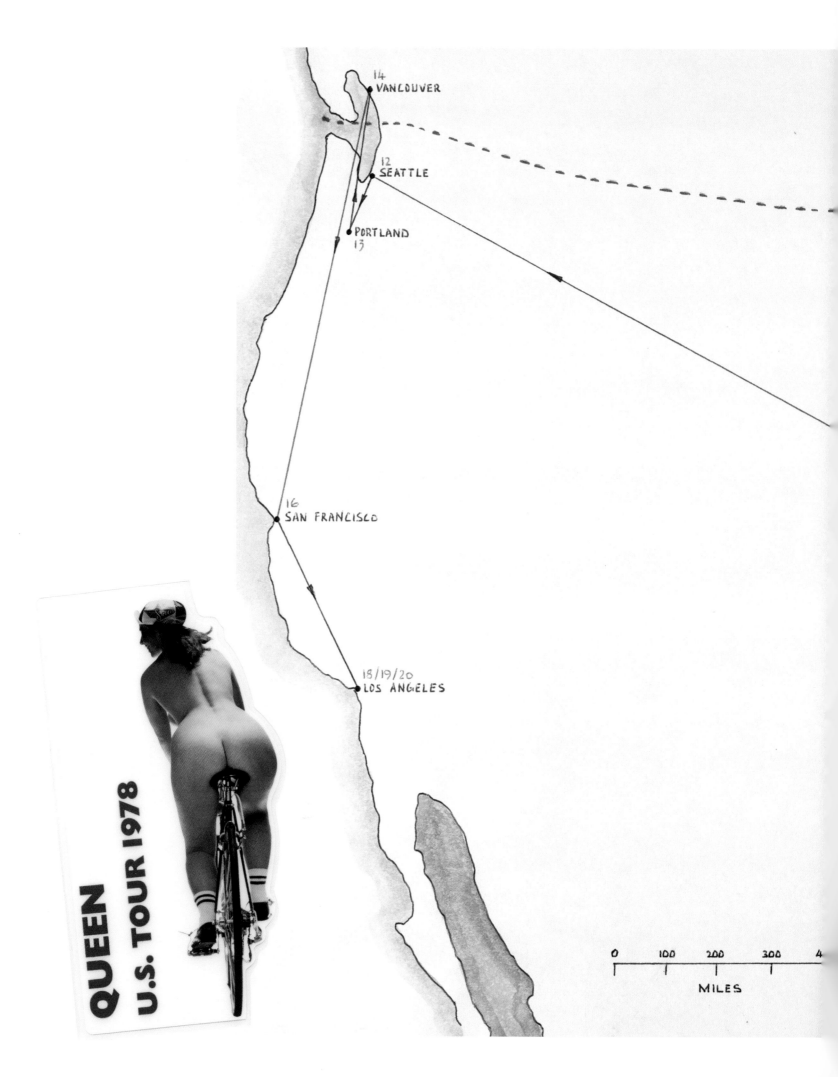

14 VANCOUVER

12 SEATTLE

PORTLAND
13

16 SAN FRANCISCO

18/19/20 LOS ANGELES

QUEEN U.S. TOUR 1978

0 100 200 300 4

MILES

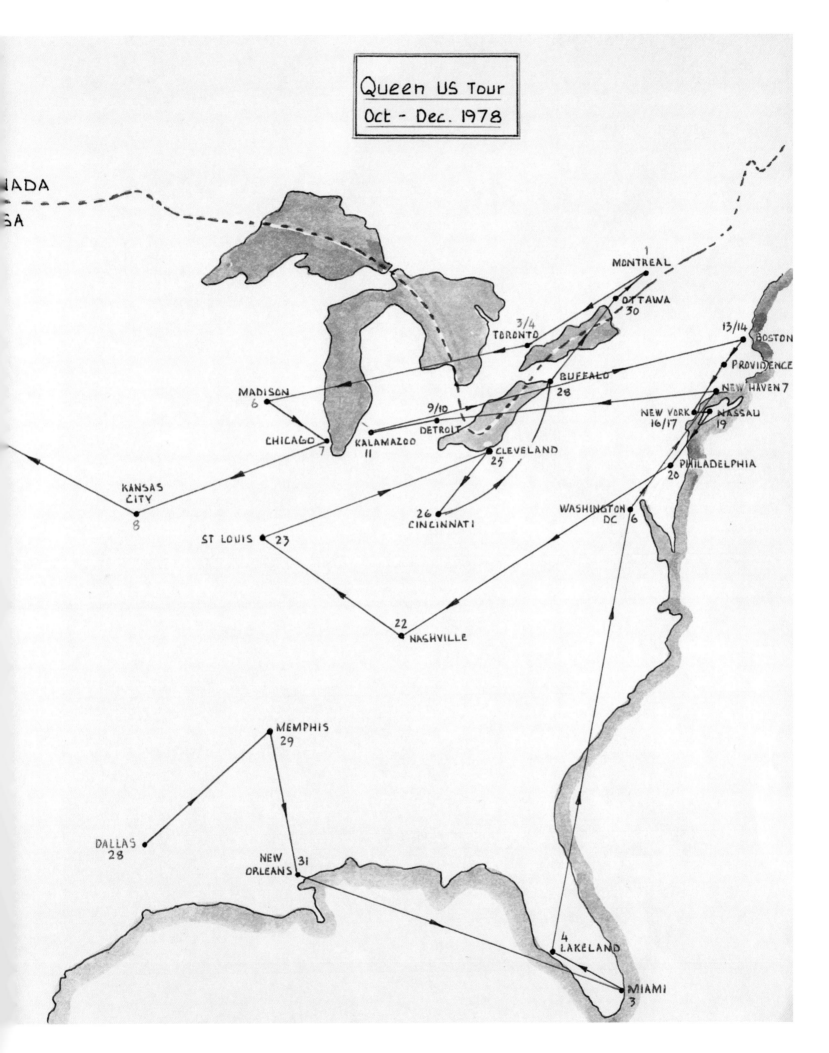

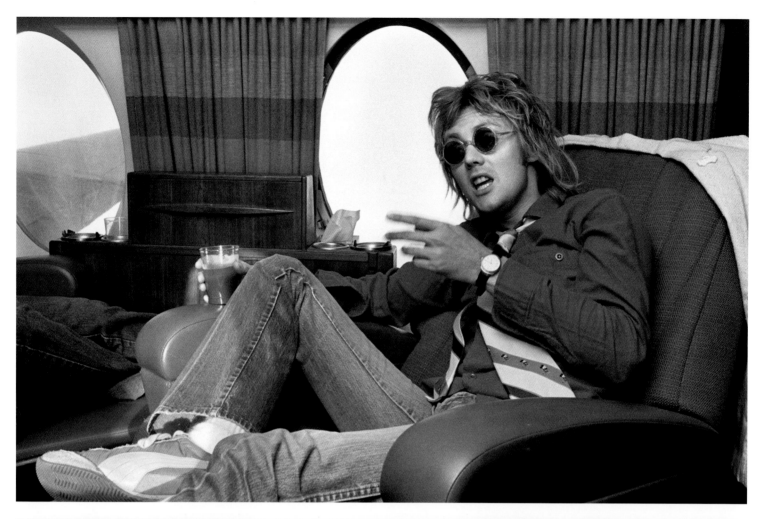

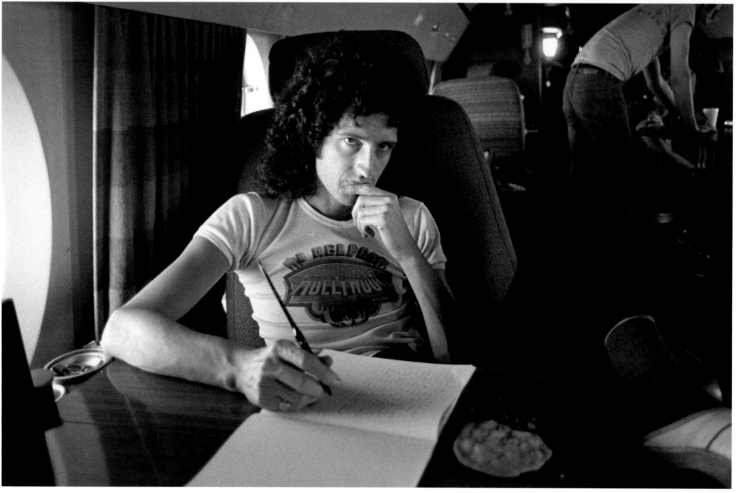

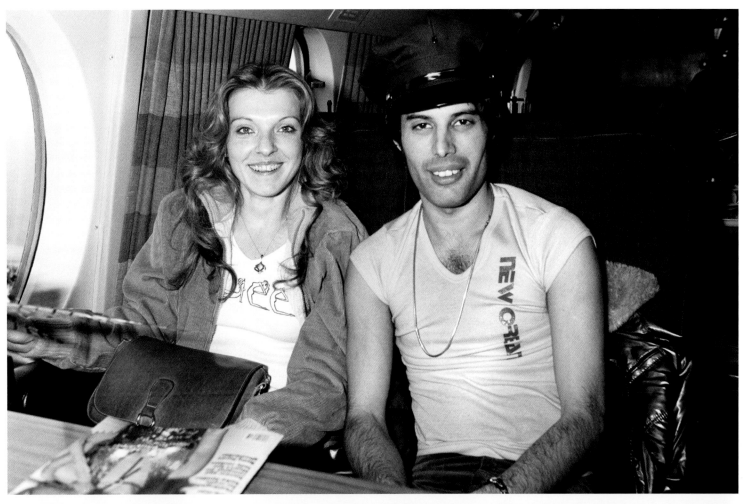

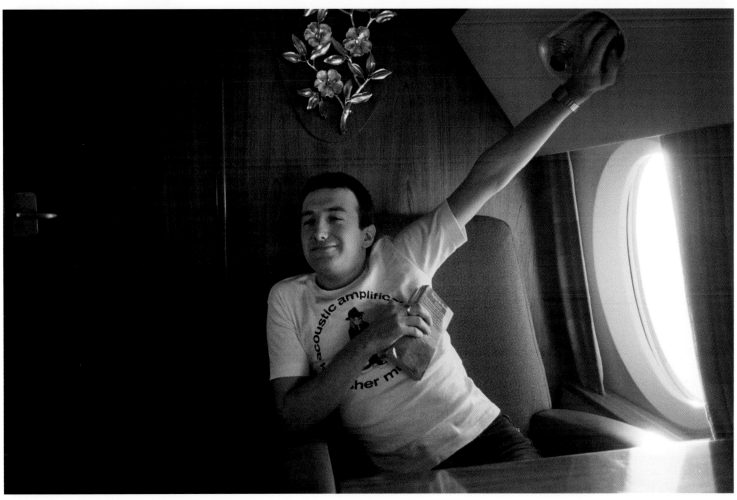

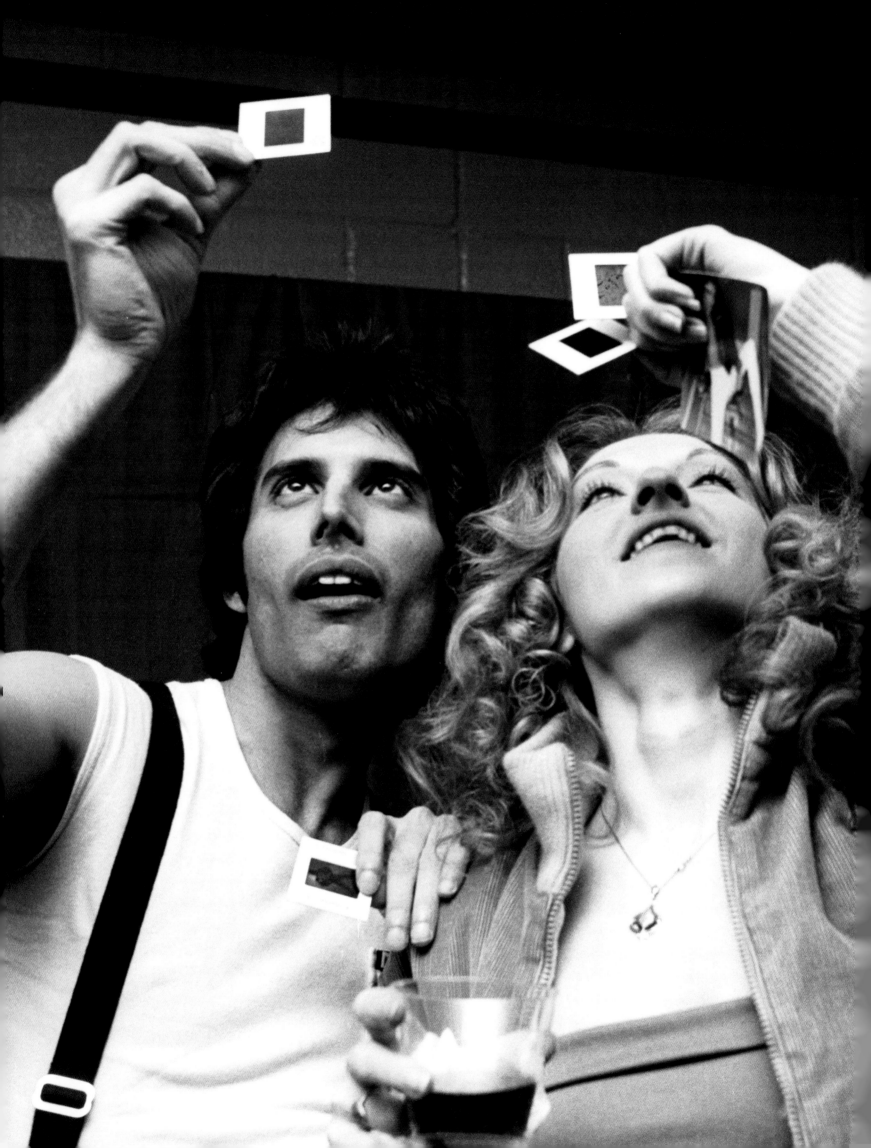

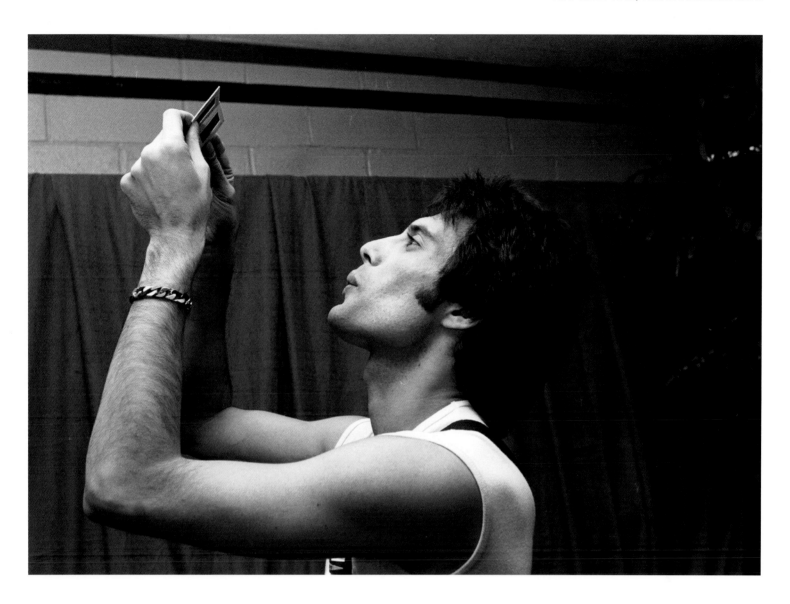

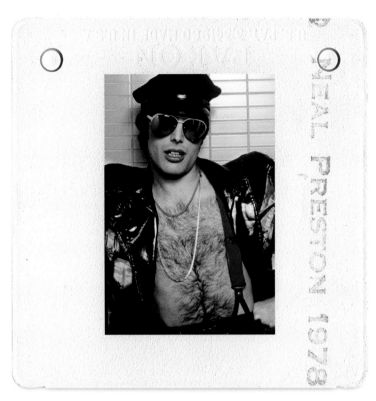
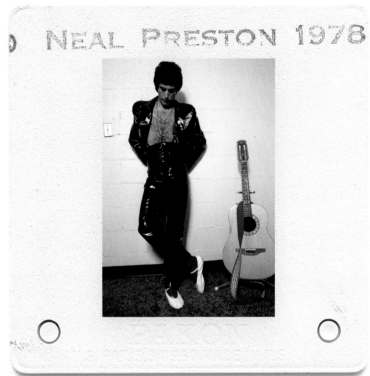
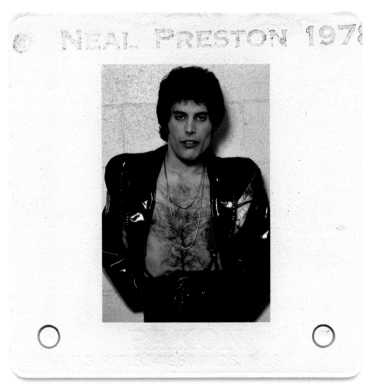
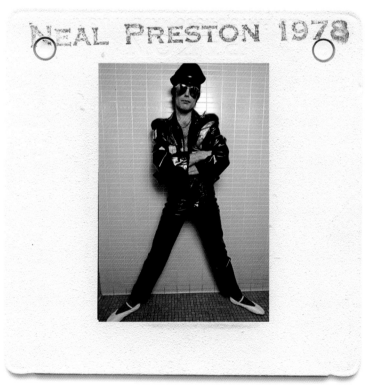

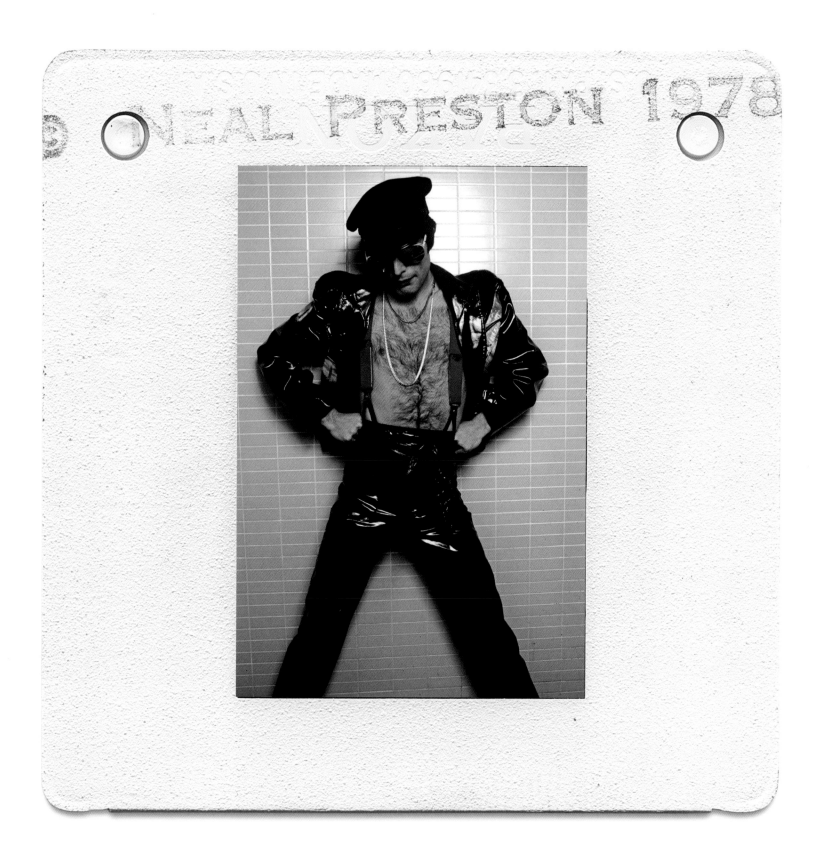

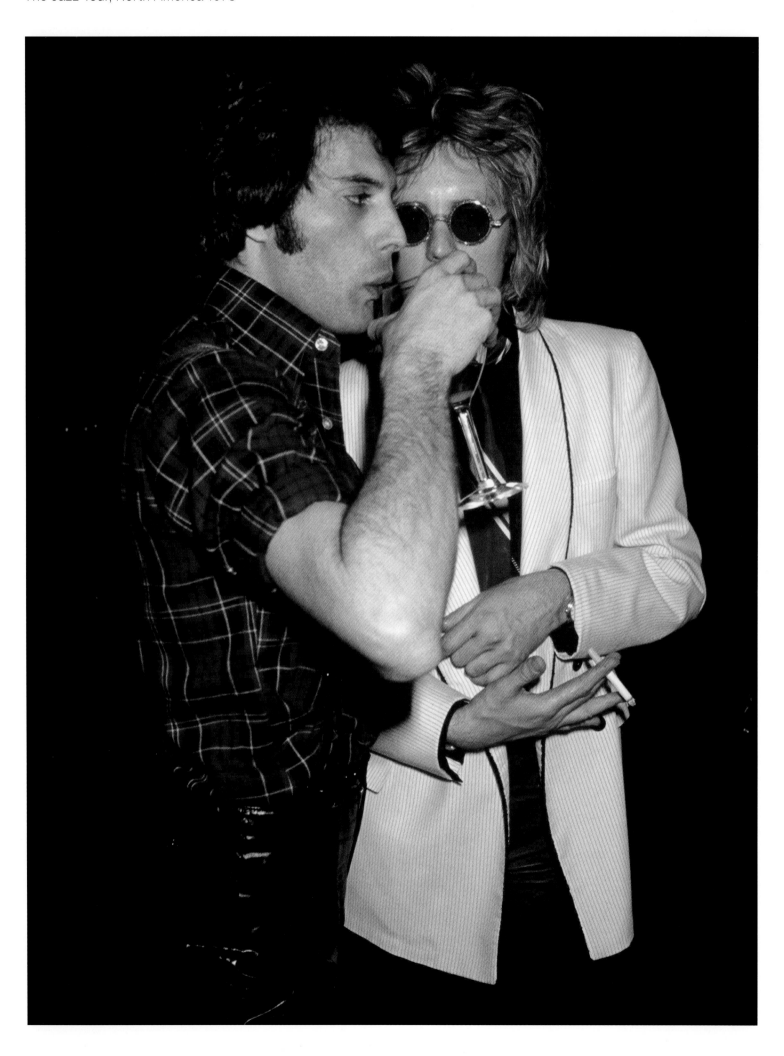

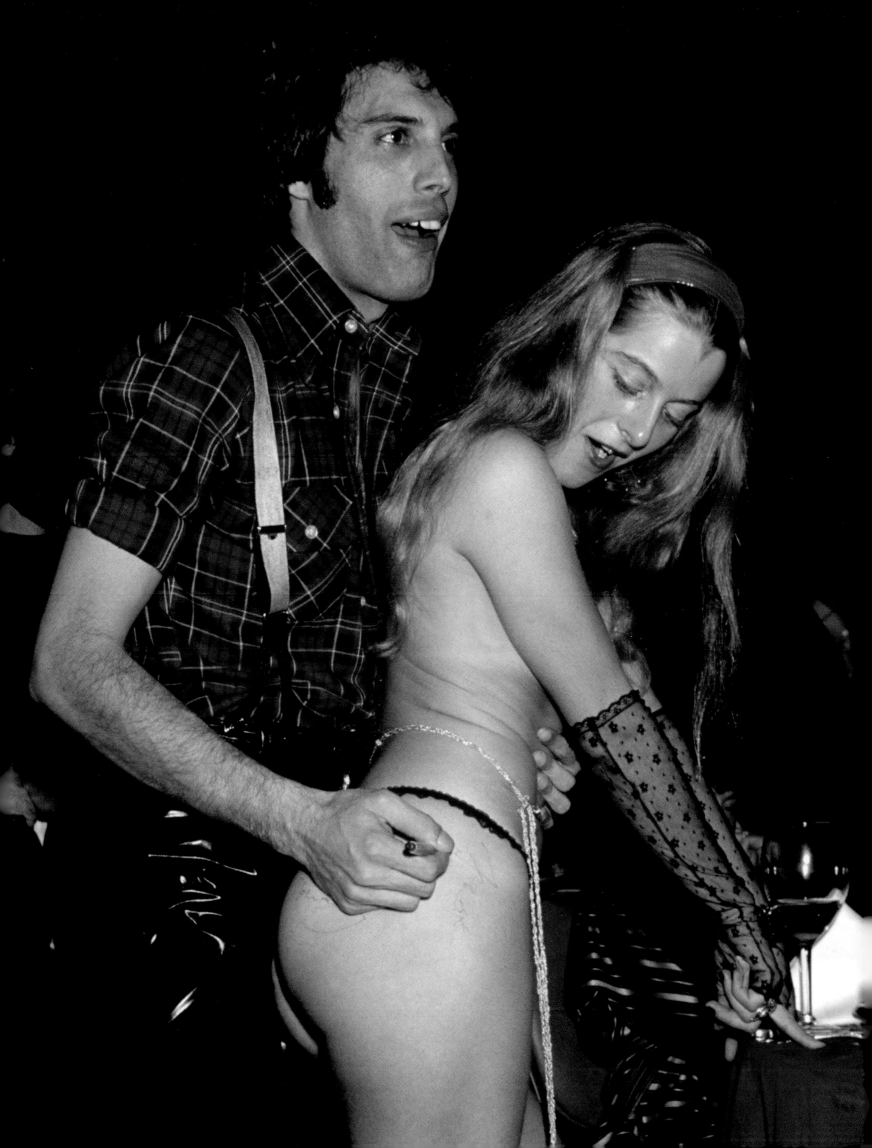

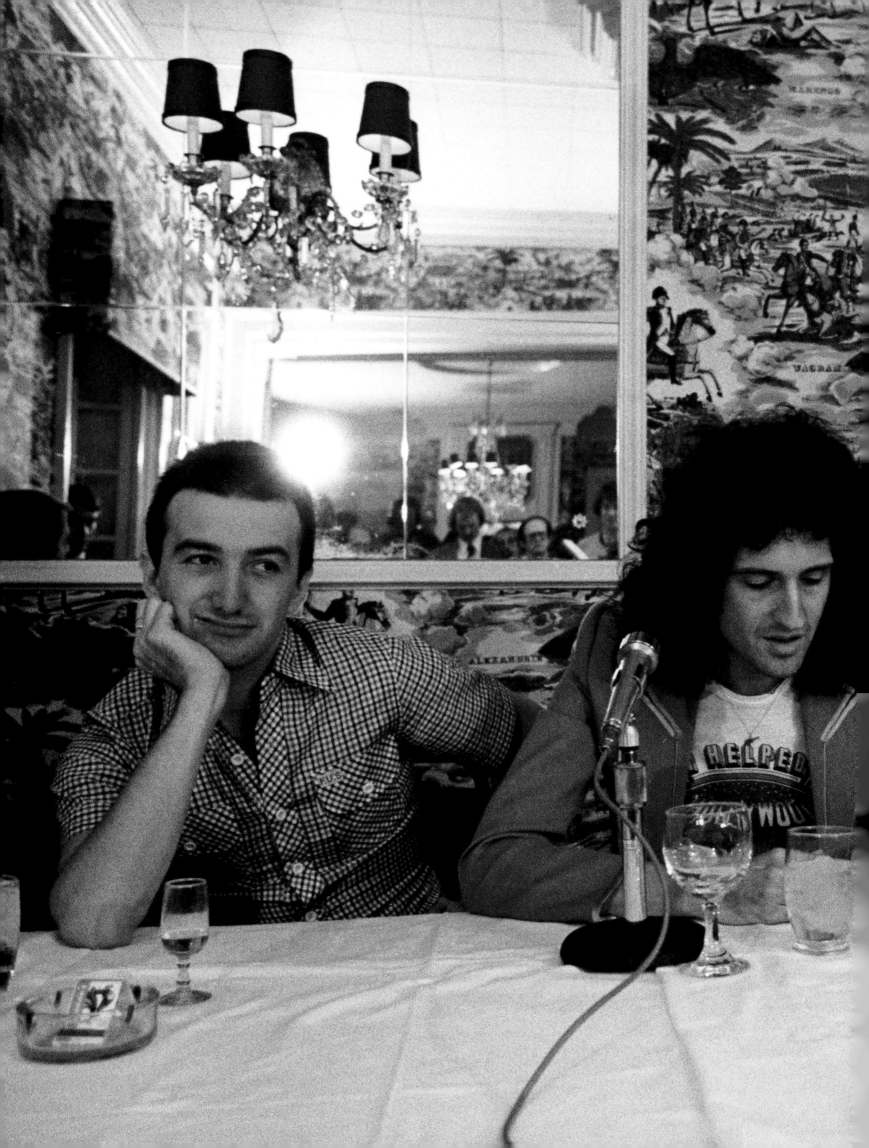

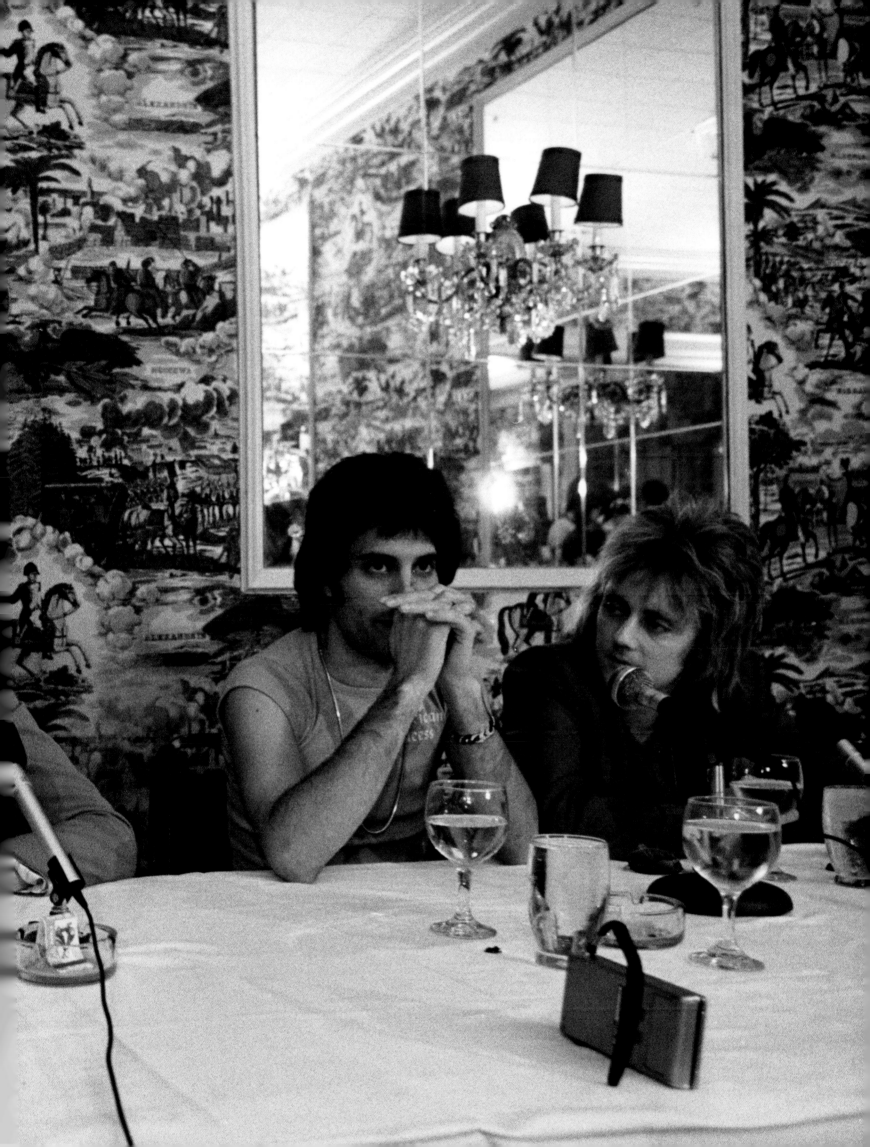

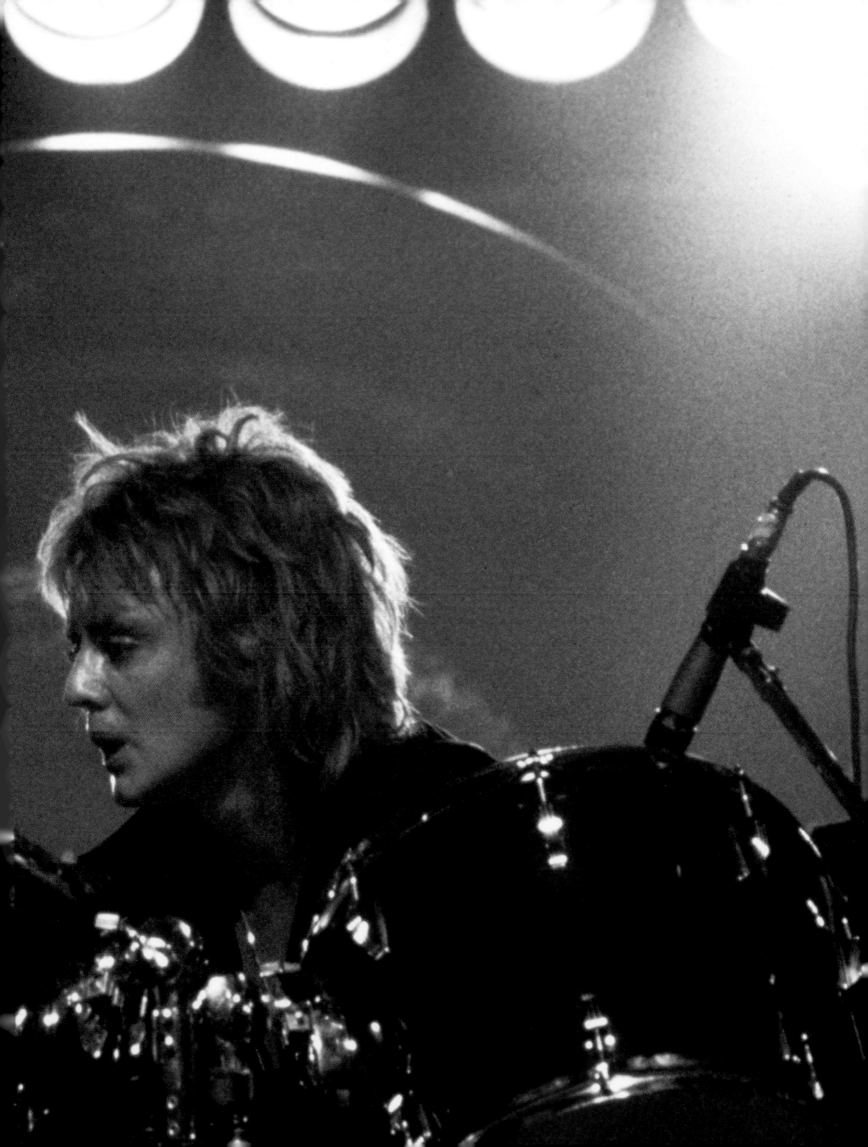

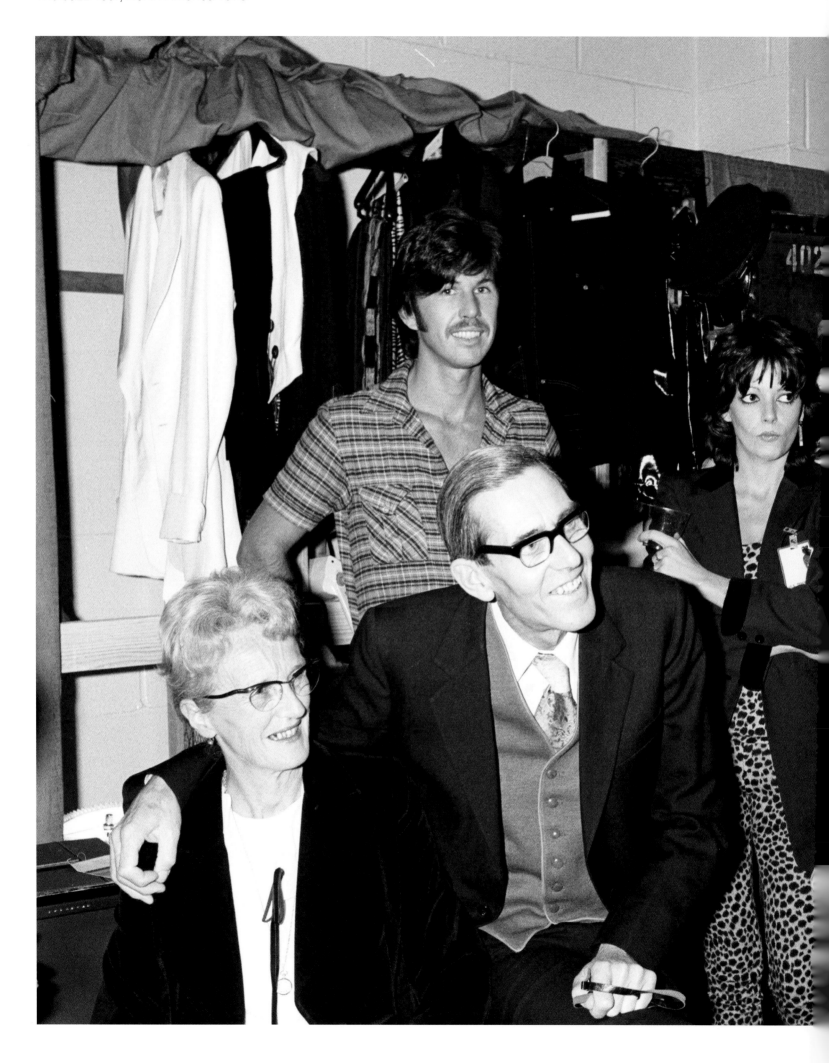

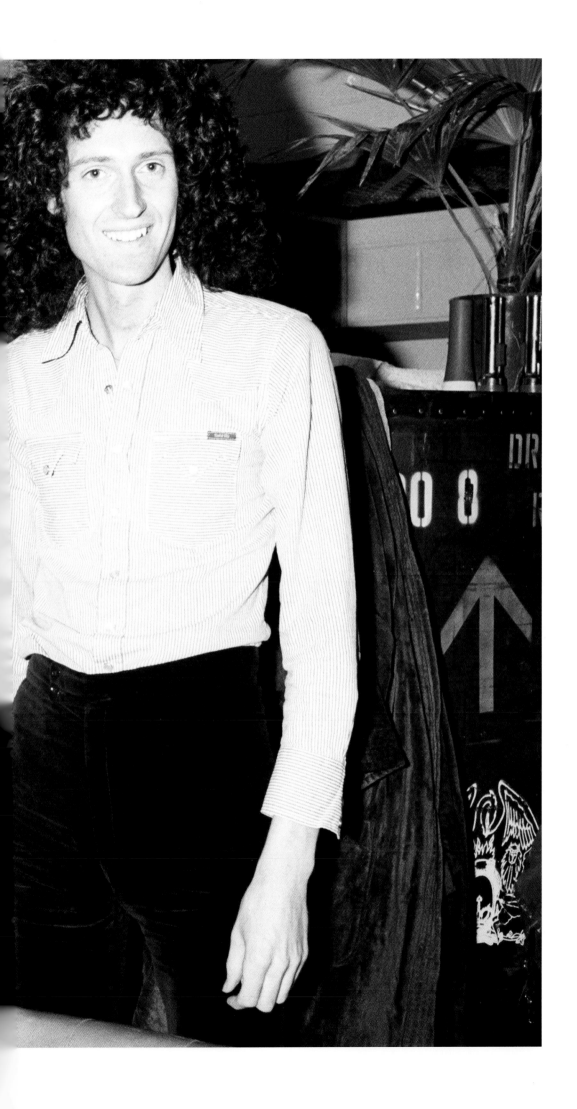

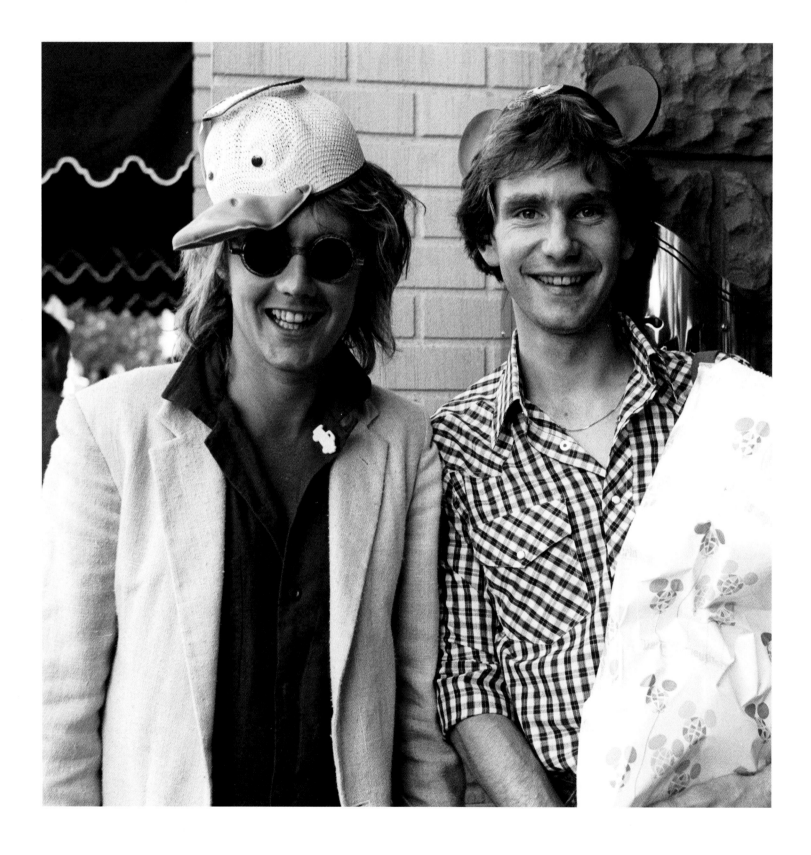

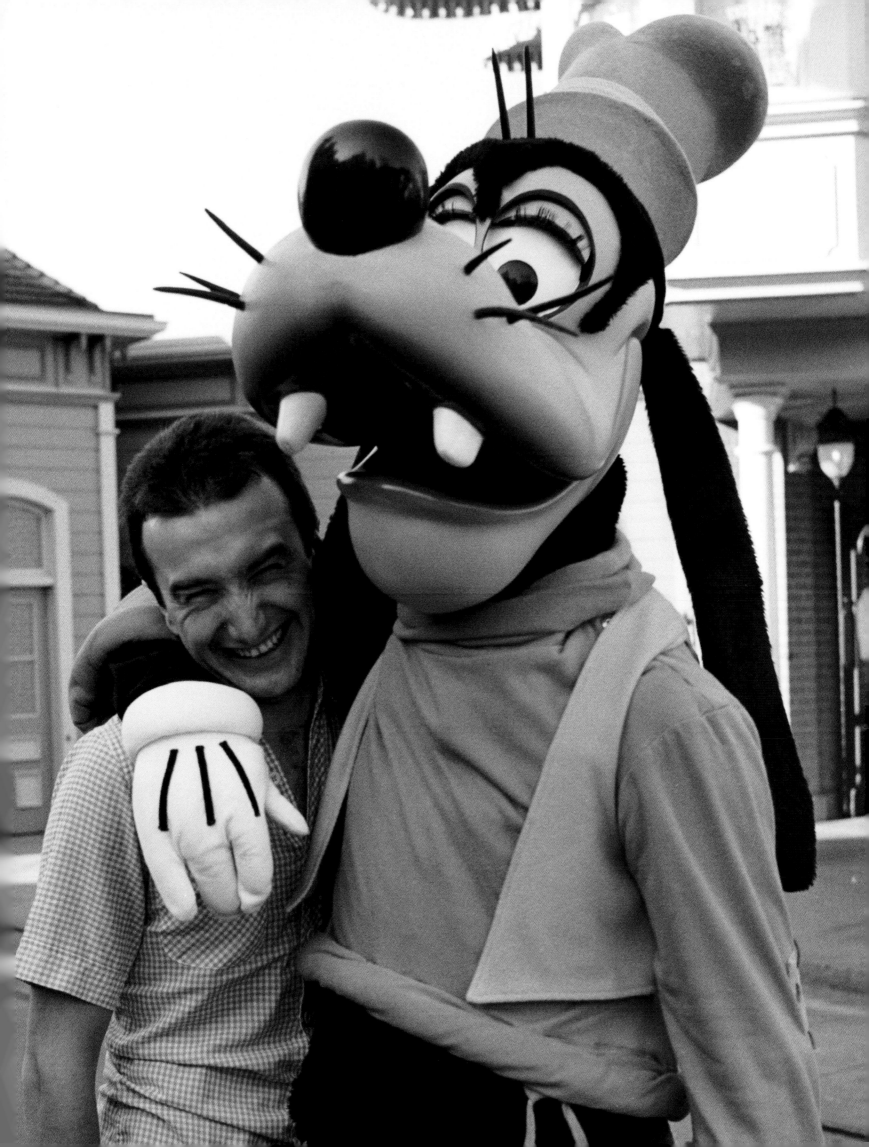

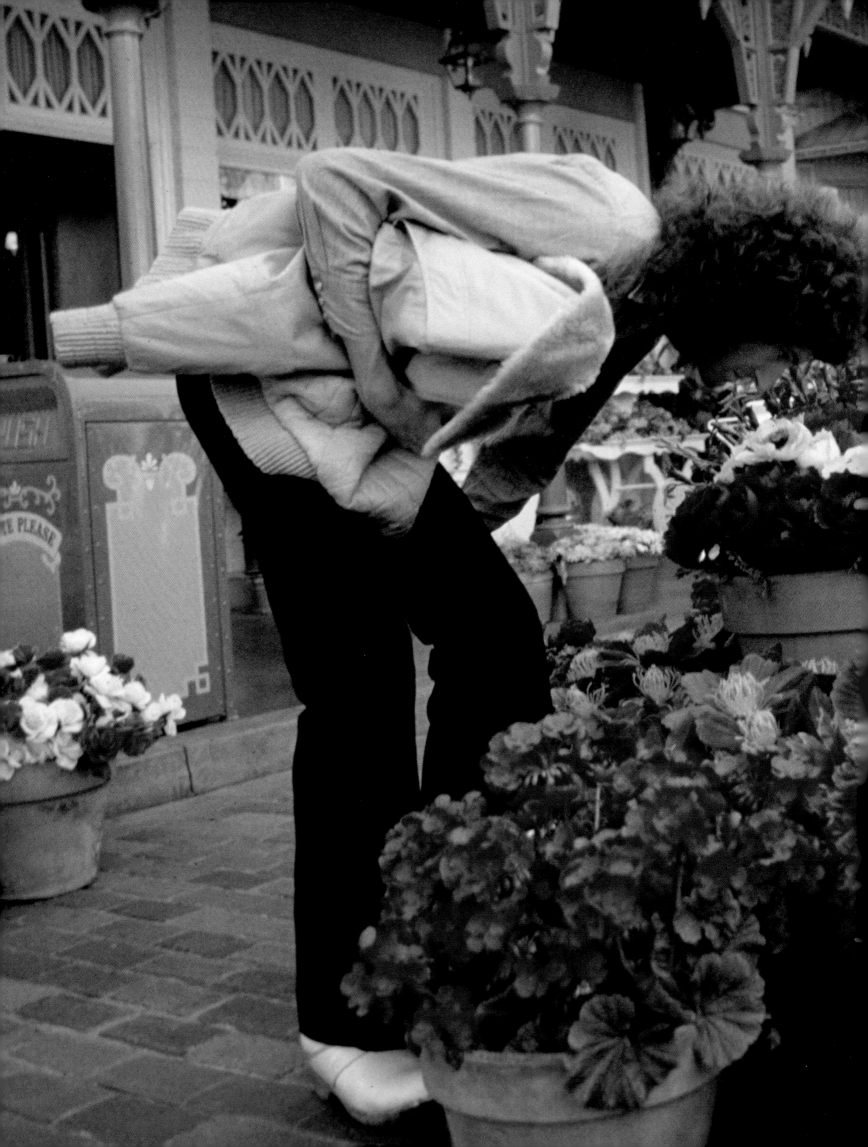

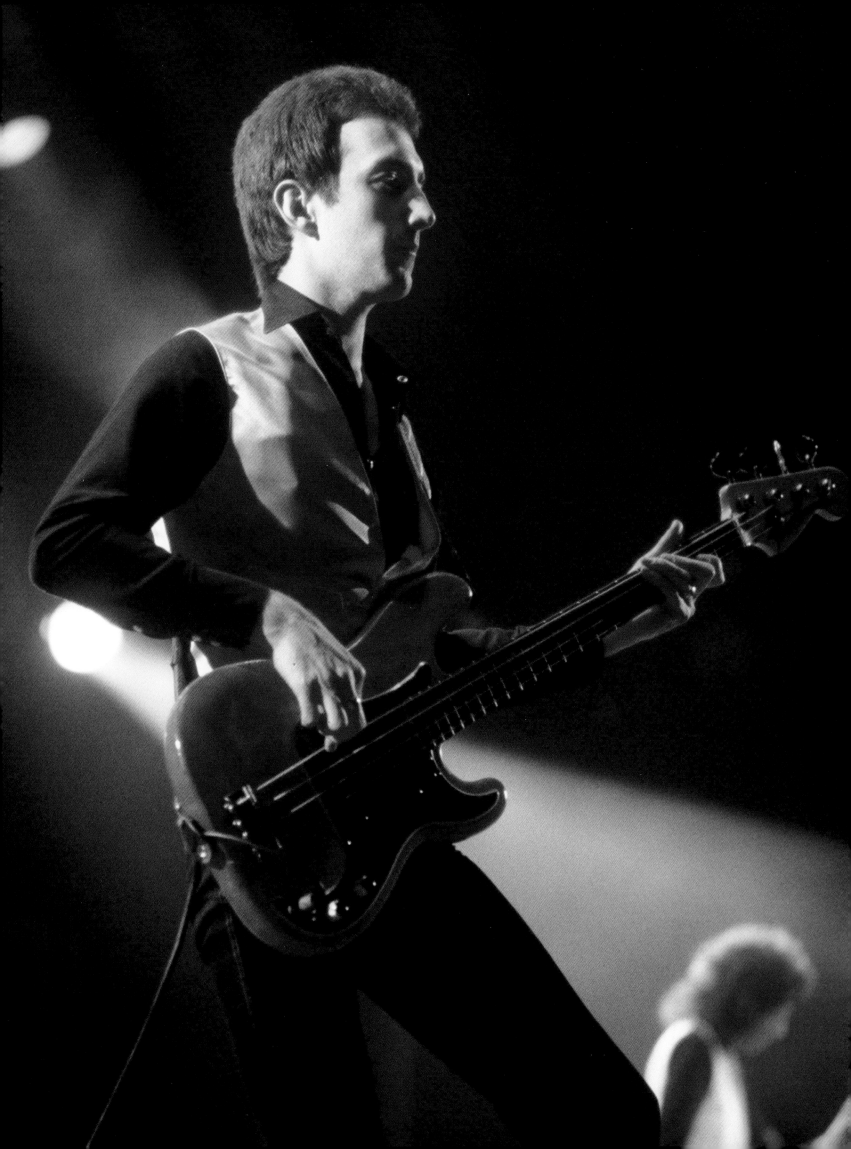

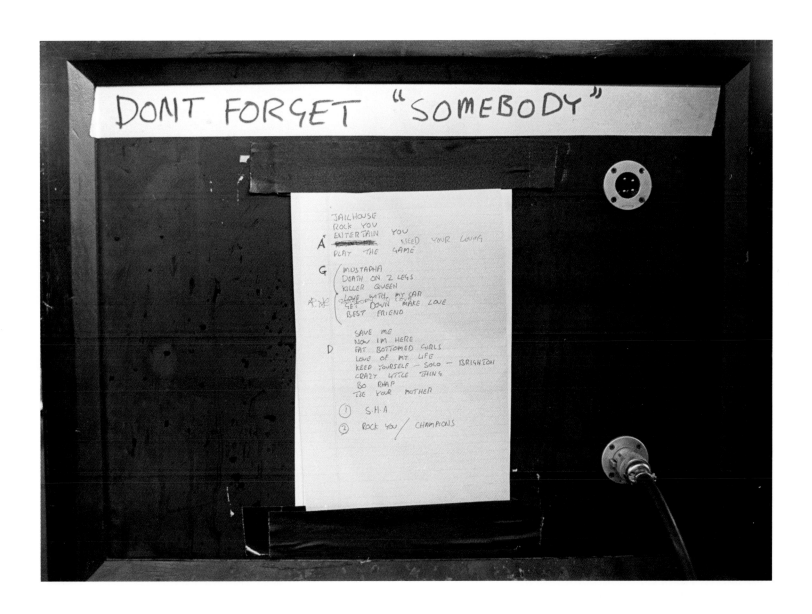

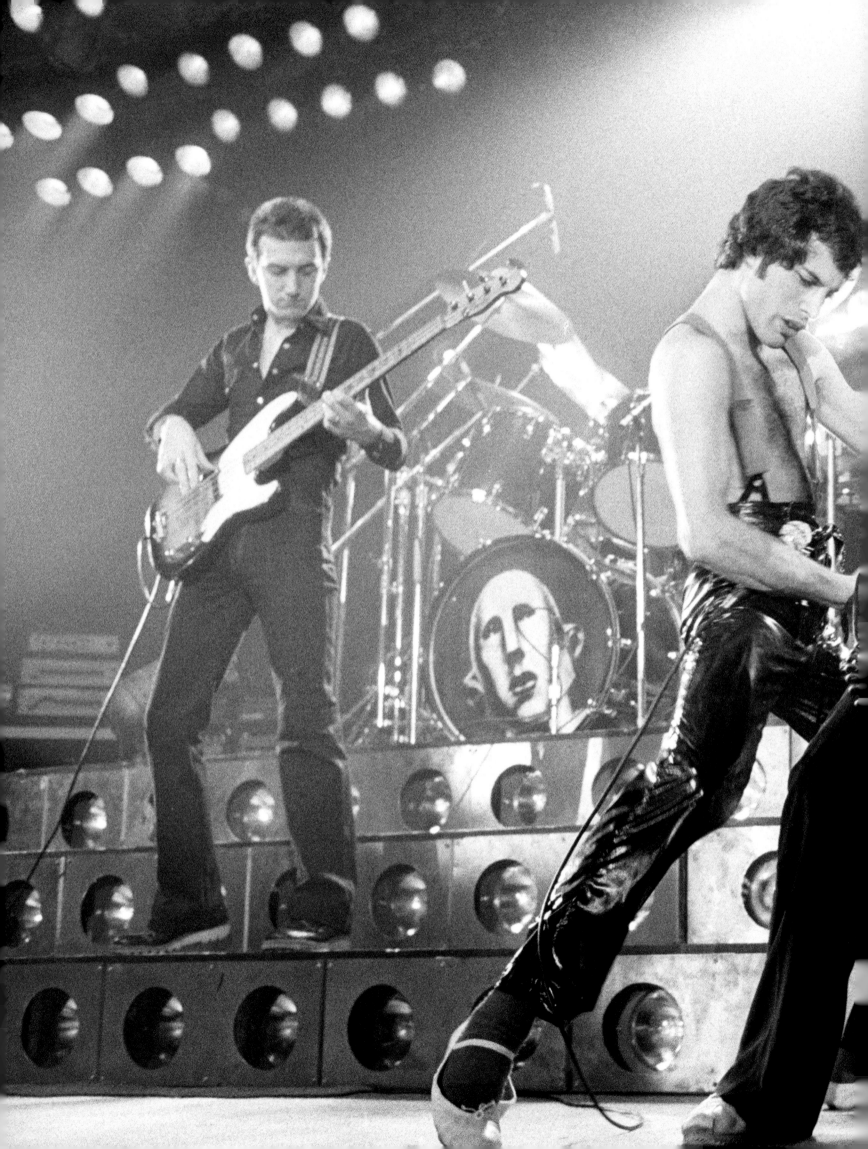

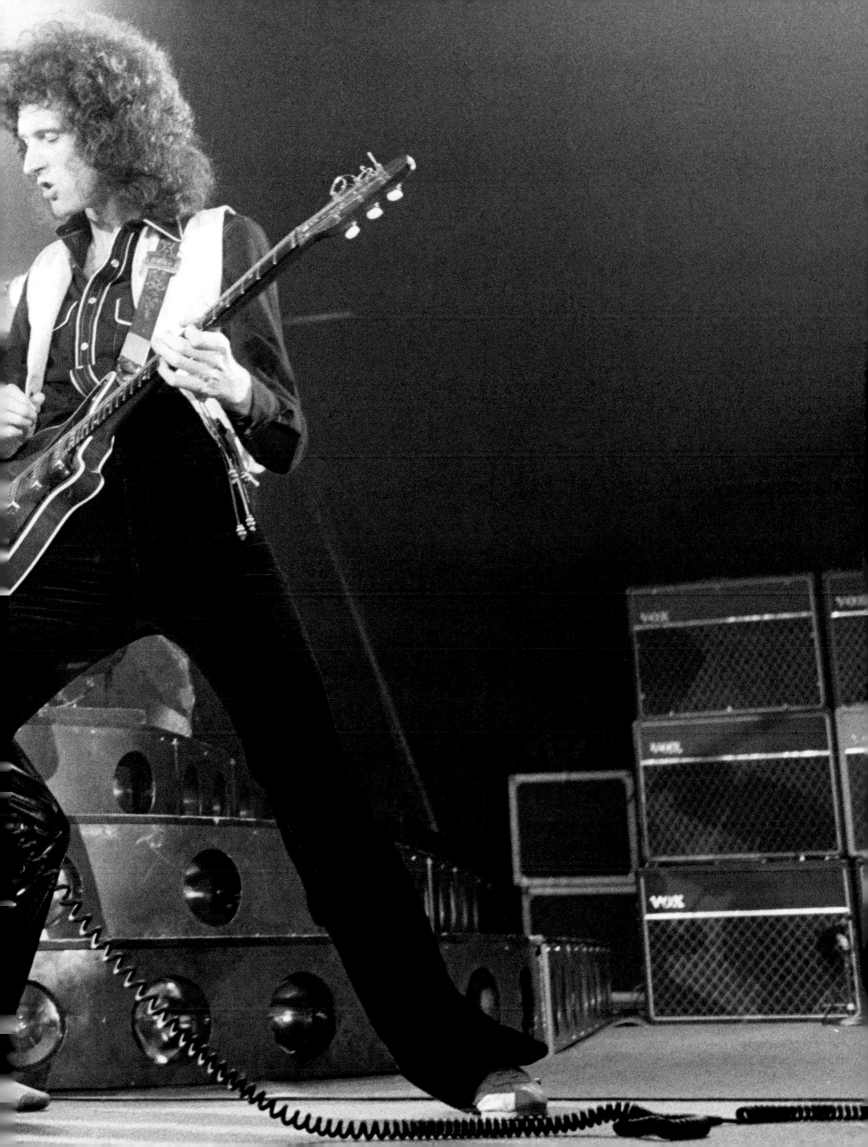

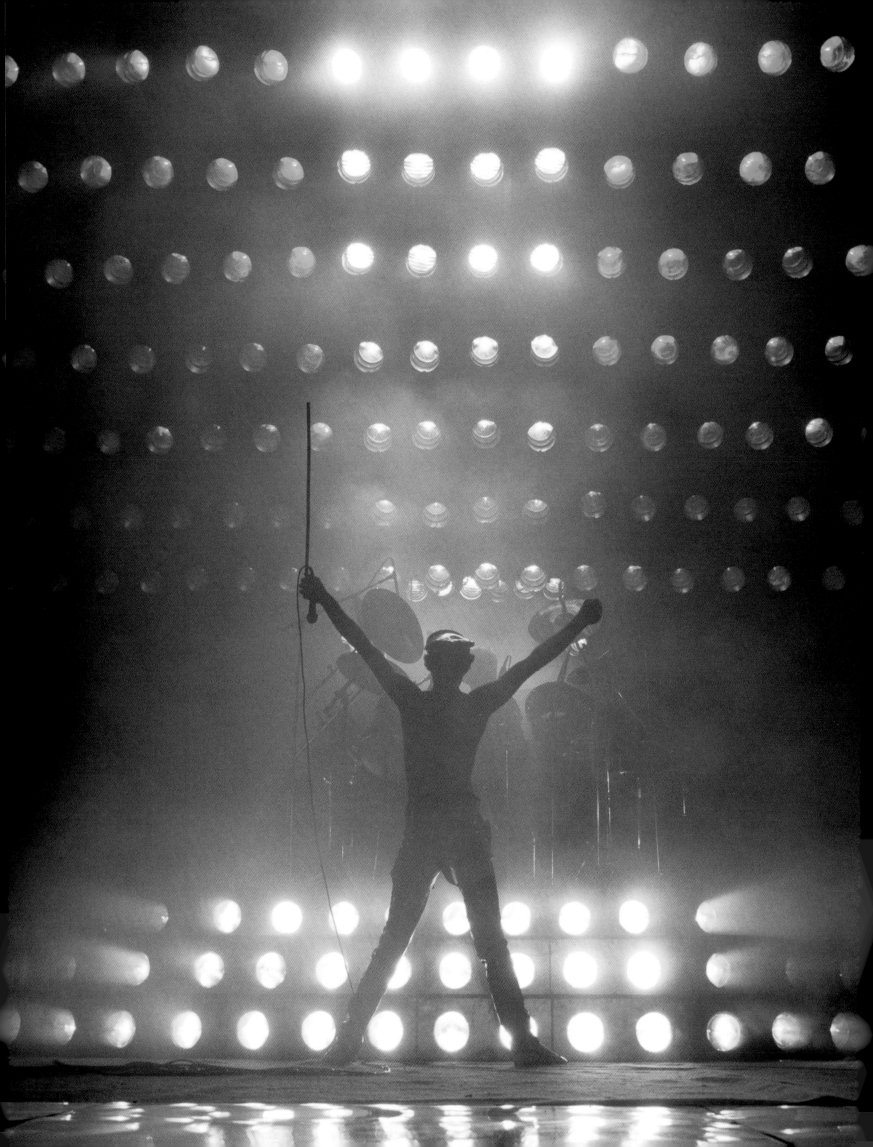

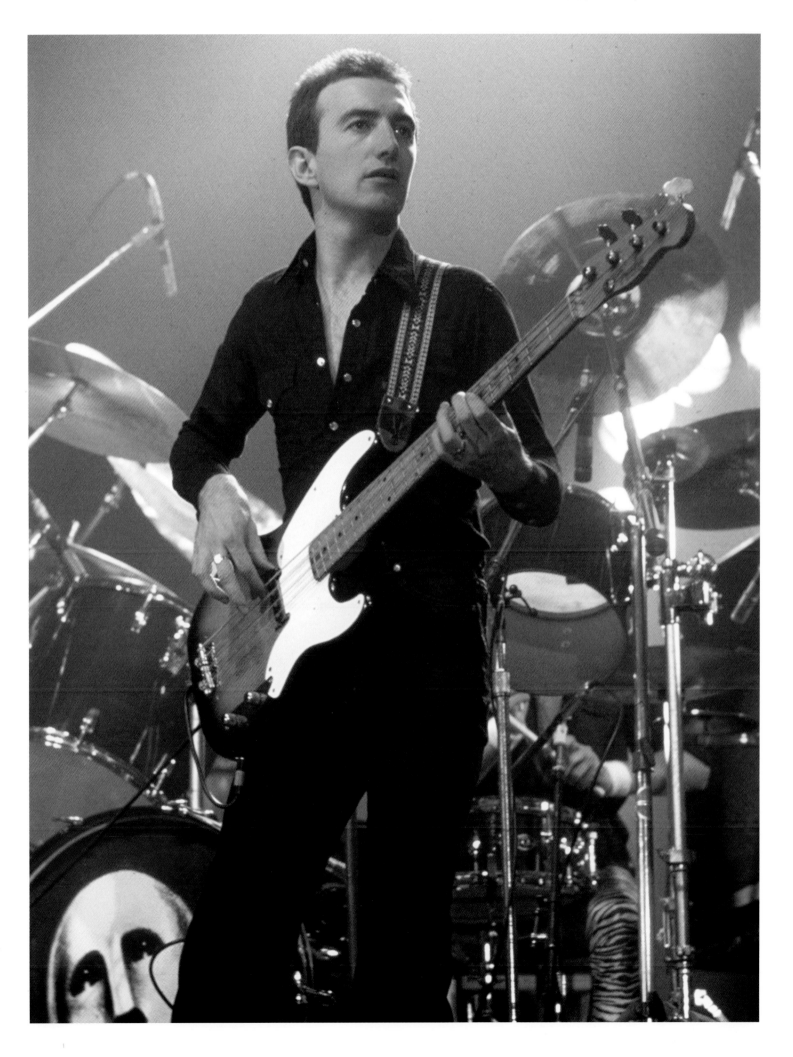

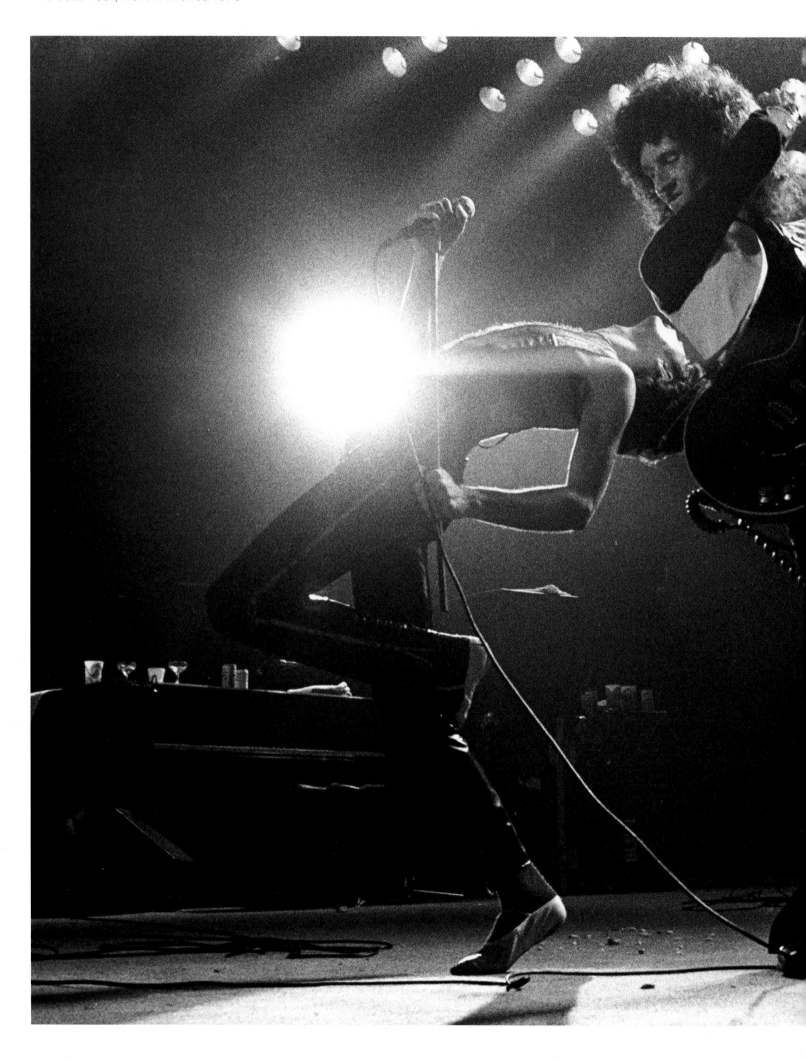

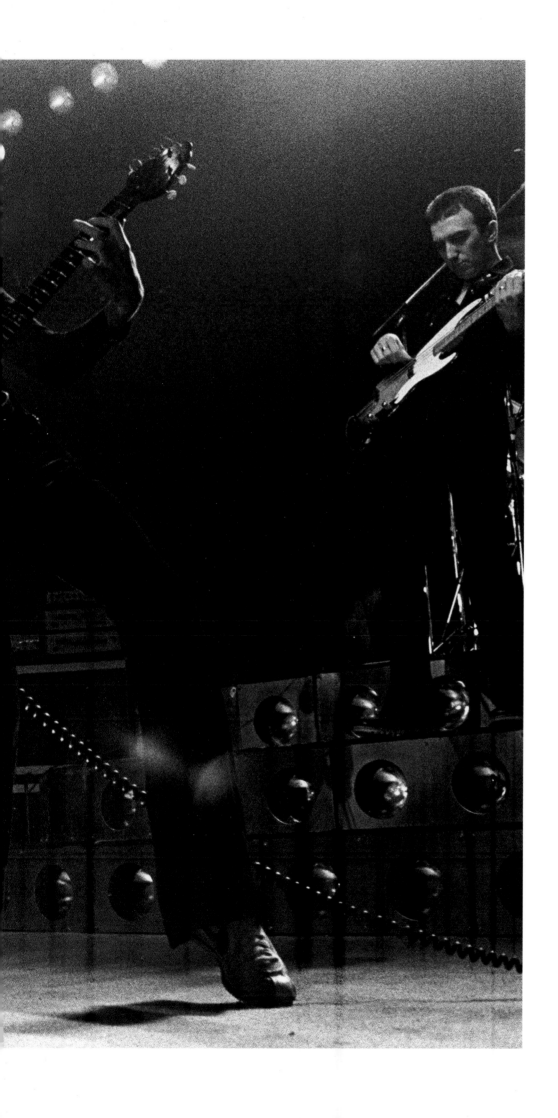

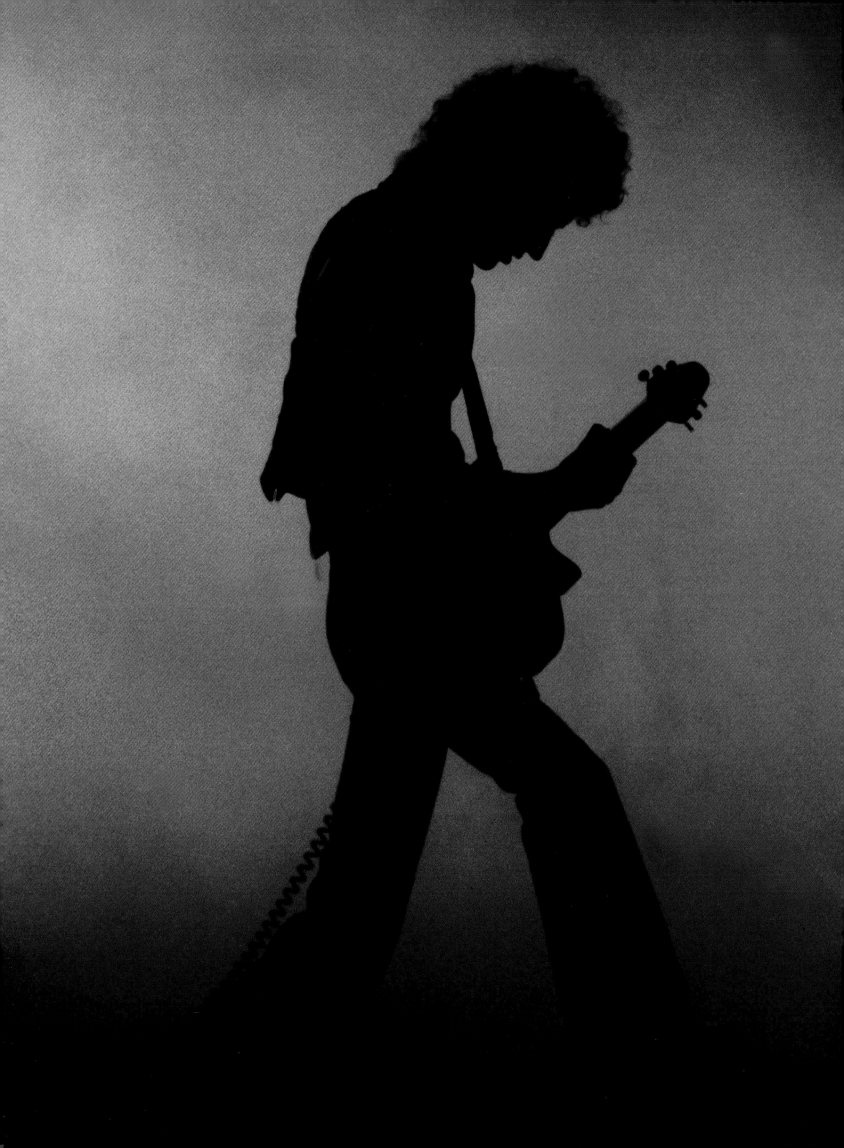

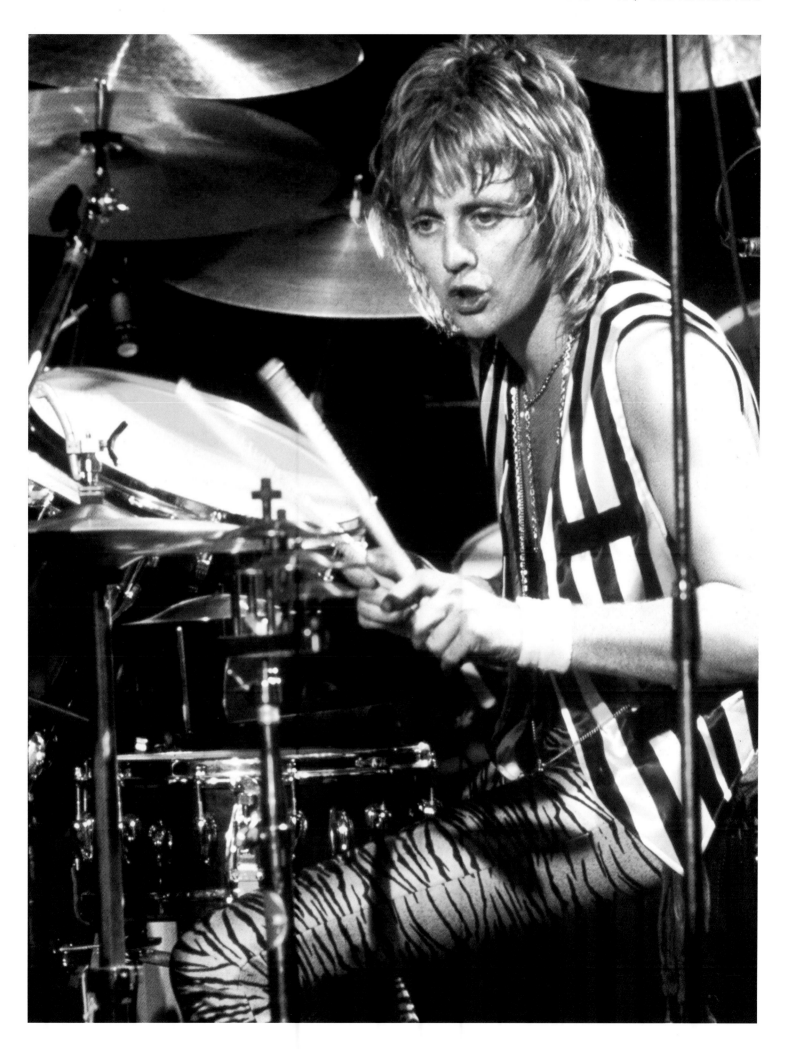

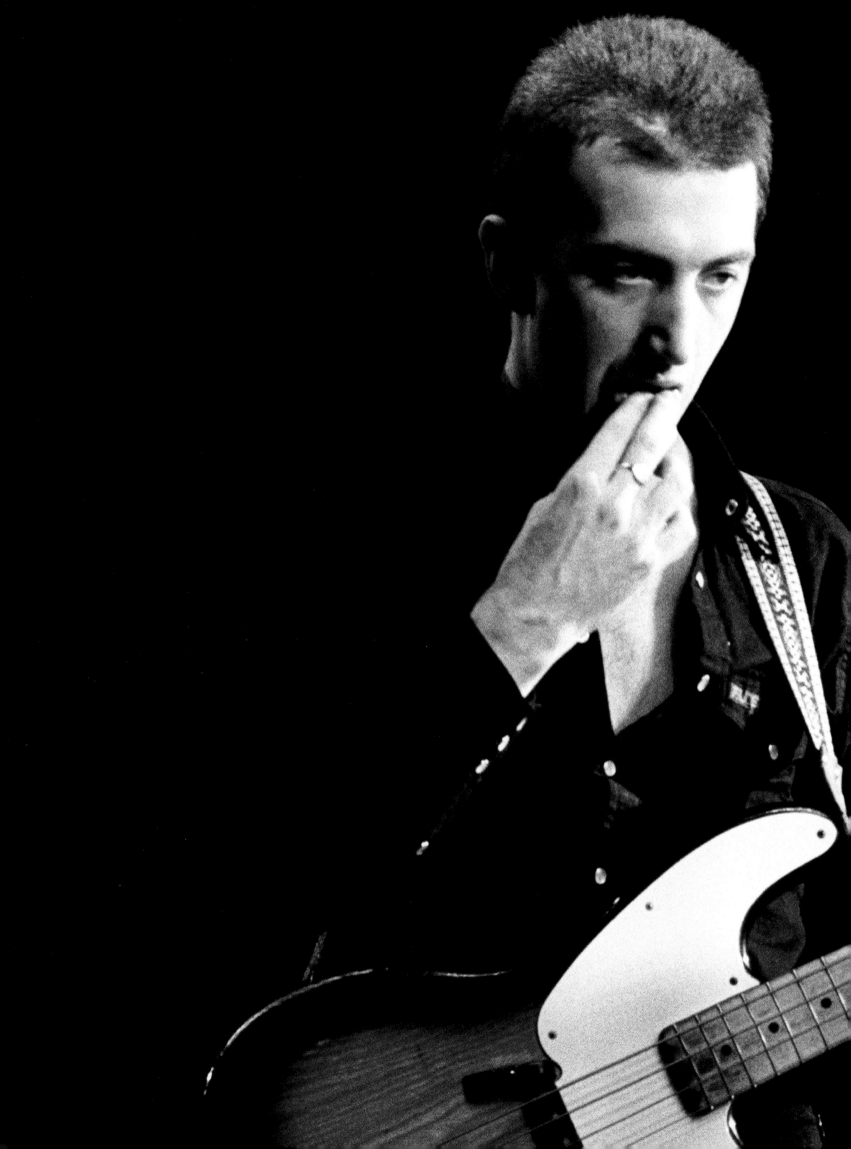

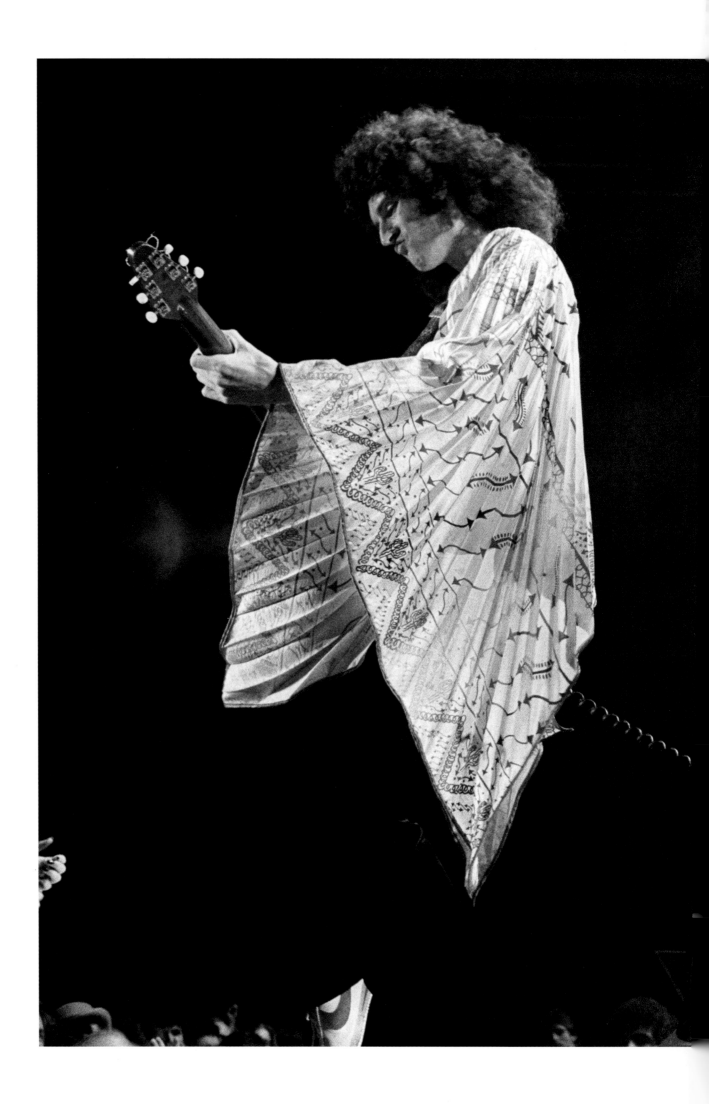

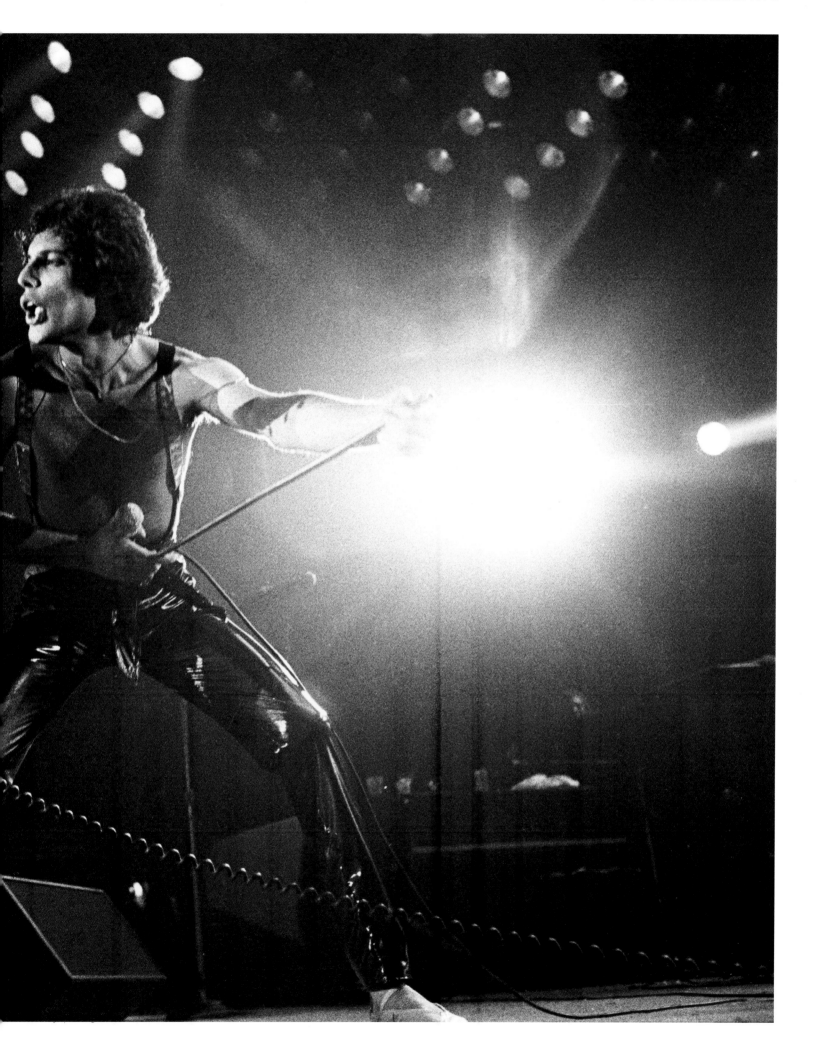

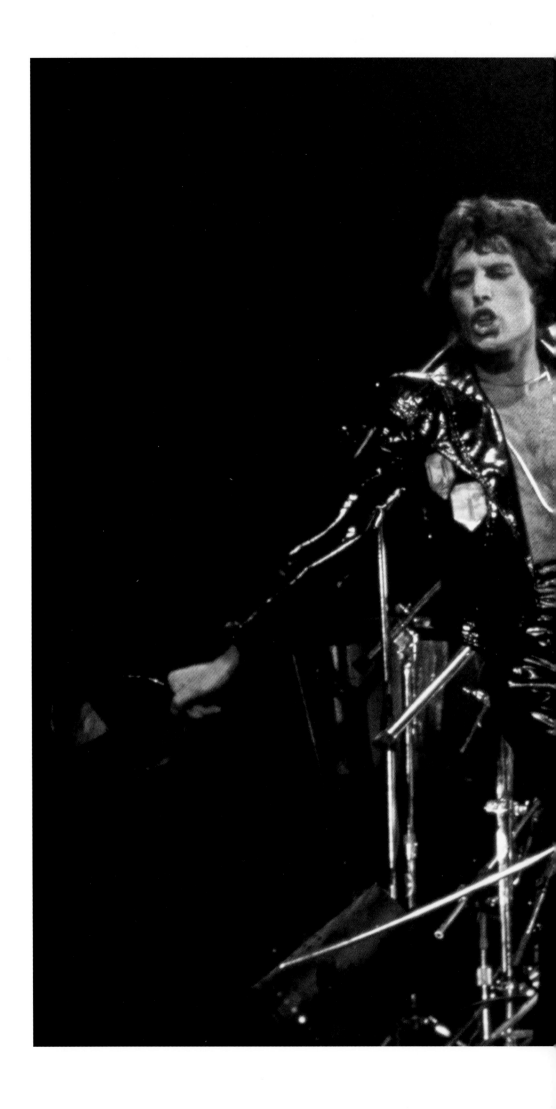

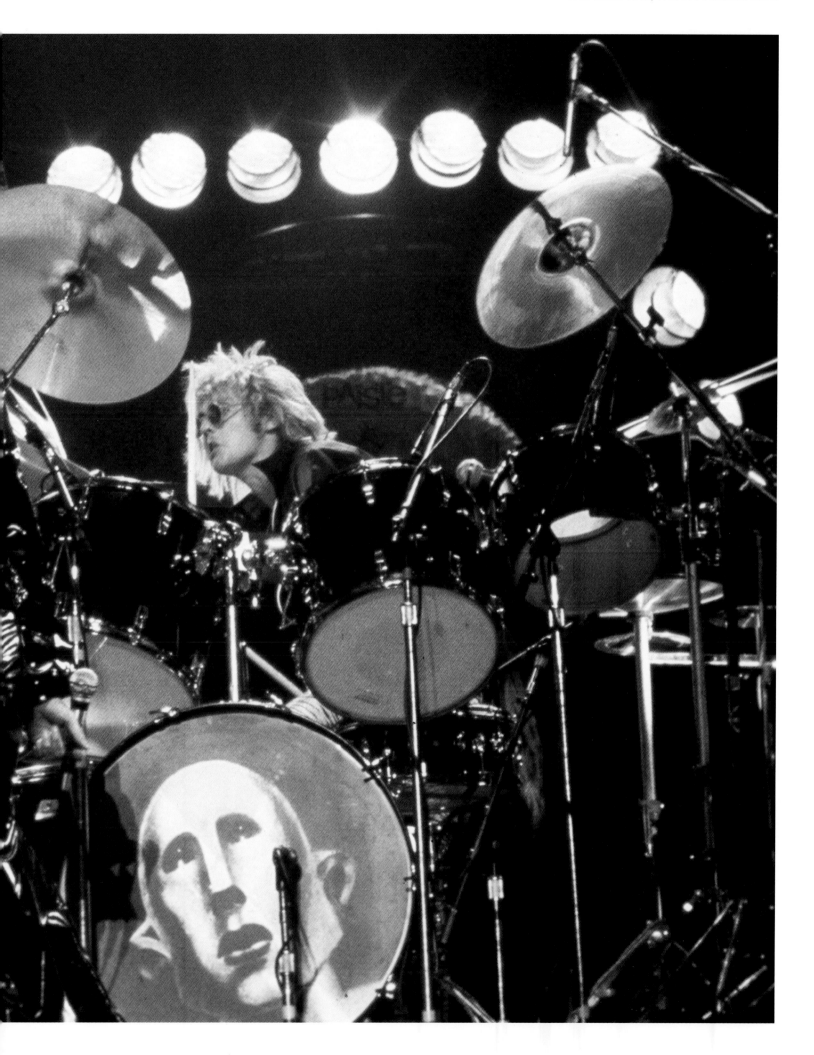

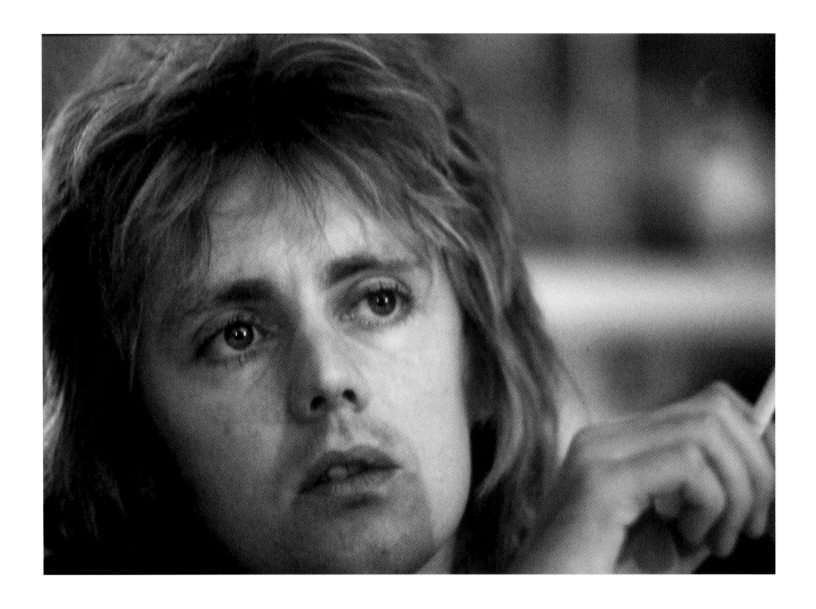

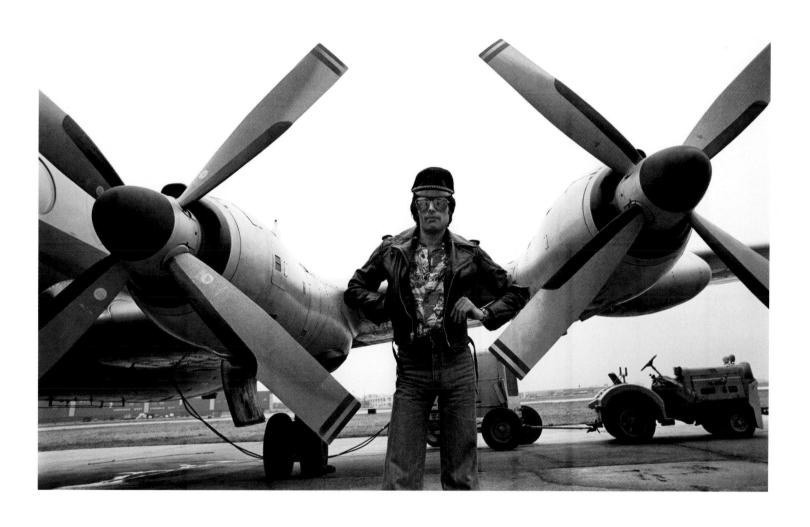

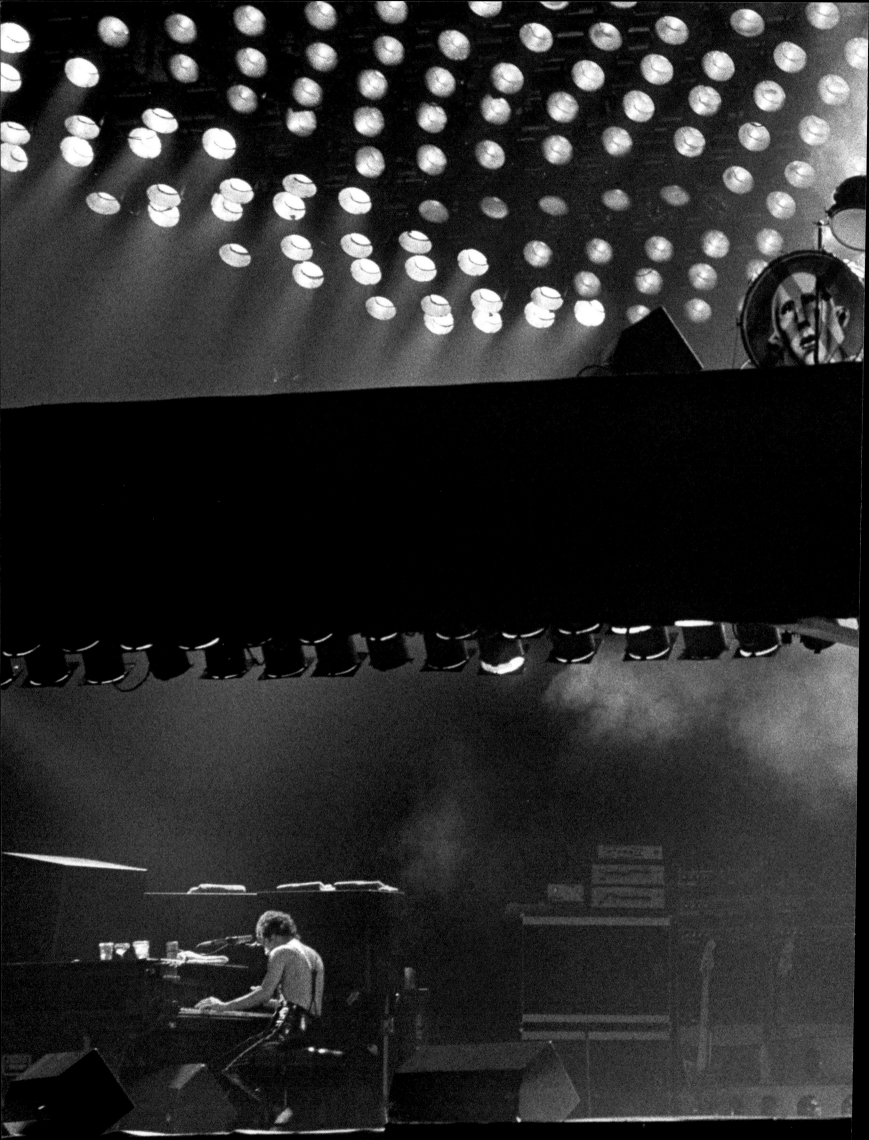

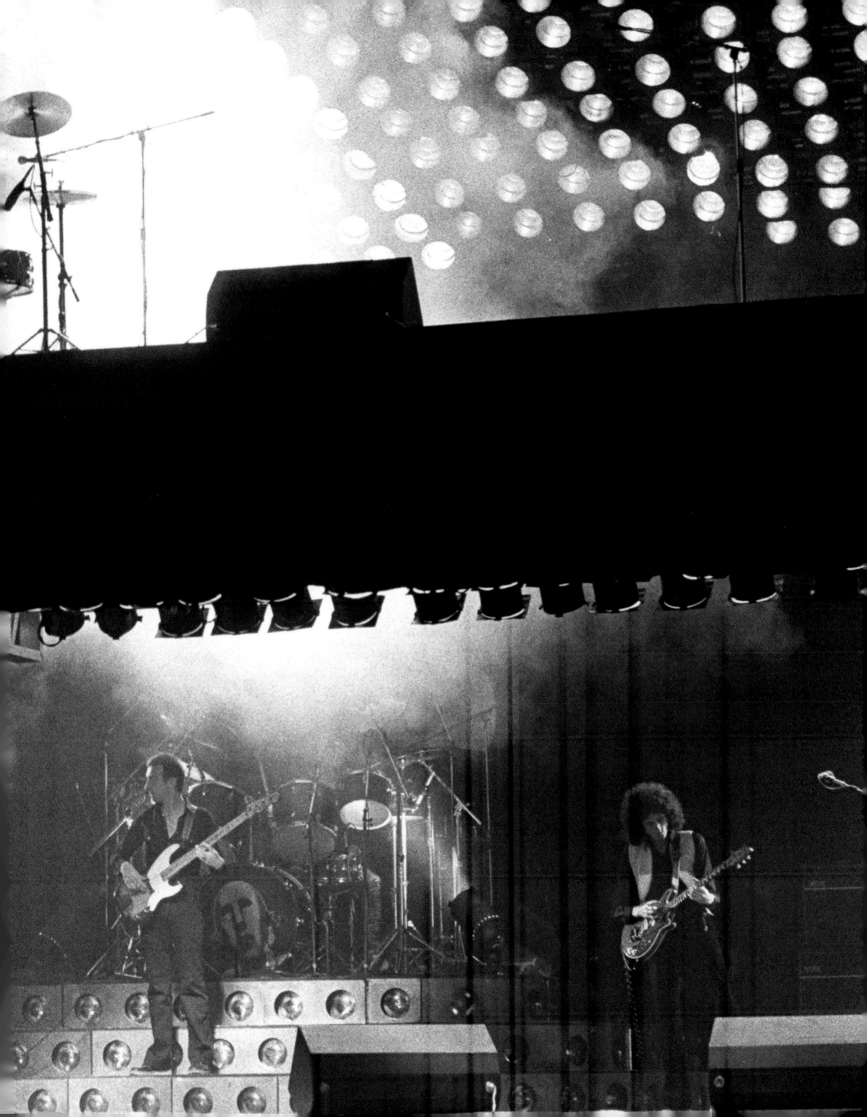

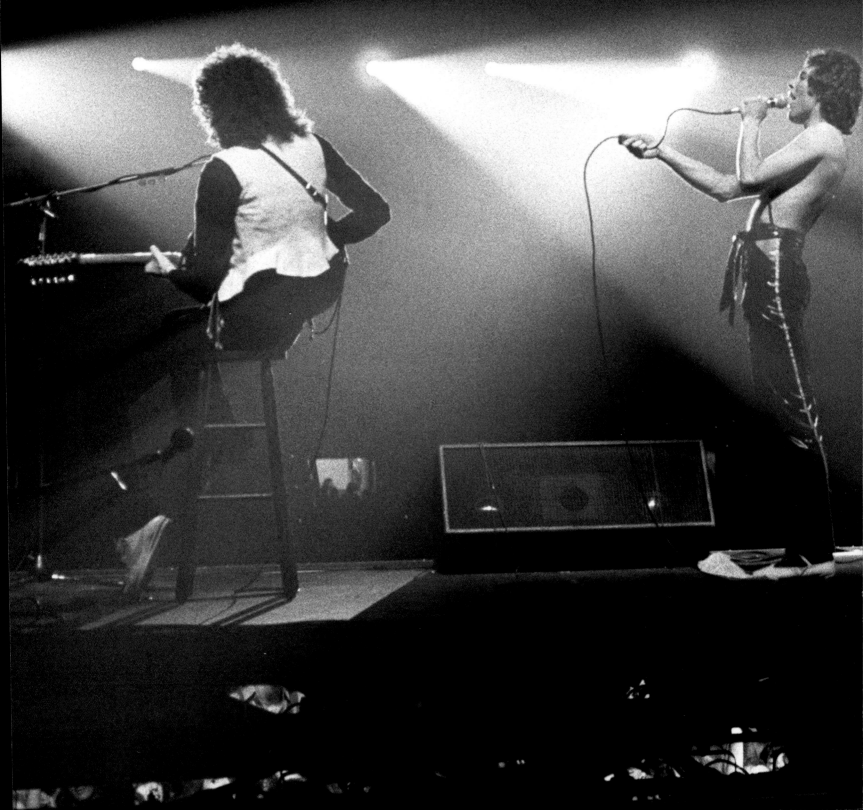

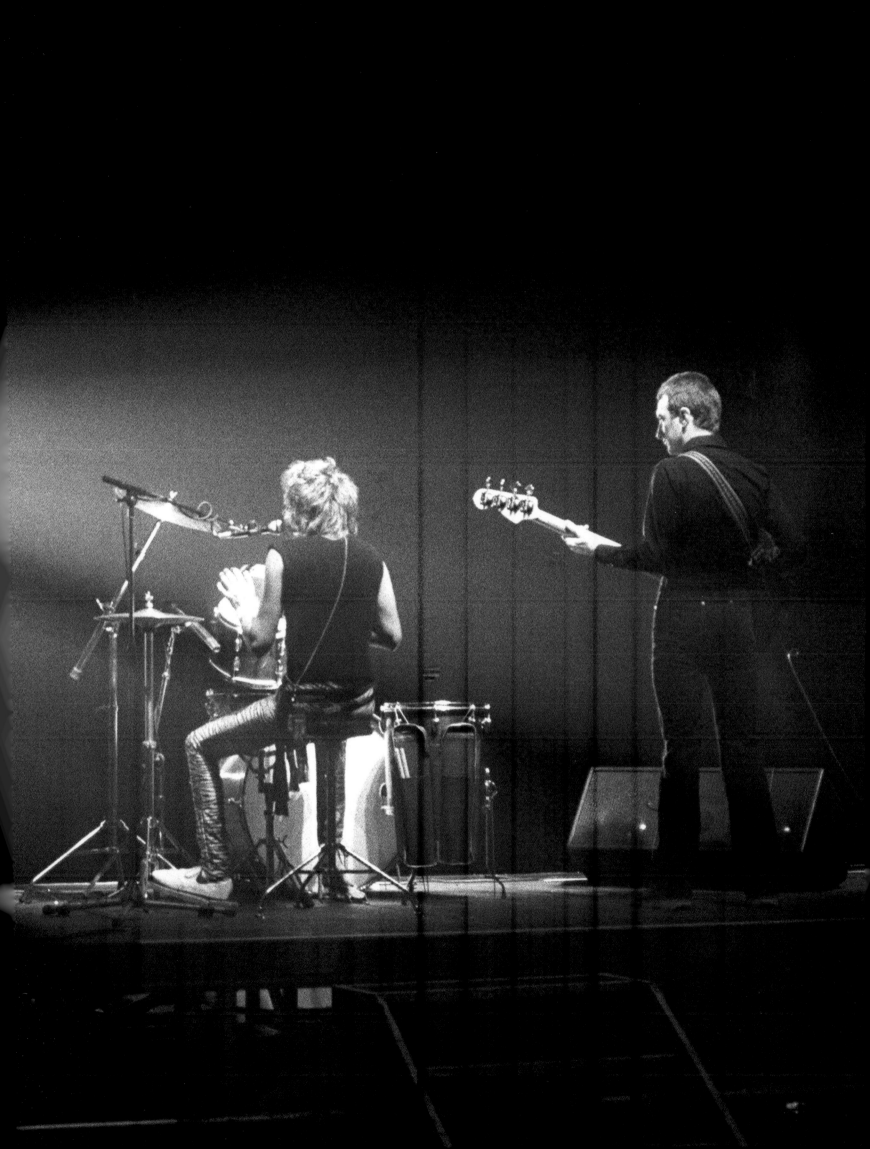

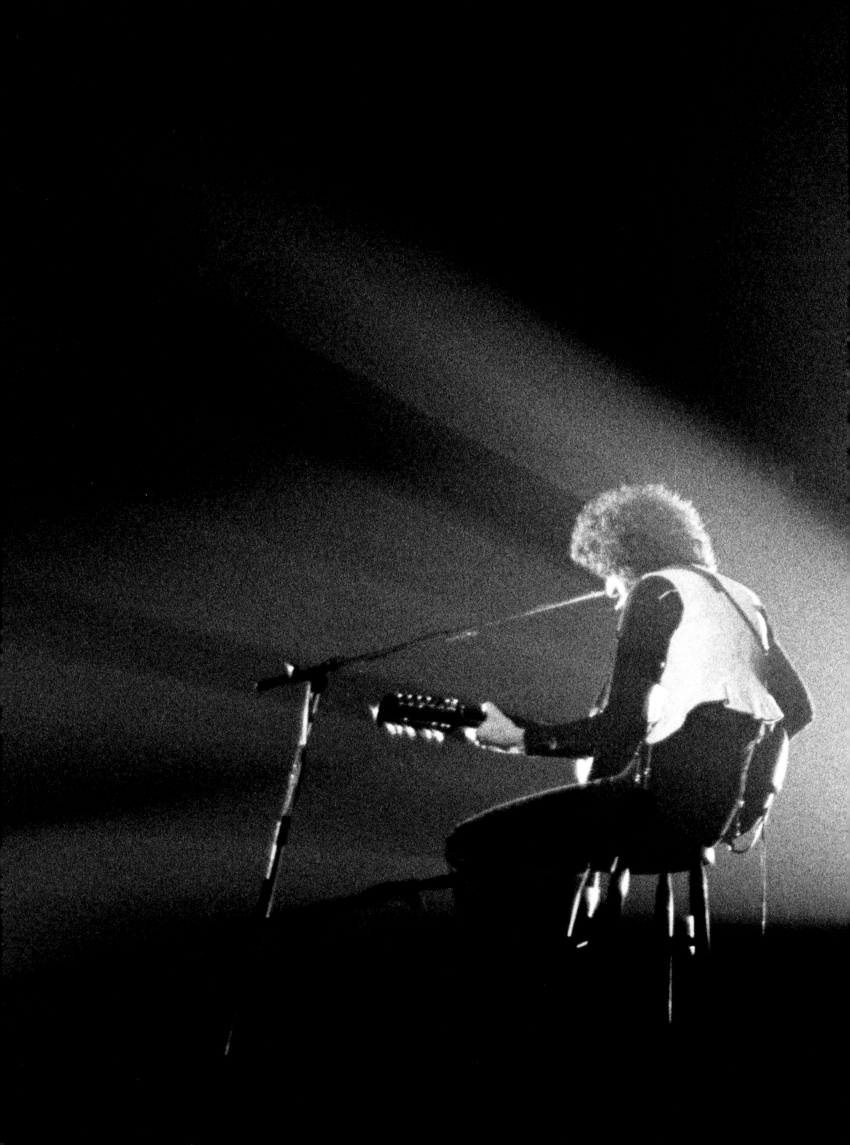

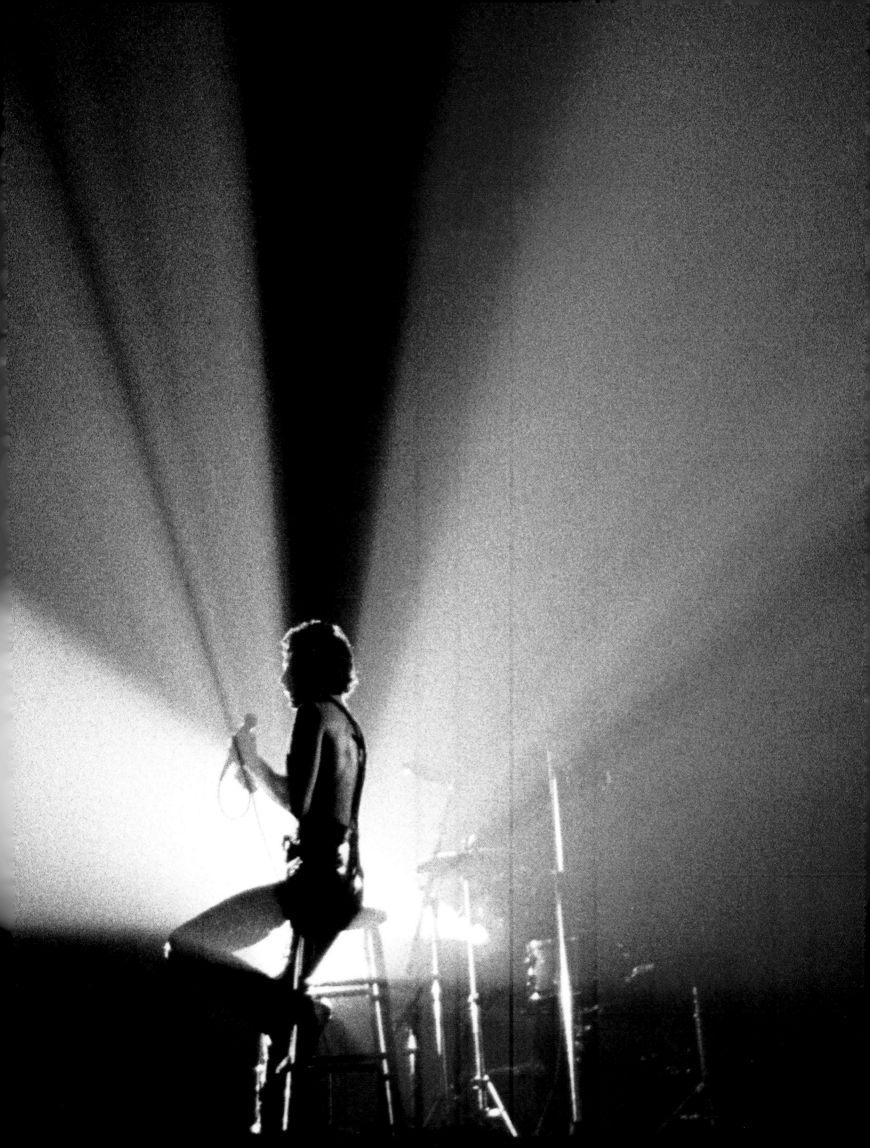

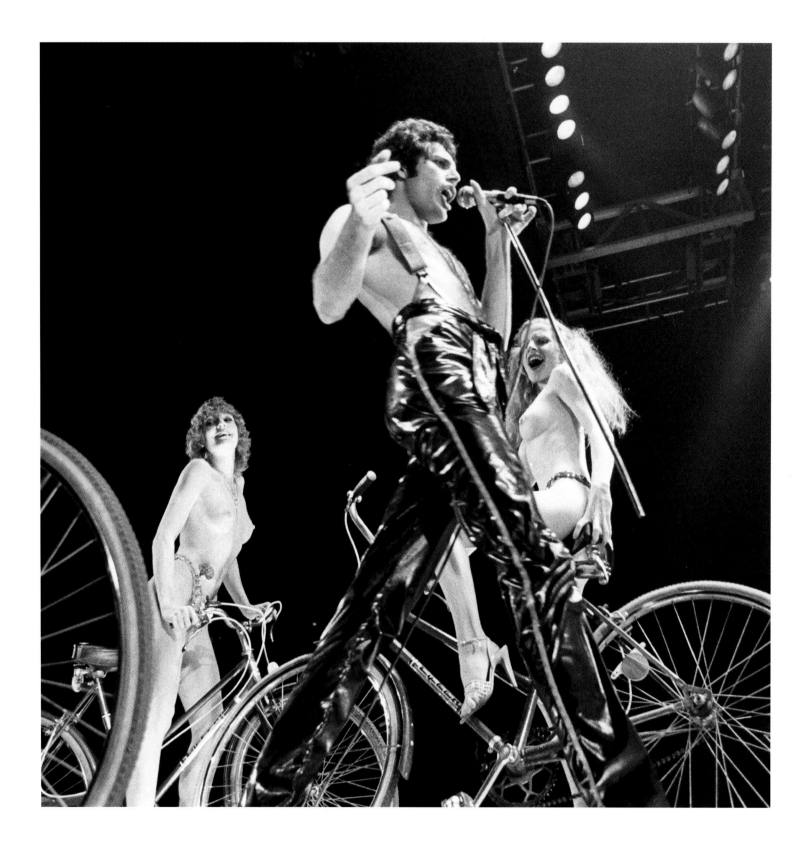

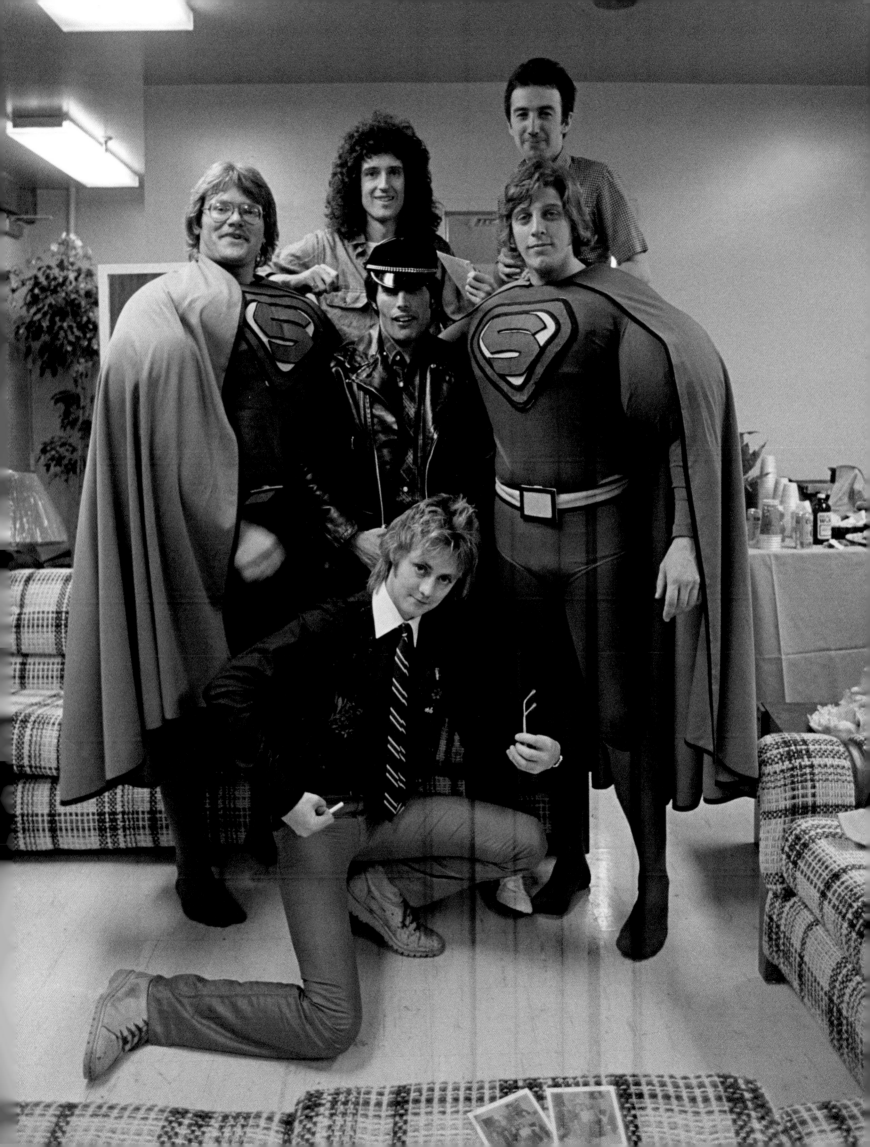

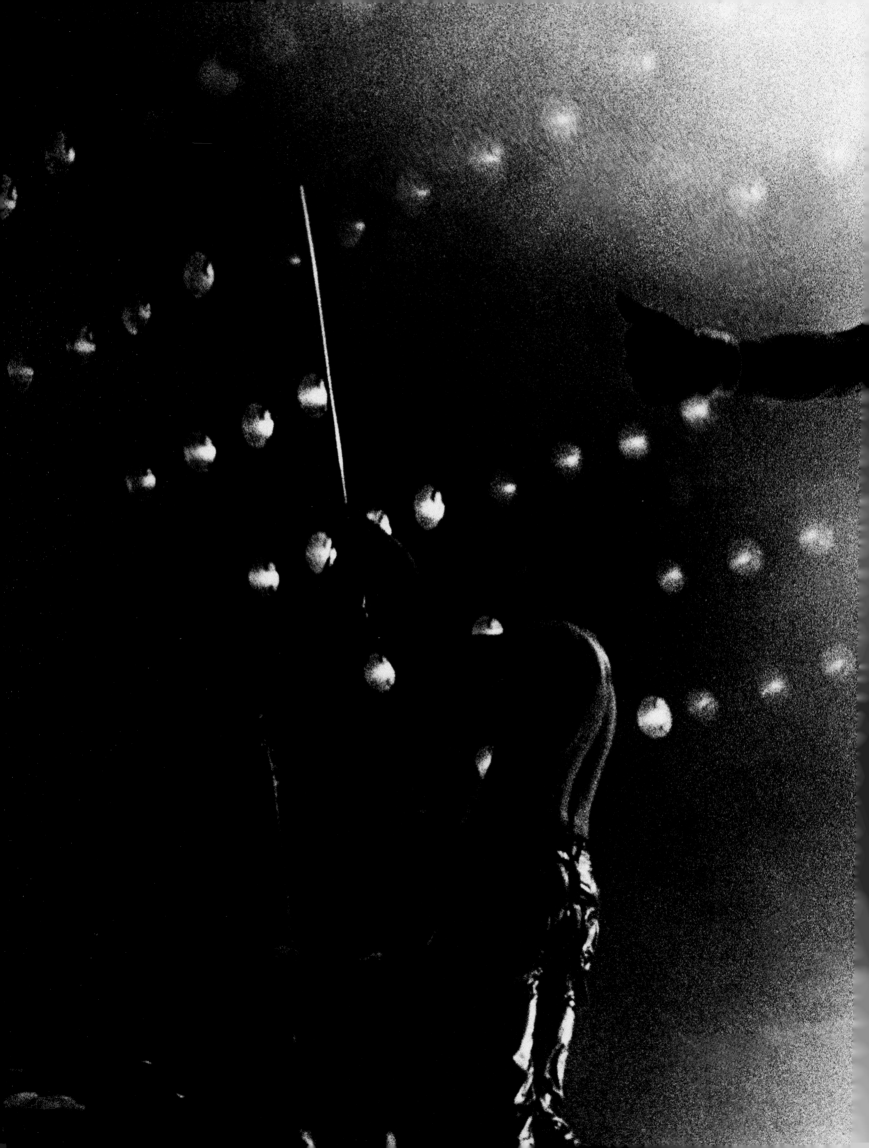

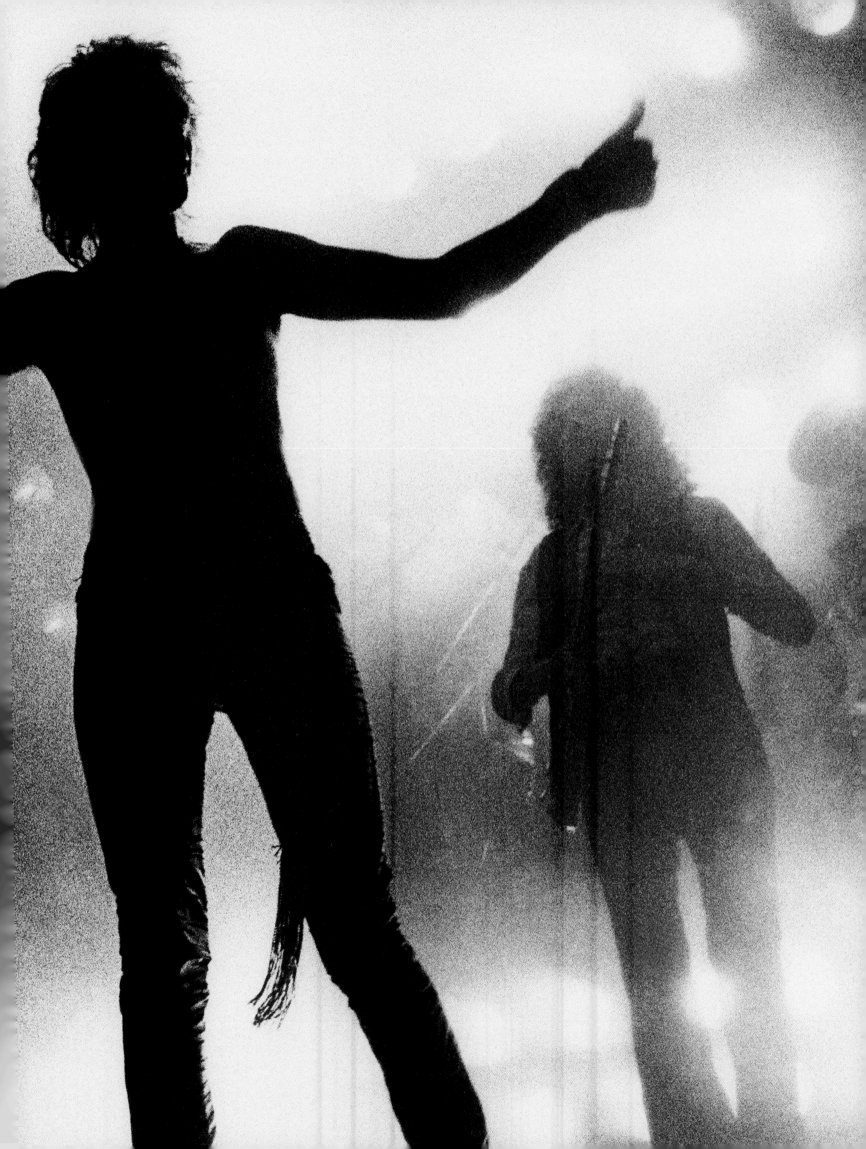

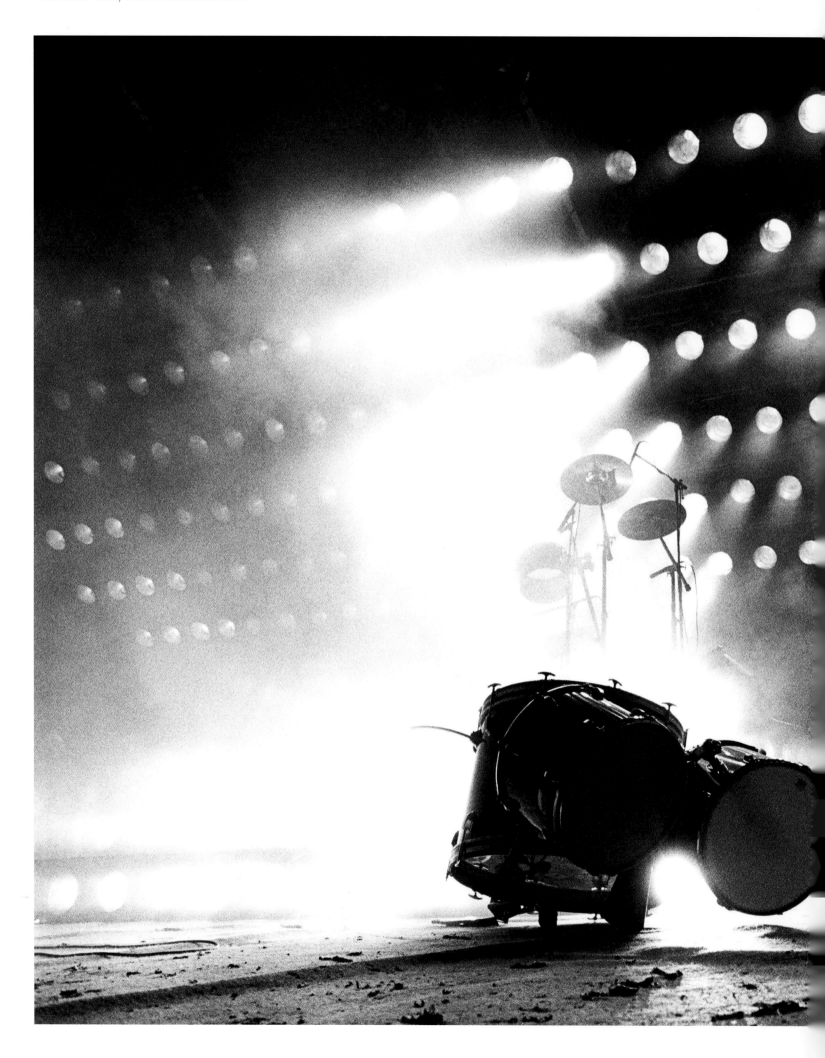

The Game Tour, North America 1980

30 June – Pacific Coliseum, Vancouver, BC, Canada
01 July – Seattle Center Coliseum, Seattle, WA, USA
02 July – Memorial Coliseum, Portland, OR, USA
05 July – Sports Arena, San Diego, CA, USA
06 July – Compton Terrace, Phoenix, AZ, USA
08 July – The Forum, Inglewood, CA, USA
09 July – The Forum, Inglewood, CA, USA
11 July – The Forum, Inglewood, CA, USA
12 July – The Forum, Inglewood, CA, USA
13 July – Oakland-Alameda County Coliseum, Oakland, CA, USA
14 July – Oakland-Alameda County Coliseum, Oakland, CA, USA
05 August – Mid-South Coliseum, Memphis, TN, USA
06 August – Riverside Centroplex, Baton Rouge, LA, USA
08 August – Myriad, Oklahoma City, OK, USA
09 August – Reunion, Dallas, TX, USA
10 August – Summit, Houston, TX, USA
12 August – Omni, Atlanta, GA, USA
13 August – Coliseum, Charlotte, NC, USA
14 August – Coliseum, Greensboro, NC, USA
16 August – Civic Center Coliseum, Charleston, WV, USA
17 August – Market Square Arena, Indianapolis, IN, USA
20 August – Civic Center, Hartford, CT, USA
22 August – The Spectrum, Philadelphia, PA, USA
23 August – Civic Center, Baltimore, MD, USA
24 August – Civic Arena, Pittsburgh, PA, USA
26 August – Civic Center, Providence, RI, USA
27 August – Cumberland County Civic Center, Portland, ME, USA
29 August – Forum, Montreal, QC, Canada
30 August – CNE Exhibition Stadium, Toronto, ON, Canada
10 September – Mecca, Milwaukee, WI, USA
12 September – Kemper Arena, Kansas City, MO, USA
13 September – Civic Auditorium Arena, Omaha, NE, USA
14 September – Civic Arena, St. Paul, MN, USA
16 September – Hilton Coliseum, Ames, IA, USA
17 September – Checkerdome, St. Louis, MO, USA
19 September – Rosemont Horizon, Rosemont, IL, USA
20 September – Joe Louis Arena, Detroit, MI, USA
21 September – Coliseum, Richfield, OH, USA
23 September – Civic Center, Glens Falls, NY, USA
24 September – Onondaga County War Memorial Auditorium, Syracuse, NY, USA
26 September – Boston Garden, Boston, MA, USA
28 September – Madison Square Garden, New York, NY, USA
29 September – Madison Square Garden, New York, NY, USA
30 September – Madison Square Garden, New York, NY, USA

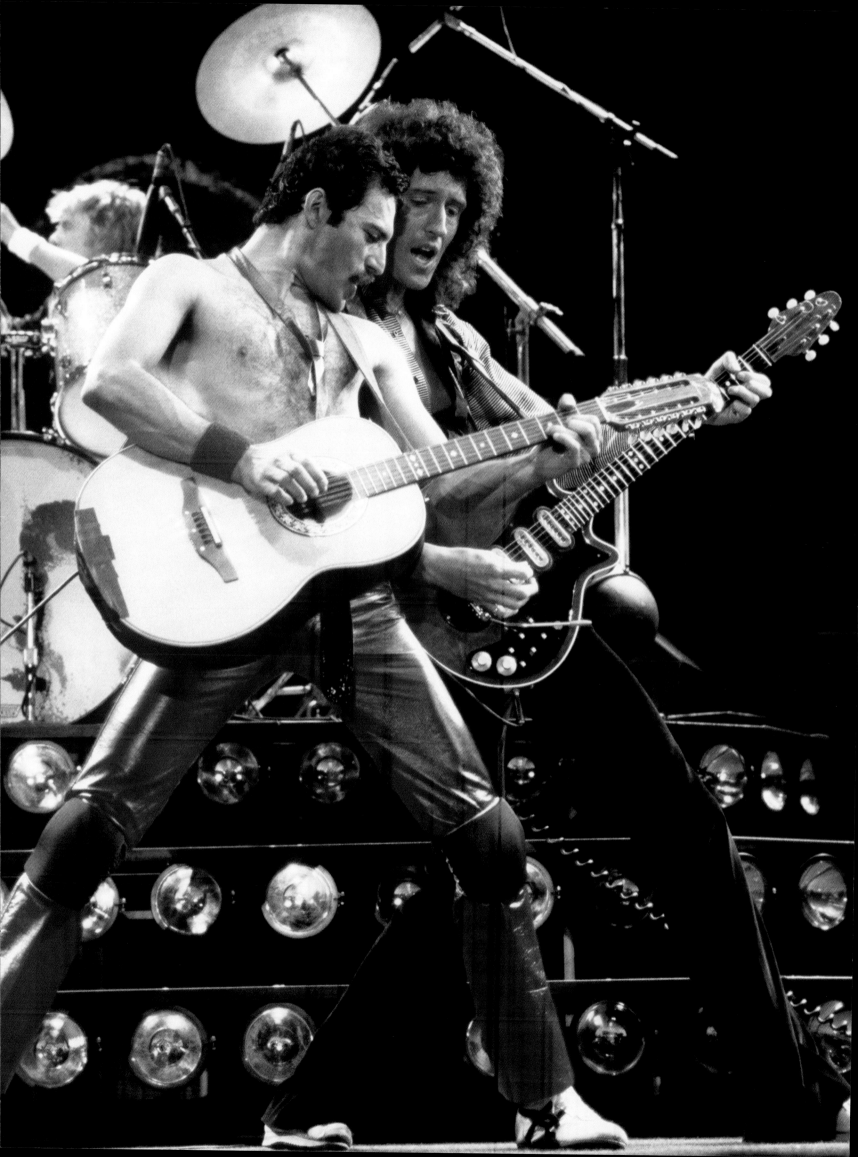

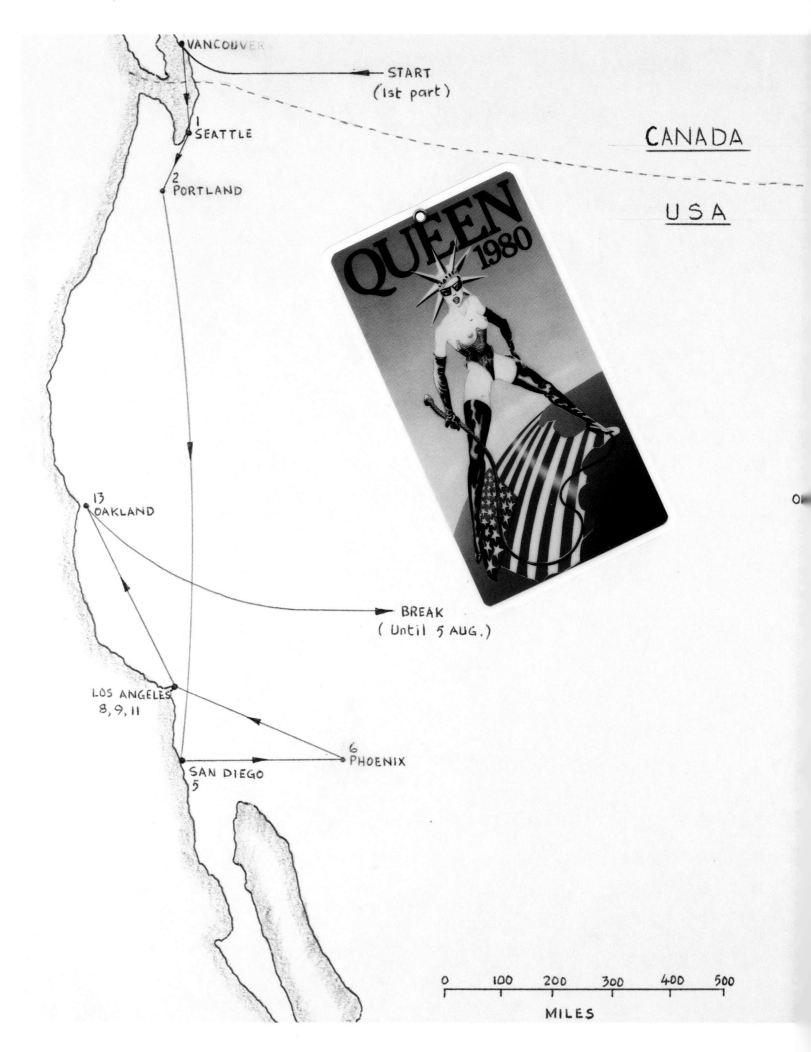

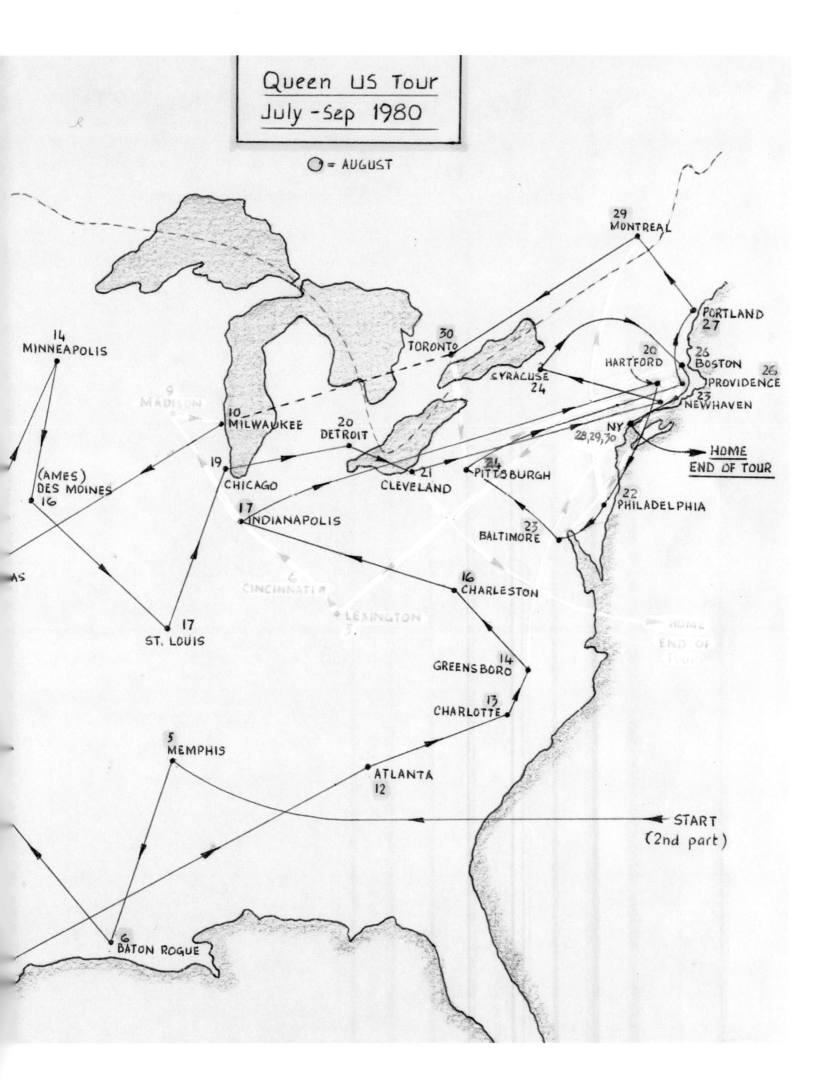

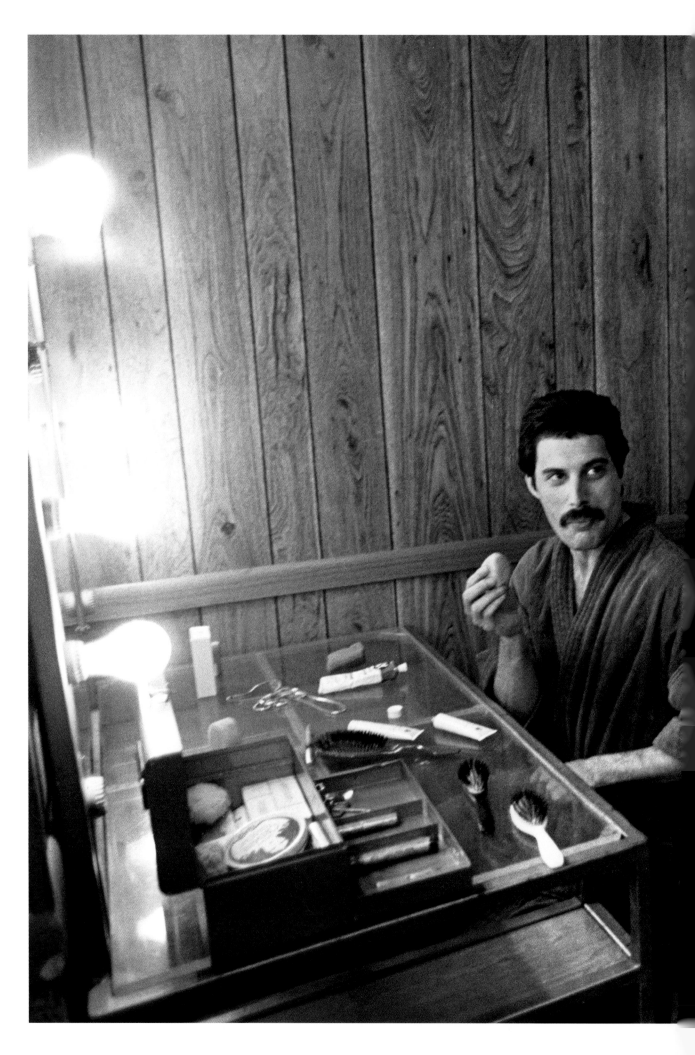

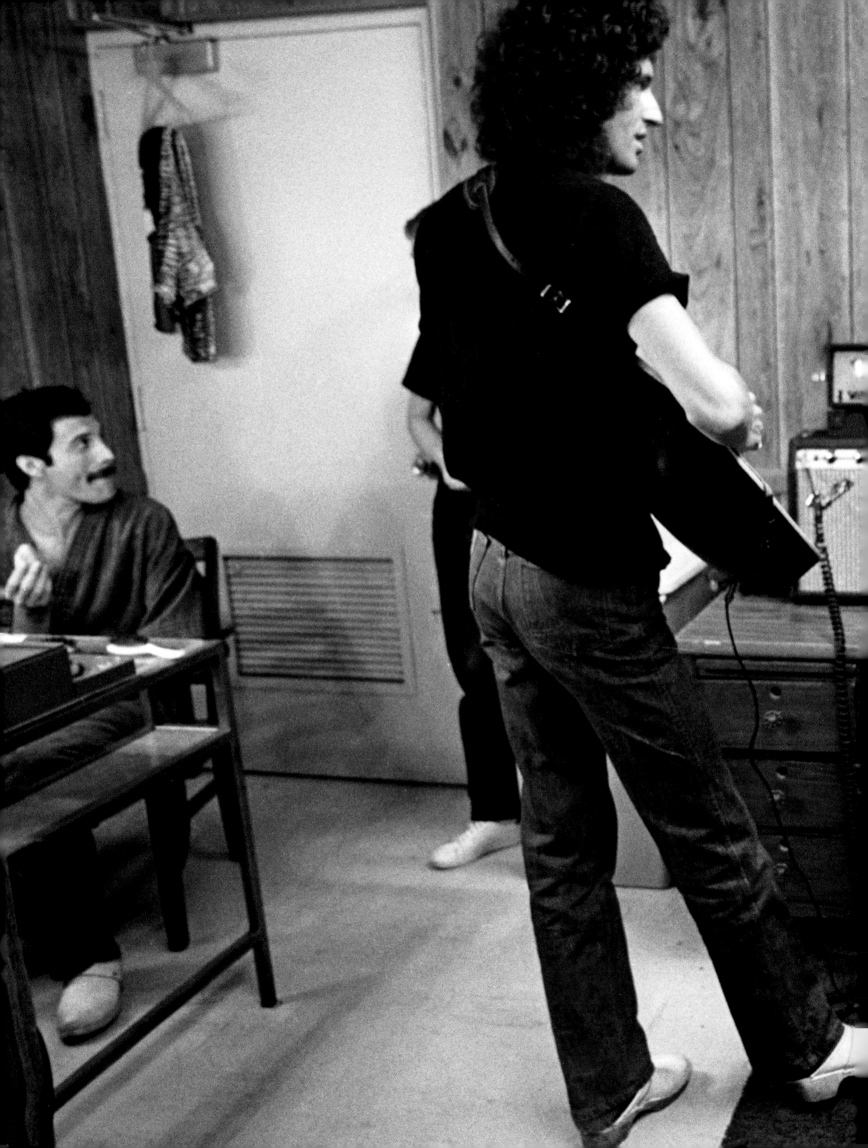

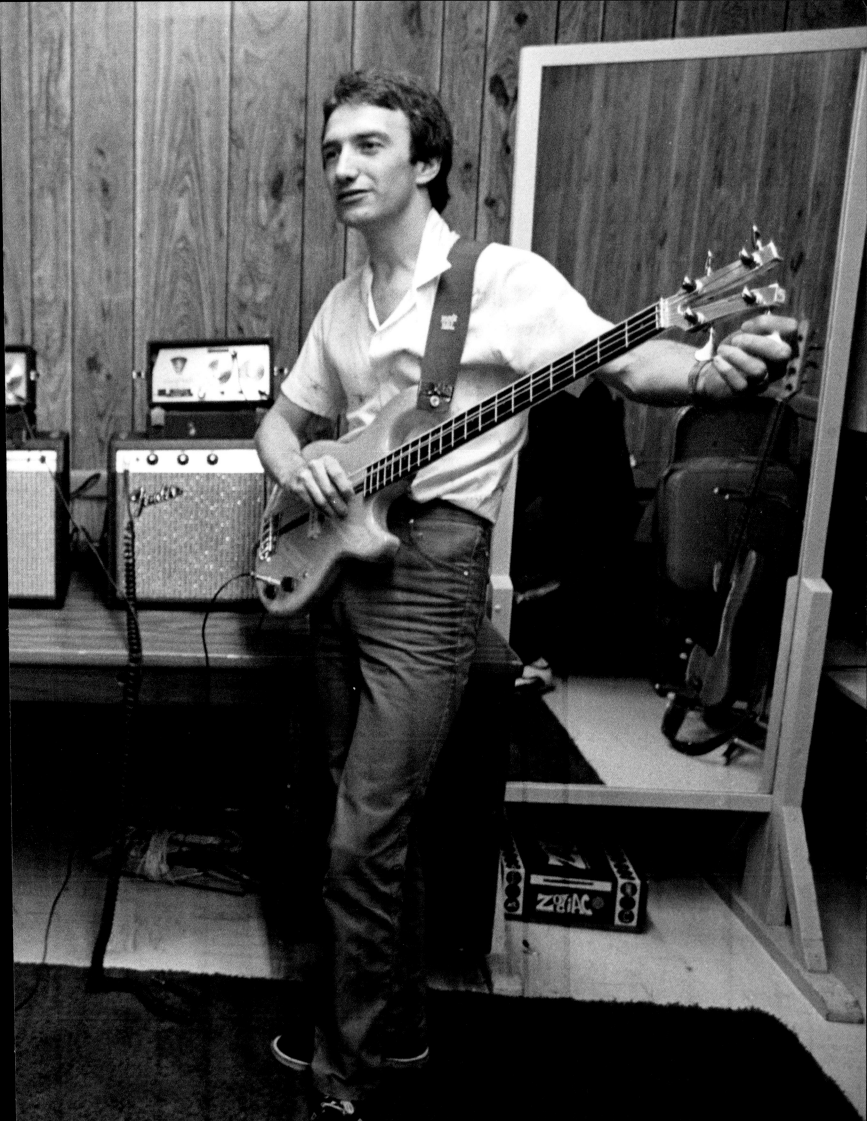

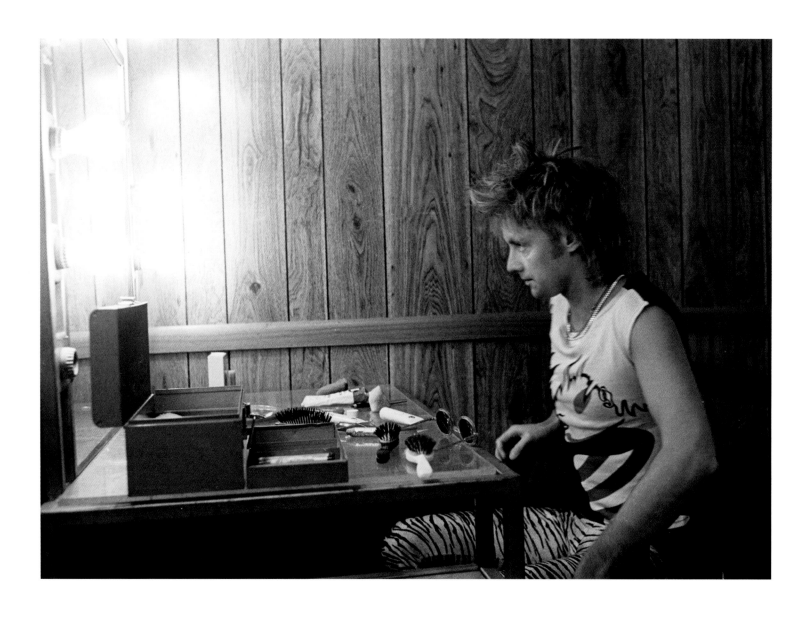

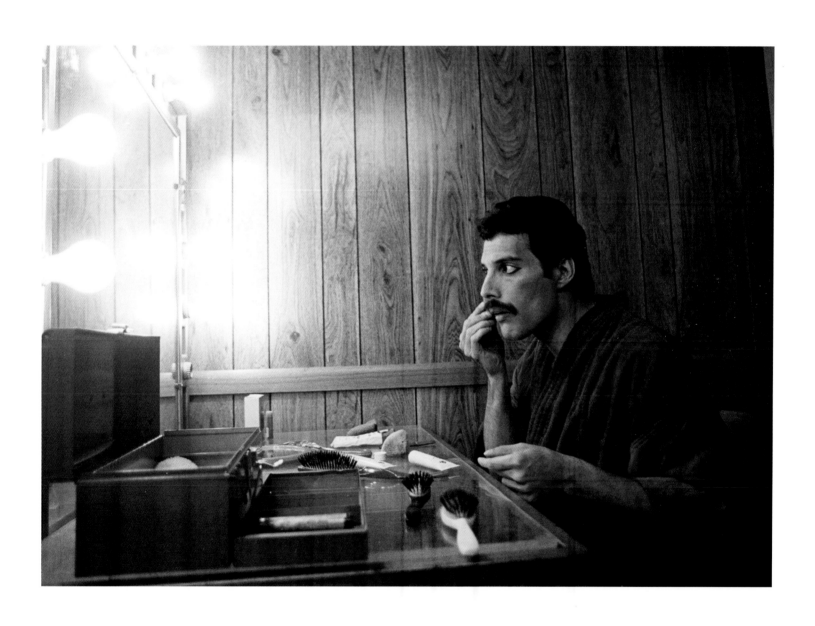

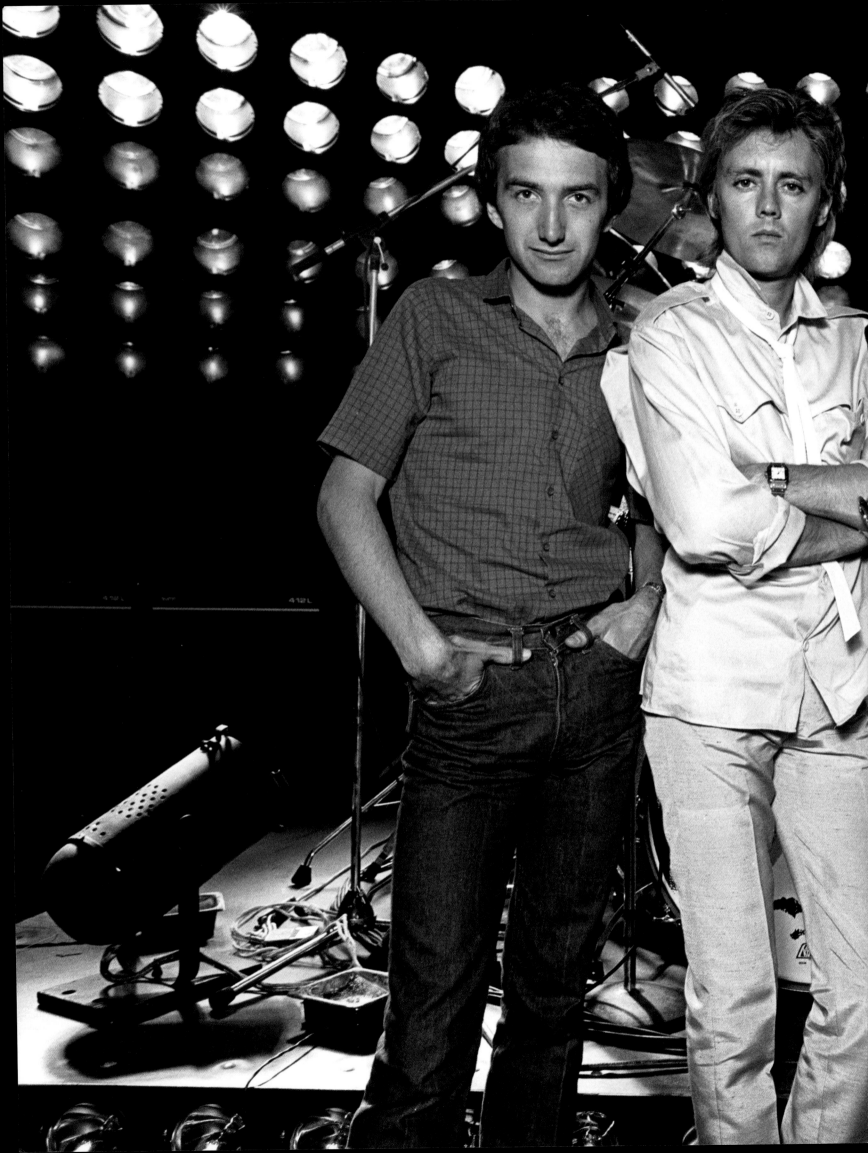

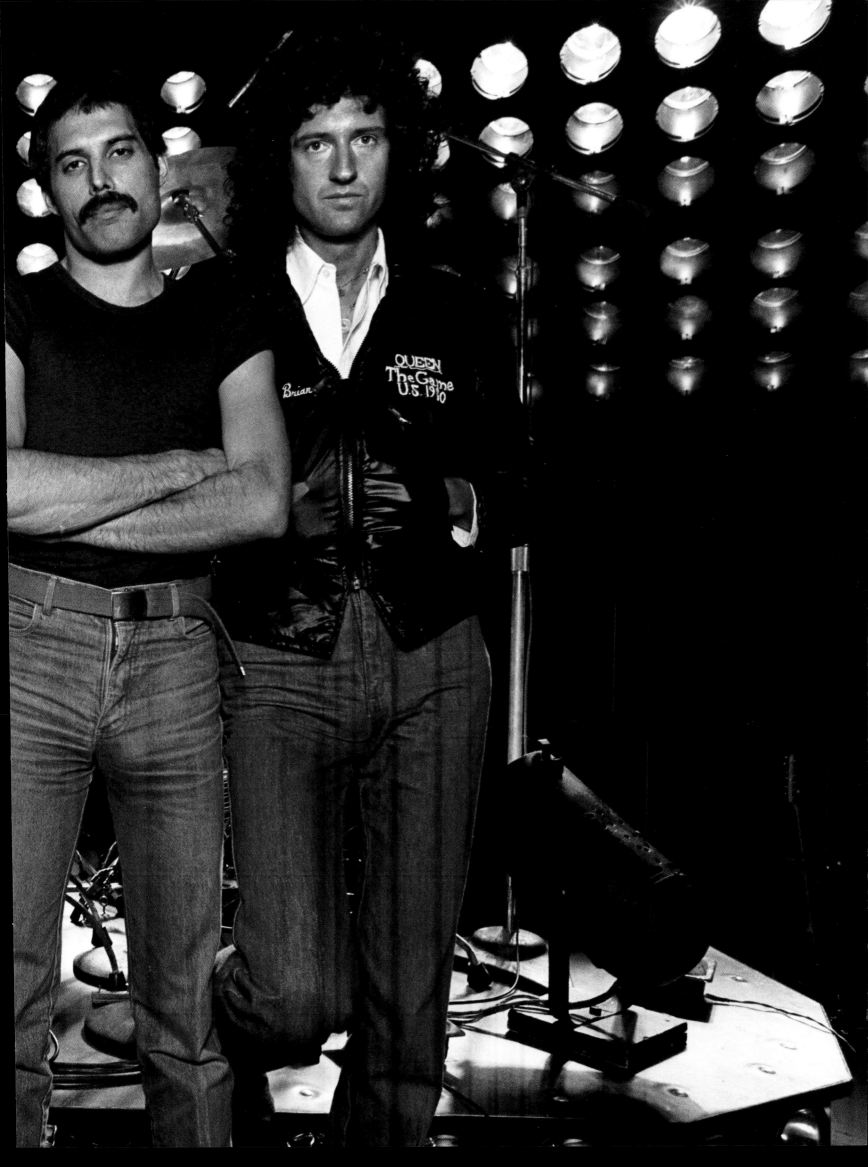

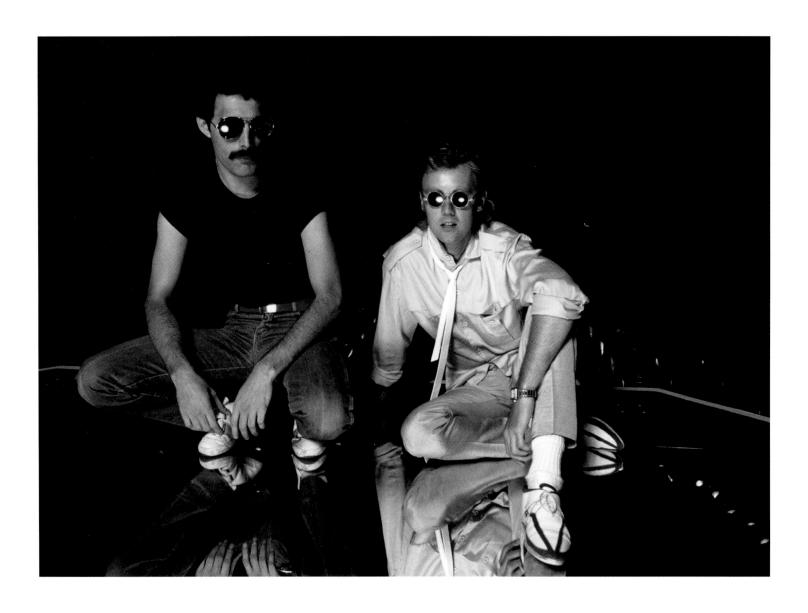

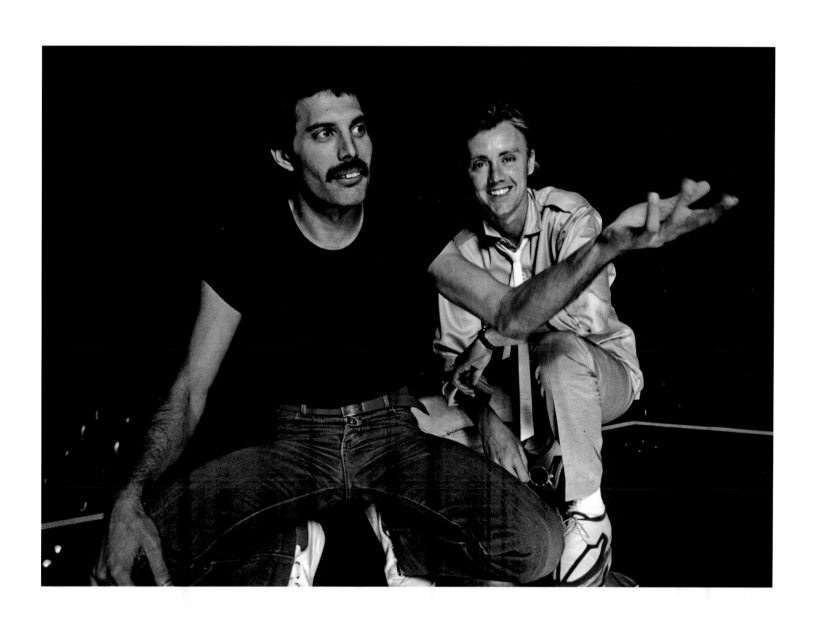

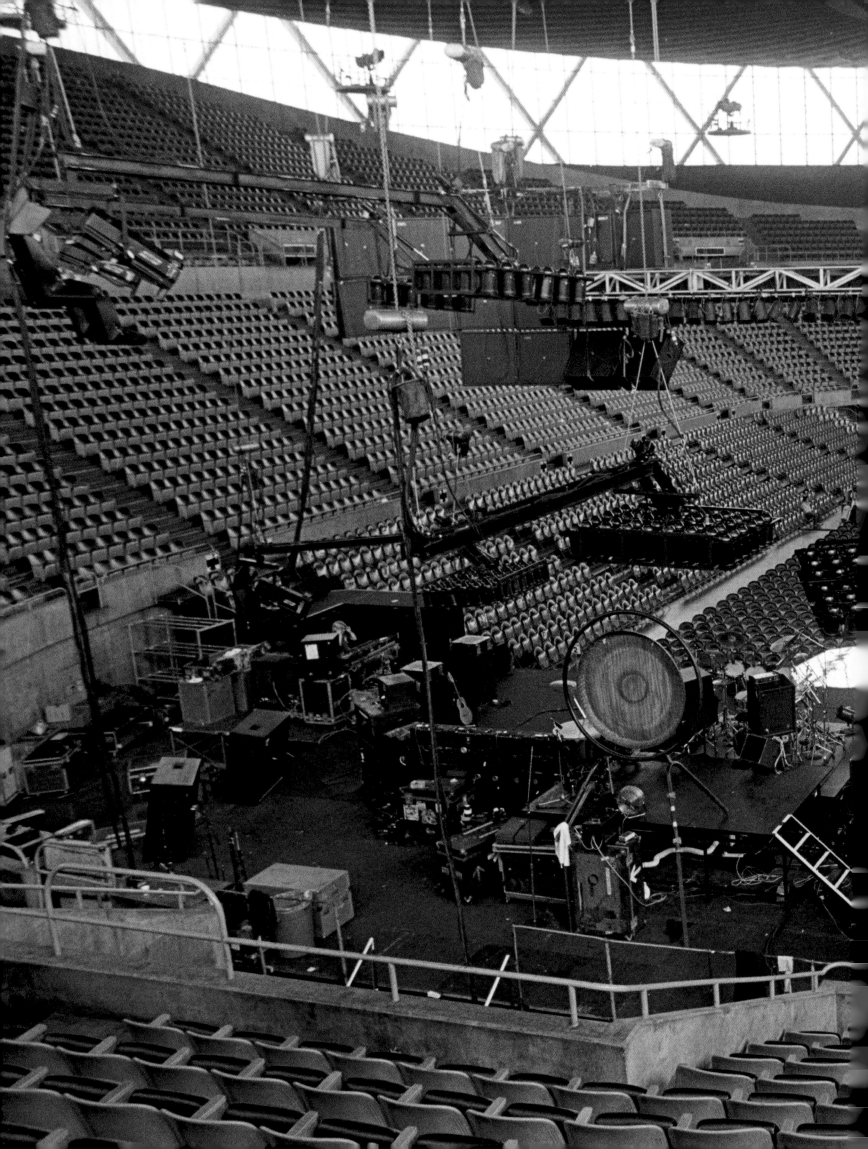

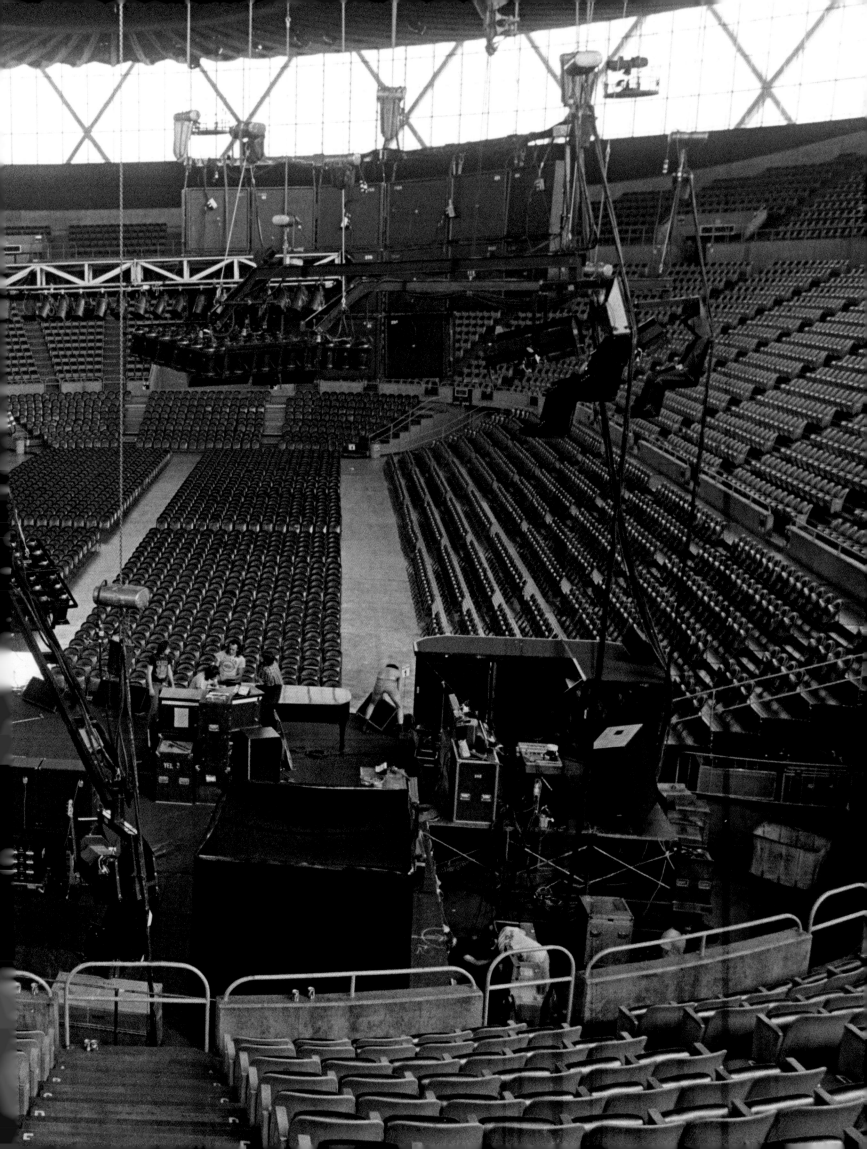

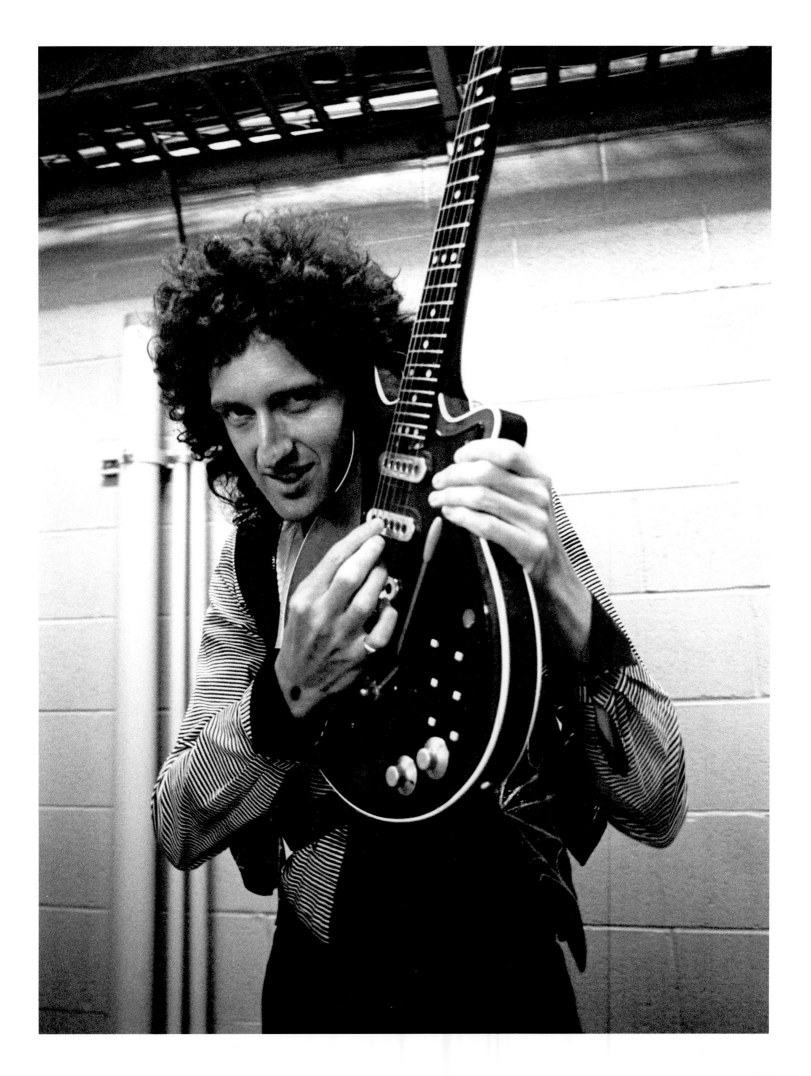

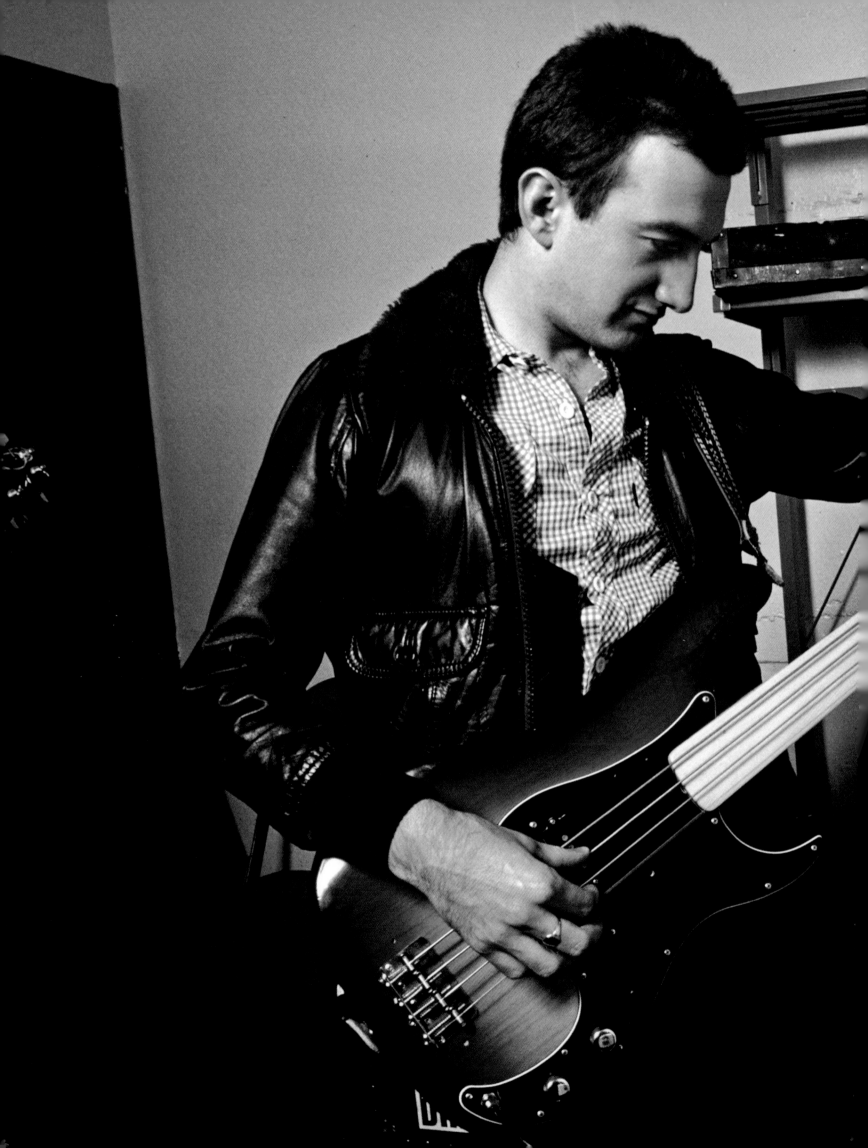

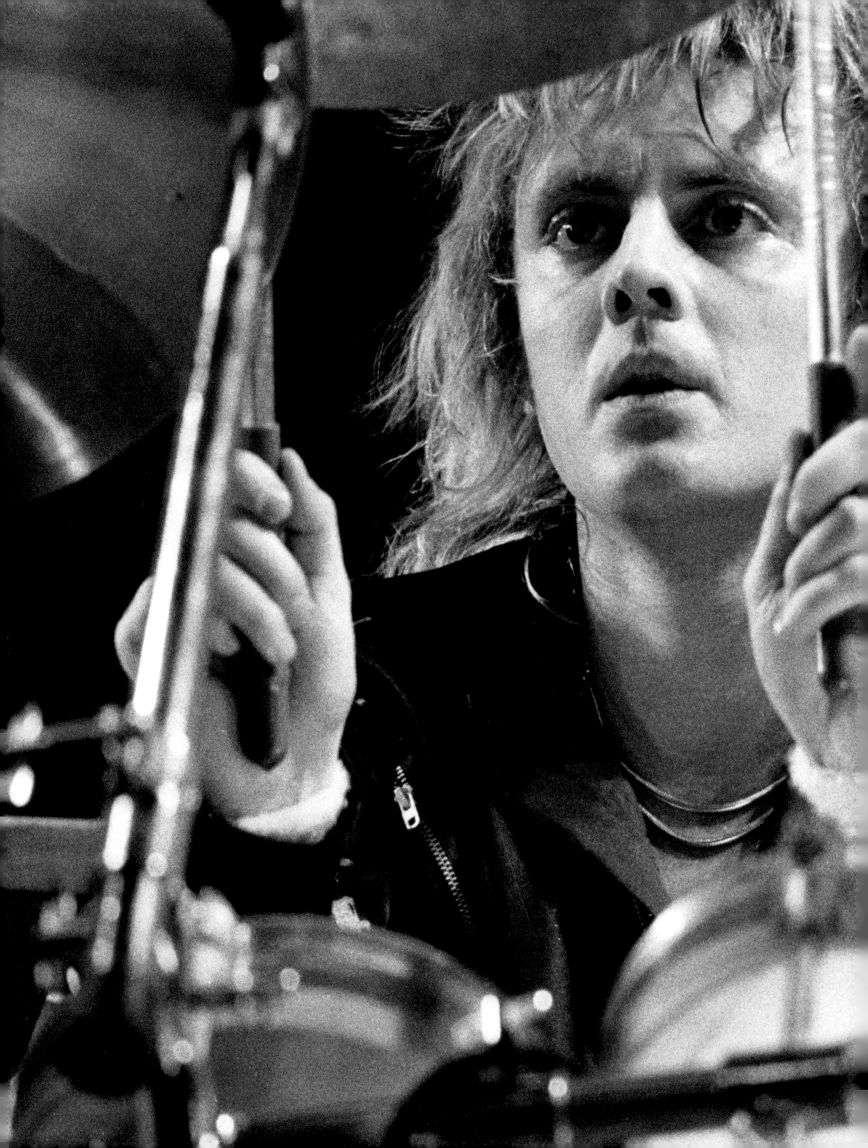

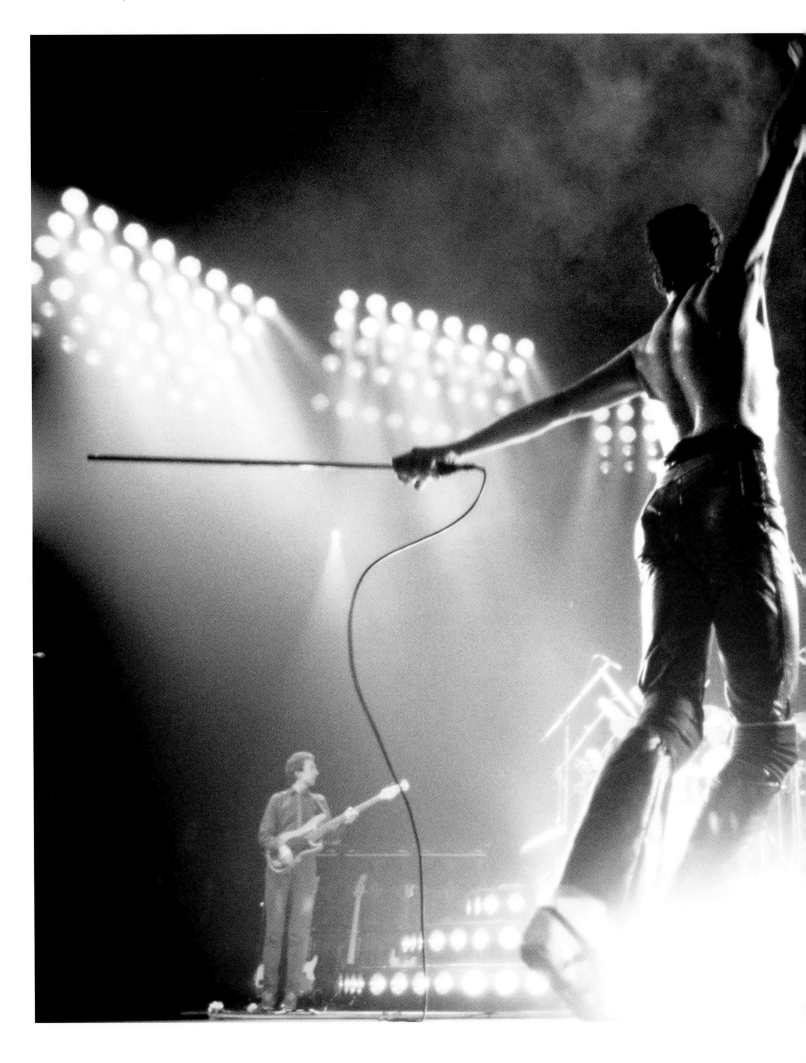

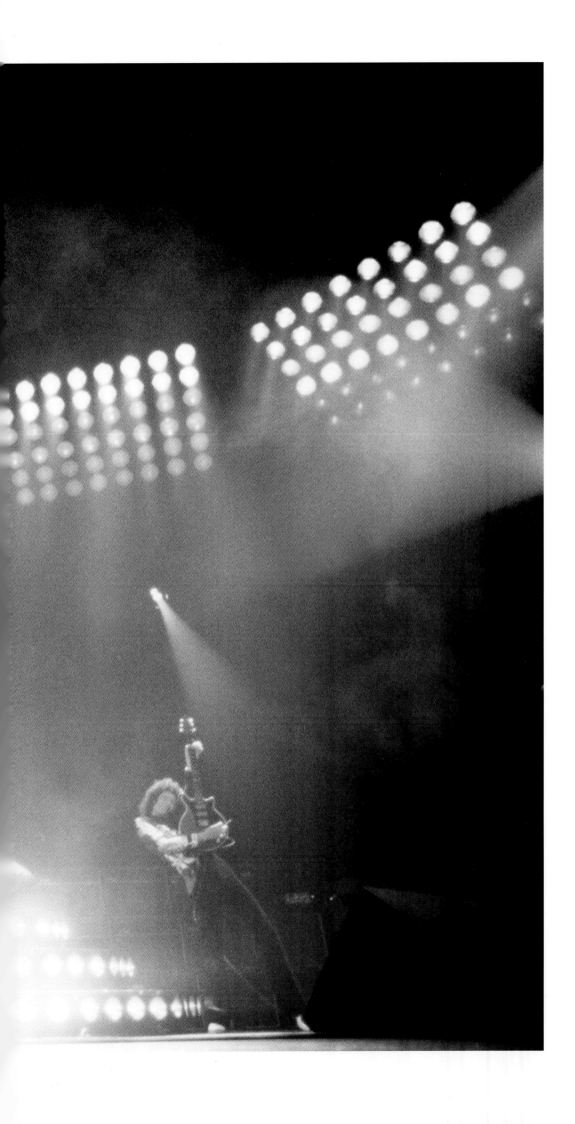

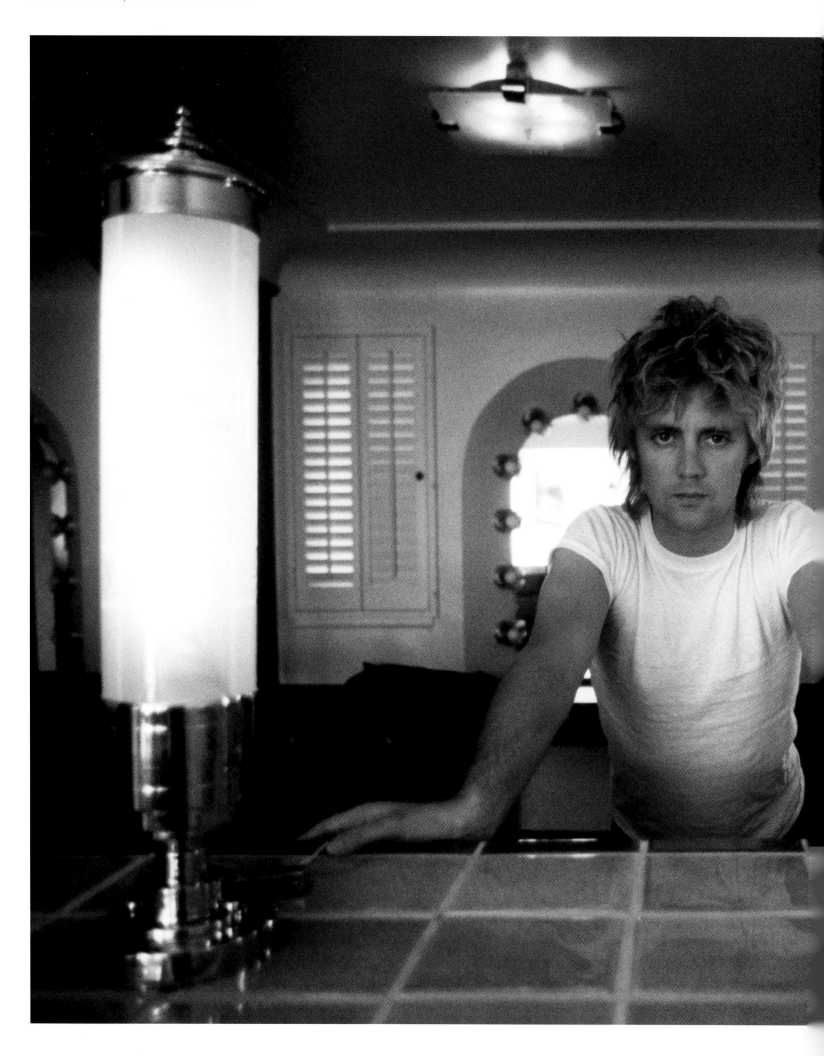

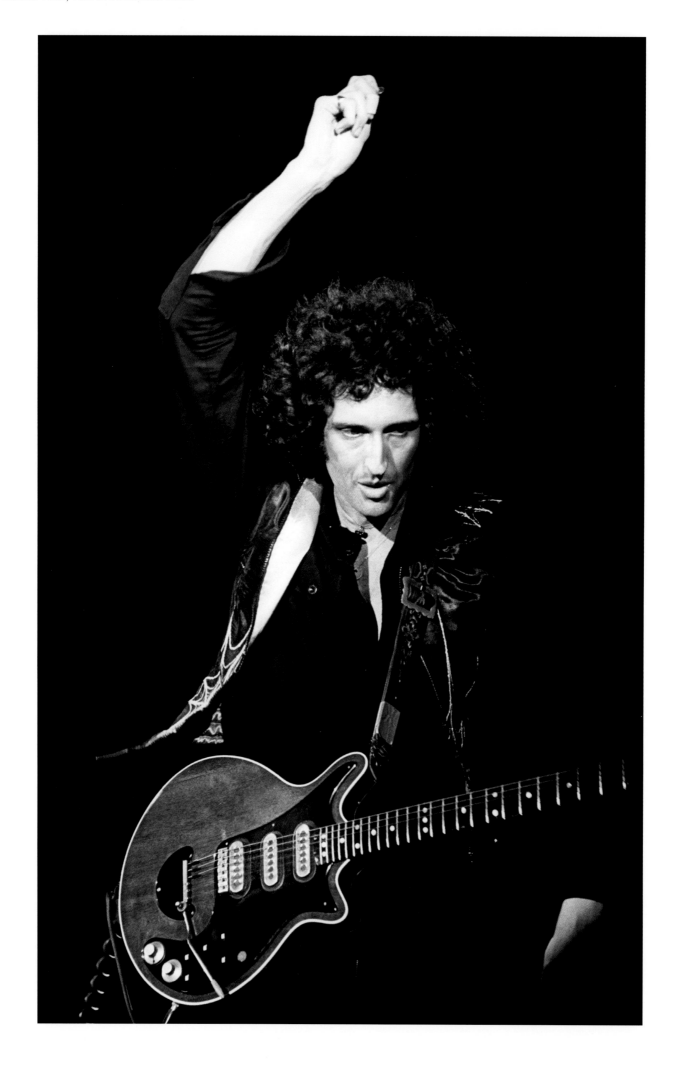

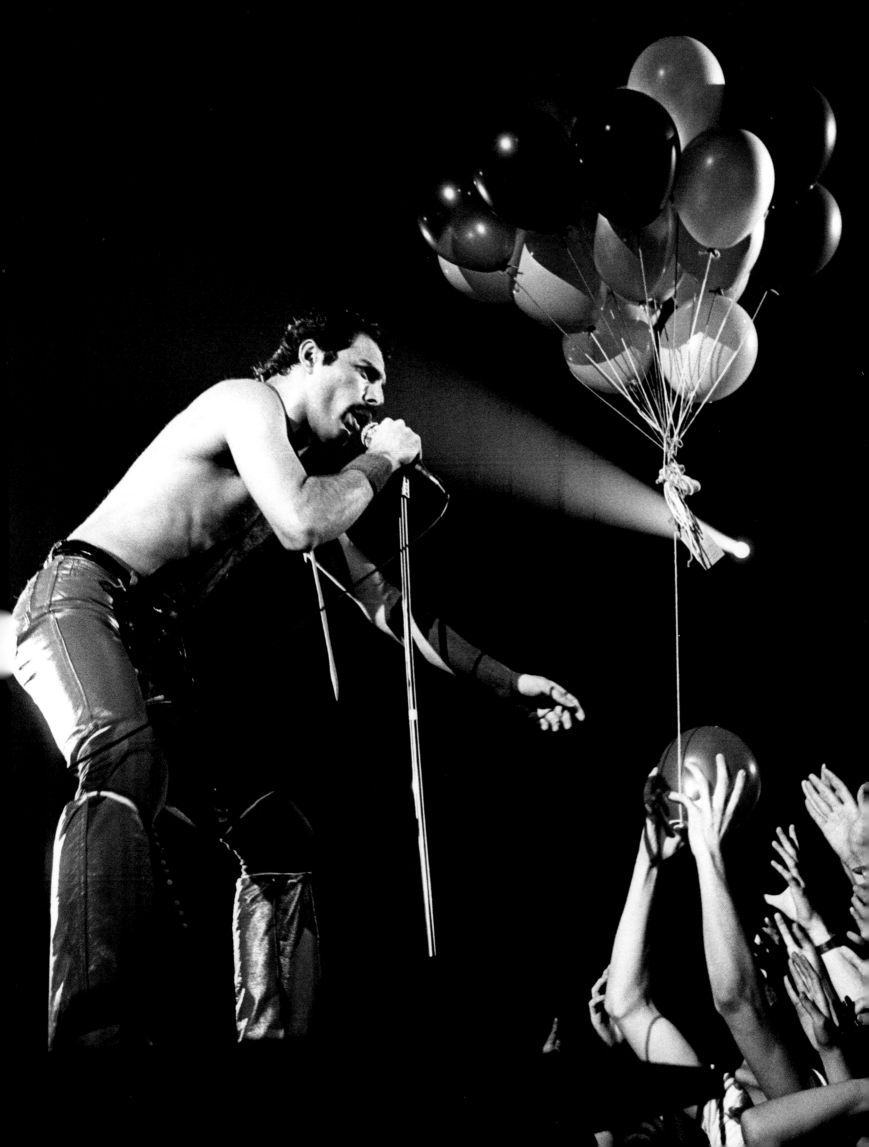

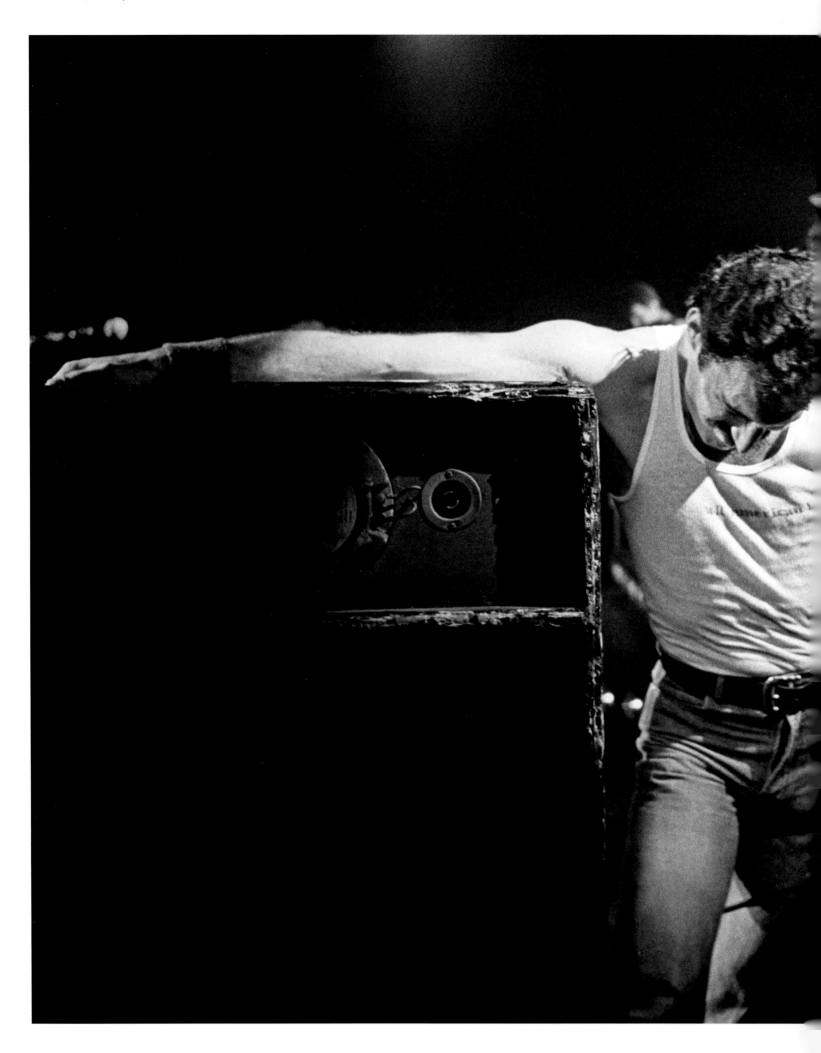

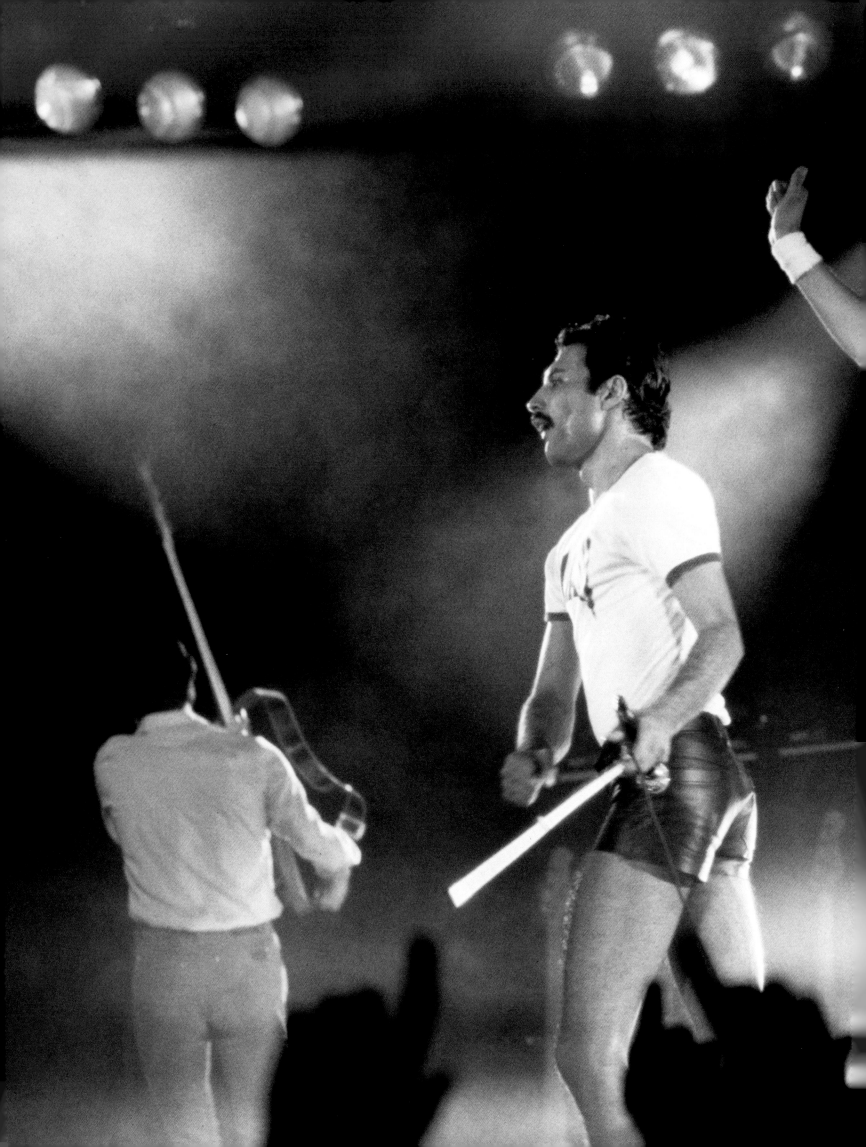

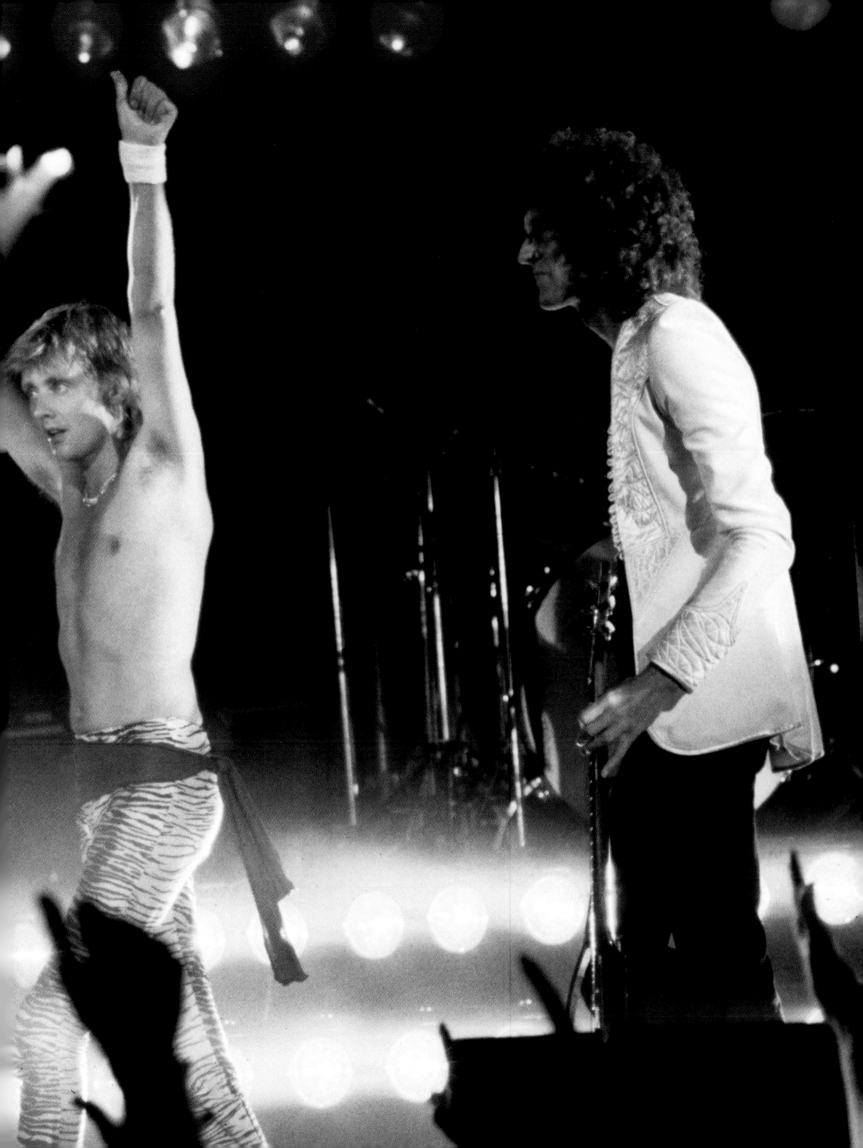

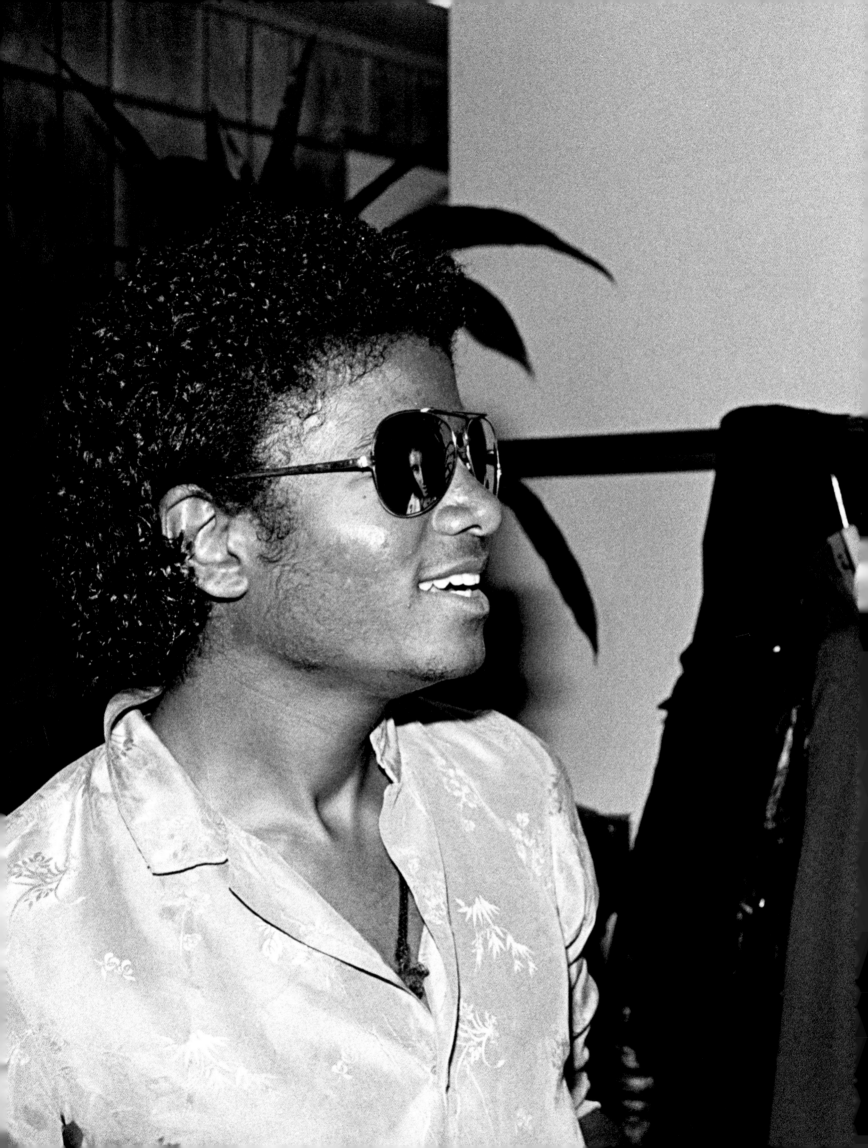

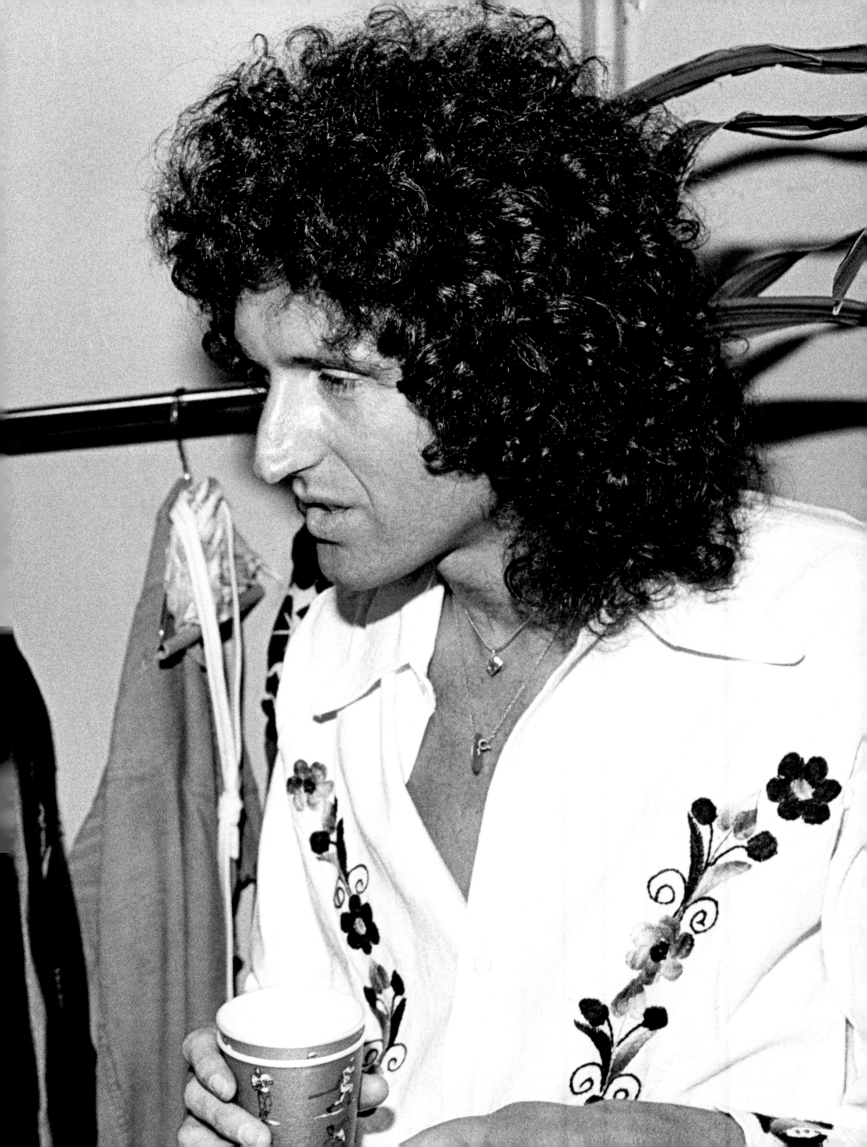

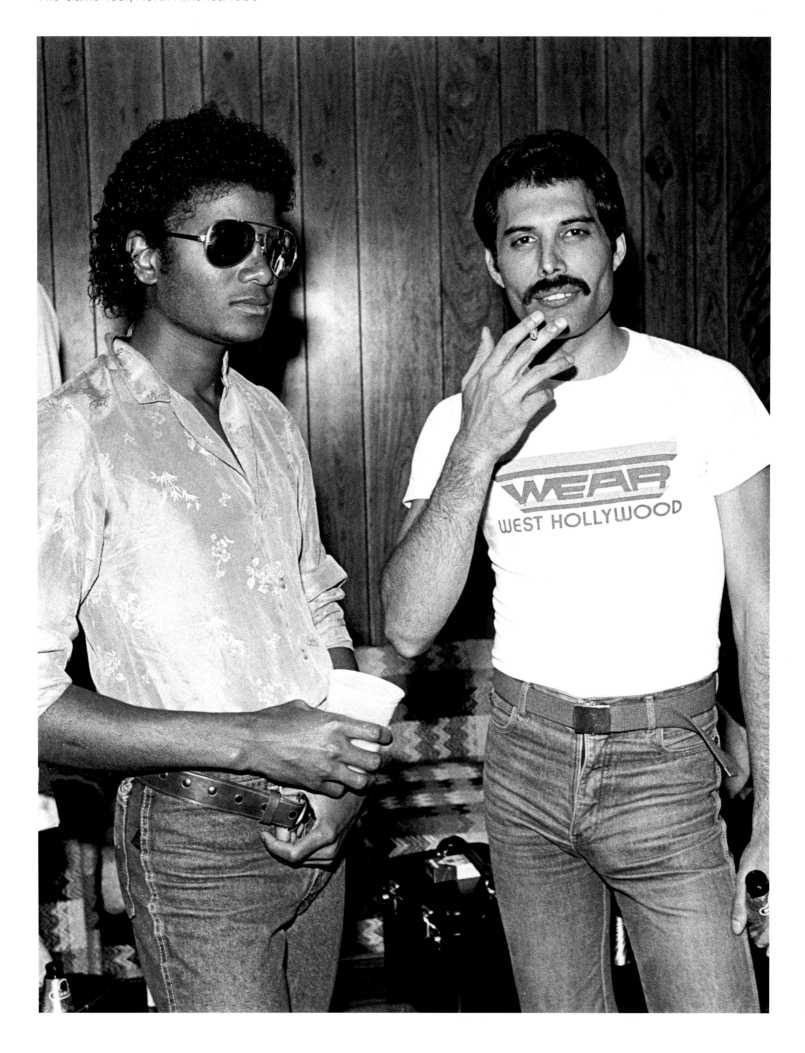

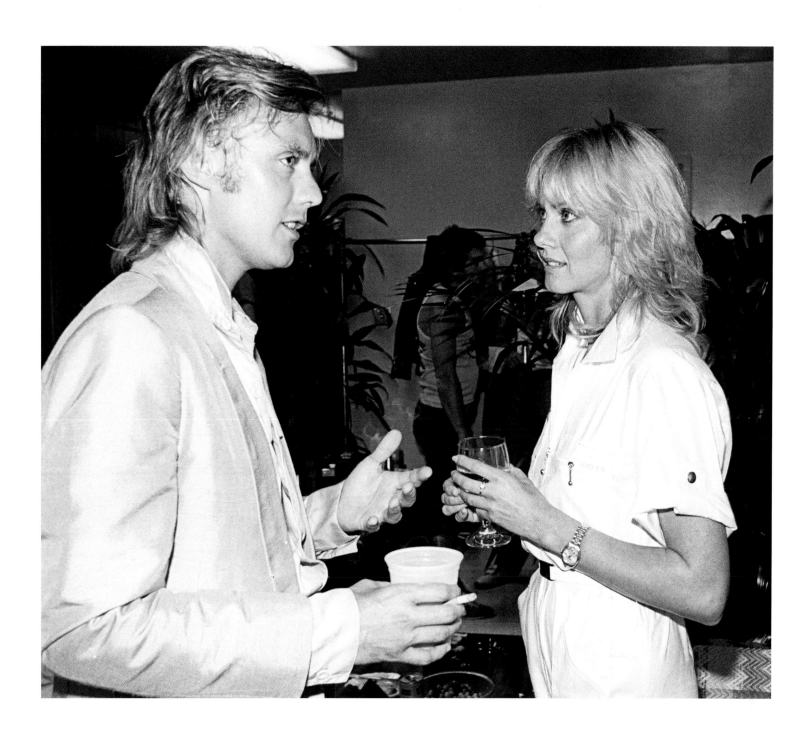

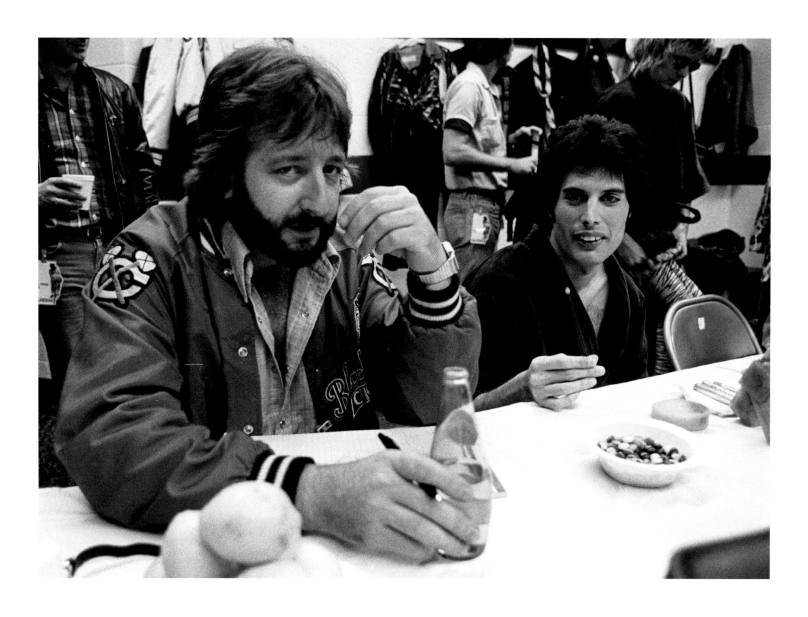

The Queen Crew

I always considered myself a small part of the Queen crew . . . but I was the one with the easy job. Nobody on earth works as hard at their job as a member of a rock and roll crew. It is grueling work under constant pressure with *huge* deadlines staring at you almost every day. I've always wondered how any of those guys, and girls, maintained any sense of humor, or even civility, much less stayed awake, while on the road.

The bottom line is that Queen's road crew is absolutely as much a part of my photos as the band is. Every single crew member in his or her own way helped pave the way for me to make the photographs on these pages.

From day one I noticed many on the crew had strange nicknames. This was not good for me as I've never been good with names, and you don't wanna go, "Hey you, can you move outta my frame?" in the middle of a show. I never asked how they got their nicknames but every one of the British roadies (yes, I'm using the outdated word "roadie" but that's what I'm used to) had them. There was Ratty, Crystal, Jobby and Phoebe, not to mention my American brothers Parnelli, Trip, Jim Devenney, Timmy Lamb, Wally, Big Paul and many whose names escape me right now. I don't know how they all put up with me but none of this would ever have happened without them.

Gerry Stickells was our tour manager, the captain that steered the ship. Gerry was a consummate professional who, in retrospect, I believe became a sort of father figure to many of us on that crew. He used to remind me of one of those guys on the *Ed Sullivan Show* that used to spin the plates, keeping twenty of them constantly whirling around on poles and never letting one hit the ground.

The legend of Gerry Stickells looms large in my career and my life. In late 1968 I shot my first big concert, a Jimi Hendrix show in Boston. I was a 17-year-old kid still in high school so the fact that the promoters had given me an actual photo pass for this show was a *Big Deal*.

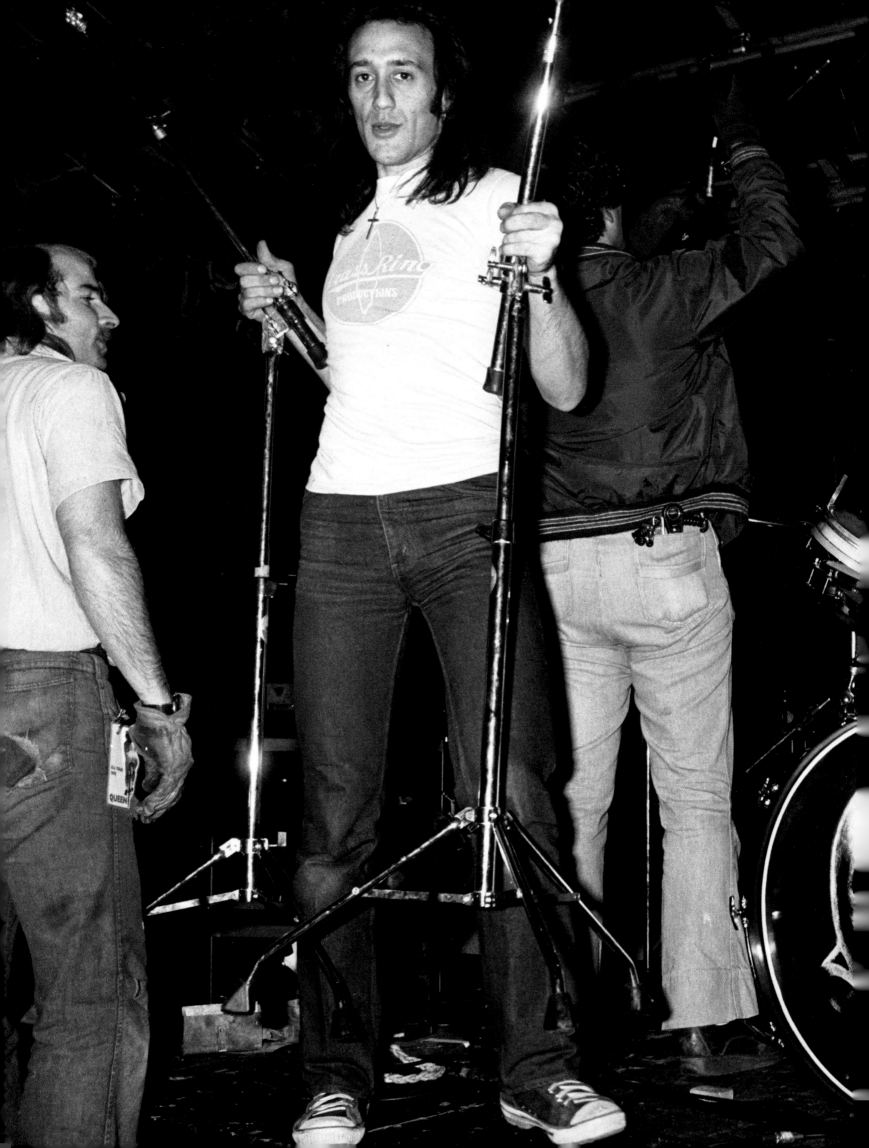

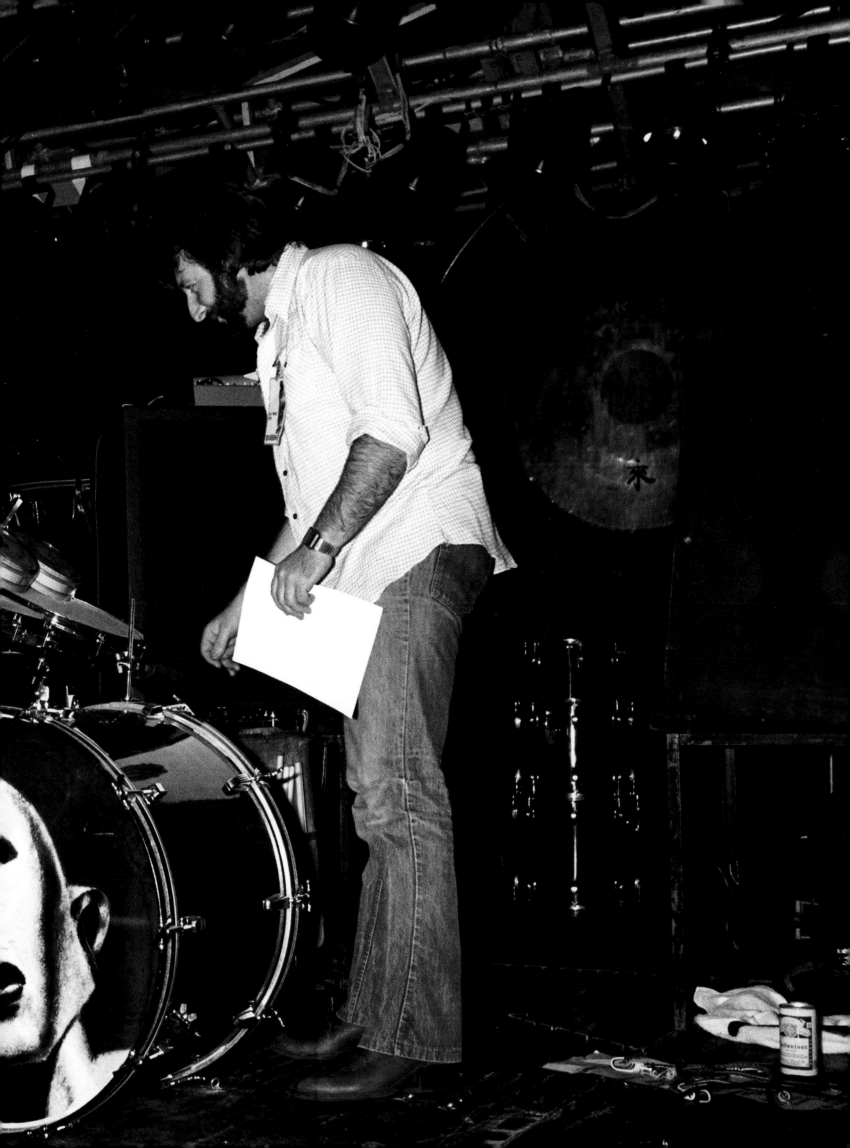

I had no idea where to go, where to stand, or even what the protocol was to find out. After soundcheck I was told by one of the promoters that I should see Jimi's road manager, some guy named Gerry Stickells, who would sort me out. This seemed easy enough.

Out of nowhere a gruff, scary-looking guy with a droopy handlebar moustache appeared. This guy looked like he had just walked out of a bar fight five minutes before and was ready for another one. It was Stickells. He peered at me with these steely little eyes, standing about a foot away from me. "I'm Gerry Stickells," he said, with a British accent so thick you could drown in it. I stuck out my hand and timidly said, "Hi, I'm Neal Preston, I'm friends with Gary and Shelly and they said you could tell me where I can shoot from during the show."

Well, whatever I had just said seemed to enrage him. He was a beast seething with anger. Stickells got even closer, maybe six inches from my face, and said the words I would never forget: "I've been known to punch fucking photographers in the mouth!" I swear I don't remember anything else about that conversation. I was catatonic with fear.

About nine years later, I was sent to go on the road with Queen. Before I left LA the record company PR person said to me, "When you get to New Haven, just go see the band's tour manager, Gerry Stickells, he'll sort out all your passes and stuff for you." This was not what I wanted to hear! Two days later I nervously walked into the Queen production office and waited to talk to Gerry. "He can't be worse than Richard Cole," I thought to myself. I had no idea if I'd get through the next three weeks alive. . . . Finally Gerry finished his call and I prepared myself to be read the riot act . . . but to my amazement he welcomed me with a big smile, a hearty handshake and a really ugly Hawaiian shirt.

I loved Gerry and since his recent passing there haven't been too many days when I haven't thought about him.

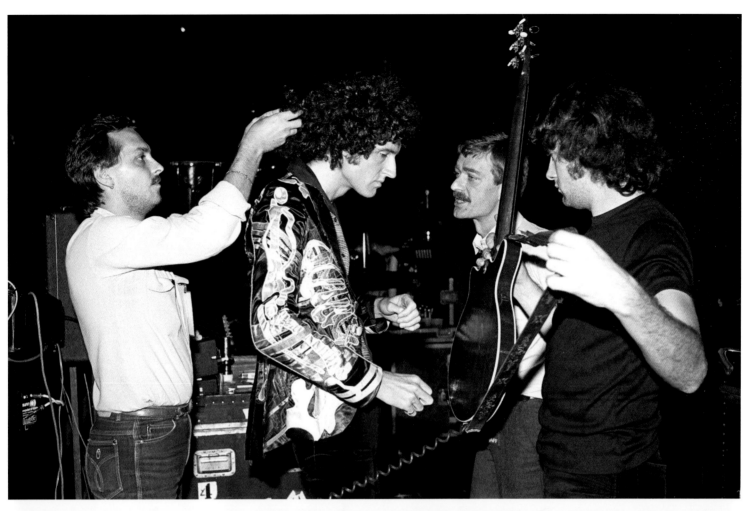

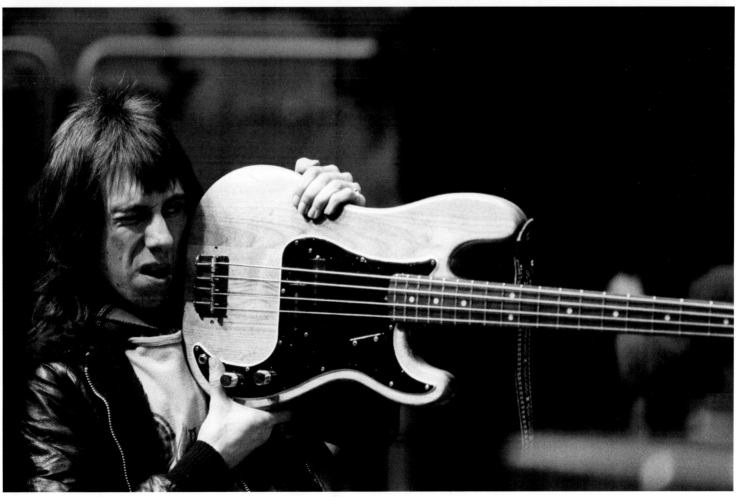

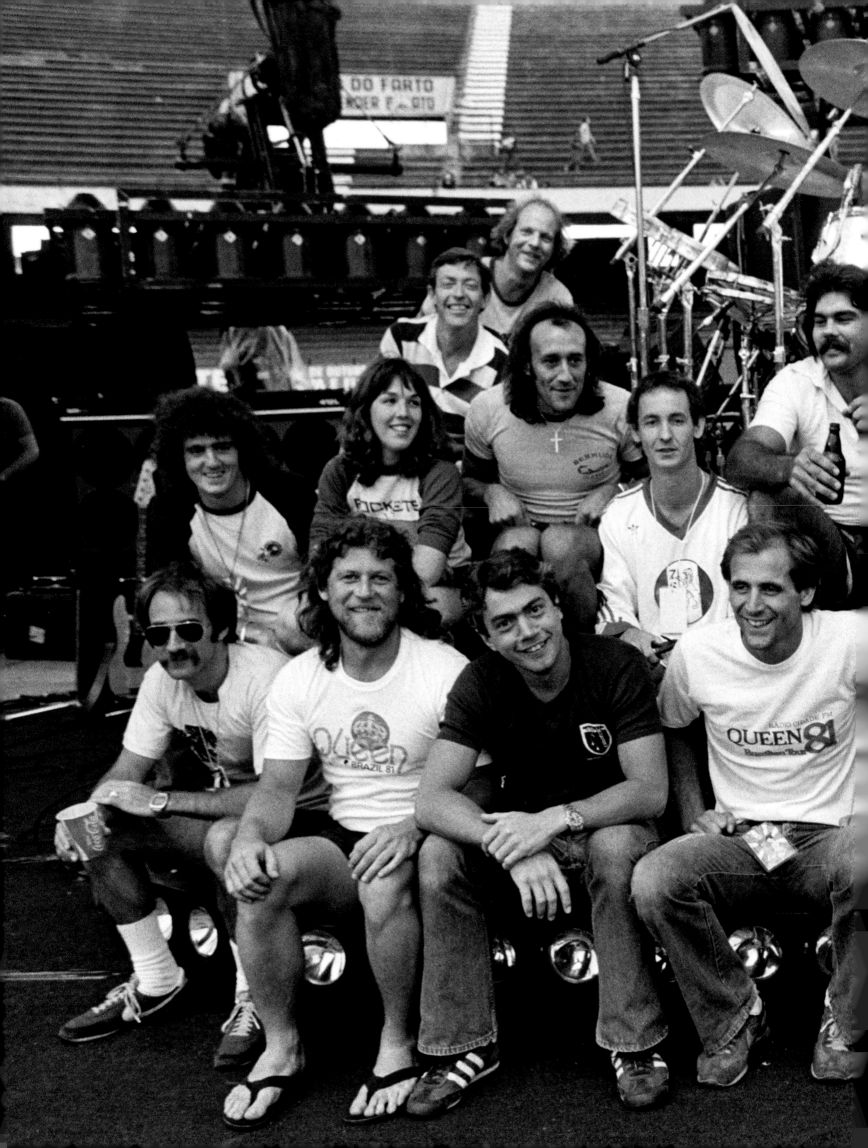

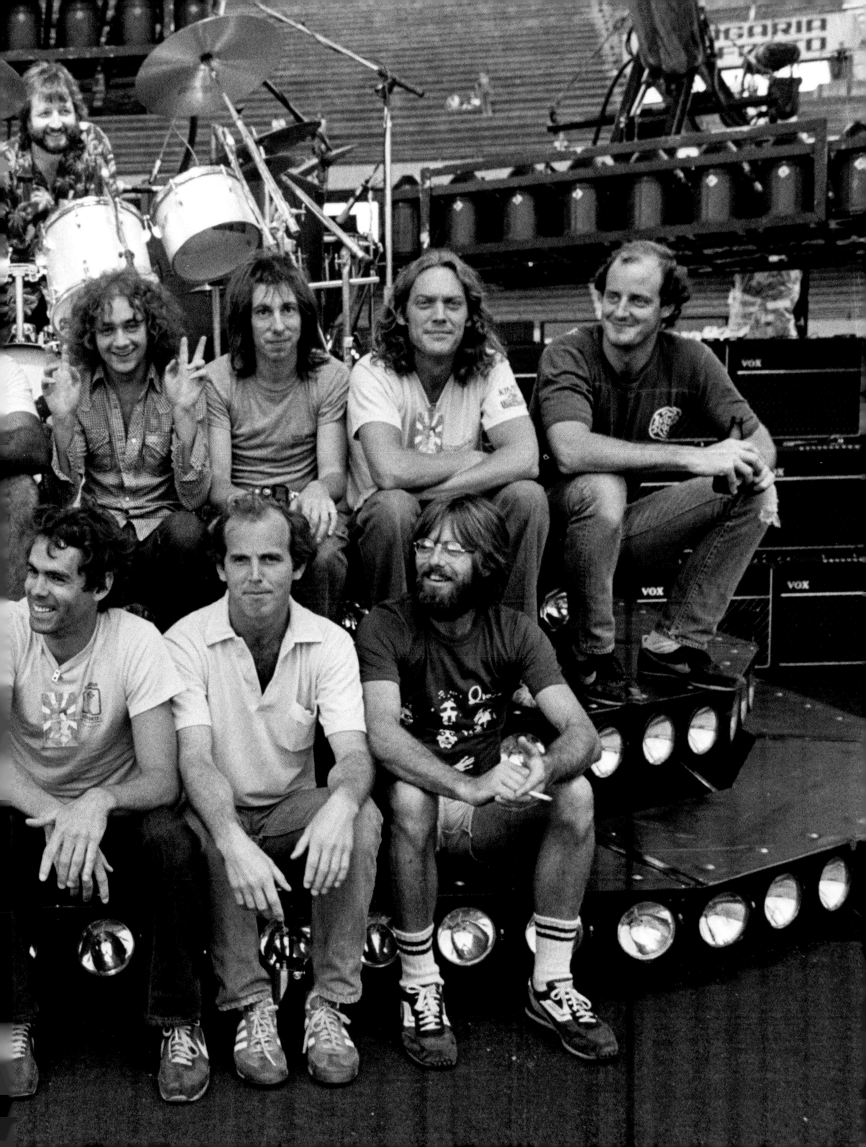

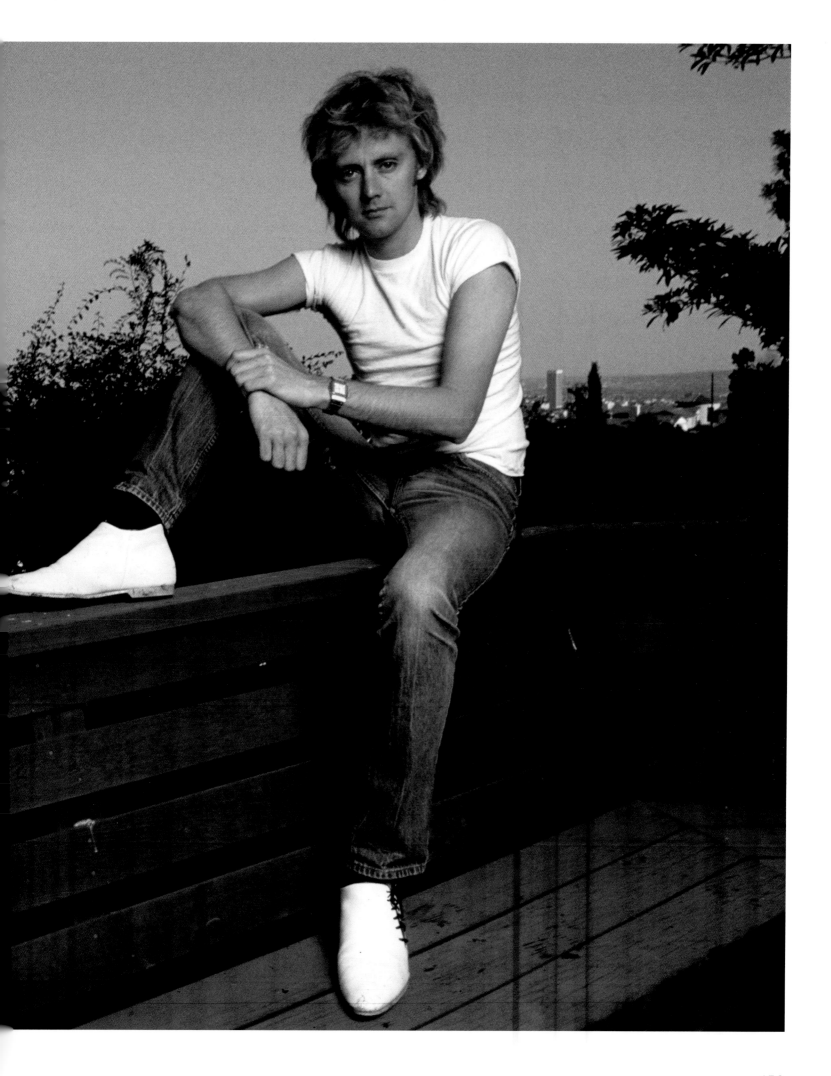

South America Bites the Dust Tour, 1981

28 February – Estadio José Amalfitani de Vélez Sarsfield, Buenos Aires, Argentina
01 March – Estadio José Amalfitani de Vélez Sarsfield, Buenos Aires, Argentina
04 March – Estadio José María Minella, Mar del Plata, Argentina
06 March – El Gigante de Arroyito (Estadio Rosario Central), Rosario, Argentina
08 March – Estadio José Amalfitani de Vélez Sarsfield, Buenos Aires, Argentina
20 March – Estádio do Morumbi, São Paulo, Brazil
21 March – Estádio do Morumbi, São Paulo, Brazil

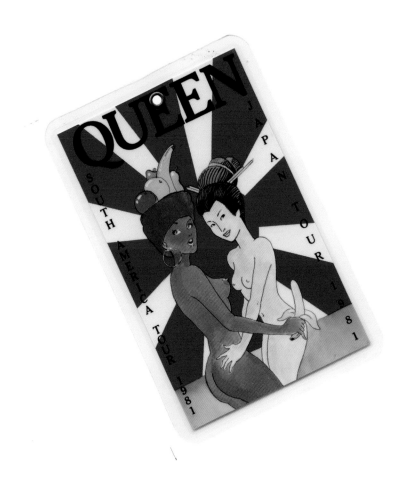

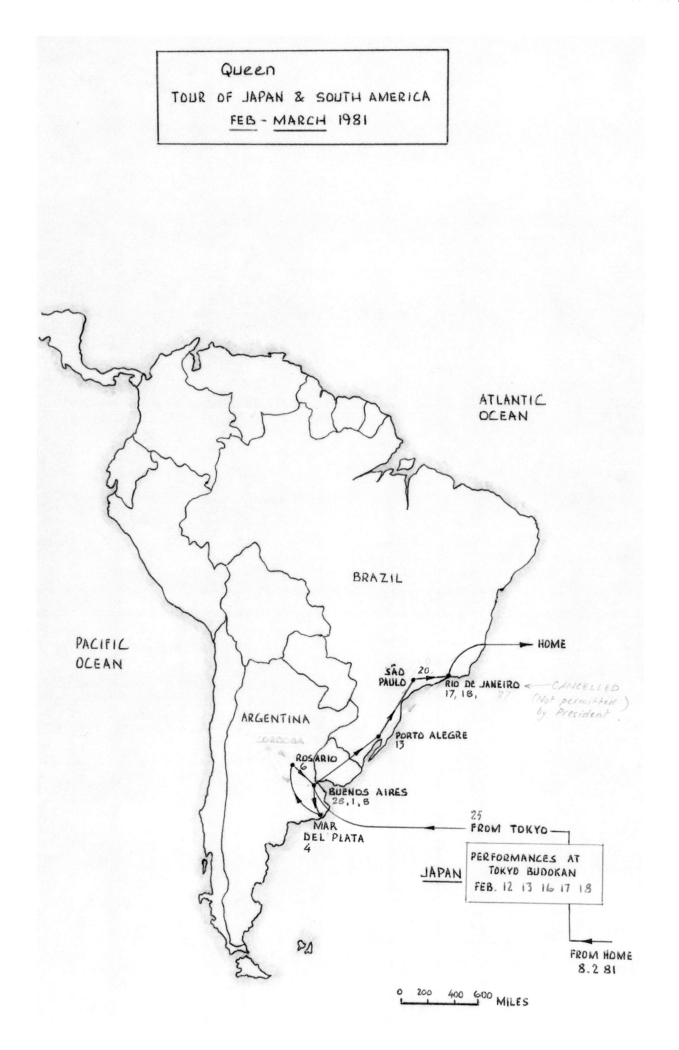

Queen
TOUR OF JAPAN & SOUTH AMERICA
FEB - MARCH 1981

ATLANTIC OCEAN

BRAZIL

PACIFIC OCEAN

HOME

SÃO PAULO 20
RIO DE JANEIRO
17, 18, 27 ← CANCELLED
(Not permitted by President)

ARGENTINA

PORTO ALEGRE
13

CORDOBA

ROSARIO
6

BUENOS AIRES
28, 1, 8

25
FROM TOKYO

MAR DEL PLATA
4

JAPAN

PERFORMANCES AT TOKYO BUDOKAN
FEB. 12 13 16 17 18

FROM HOME
8.2 81

0 200 400 600 MILES

In 1981 (at least beyond the shores of the USA), Queen was the biggest band in the world and the plan was simple: bring the band's entire production, lights, sound, pyro, the whole enchilada, and invade Brazil, Argentina, Venezuela and Mexico. Take no prisoners, boys! Just blow the whole continent out of the water. By any measure this was gonna be an experience of a lifetime.

Gerry Stickells explained to me that South America had never hosted anything close to the rock and roll beast we were about to show up with. I was elated to be asked to go and document the entire tour. My only concern was that I spoke zero Spanish, not to mention Portuguese. I couldn't even speak half-decent Spanglish and I'd lived in LA for ten years at that point. I was going to have to find labs, camera stores, and anything else I needed for support. This was not gonna be a jaunty tour down the West Coast, this was uncharted territory. Even though I was already a seasoned traveler, the flight was long and I was miserable. From LA I had to fly to Miami and switch planes to Rio. I thought the flight would never end. I don't recommend anyone trying to do that trip in coach.

It was difficult logistically but this tour was a photographer's dream. From the moment we landed the band was treated like the Beatles. Better than the Beatles. The fans were rabid, the screams of "Freddie, Freddie" incessant, the hotel lobbies packed—all the usual hazards of rock stardom but more . . . elegant. Definitely more foreign. The day before the first gig the band held a large press conference, which was attended by over a hundred print and broadcast journalists. Our local press rep spoke to the crowd first and in Portuguese (then English) he told them they were welcome to ask the band anything about the production or their music but that they didn't need to go beyond those parameters, and that they shouldn't ask Freddie about his sexual orientation. Of course, the very first question from the audience was from some journalist who asked Freddie, "Are you gay?" Now this was the first time I'd ever heard anyone ask Freddie about this because it was simply never an issue. Freddie just let the question roll off his back with a simple response like, "Oh darling, do we *really* need to discuss that?"

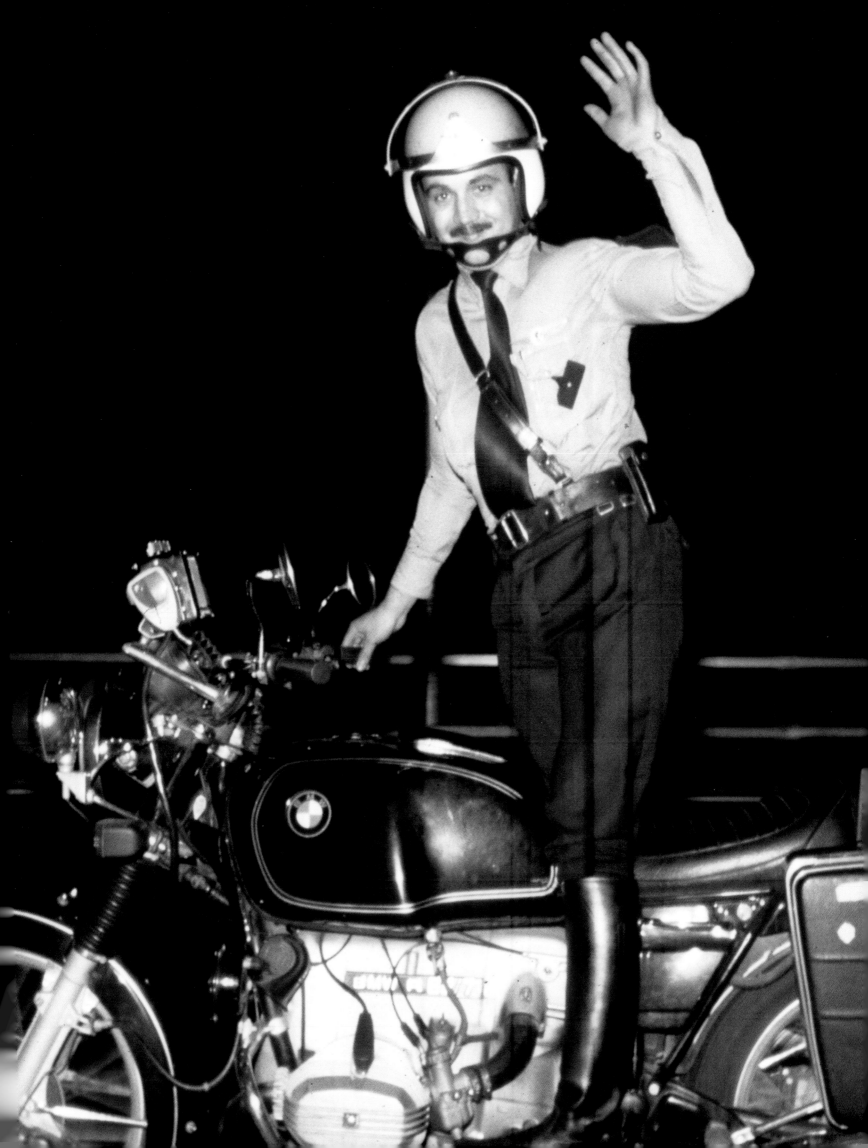

It was also a shitload of work. I'm absolutely certain that the Queen crew worked harder in South America than on any five tours combined. Every day the deep dark circles and bags under their eyes doubled in size. Mind you, I had it relatively easy, staying at a big luxury hotel at the far end of Copacabana beach. But without my buds on the crew I would have had no laughs at all. How they kept any sense of humor I'll never know.

I was more or less assigned one of the crew's translators to help me out on lab and shipping runs and *Thank God* they were there . . . I'd probably still be at some camera store today trying to say, "Can you please repair this 24mm lens and do you have any Tri-X in stock?"

The gigs were all wild and mammoth in size. We played huge soccer stadiums that featured fences around the field along with a moat. I guess soccer fans get pretty toasted and their level of bravado goes sky high. Hence the moat. And the most bizarre thing of all was that we had soldiers, fully locked and loaded, on stage and on the pitch, just standing around stoically, hands on their machine guns while we played. They were backstage at all times too. Apparently an M16 was better than a laminate down there.

The South American gigs kind of all meld together in my brain. I don't recall one gig being exponentially better than any other one. The fans, though, went haywire. It seemed like the people we met wanted to just meet someone, anyone, who knew the band, never mind worked for them.

Soon after I arrived in Rio, I began trying to find a decent photo lab to use. I was given the phone number of a local photographer who was very well known throughout South America as a big deal fashion photographer. I called him up and introduced myself and explained that I was in dire need of a good lab. Not only did he speak fluent English but he said that he had the best lab in town and he would be thrilled to make it available to me.

When the job was ready I was taken to an apartment building on the outskirts of town. I was mortified to find out this guy had processed all my color film in his own kitchen. I sat down at a lightbox to look at everything while he extolled the virtues of

young girls and even younger sex, while his 16-year-old wife sat obediently at his feet. Mr. Sleazeball did a perfect job on my film but the topic of conversation made me extremely uncomfortable so I abruptly paid him and left.

In Brazil I was so happy to have my own translators because I could actually get my work done at the speed I needed to. Every time one of them asked me if I had what I needed I'd say yes, and give them the "ok" sign with my right hand fingers, and they'd always give me a strange smile in return. The day we left Brazil one of them pulled me aside to let me know that in Brazil the sign for "ok" actually means "asshole". Par for the course for me.

South America was also where I broke one of my hard and fast rules—that as a photographer you must remember you are not a member of the band. I had been sitting in the lobby of our hotel in São Paulo when someone came up to me with a microphone and started asking me various questions about the tour. I spent about five minutes having a conversation with him and then I had to leave. Sure enough, a couple of hours later Roger and Deacon told me they really enjoyed hearing my "exclusive" radio interview while they were in a limo going to soundcheck. I was mortified. I still am.

Brazil was one thing but Argentina was another. Buenos Aires was certainly more beautiful than any city I'd ever seen up to that point. Everything was gorgeous—the stores, the restaurants, the girls, and especially the buildings.

However, the "security detail" at the Argentine gigs were apparently members of the secret police. And although they were friendly to us it was obvious the guns they brandished in a very cavalier way had been used. Frequently. One of them took his gun and stuck it down Deacon's pants for a photo, like a psychotic clown at a kid's birthday party would do.

After a break we went to Venezuela and Mexico. It was basically more of the same—crazed fans everywhere. The crew was completely beaten up. We all were. The band continued to kick ass at every gig.

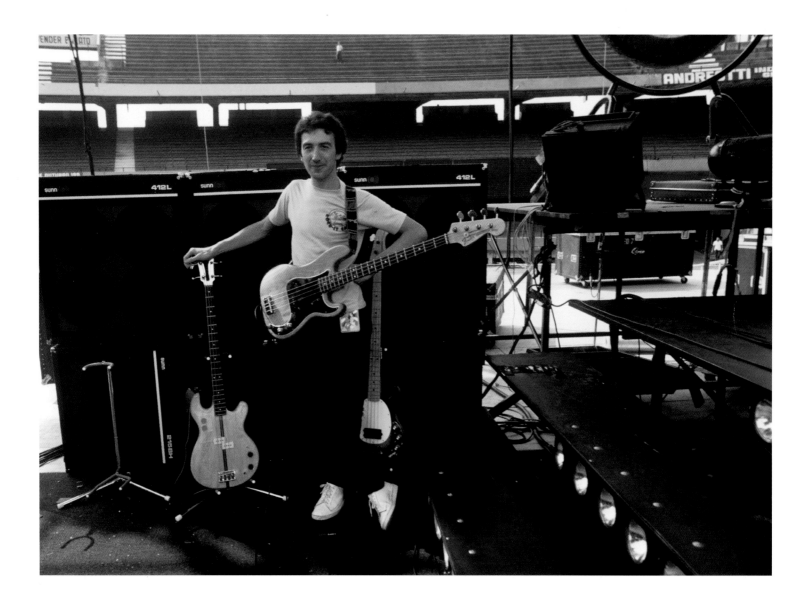

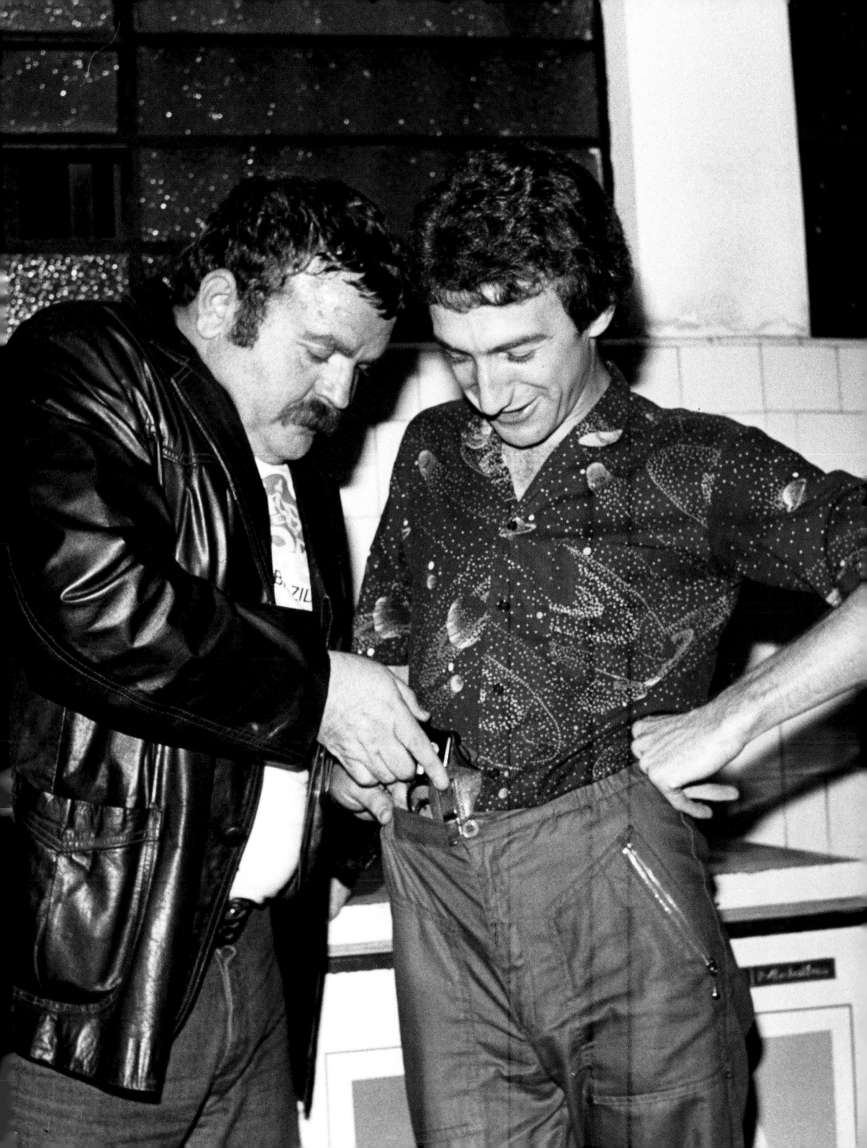

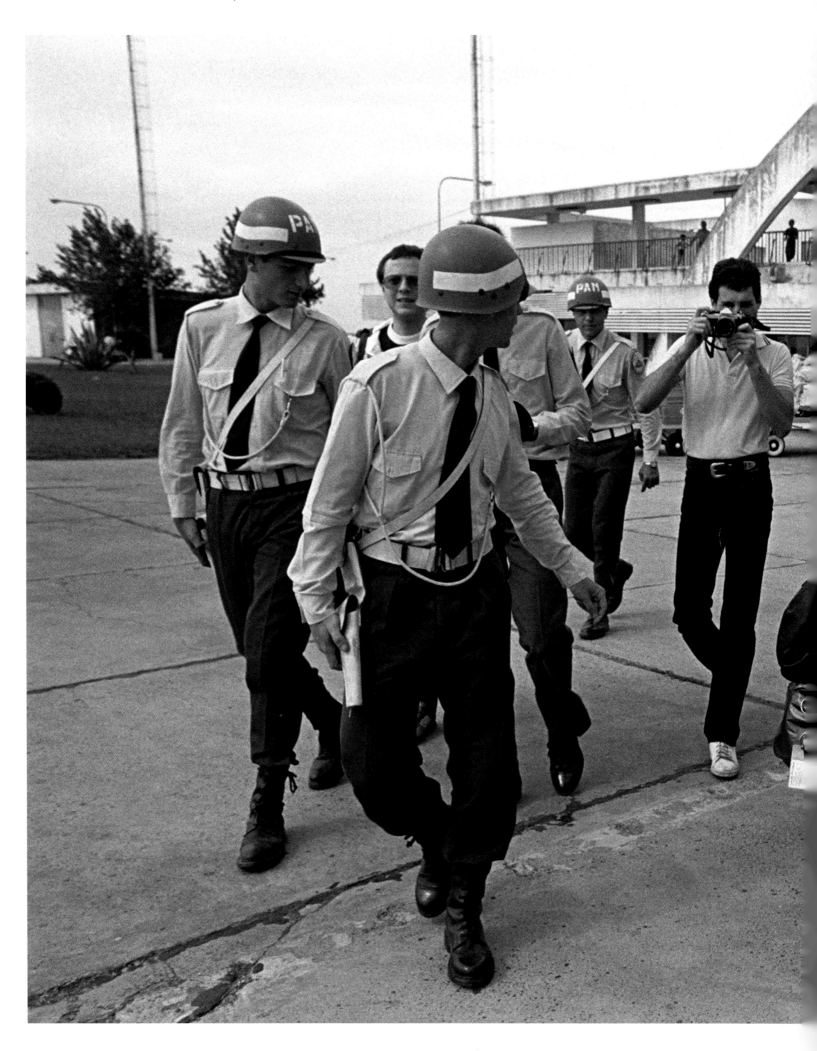

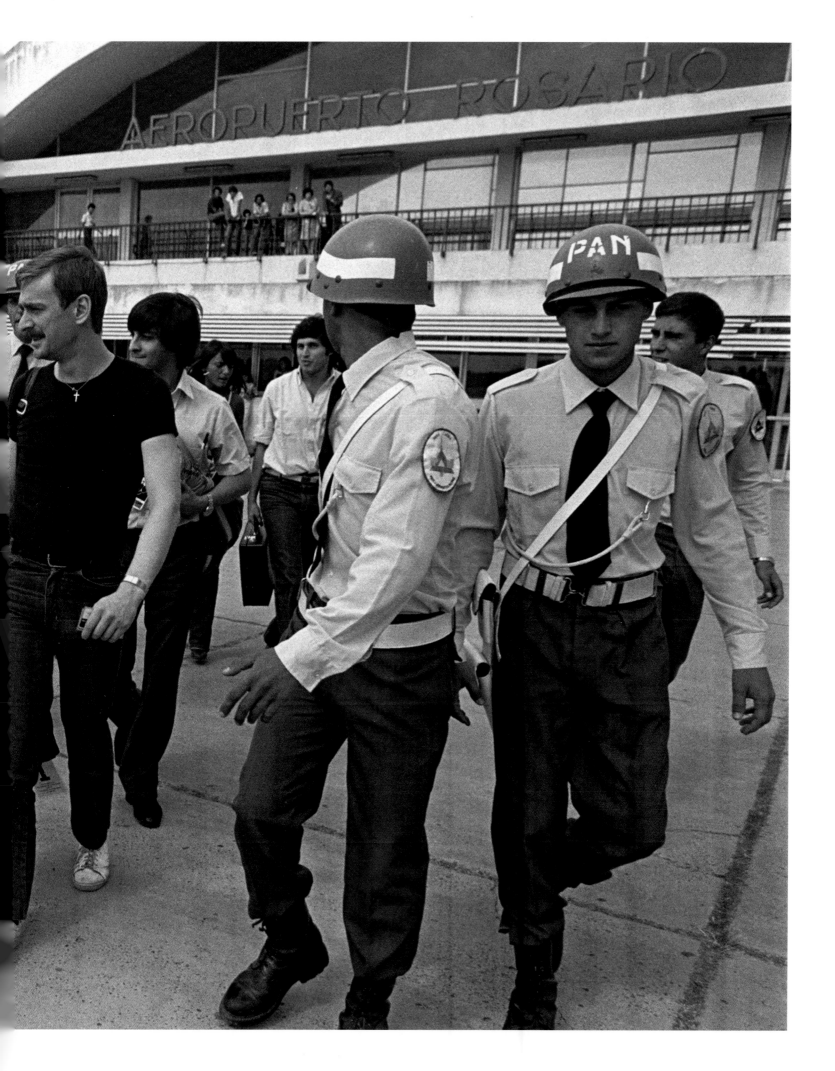

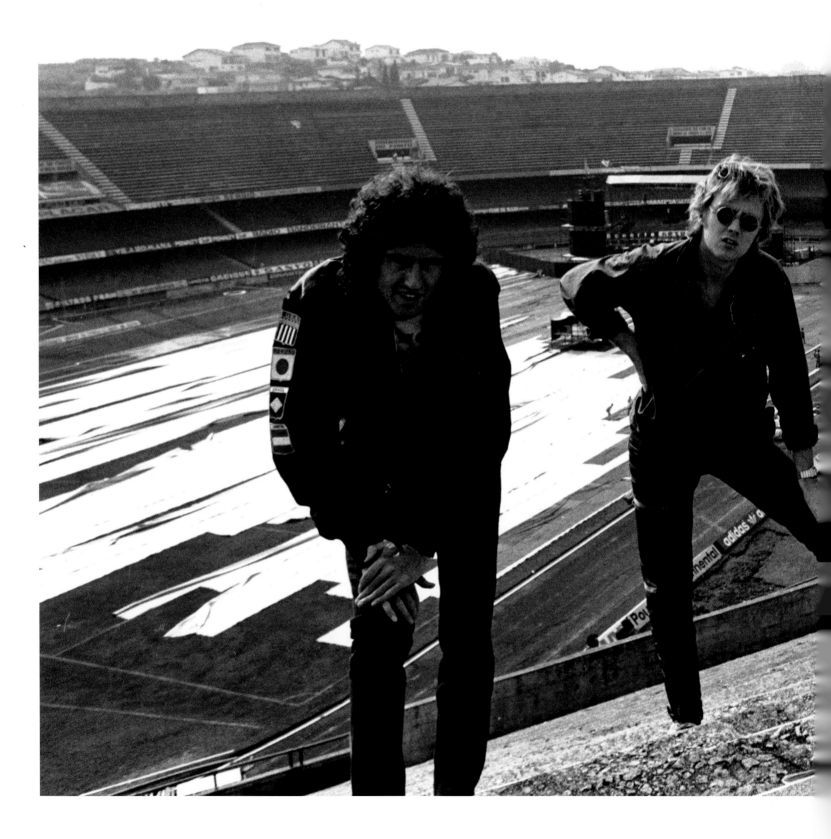

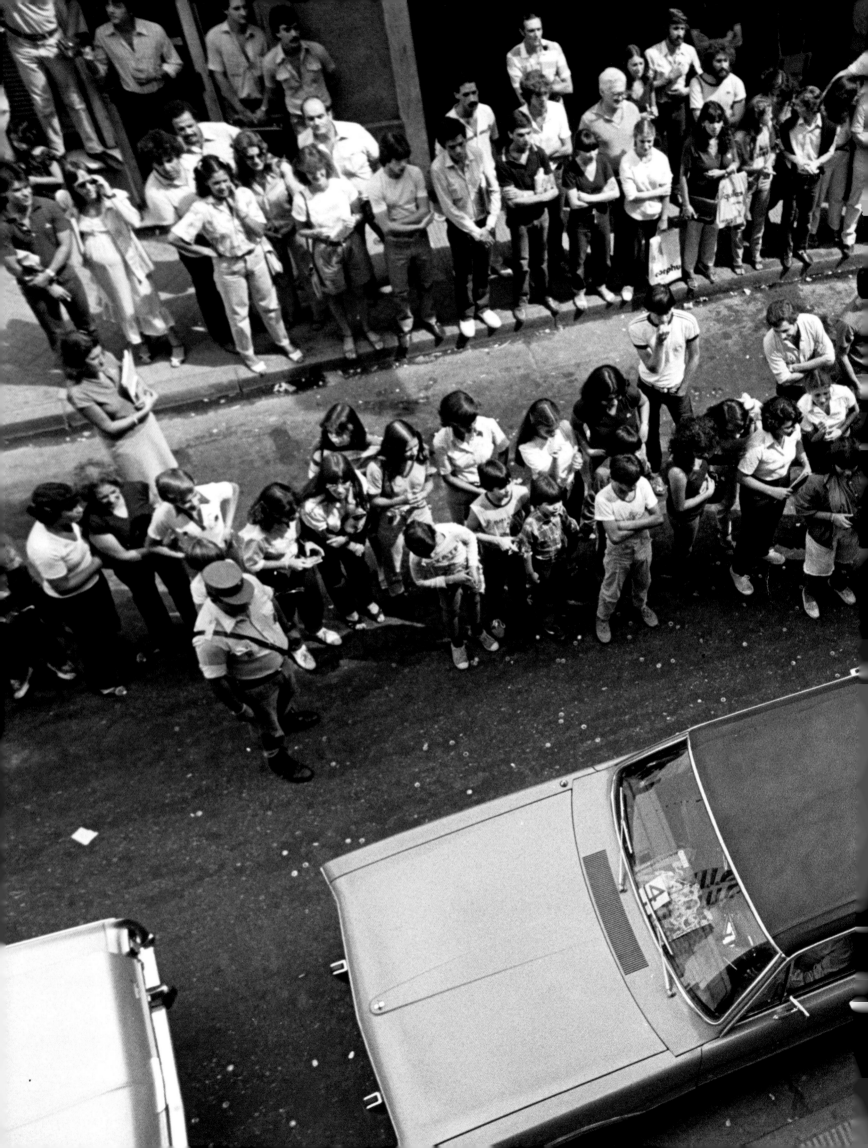

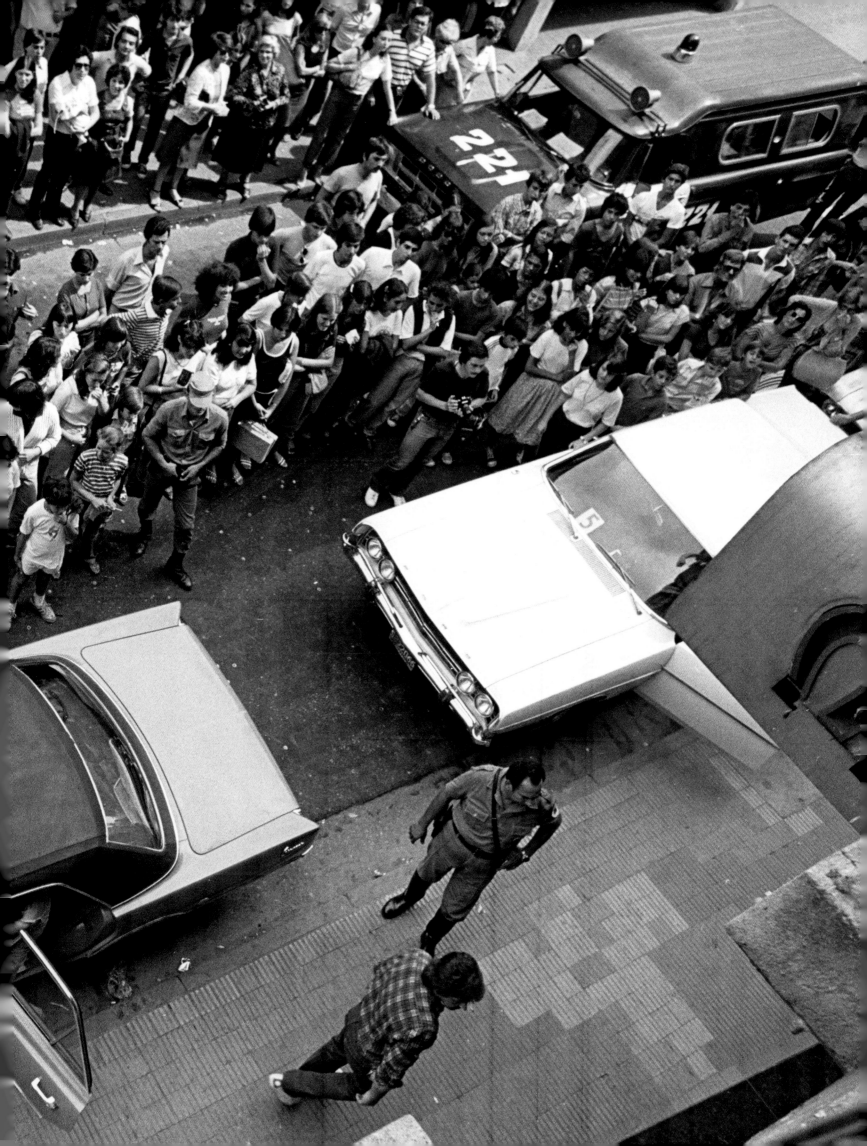

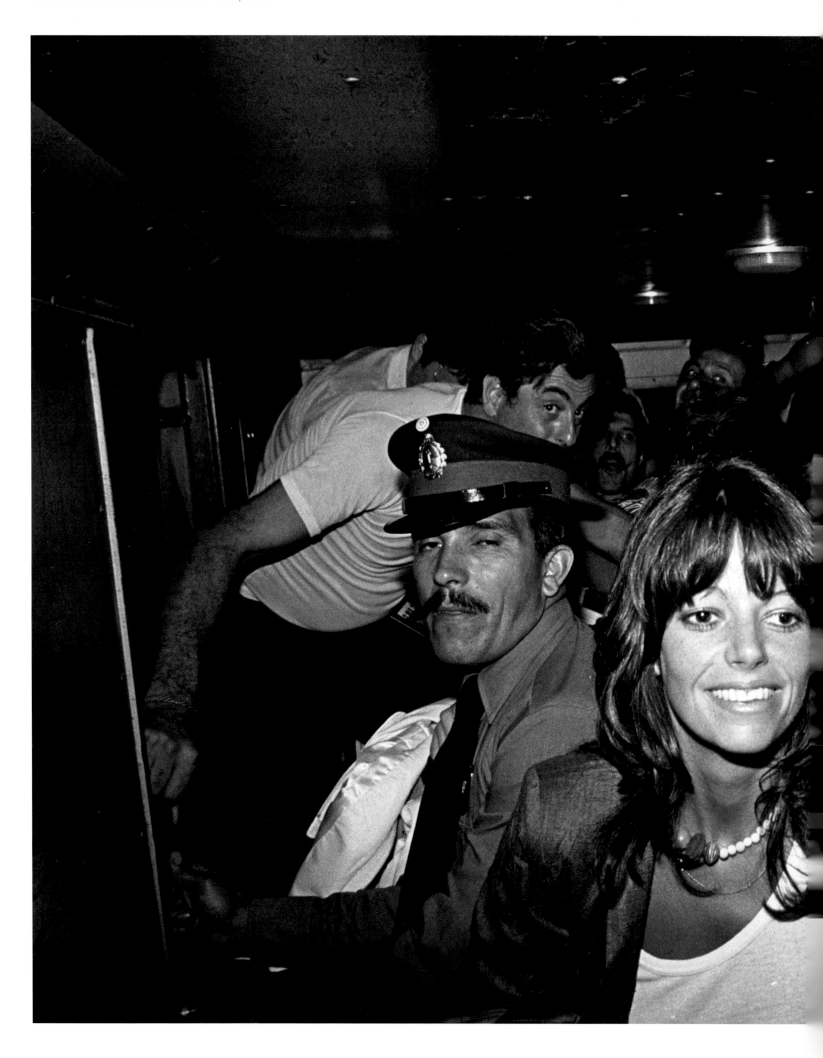

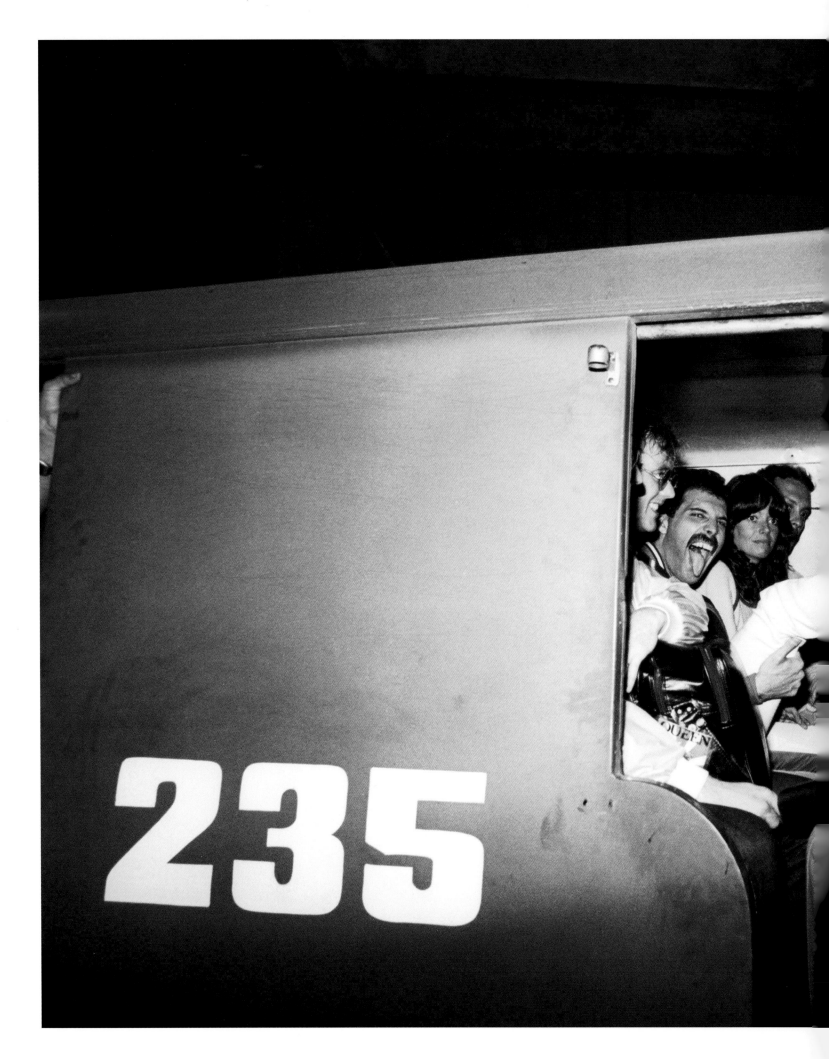

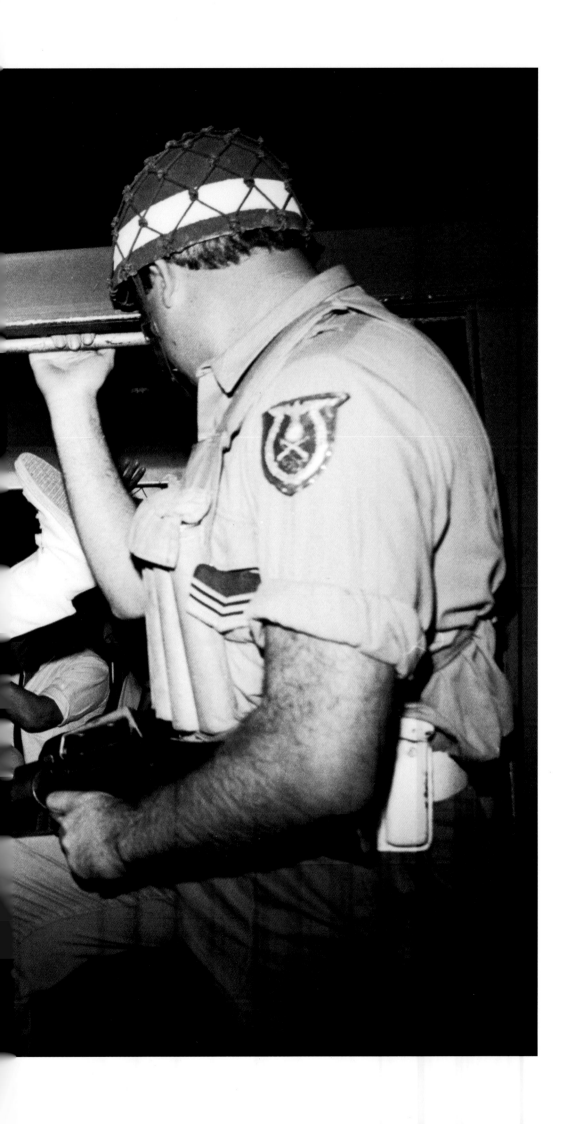

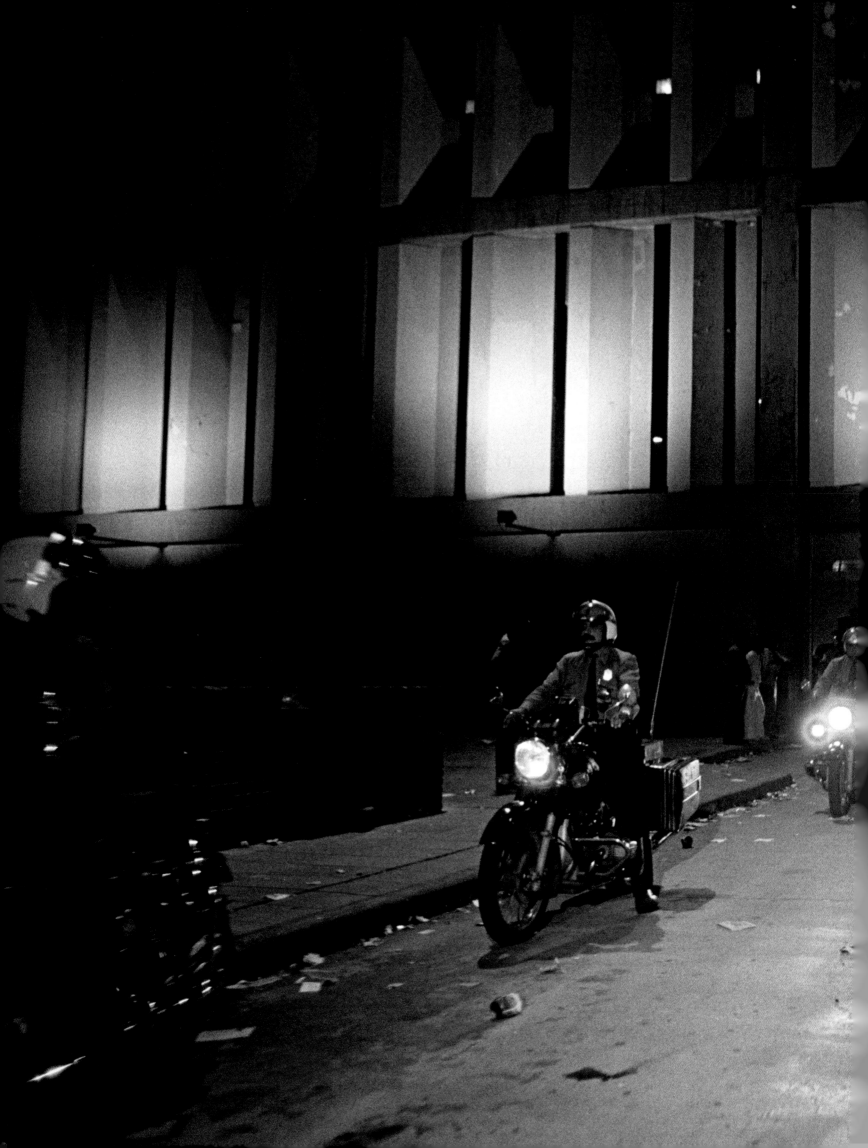

QUEEN

CARNAVAL
1981

QUEEN

FEBRERO 28
MARZO 1°

QUEEN

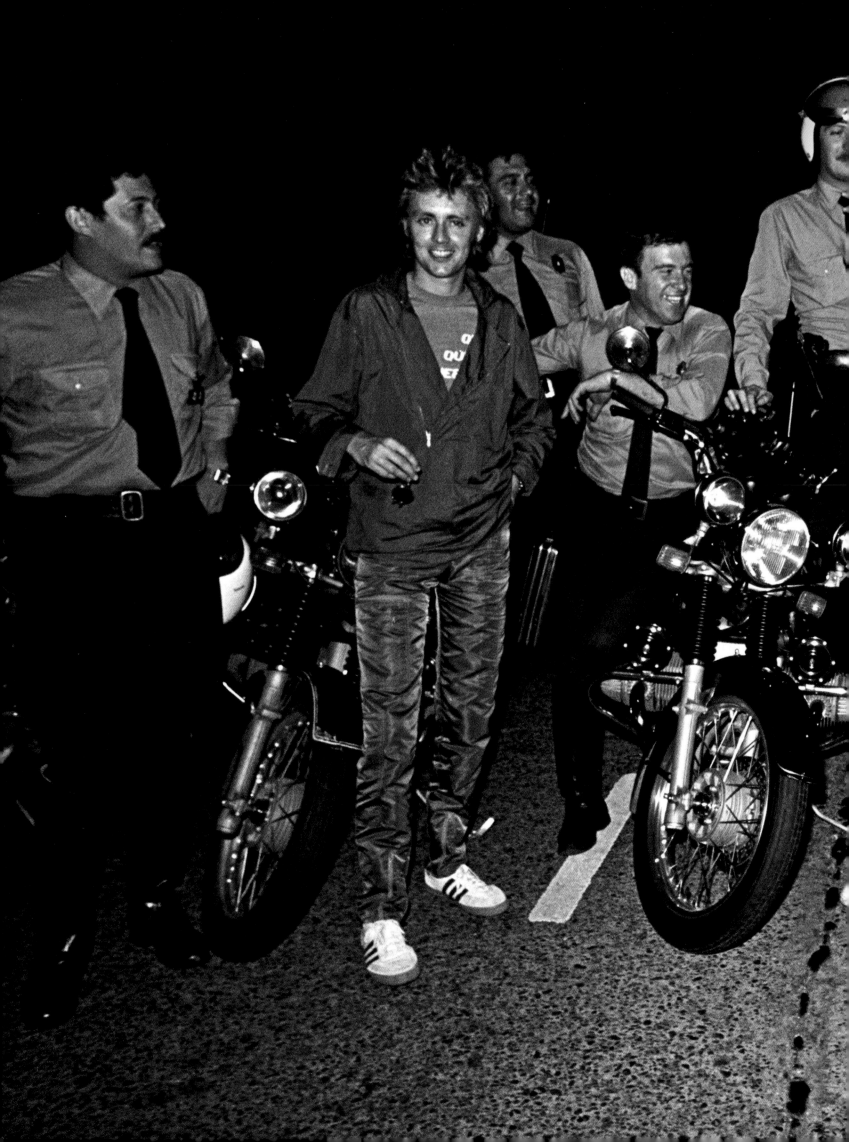

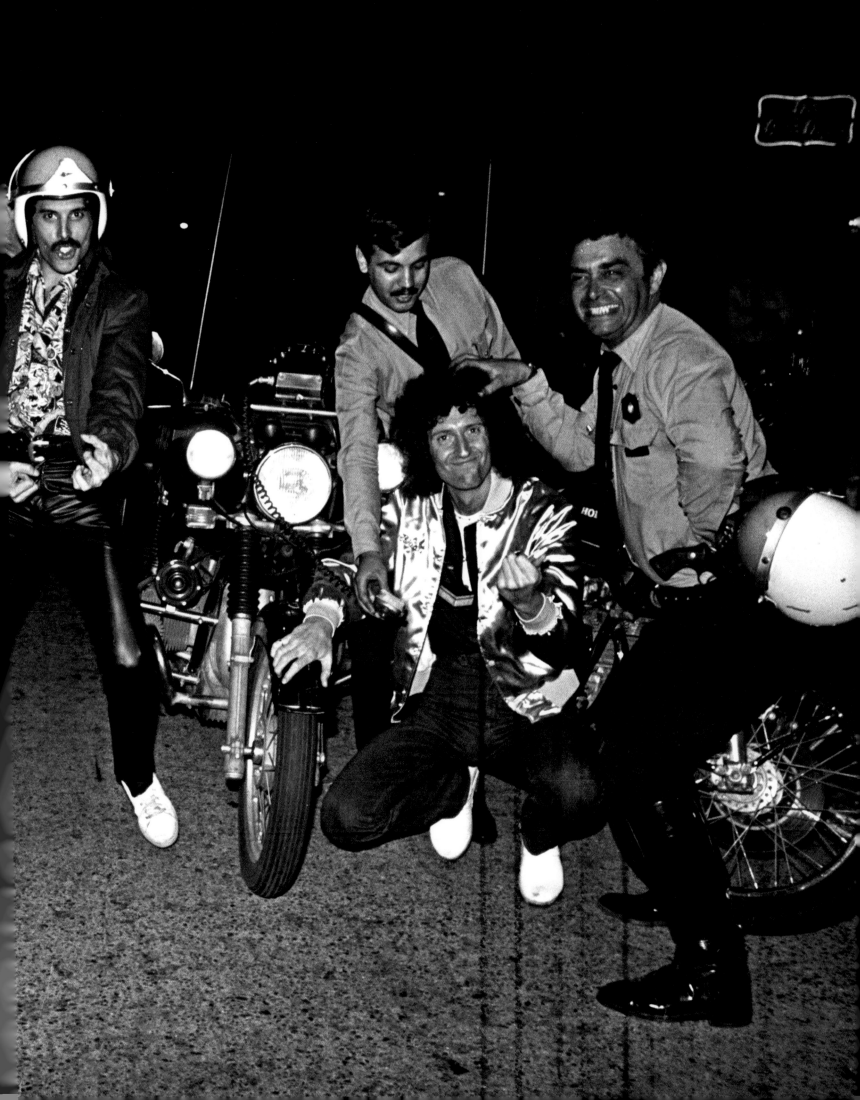

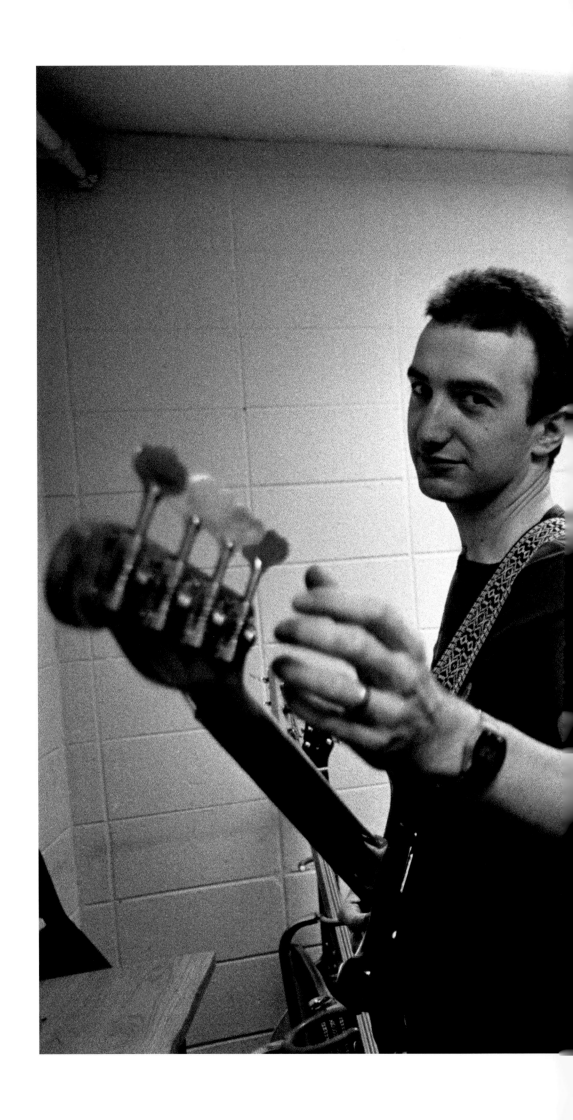

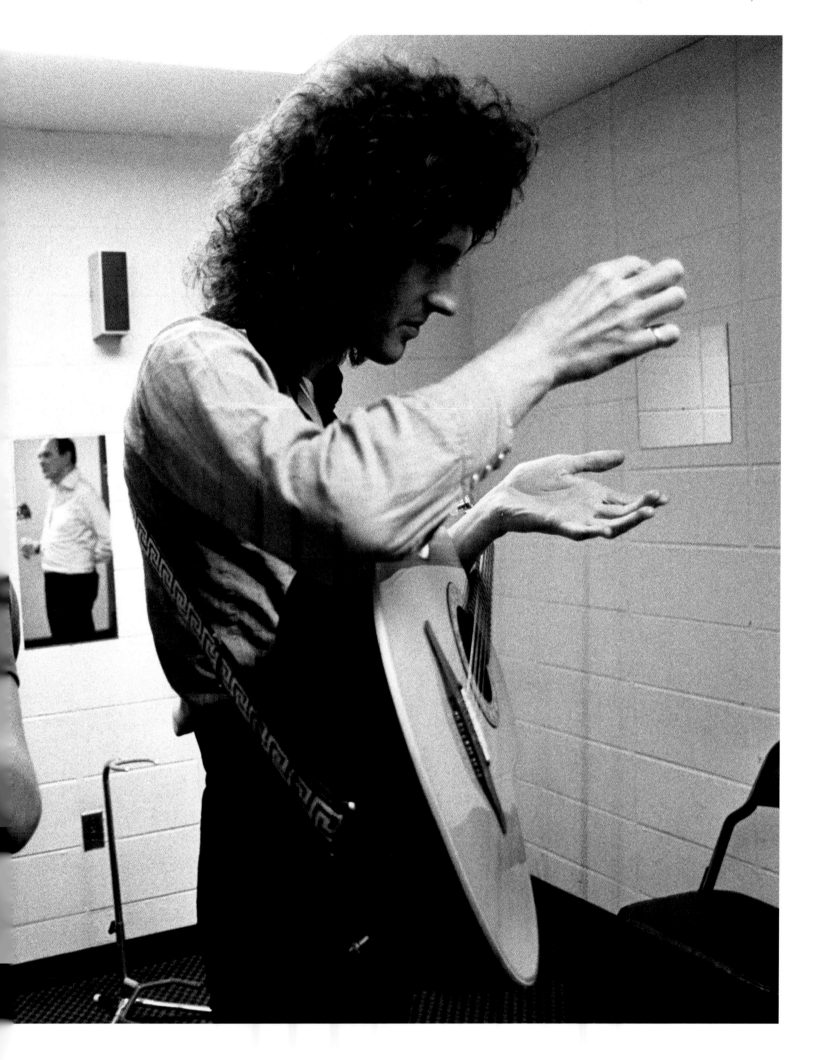

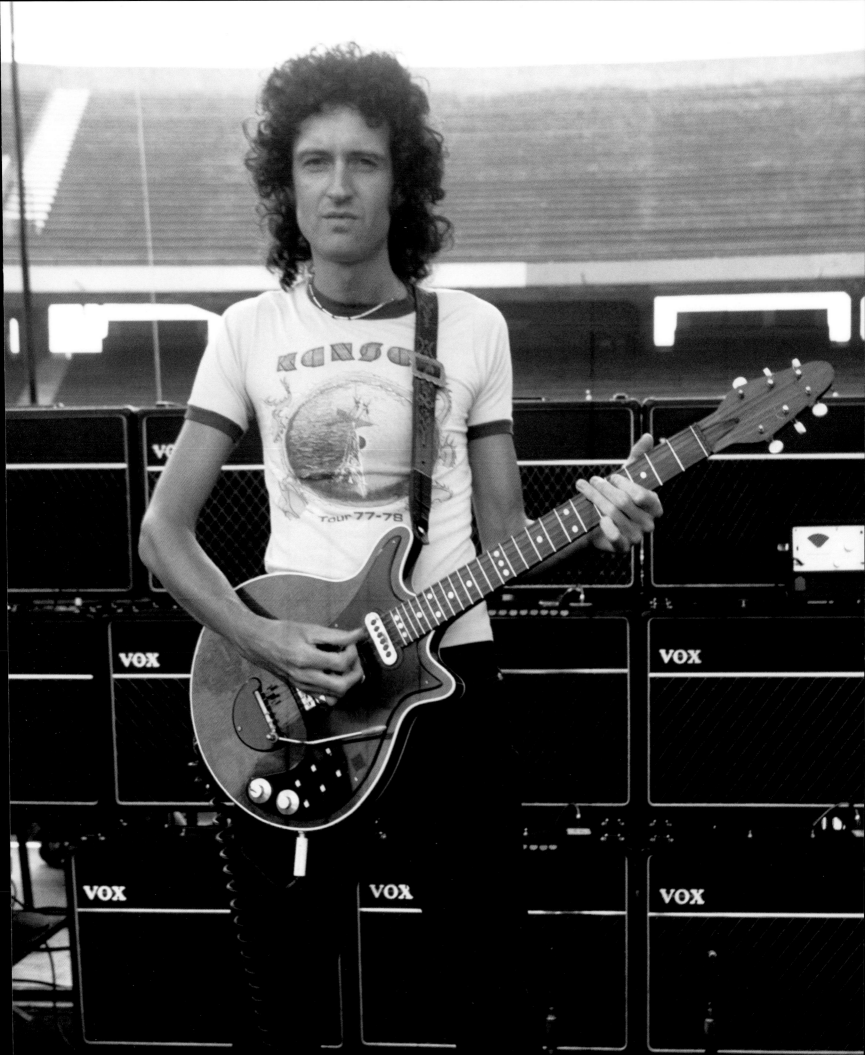

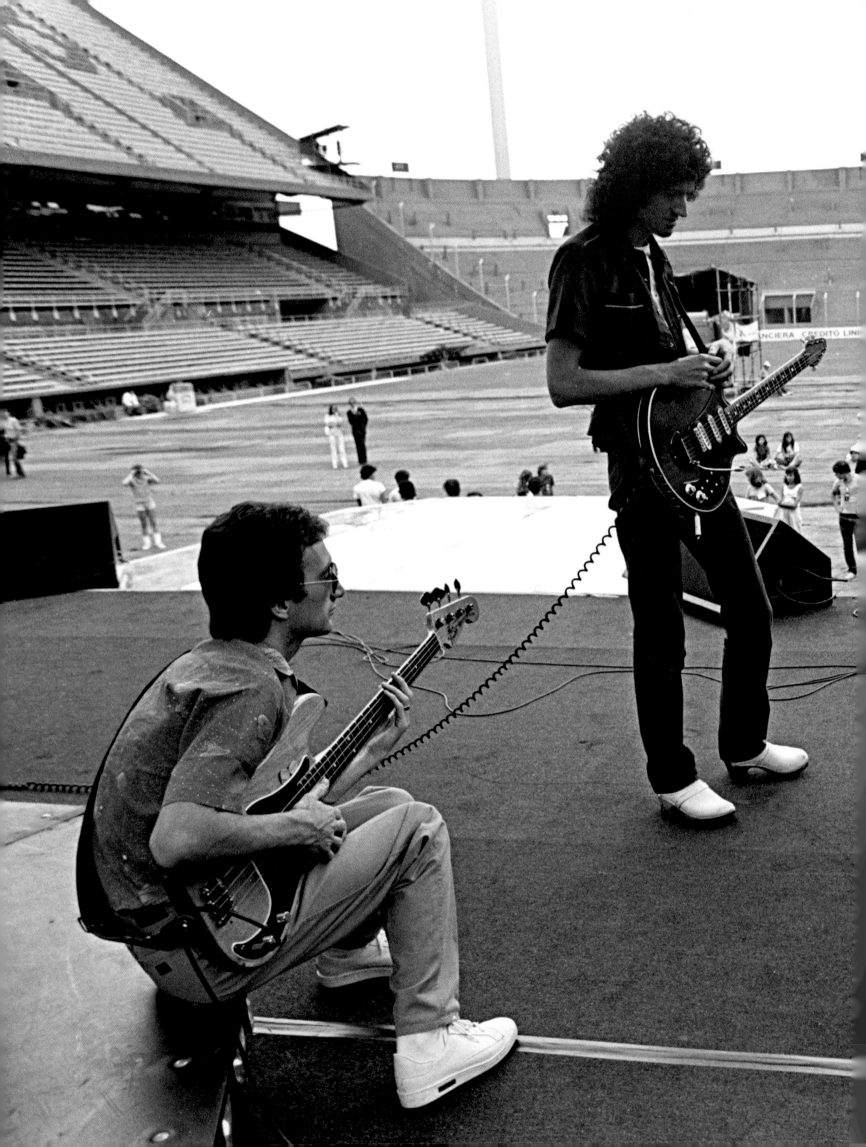

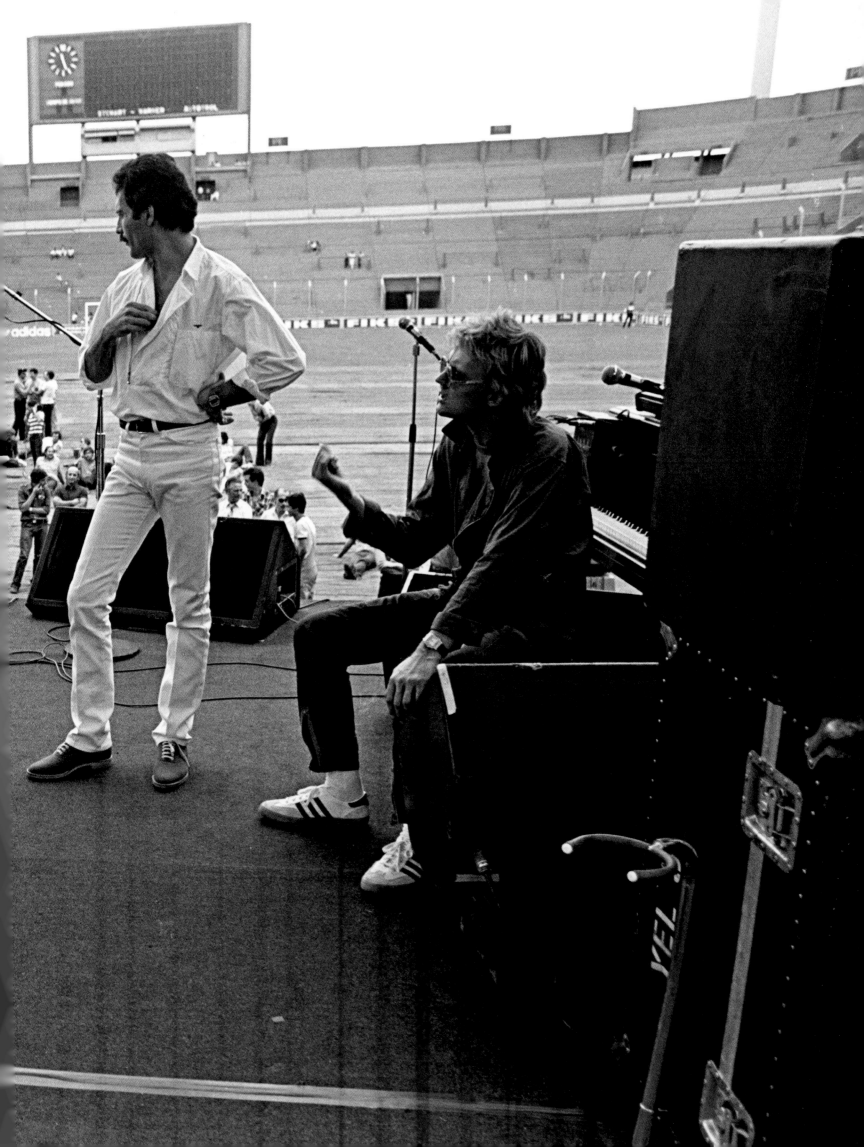

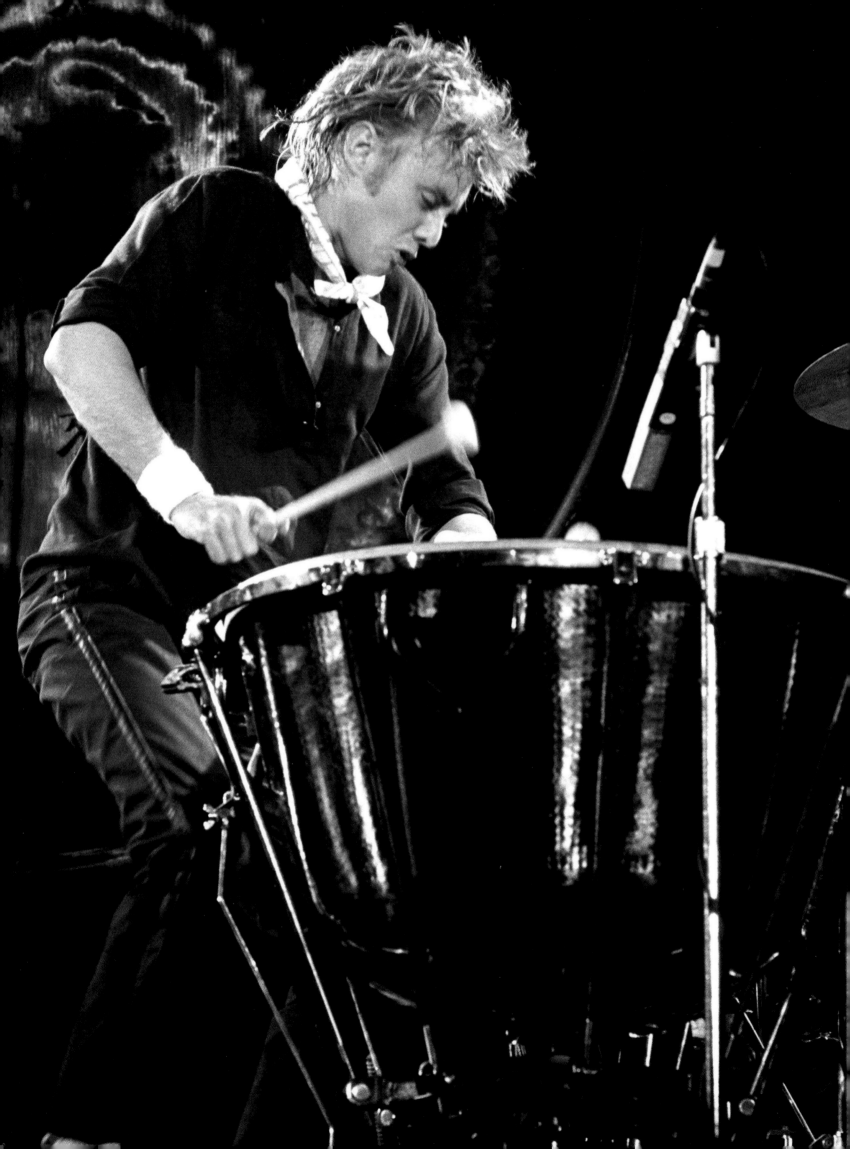

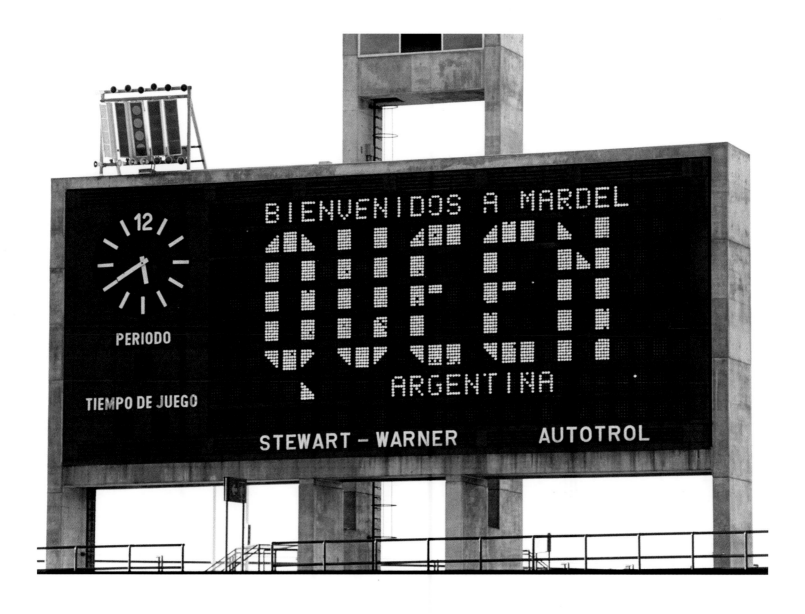

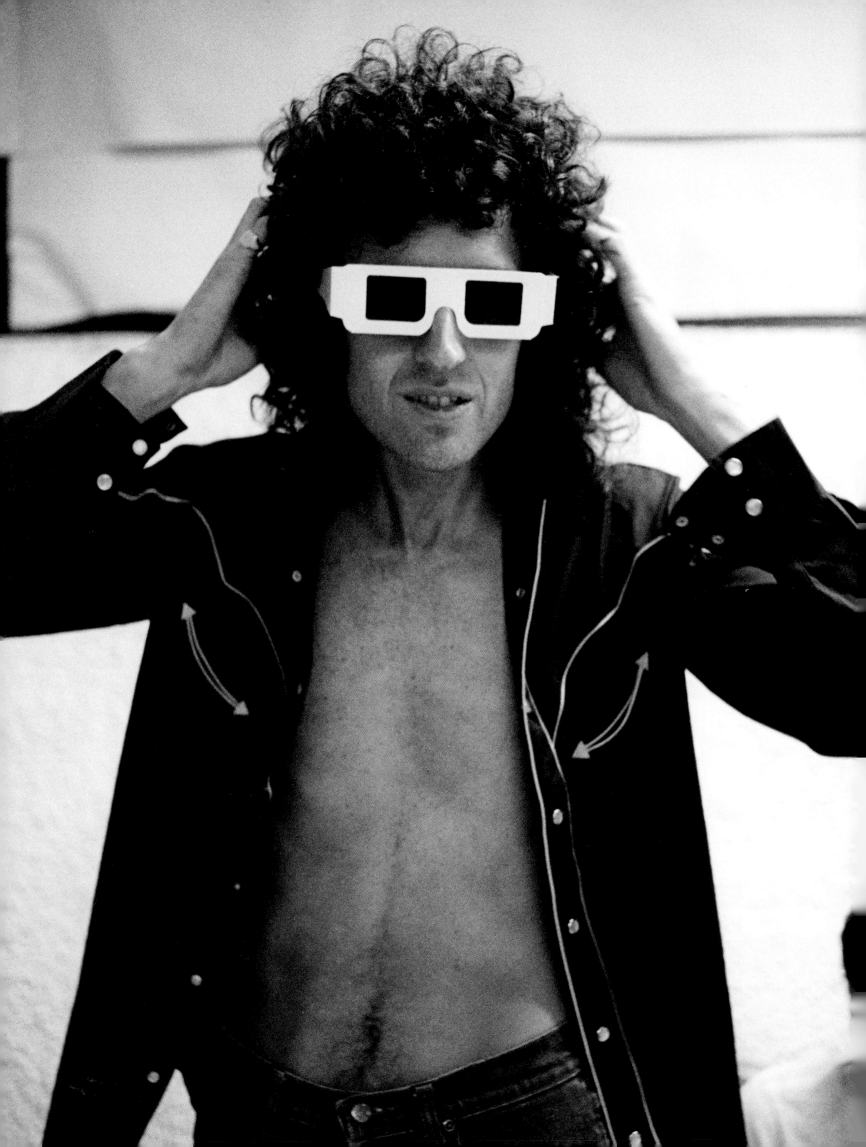

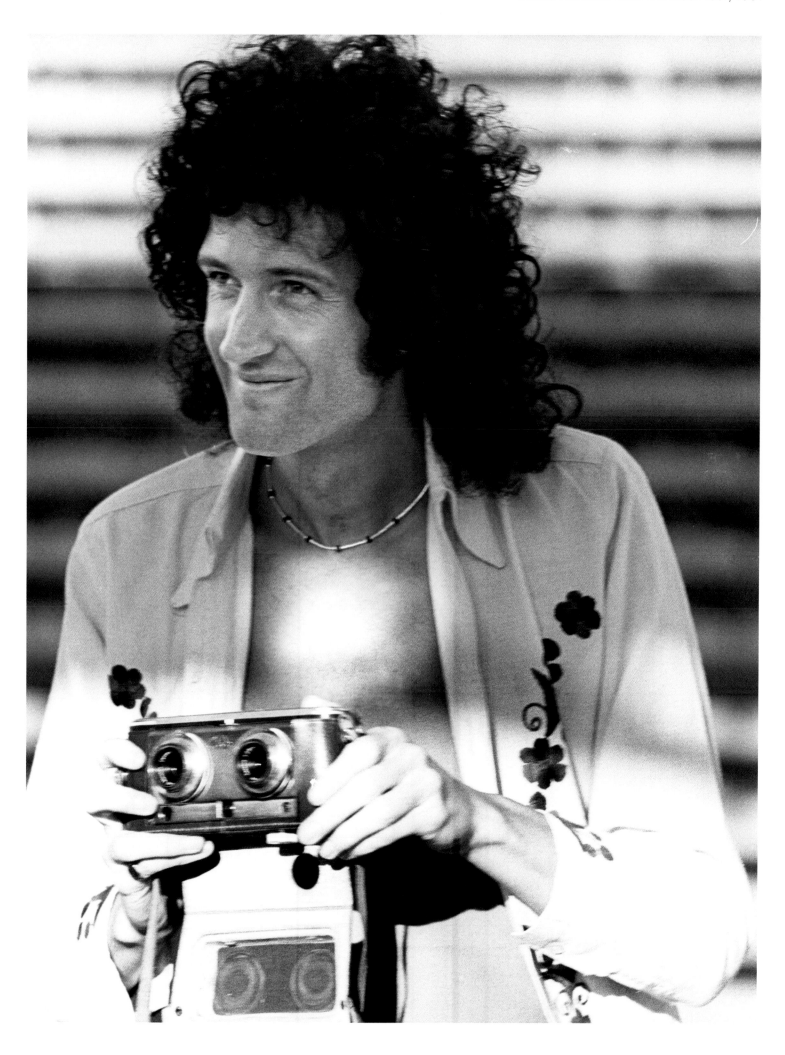

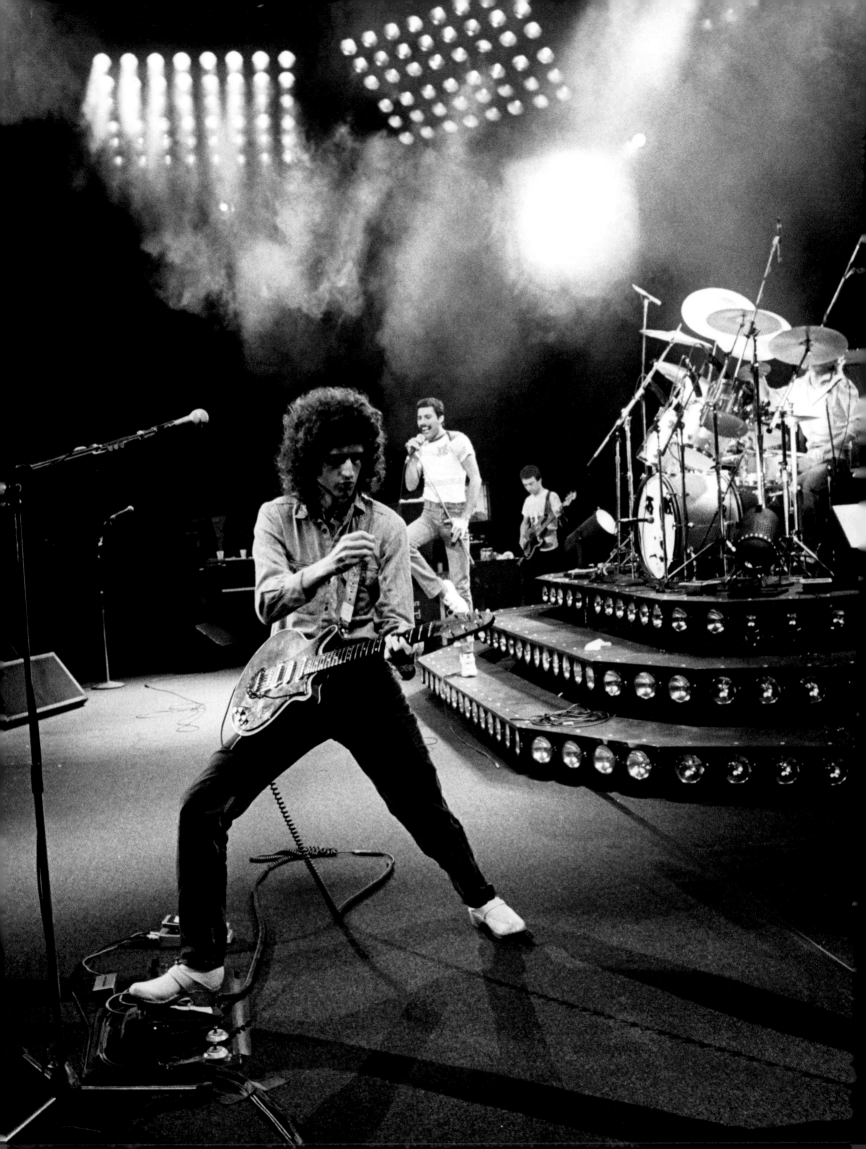

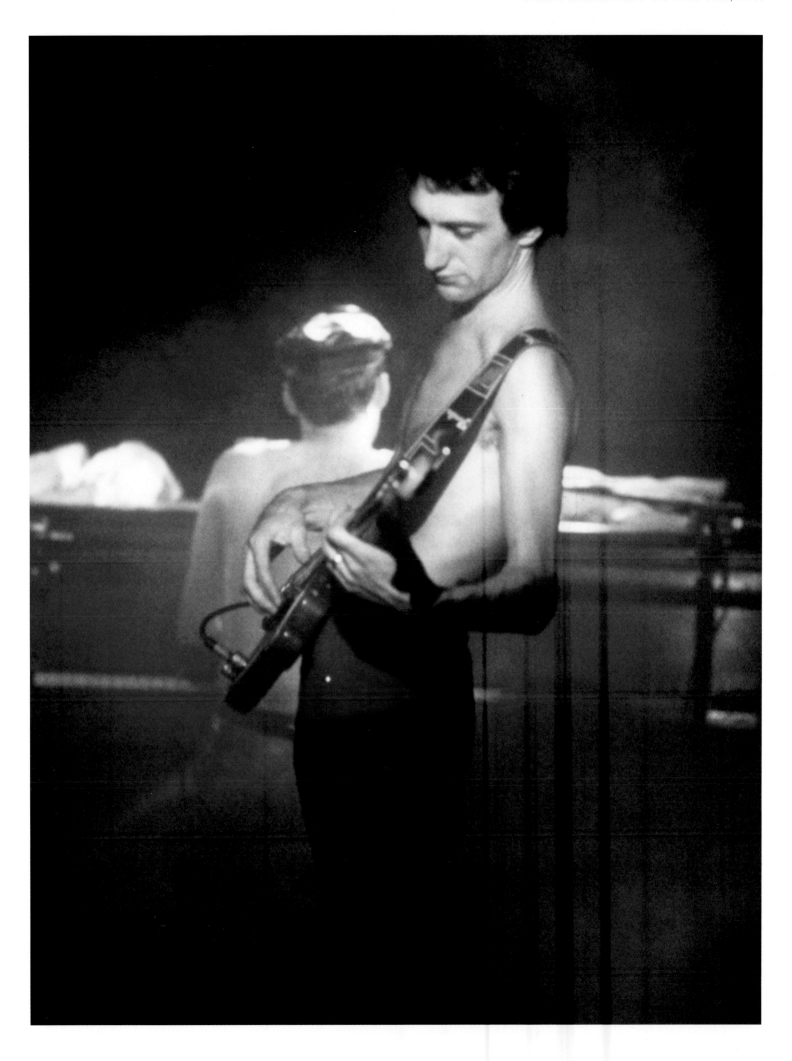

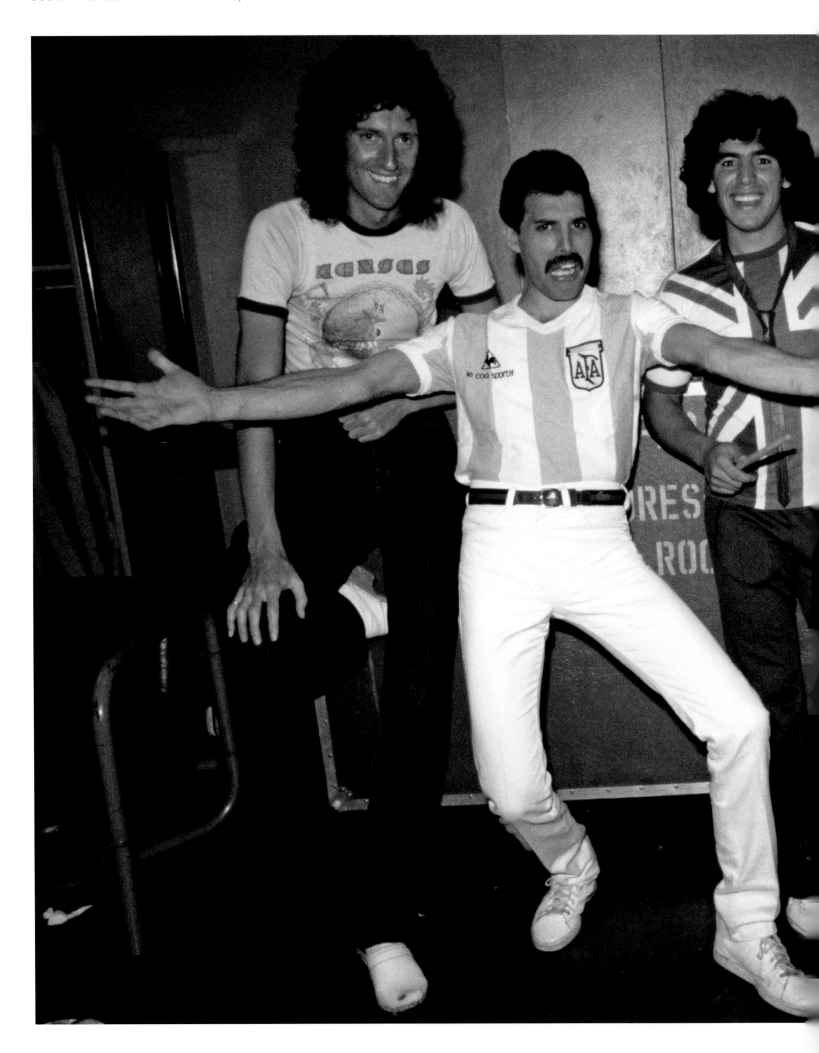

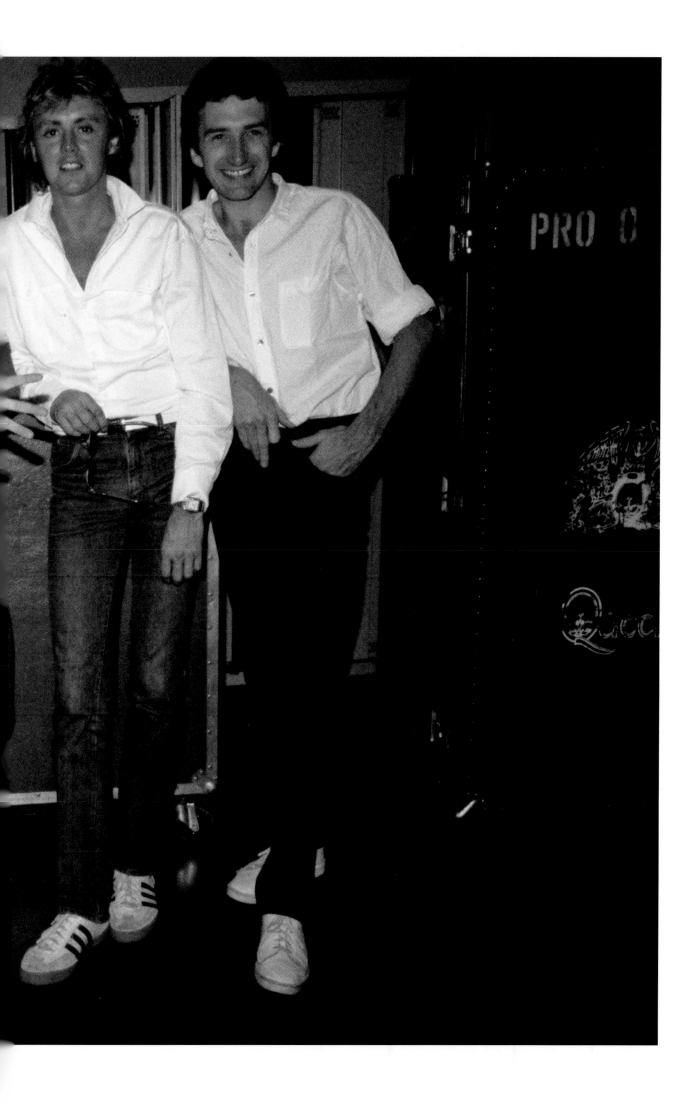

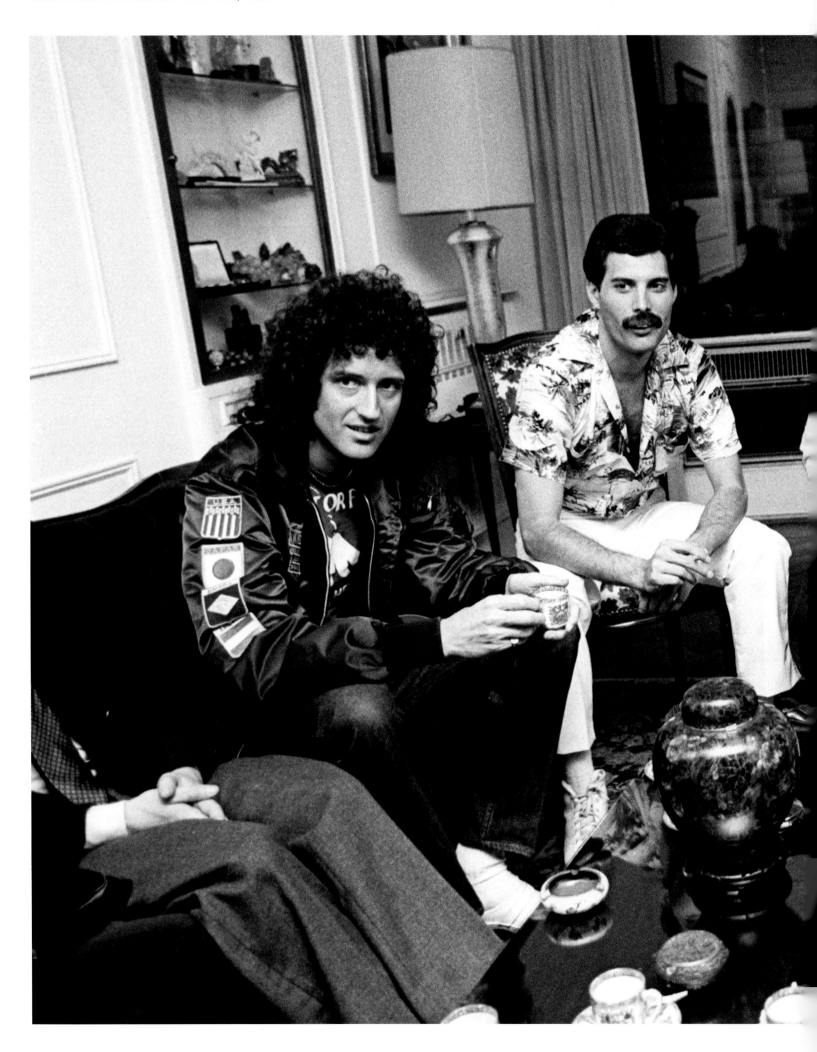

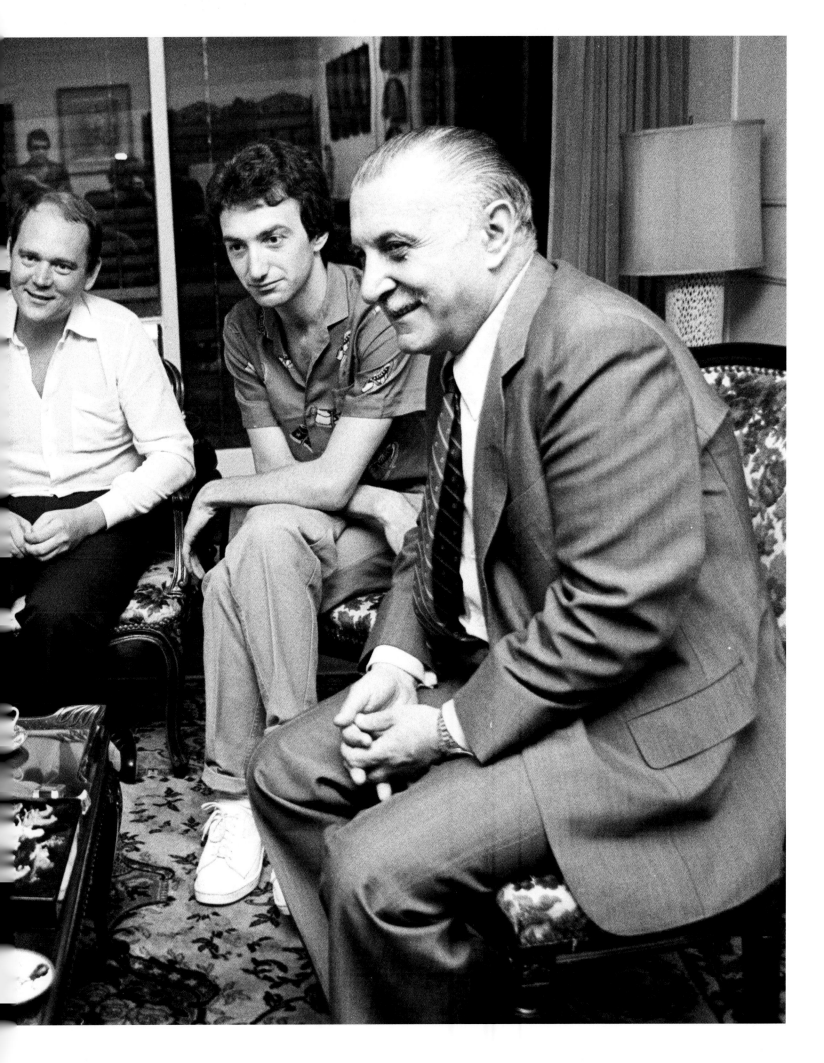

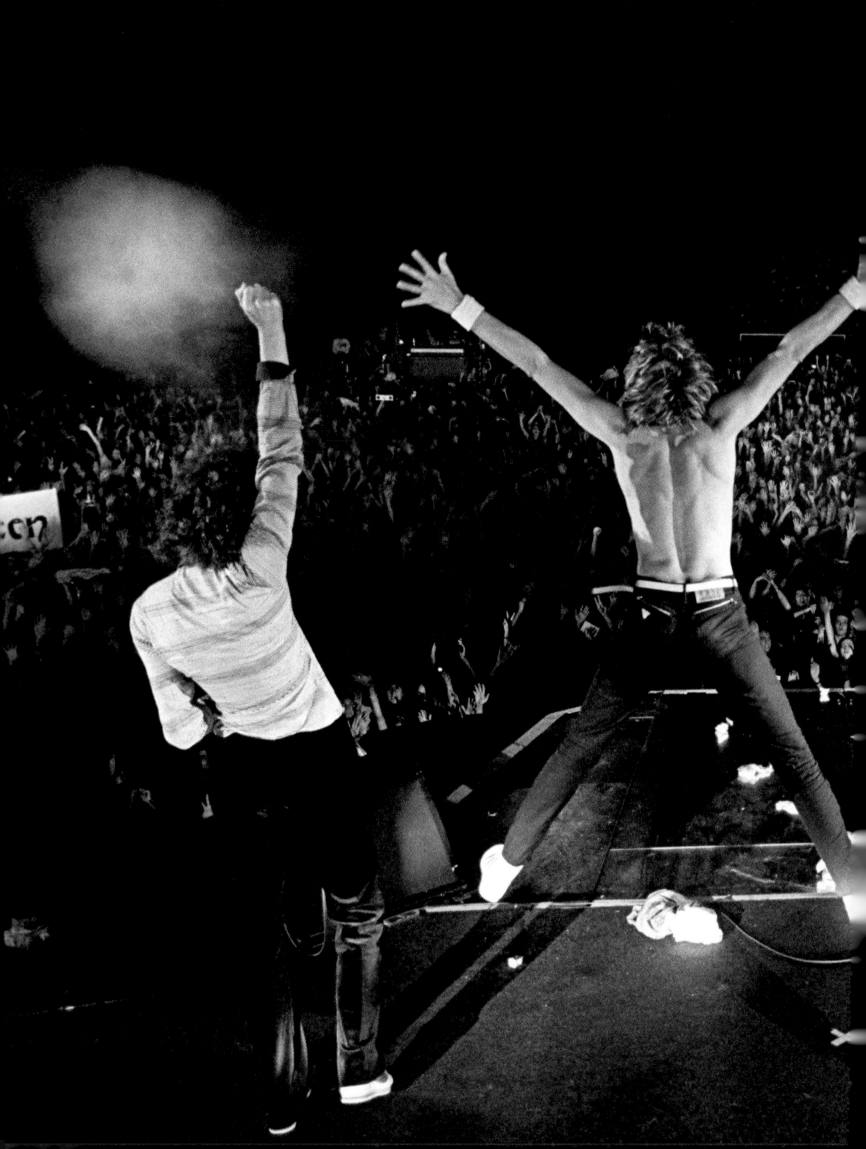

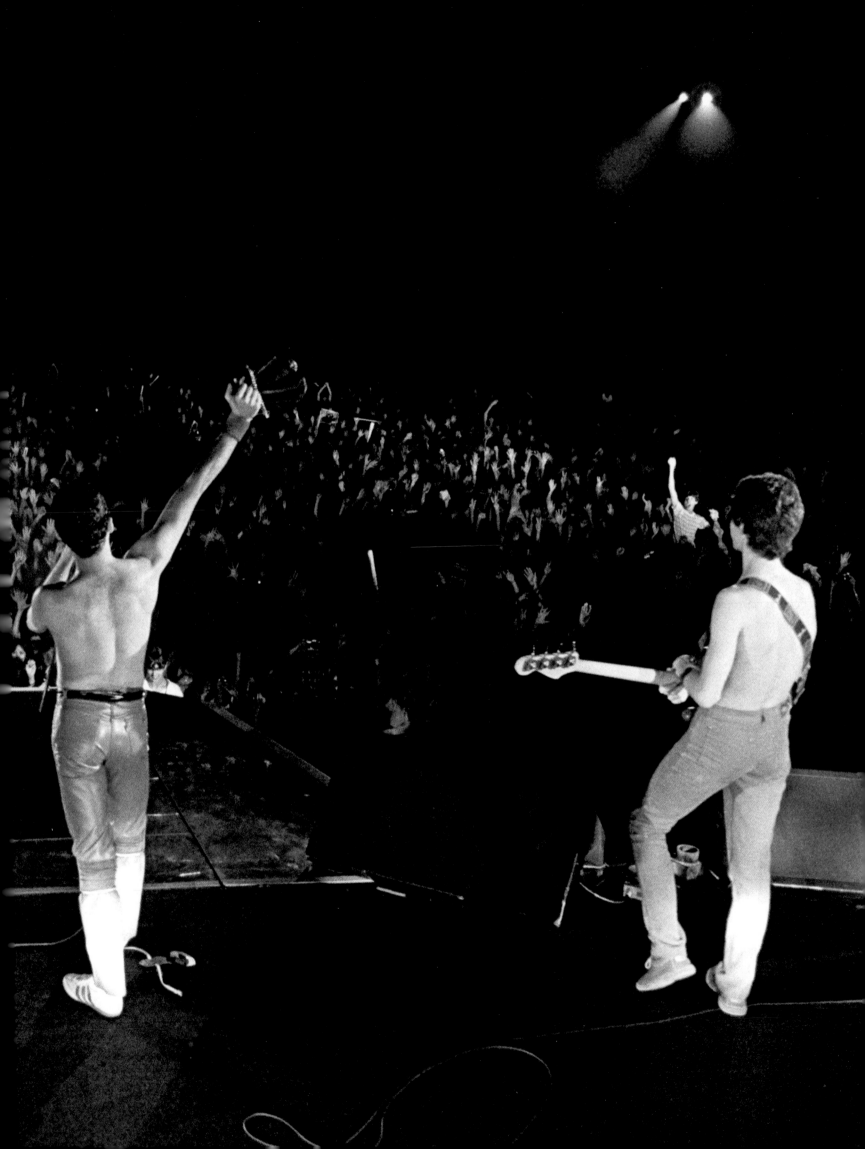

Gluttons For Punishment Tour, South America 1981

25 September – Poliedro De Caracas, Caracas, Venezuela
26 September – Poliedro De Caracas, Caracas, Venezuela
27 September – Poliedro De Caracas, Caracas, Venezuela
09 October – Estadio Universitario, Monterrey, Mexico
17 October – Estadio Olímpico Ignacio Zaragoza, Puebla, Mexico
18 October – Estadio Olímpico Ignacio Zaragoza, Puebla, Mexico

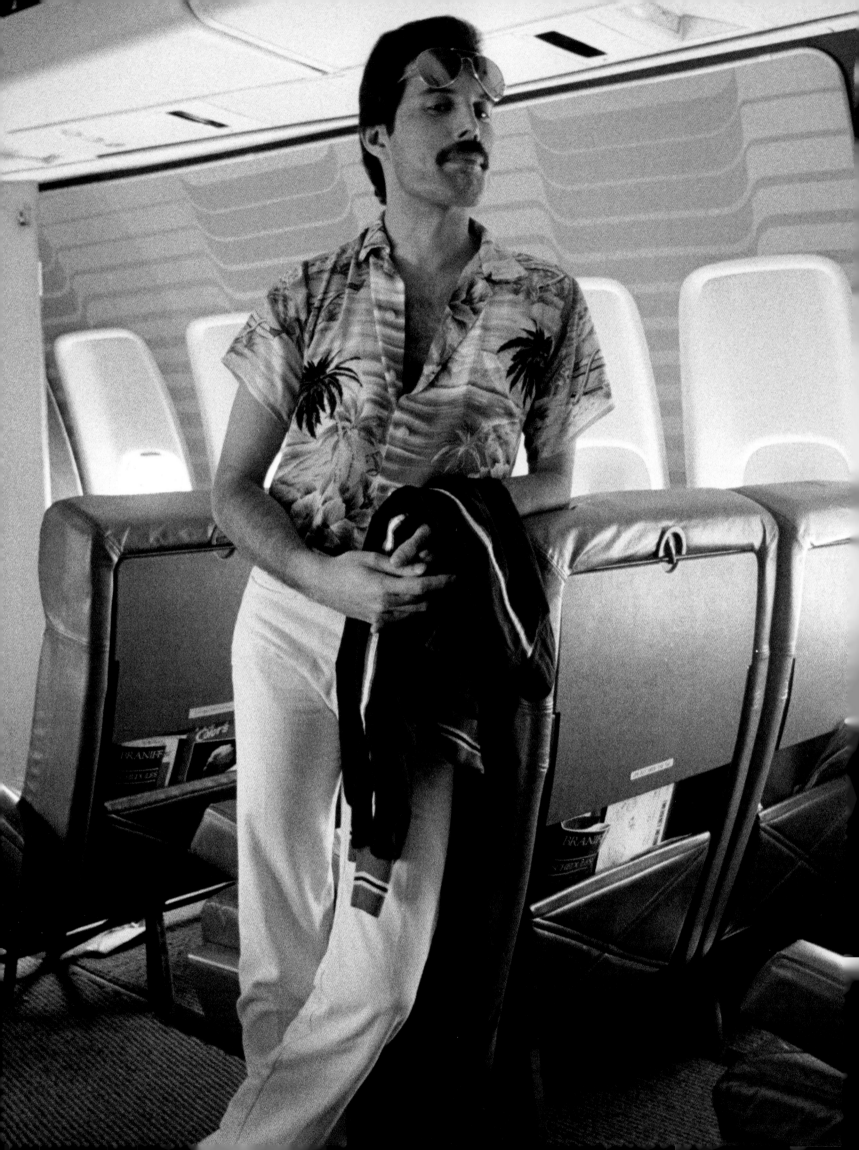

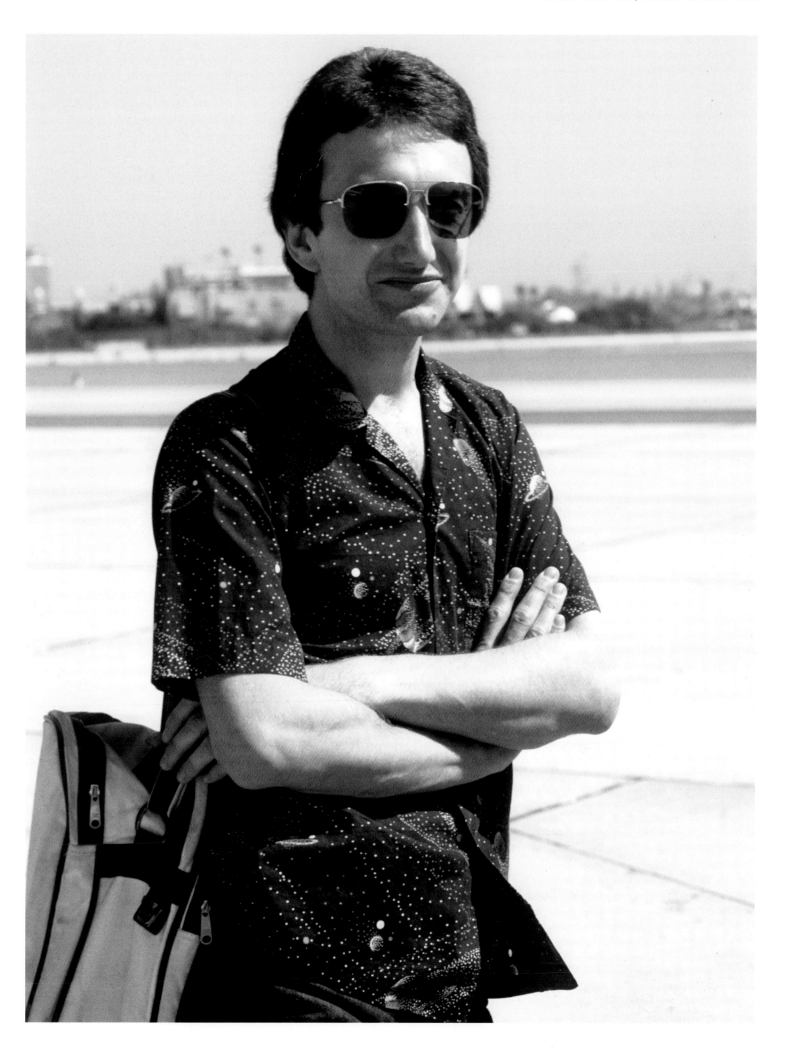

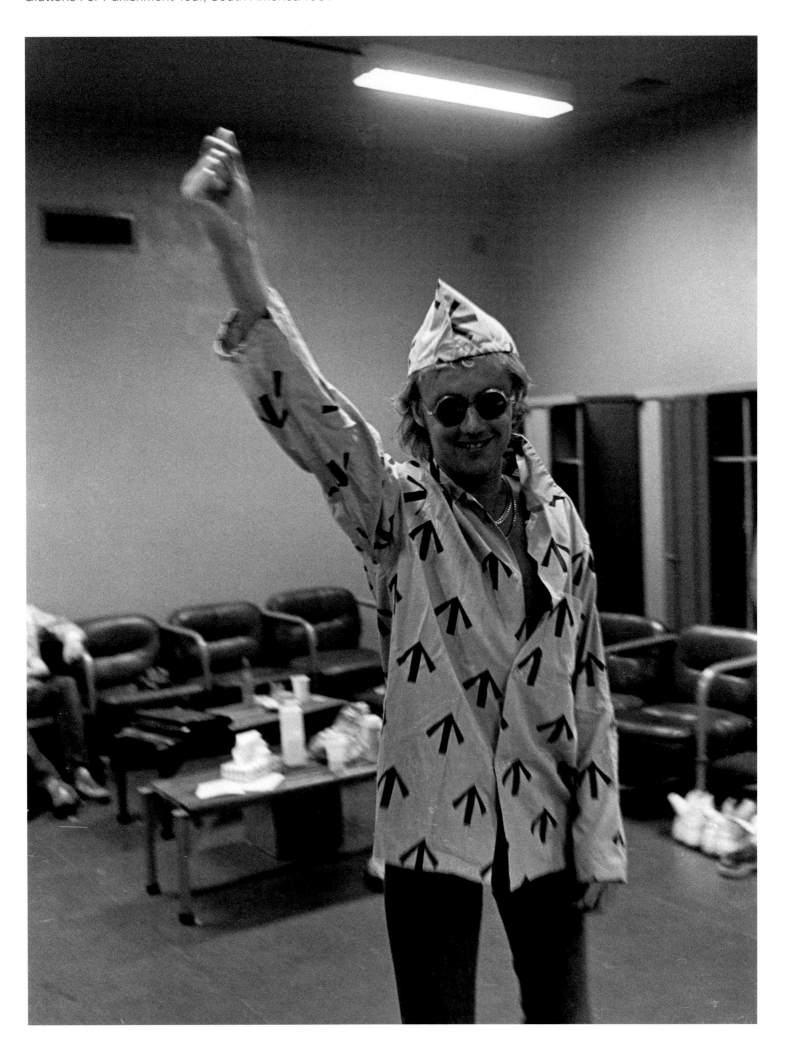

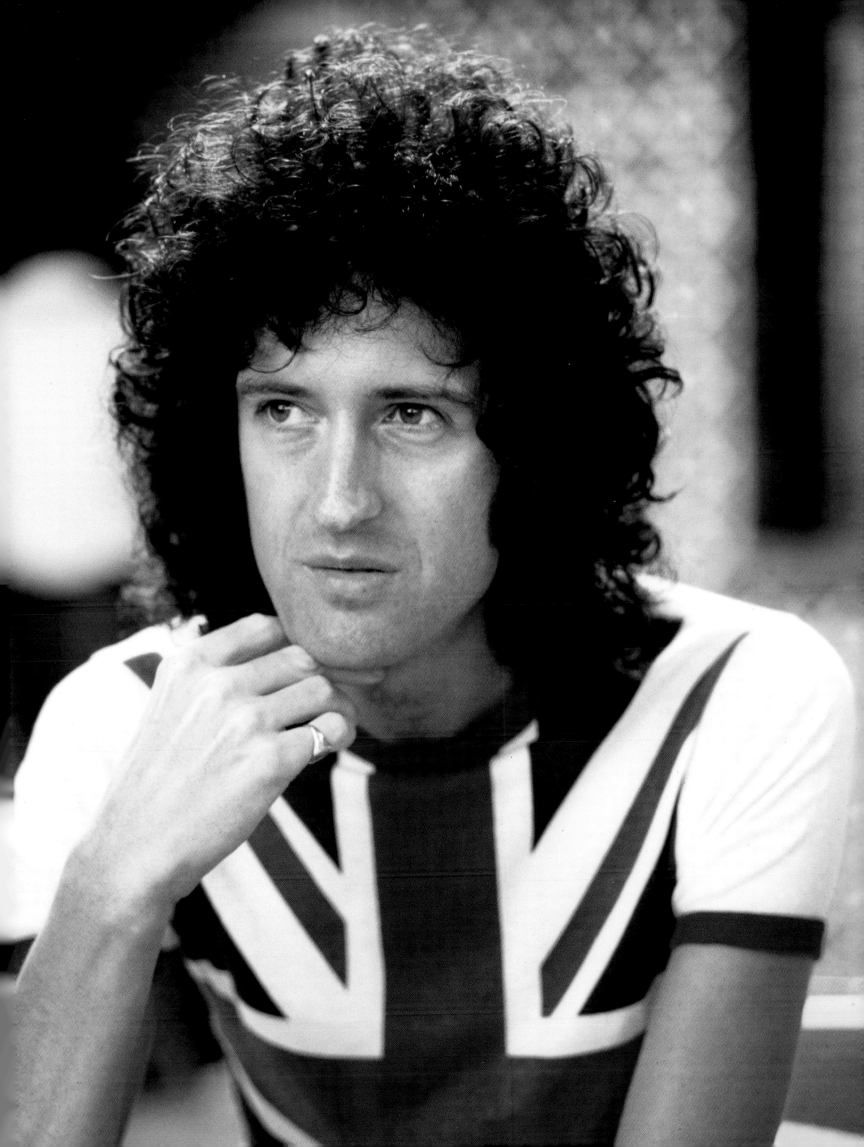

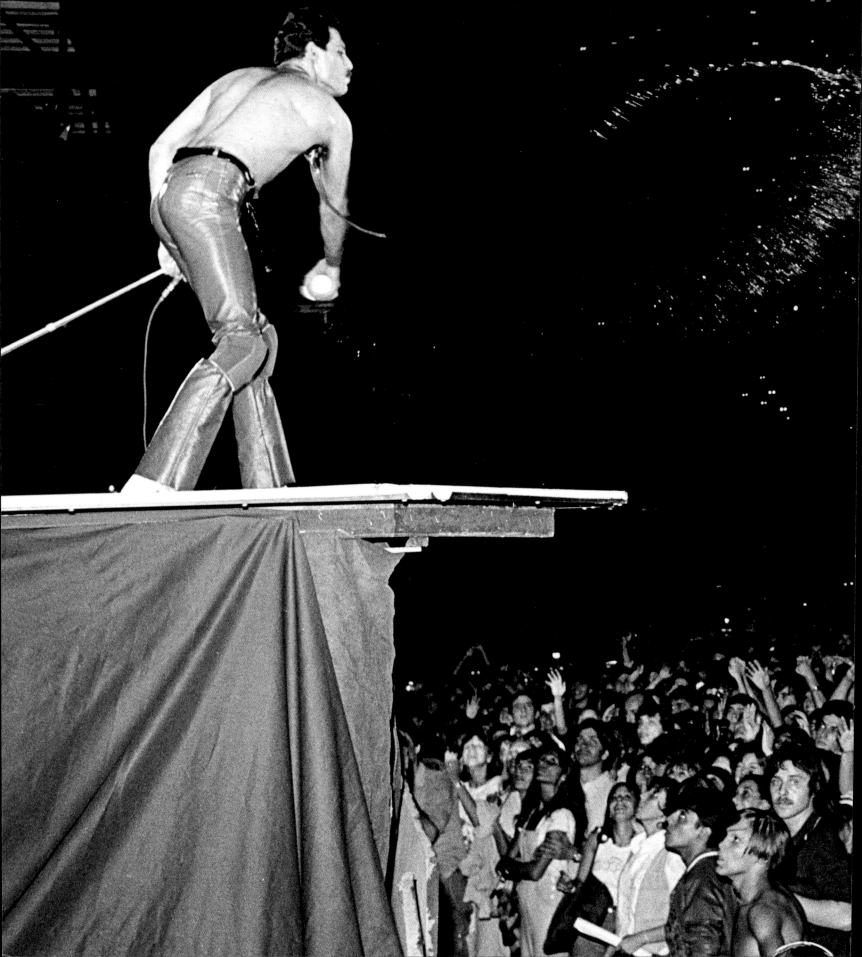

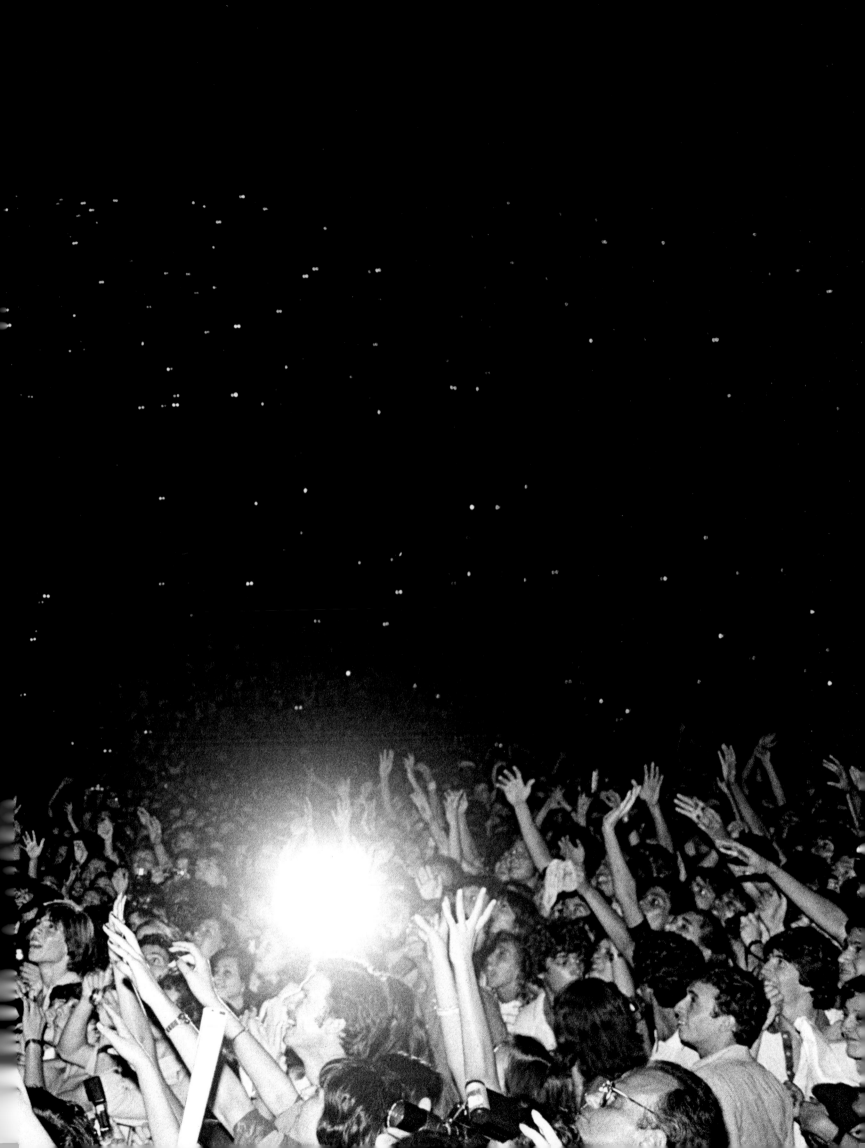

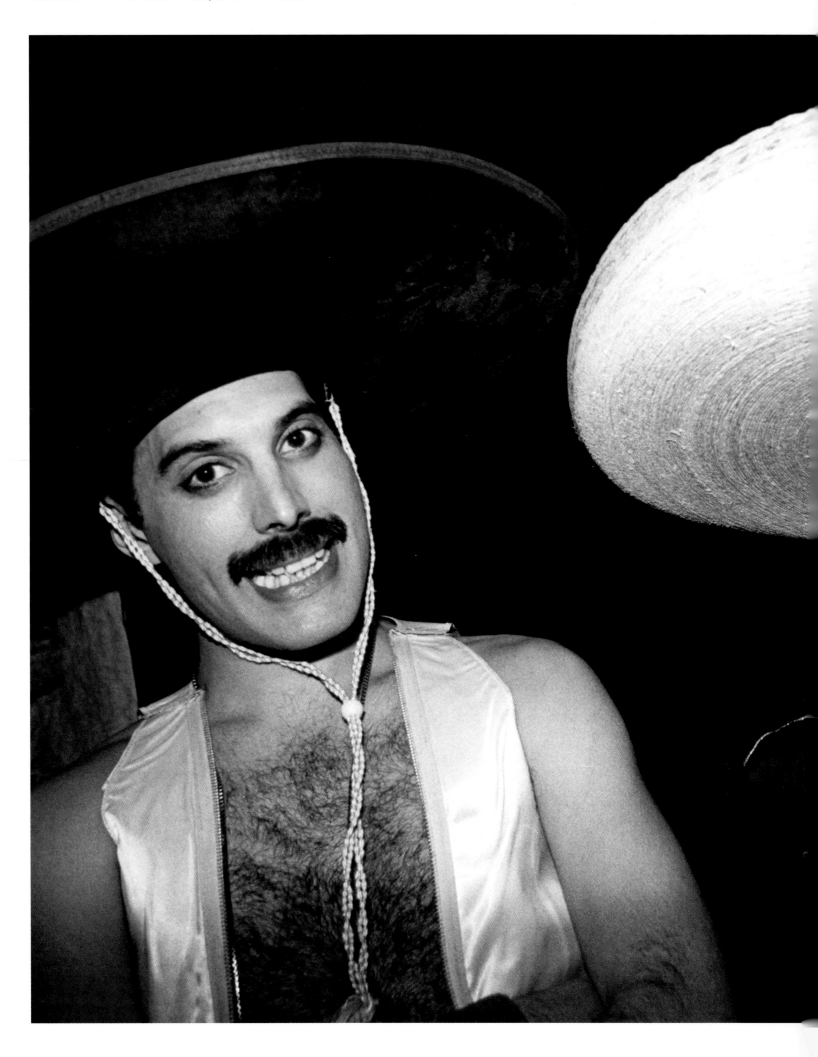

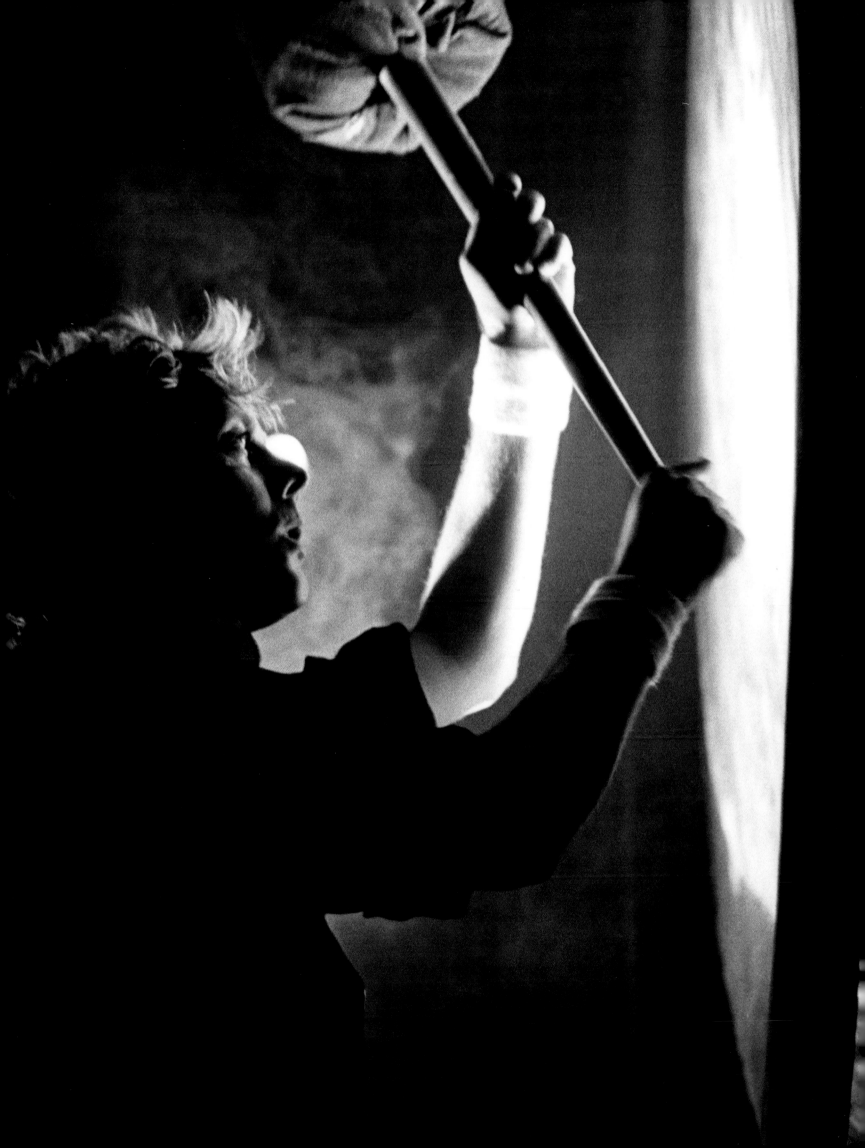

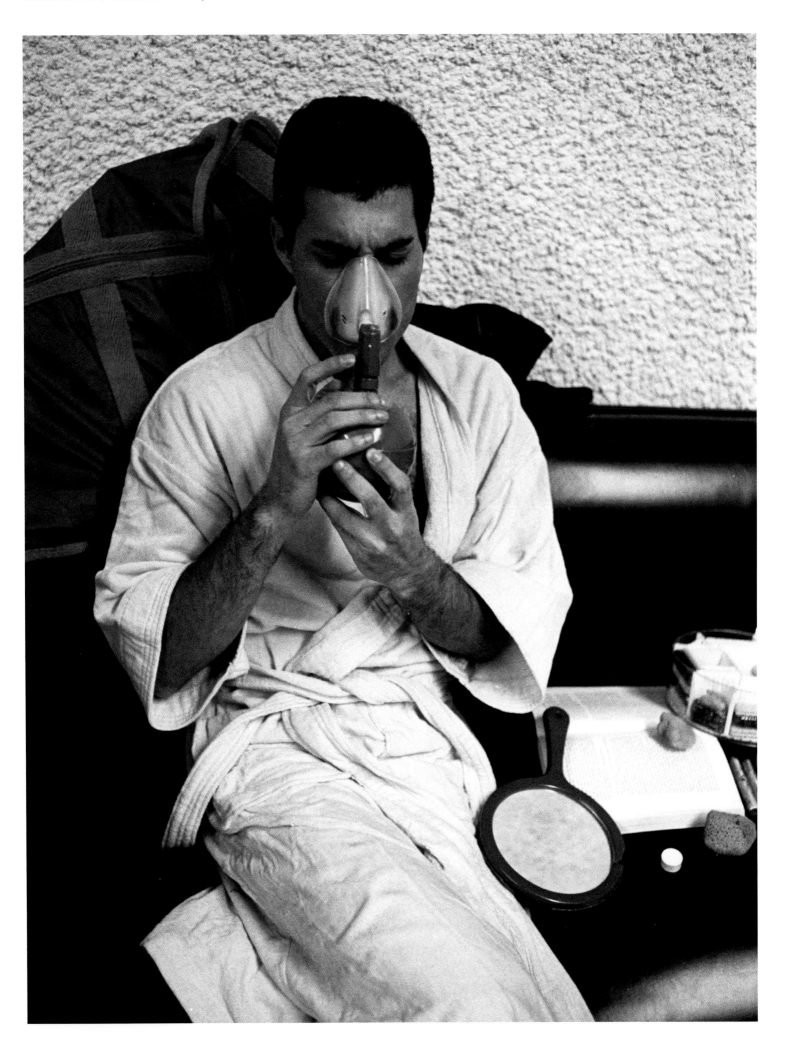

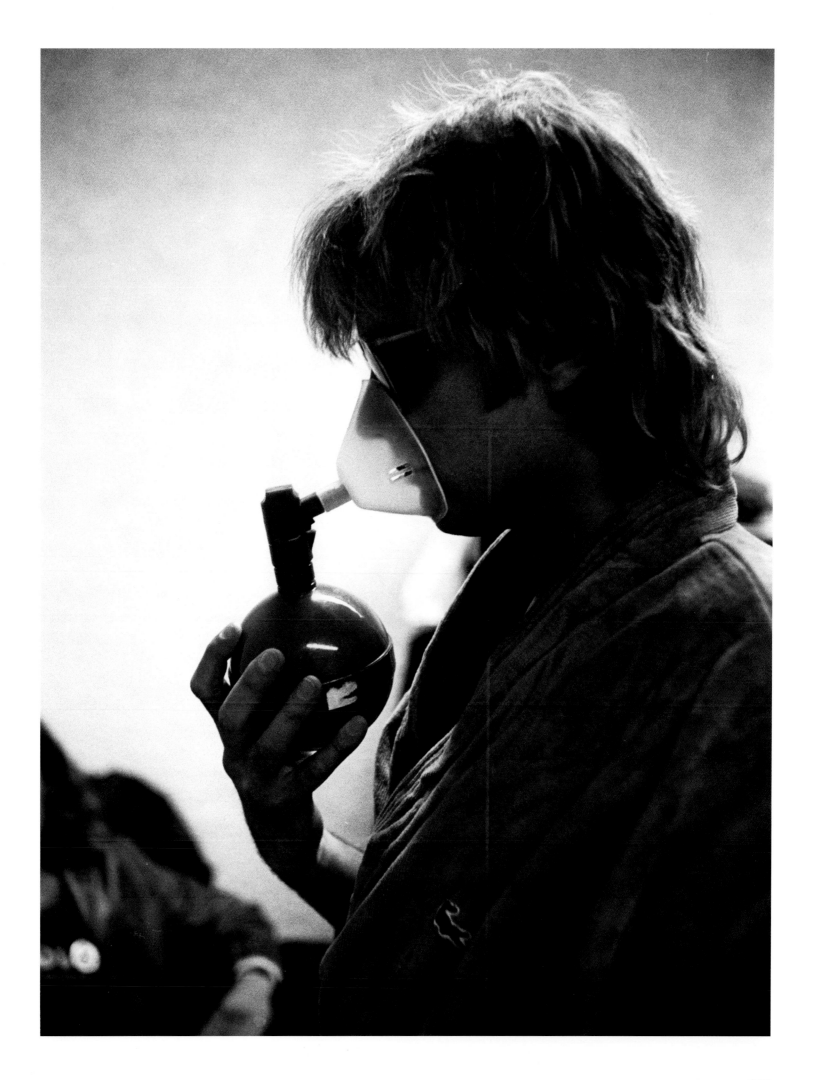

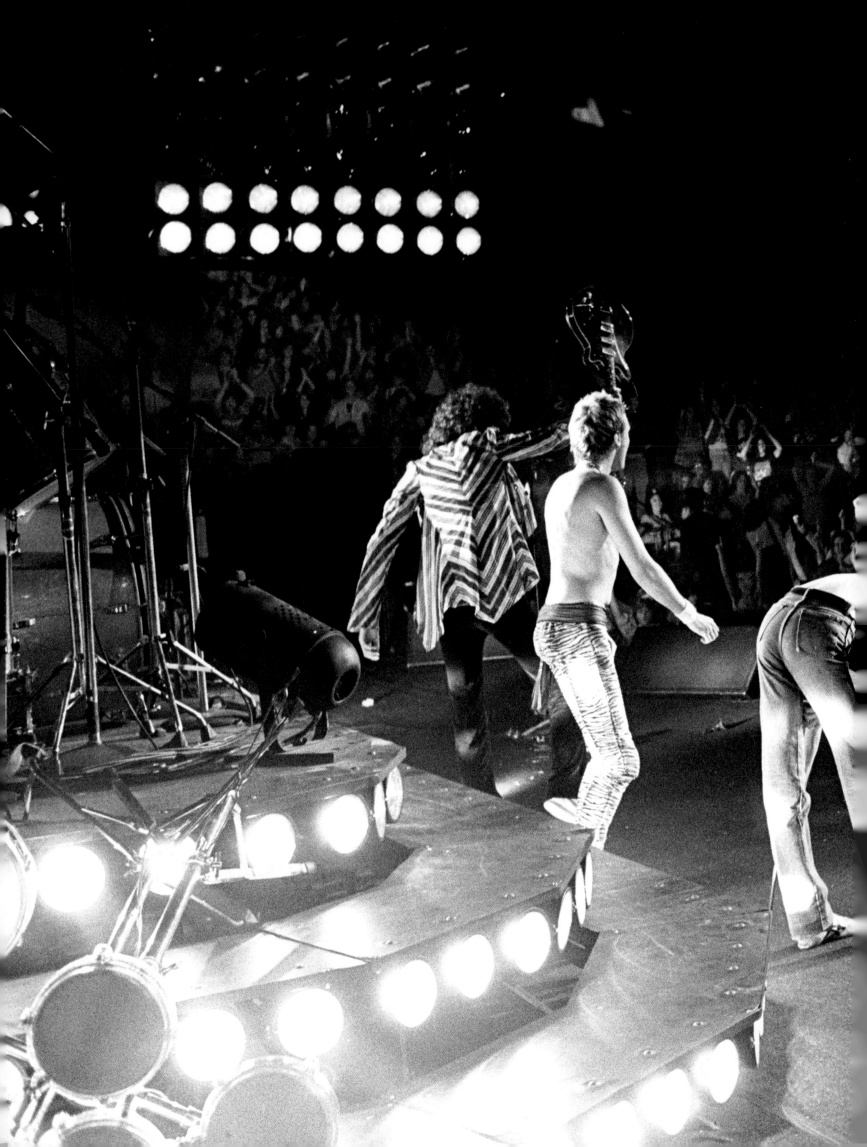

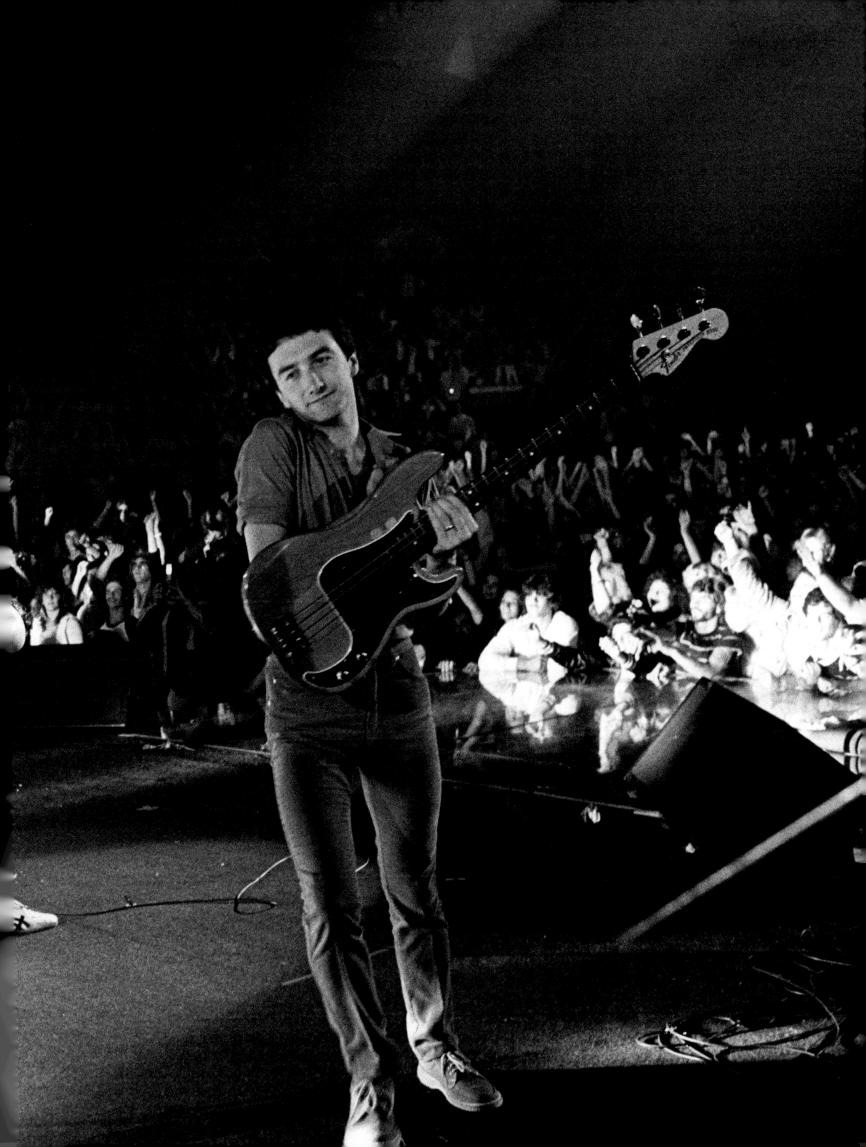

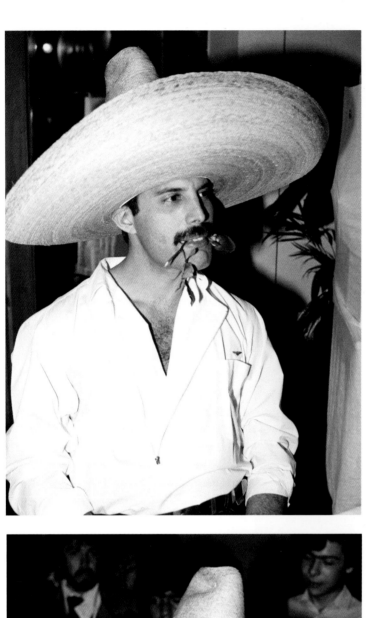

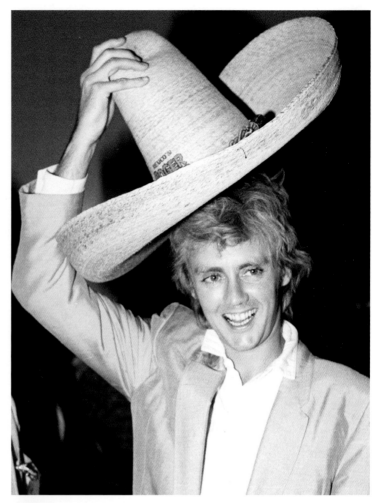

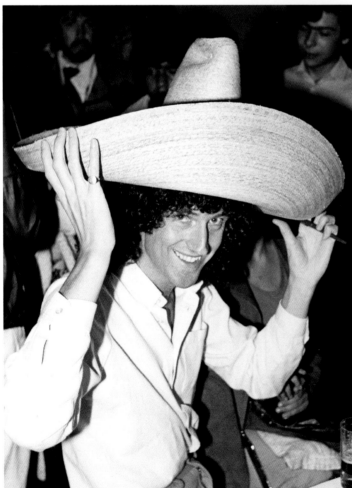

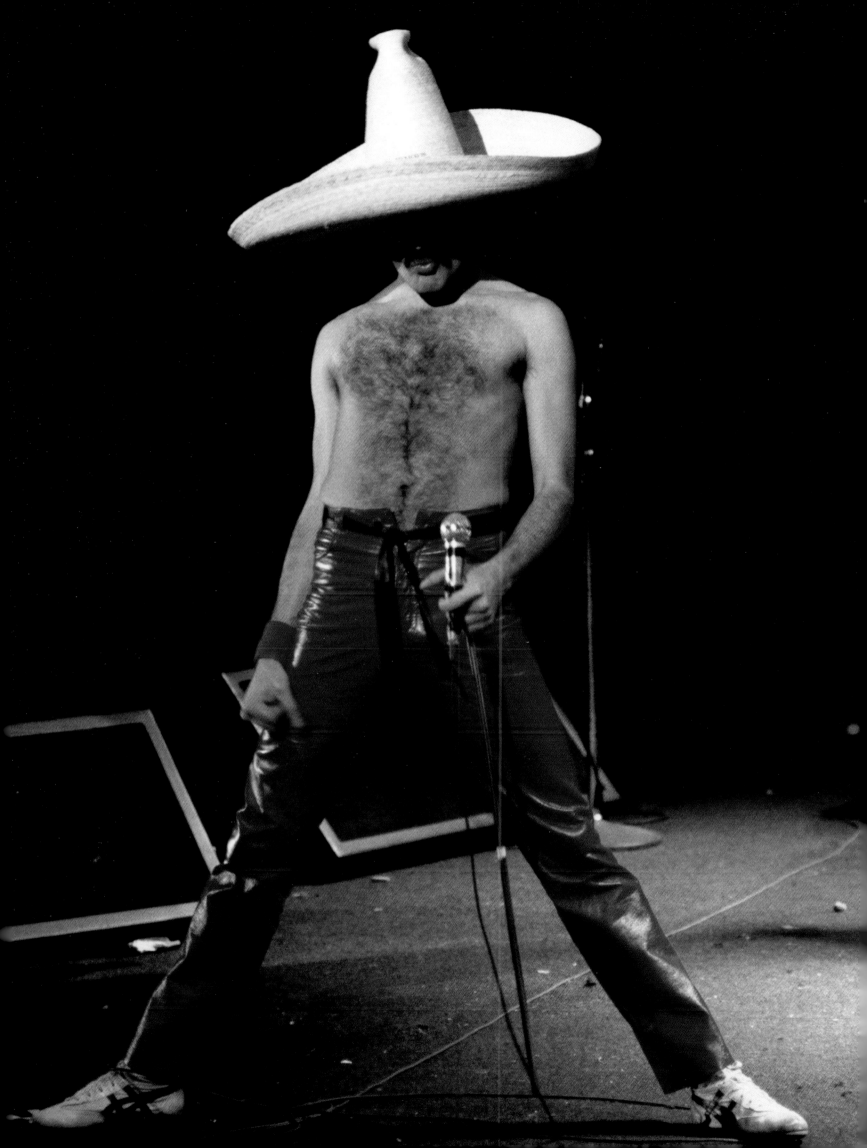

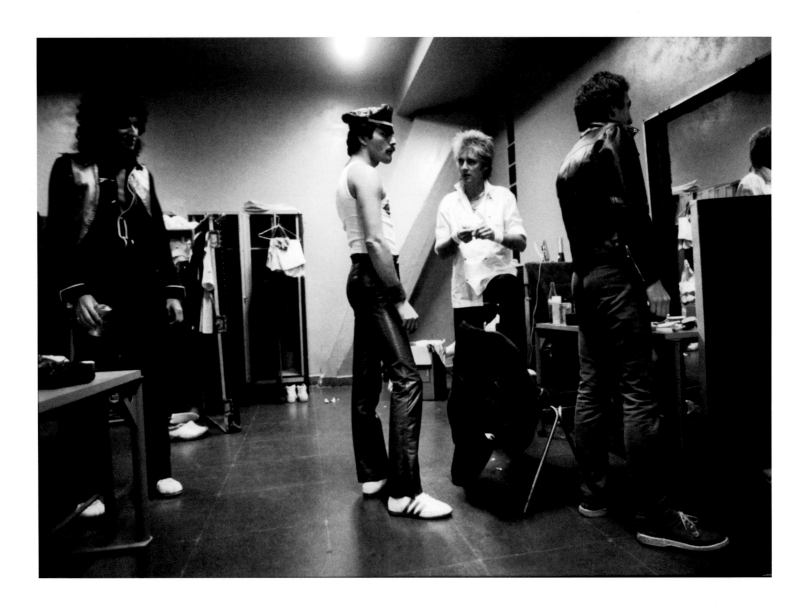

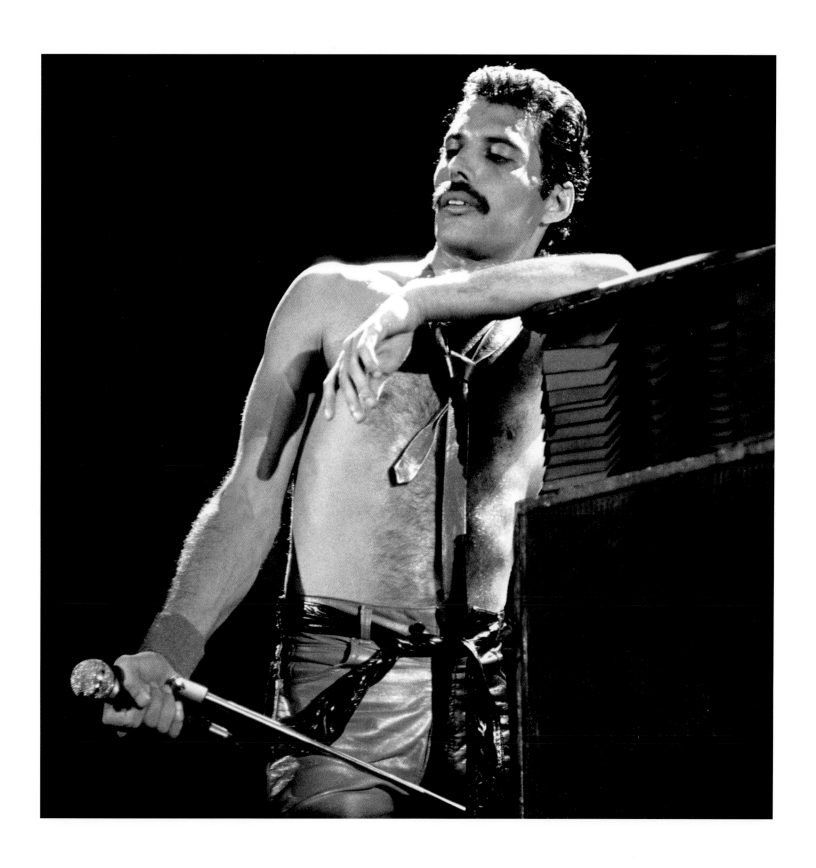

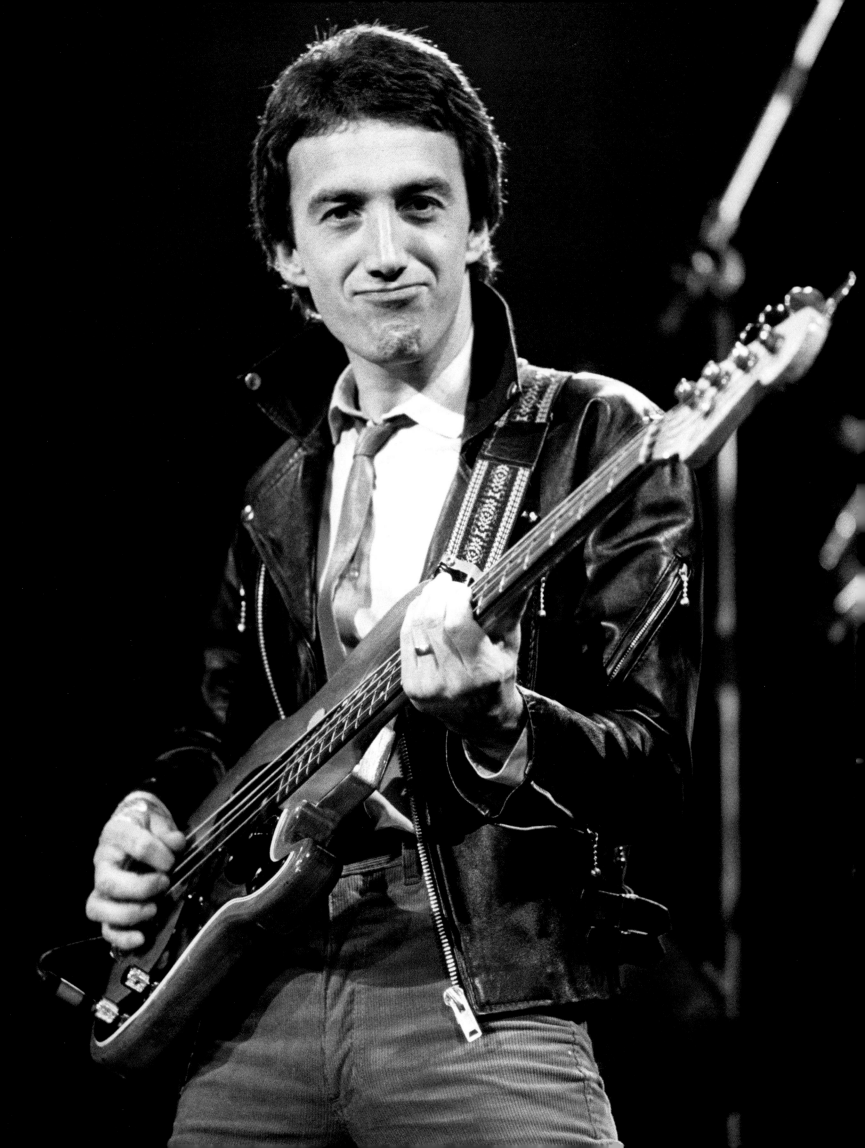

The Hot Space Tour, North America 1982

21 July – Forum, Montreal, Canada
23 July – Boston Garden, Boston, MA, USA
24 July – The Spectrum, Philadelphia, PA, USA
25 July – Capital Center, Landover, MD, USA
27 July – Madison Square Garden, New York, NY, USA
28 July – Madison Square Garden, New York, NY, USA
31 July – Coliseum, Richfield, OH, USA
02 August – Maple Leaf Gardens, Toronto, Canada
03 August – Maple Leaf Gardens, Toronto, Canada
05 August – Market Square Arena, Indianapolis, IN, USA
06 August – Joe Louis Arena, Detroit, MI, USA
07 August – Riverfront Coliseum, Cincinnati, OH, USA
09 August – Brendan Byrne Arena, East Rutherford, NJ, USA
10 August – Veterans Memorial Coliseum, New Haven, CT, USA
13 August – Poplar Creek Music Theater, Hoffman Estates, IL, USA
14 August – Poplar Creek Music Theater, Hoffman Estates, IL, USA
15 August – Civic Arena, St. Paul, MN, USA
19 August – Mississippi Coast Coliseum, Biloxi, MS, USA
20 August – Summit, Houston, TX, USA
21 August – Reunion, Dallas, TX, USA
24 August – Omni, Atlanta, GA, USA
27 August – Myriad, Oklahoma City, OK, USA
28 August – Kemper Arena, Kansas City, MO, USA
30 August – McNichols Arena, Denver, CO, USA
02 September – Veterans Memorial Coliseum, Portland, OR, USA
03 September – Seattle Center Coliseum, Seattle, WA, USA
04 September – Pacific Coliseum, Vancouver, Canada
07 September – Oakland-Alameda County Coliseum, Oakland, CA, USA
10 September – Veterans Memorial Coliseum, Phoenix, AZ, USA
11 September – Irvine Meadows, Irvine, CA, USA
12 September – Irvine Meadows, Irvine, CA, USA
14 September – The Forum, Inglewood, CA, USA
15 September – The Forum, Inglewood, CA, USA

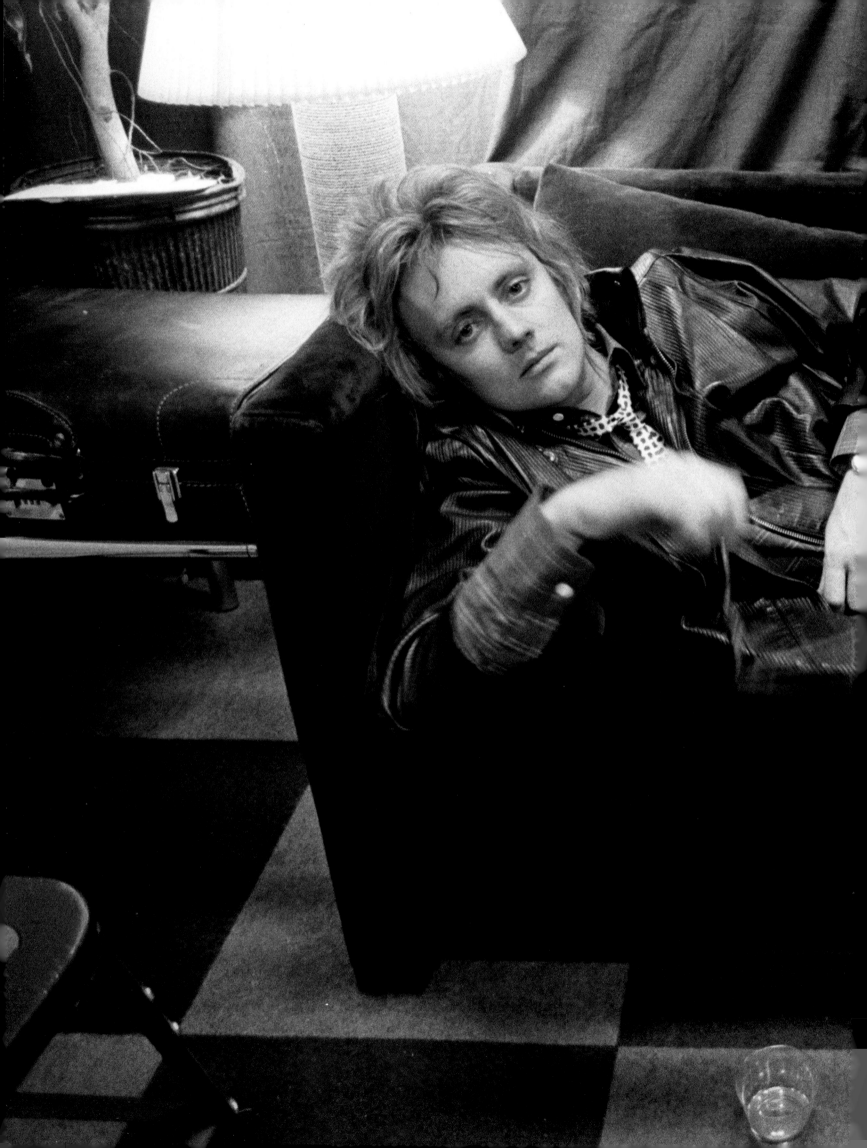

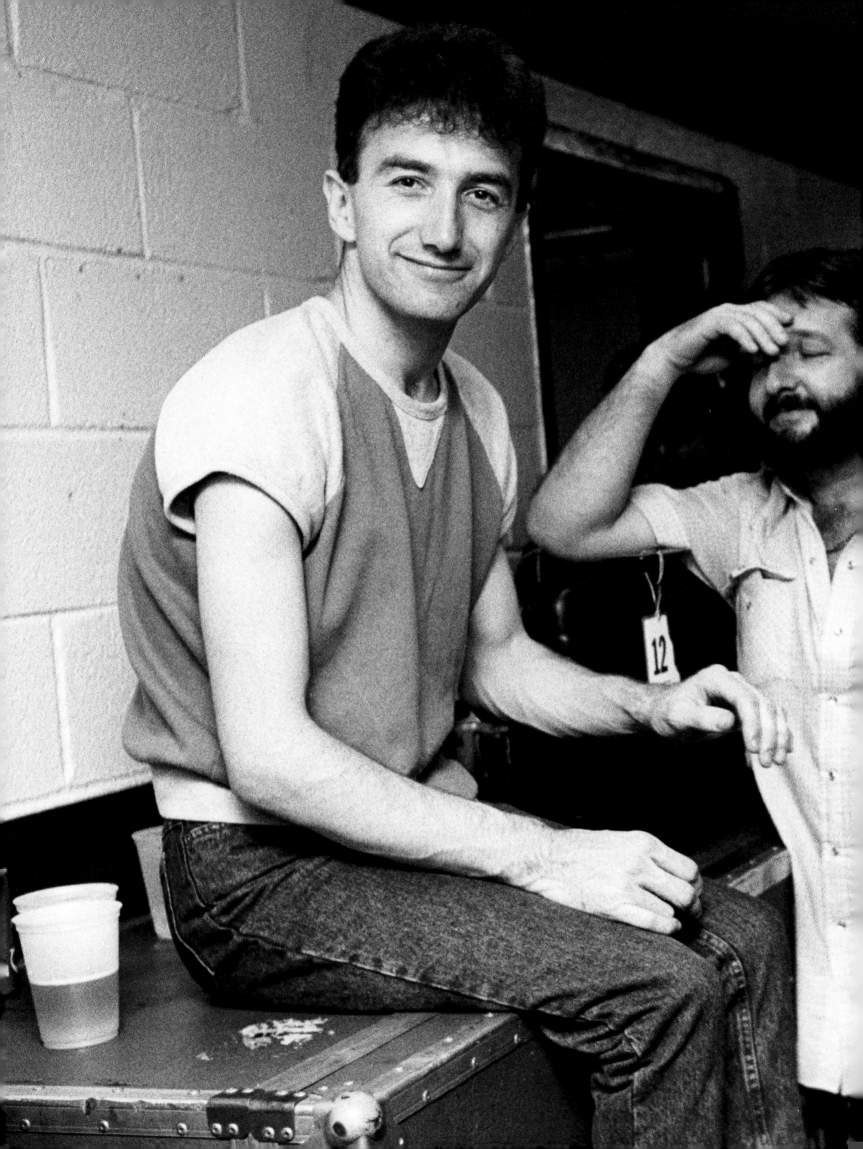

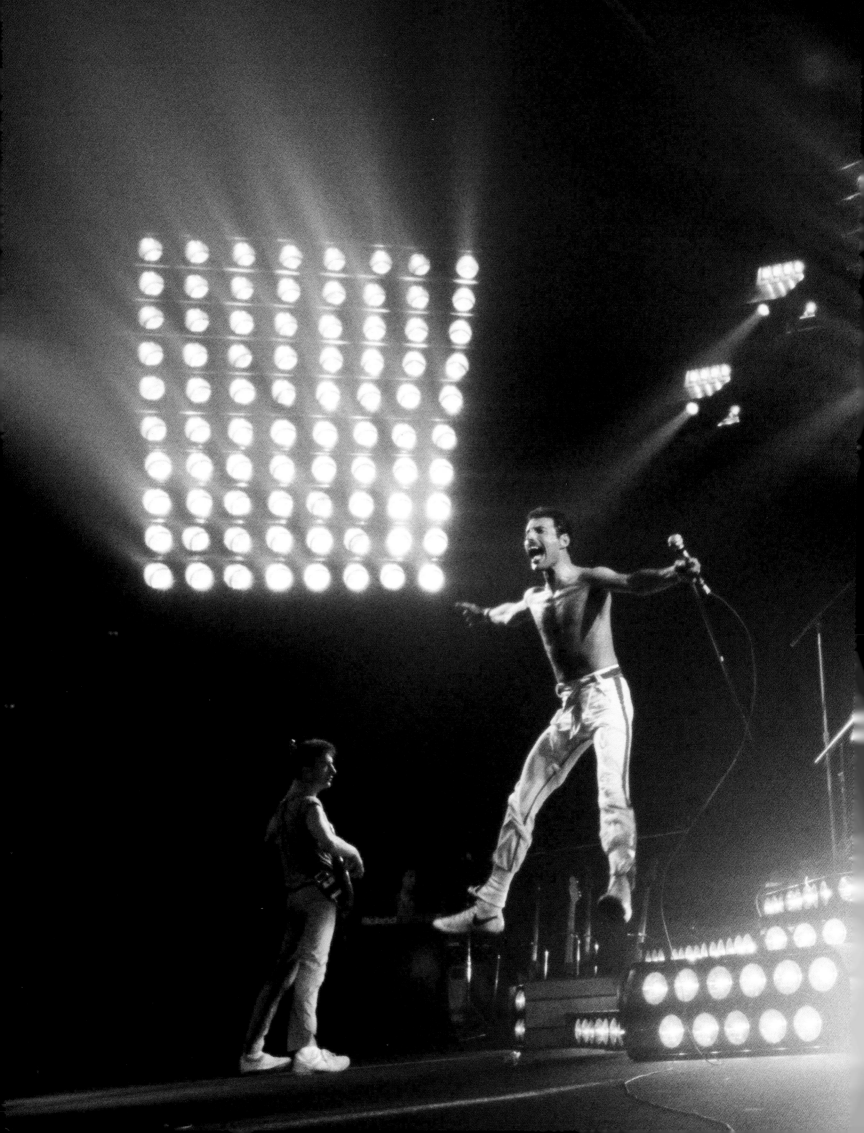

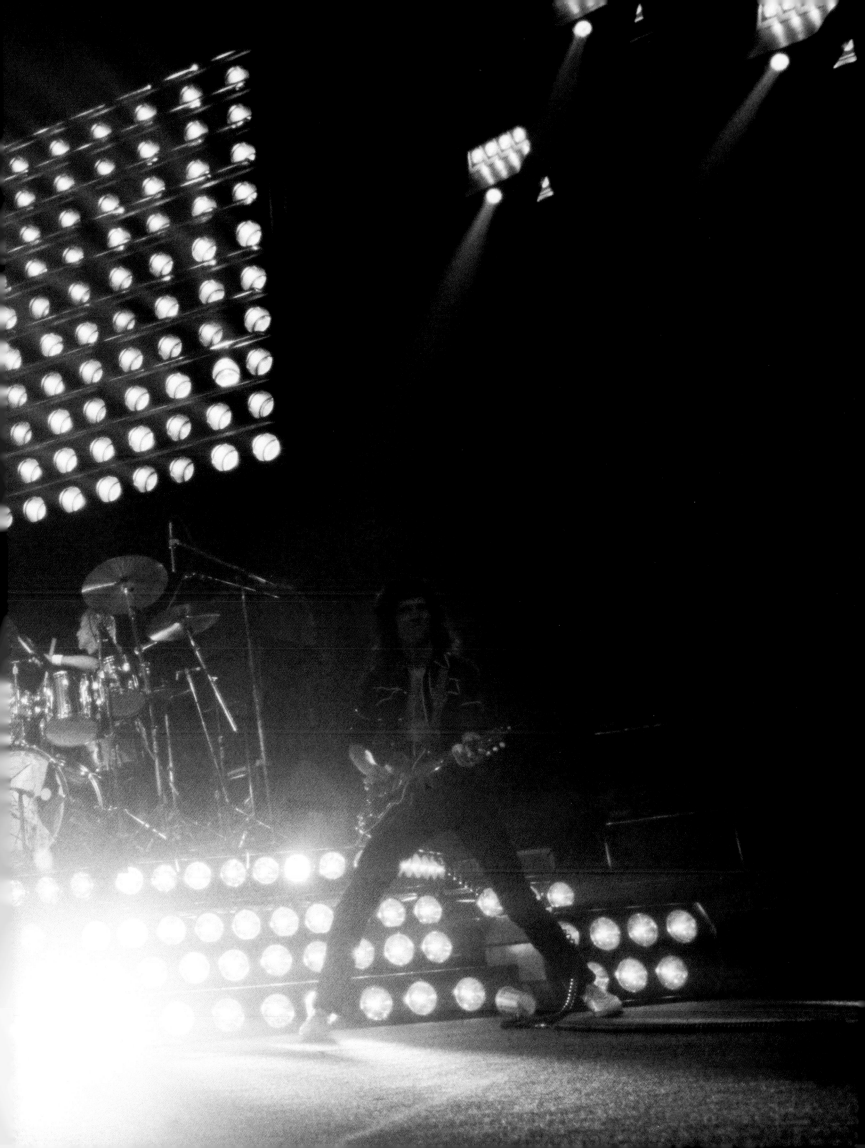

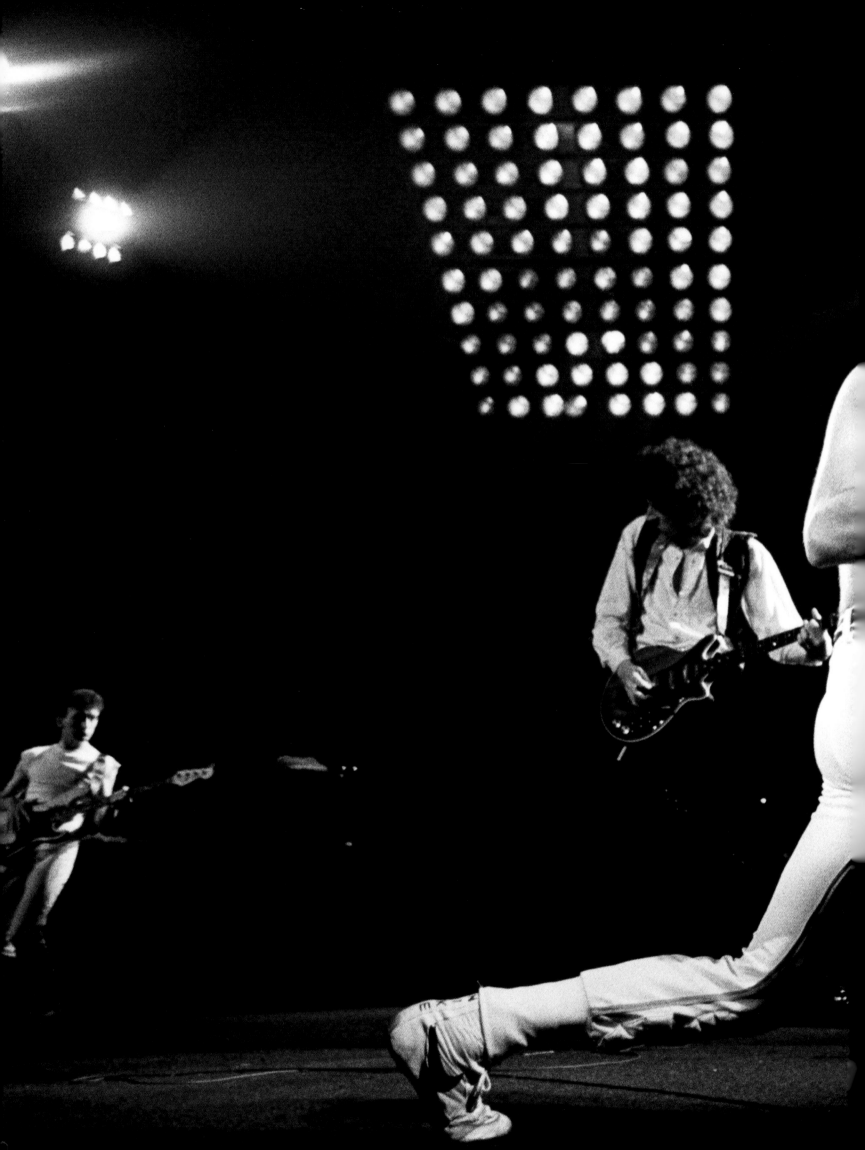

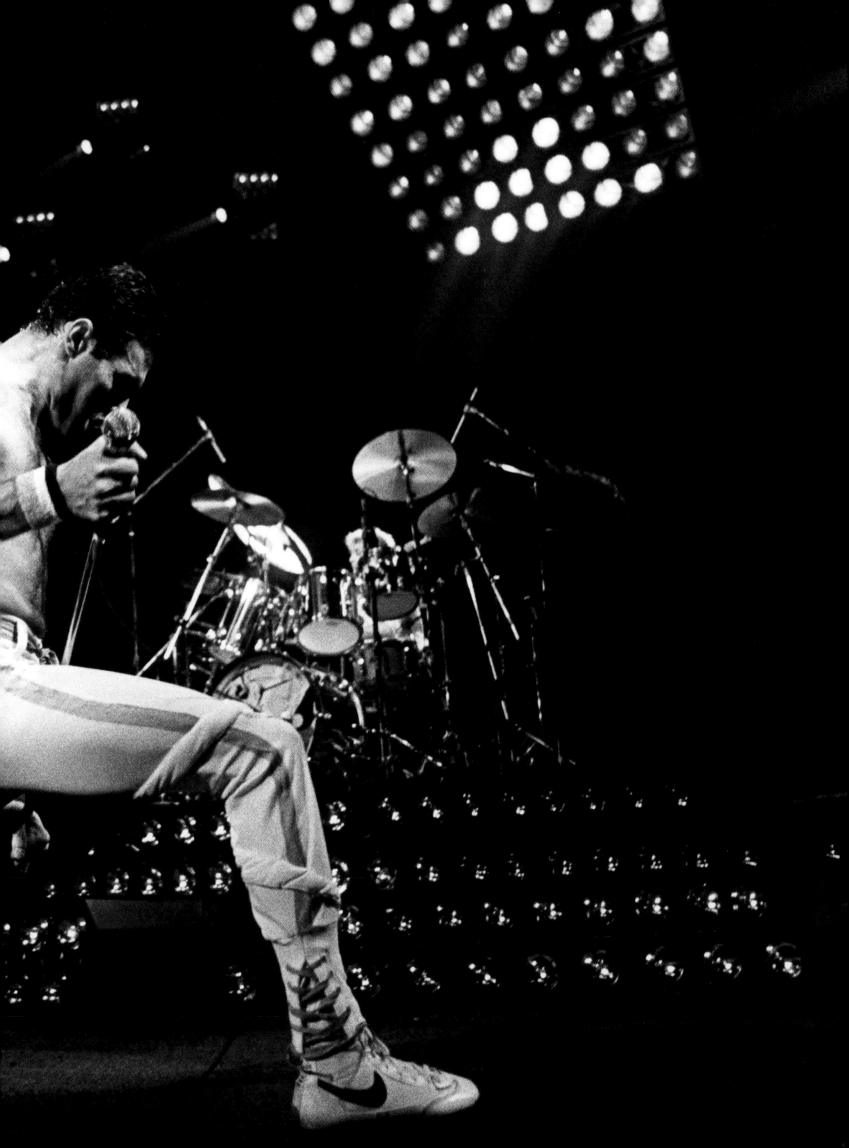

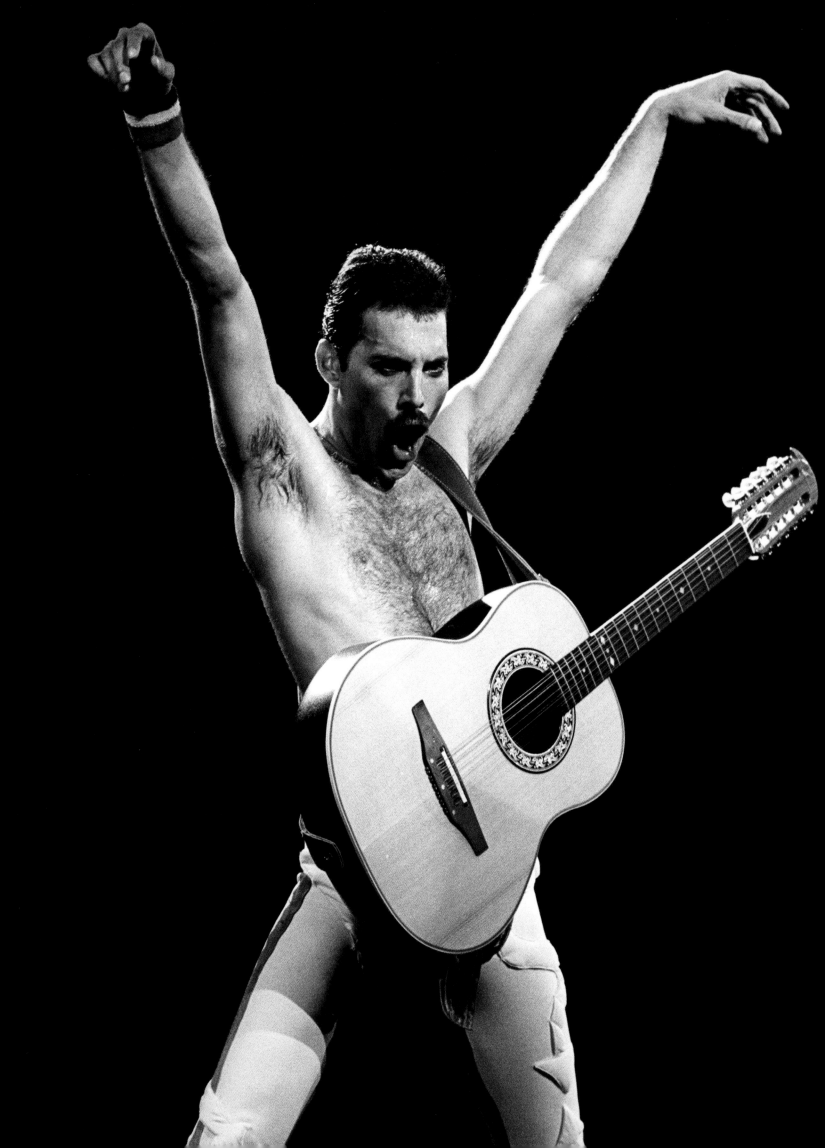

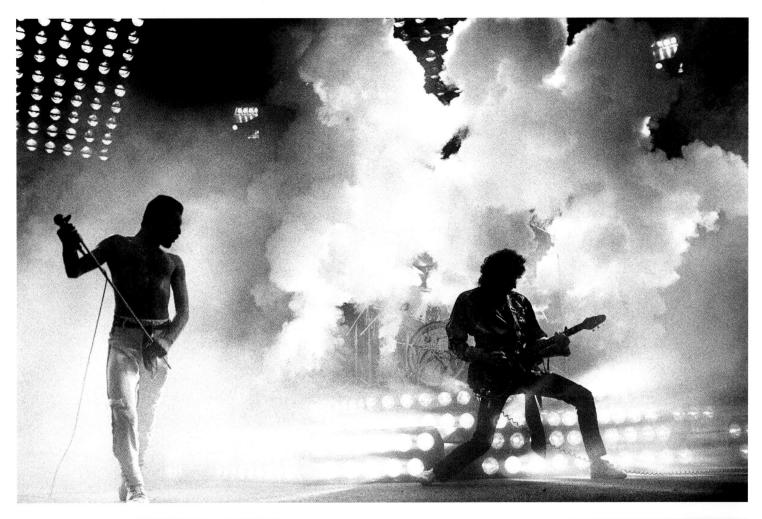

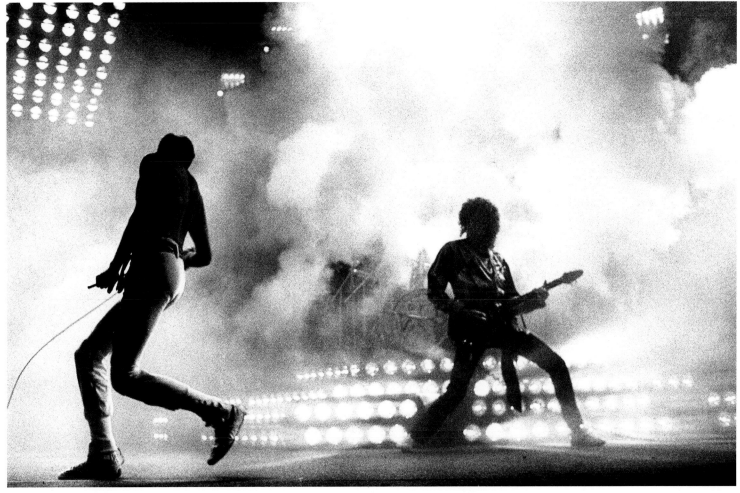

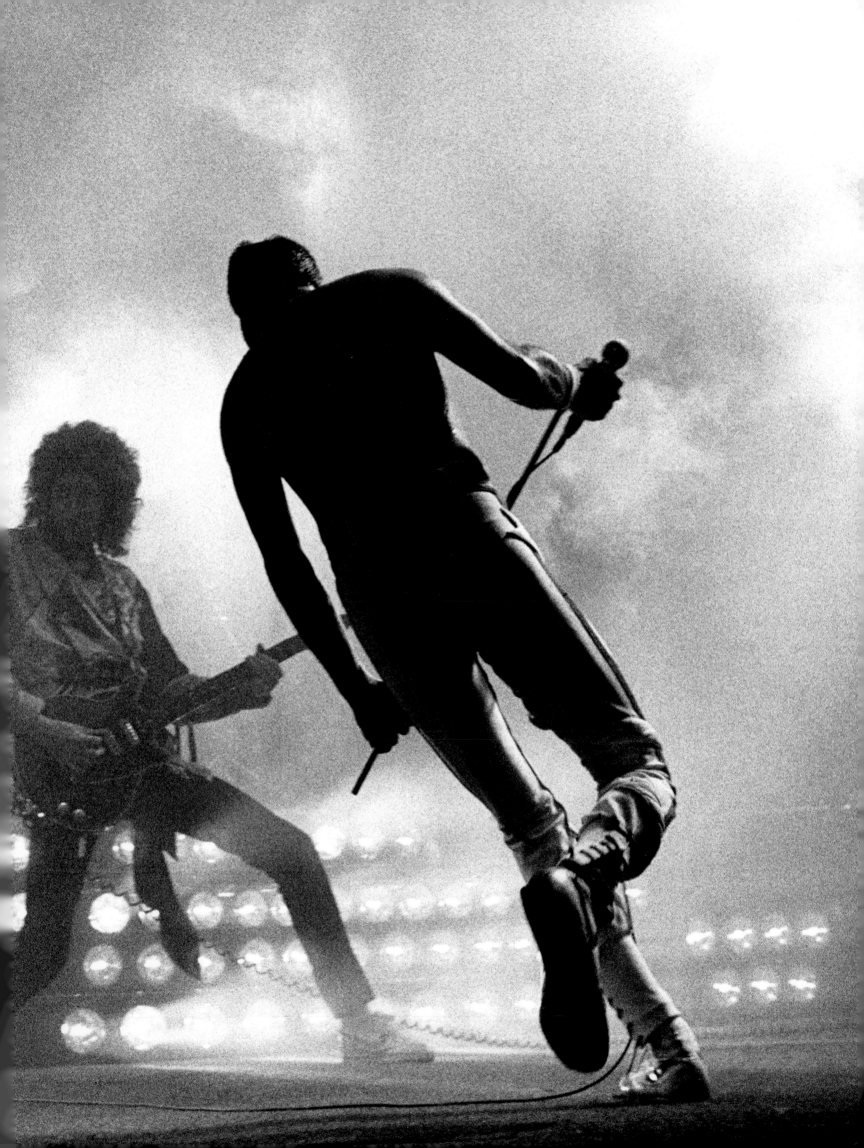

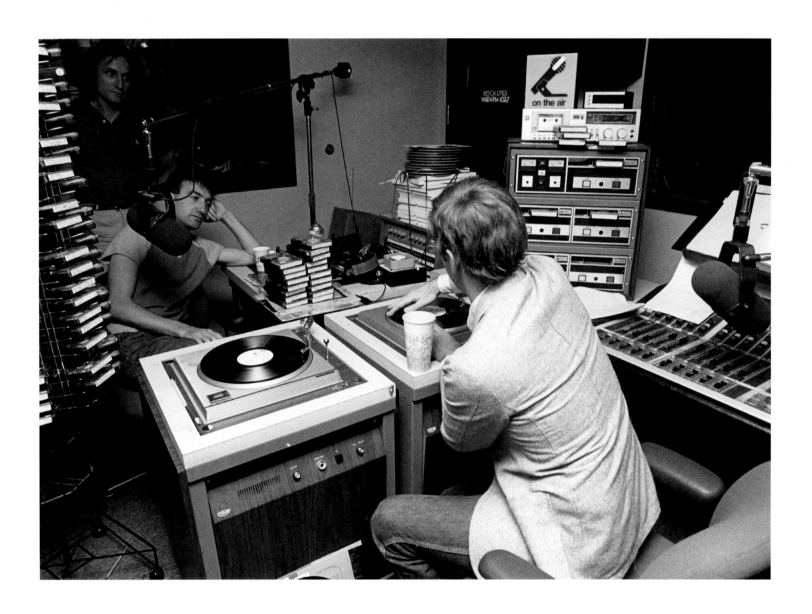

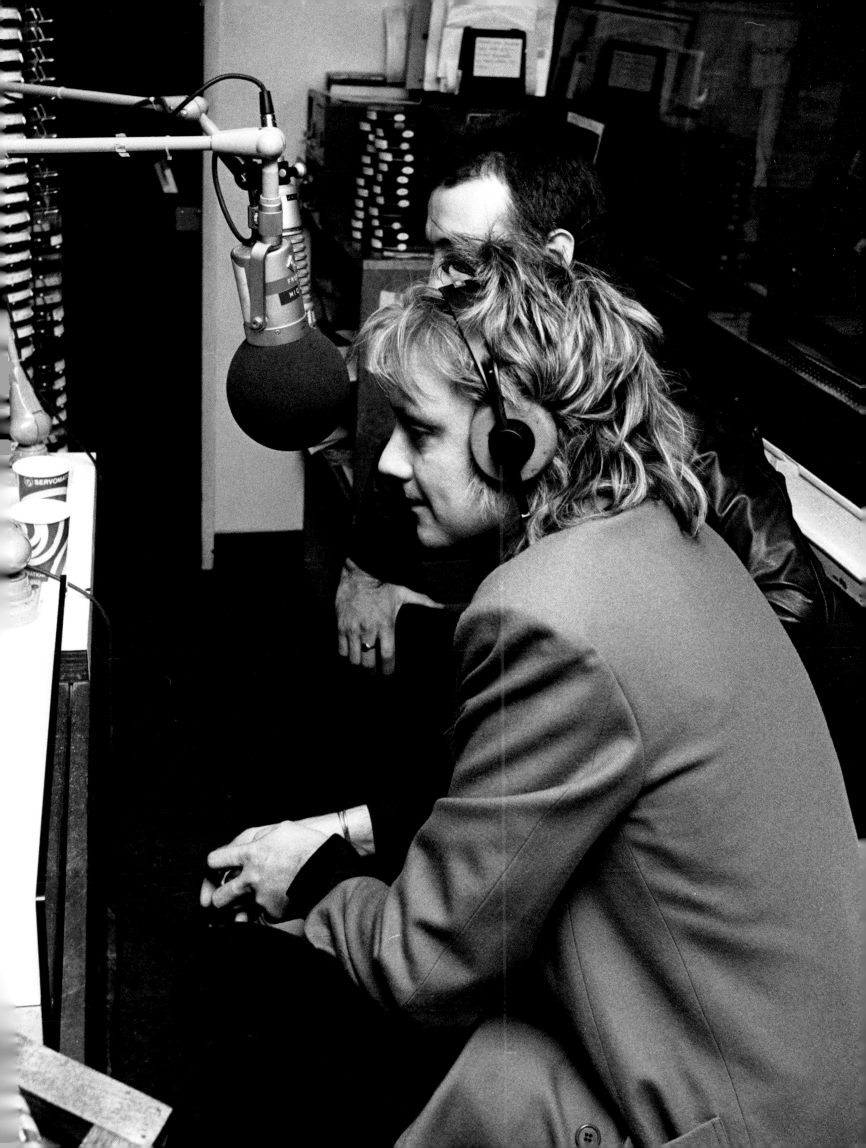

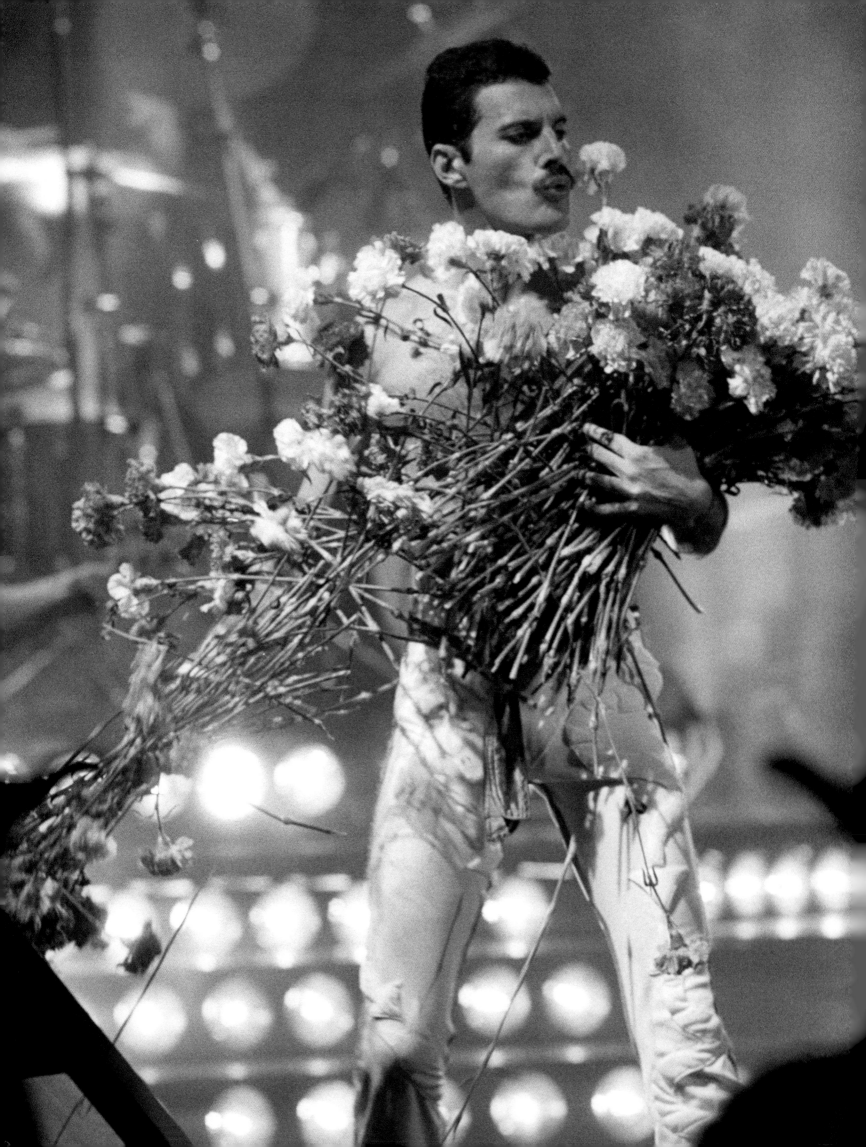

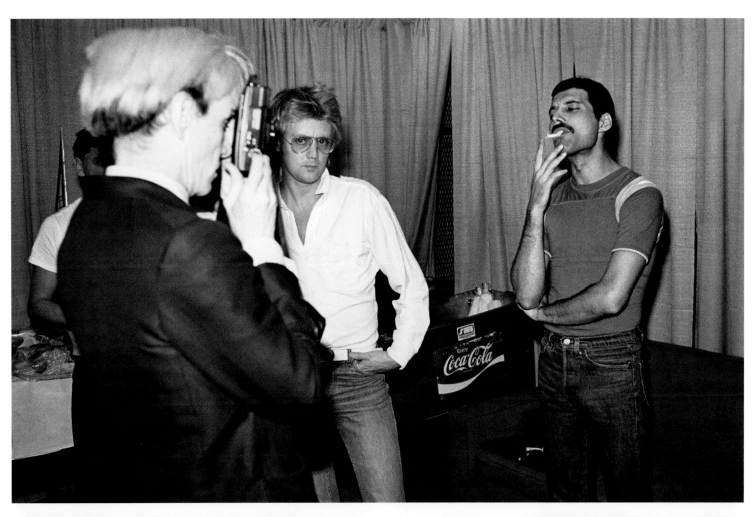

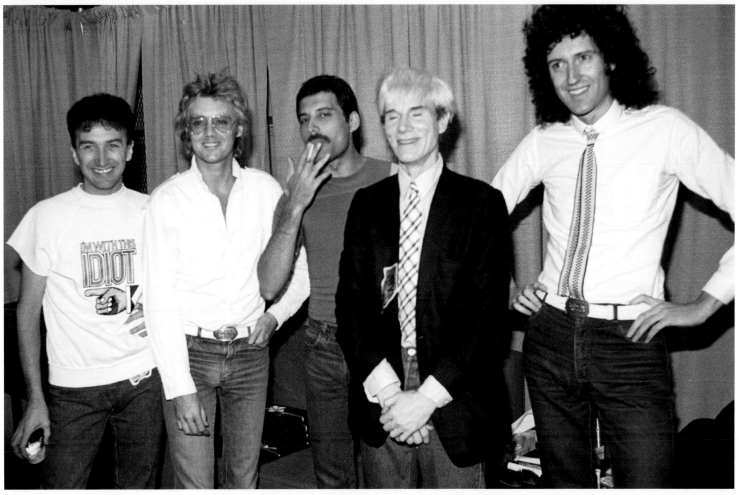

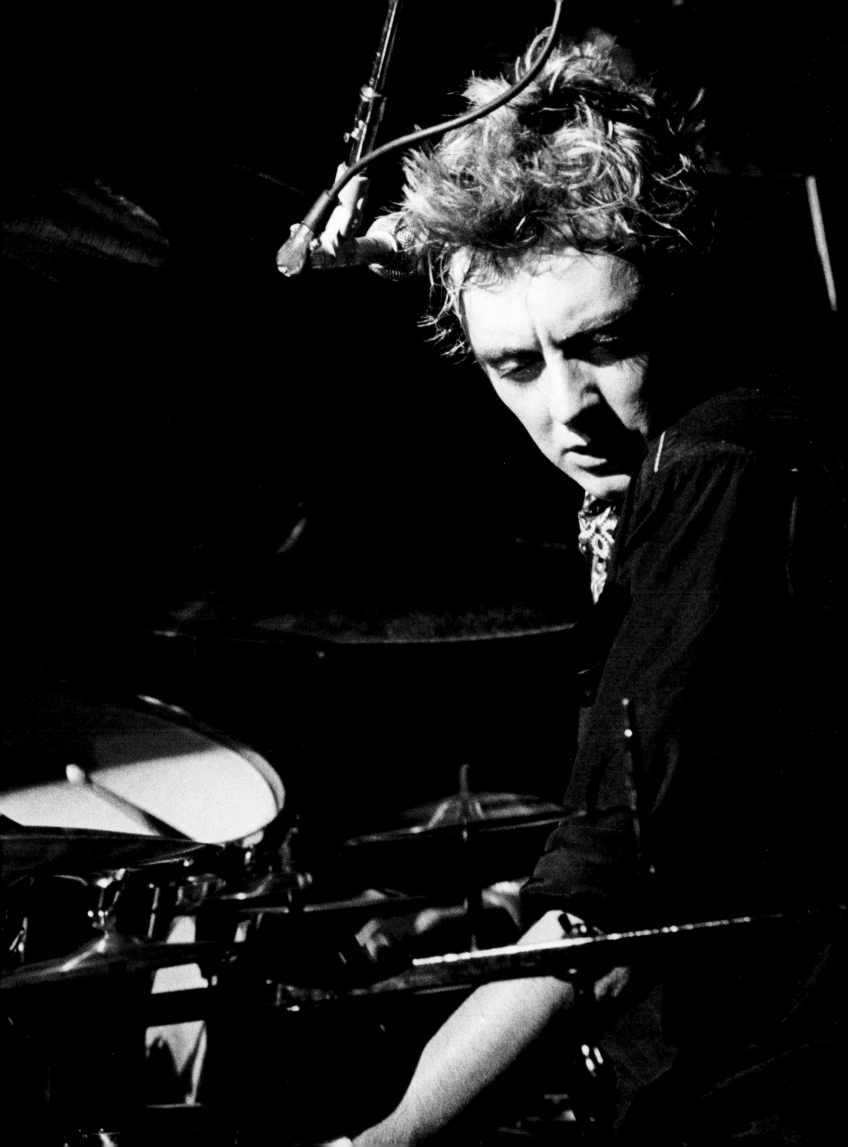

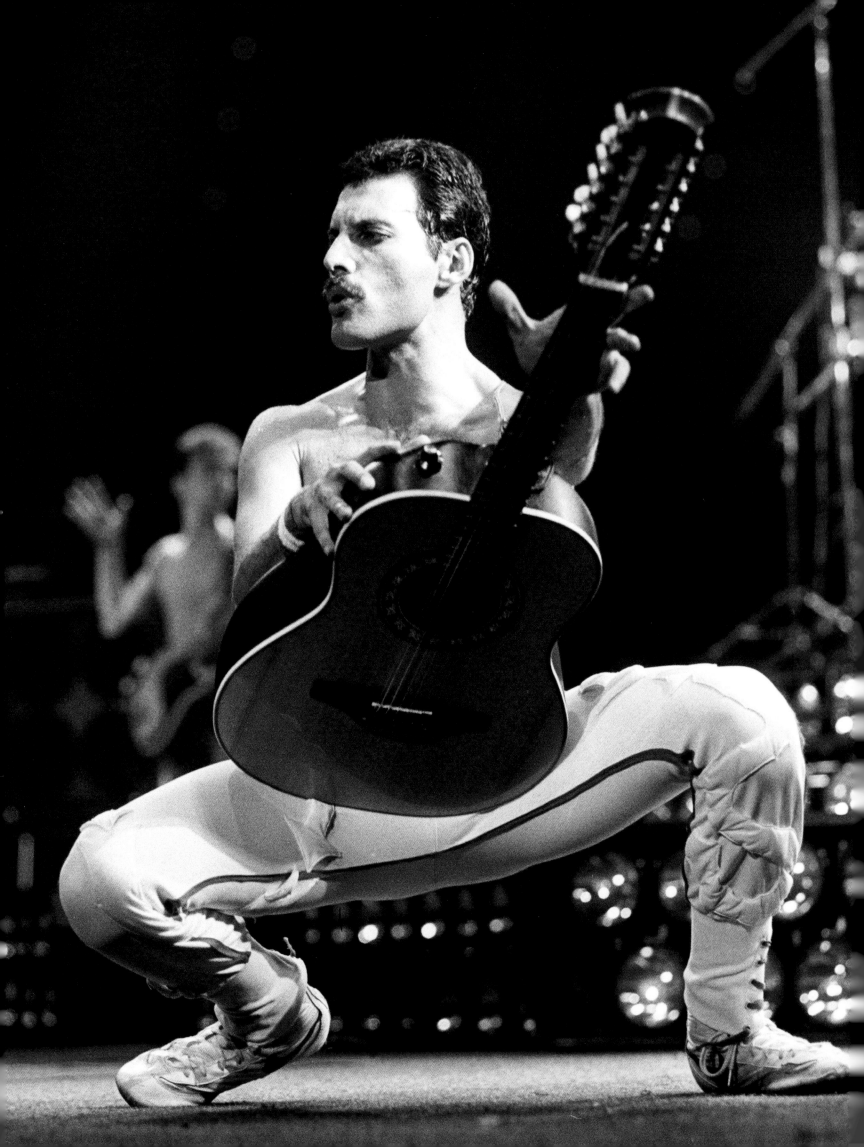

241

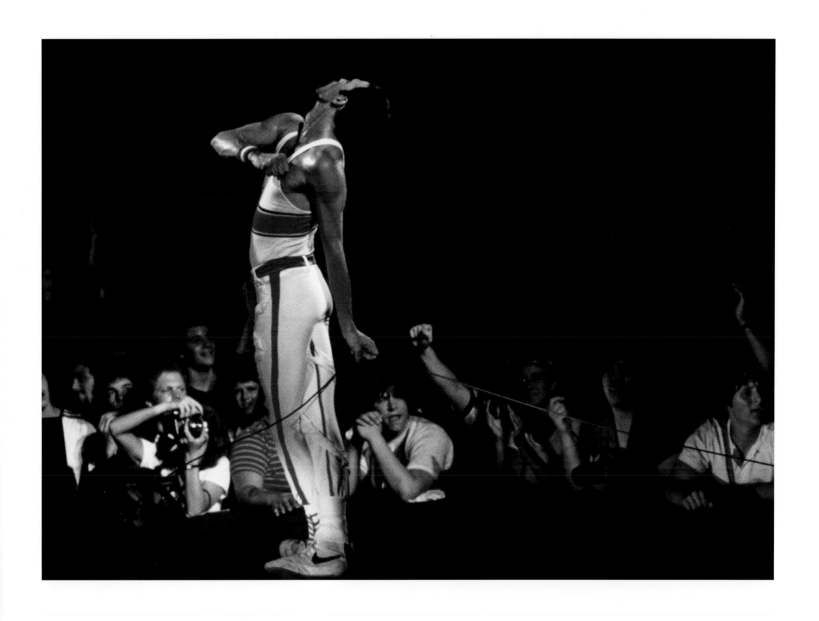

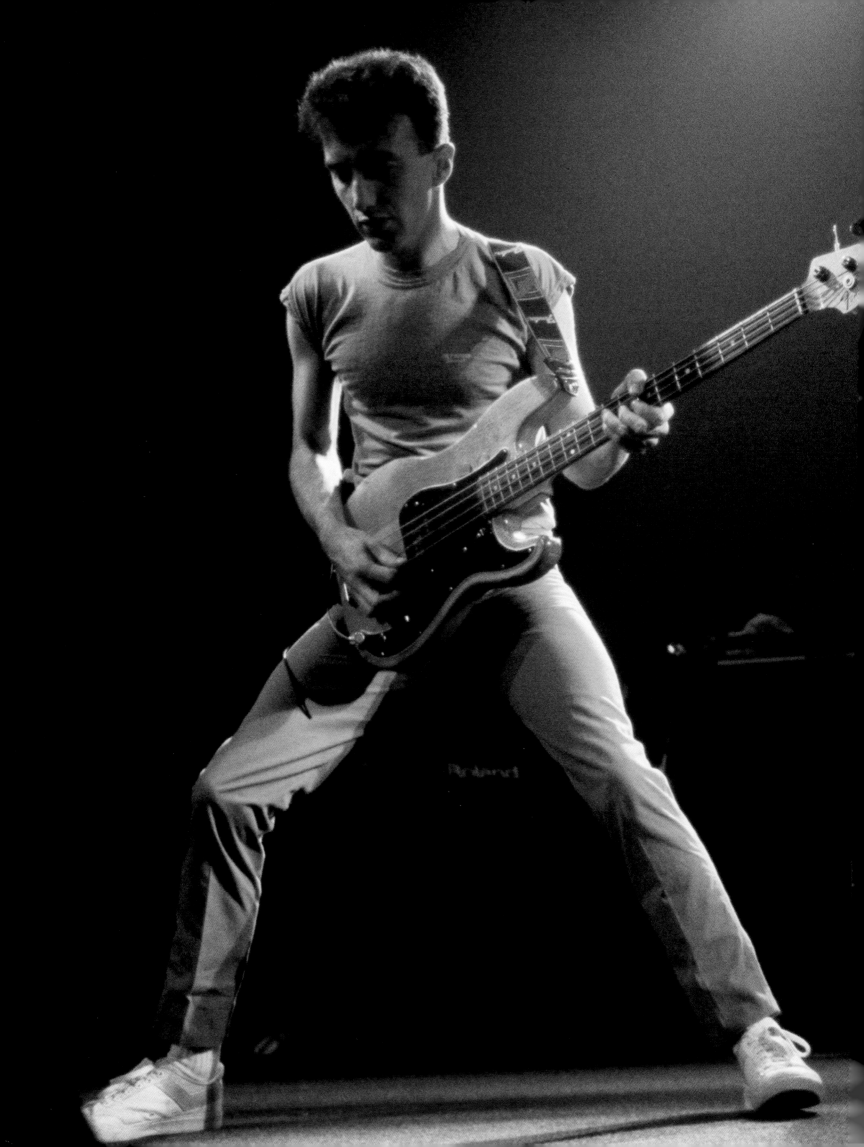

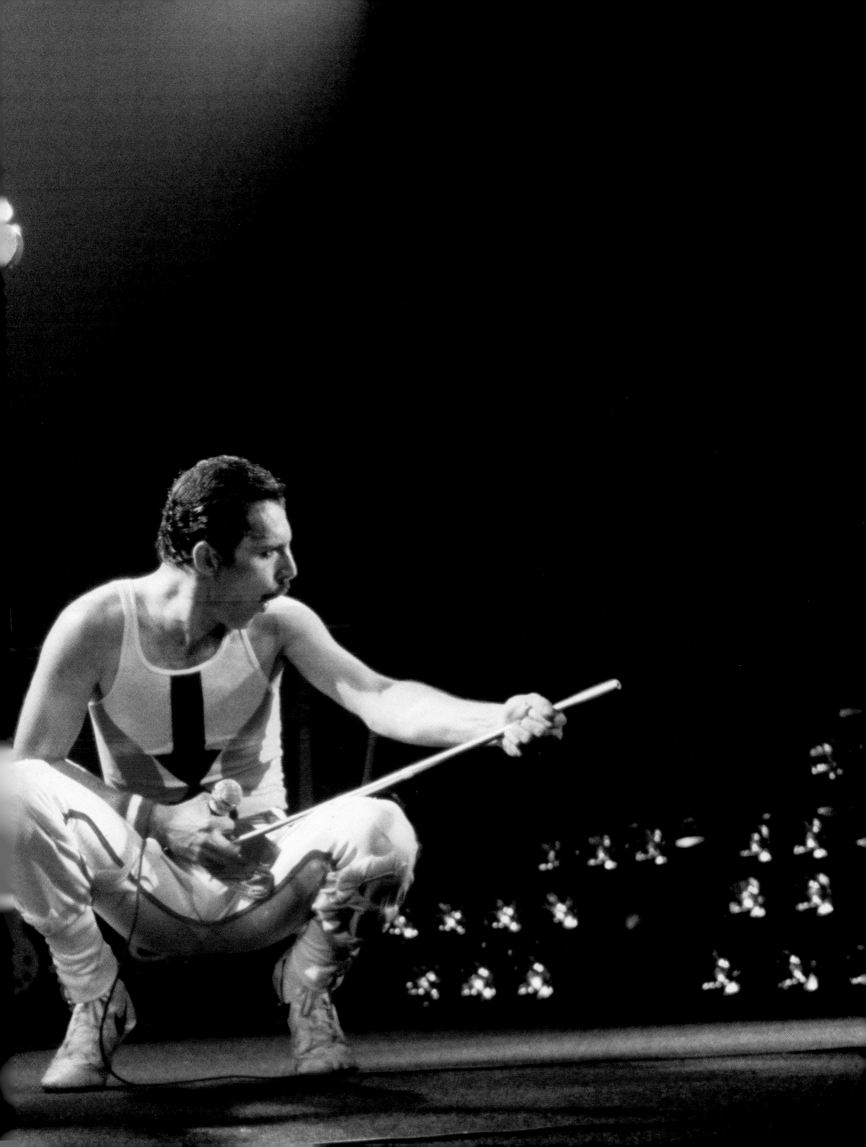

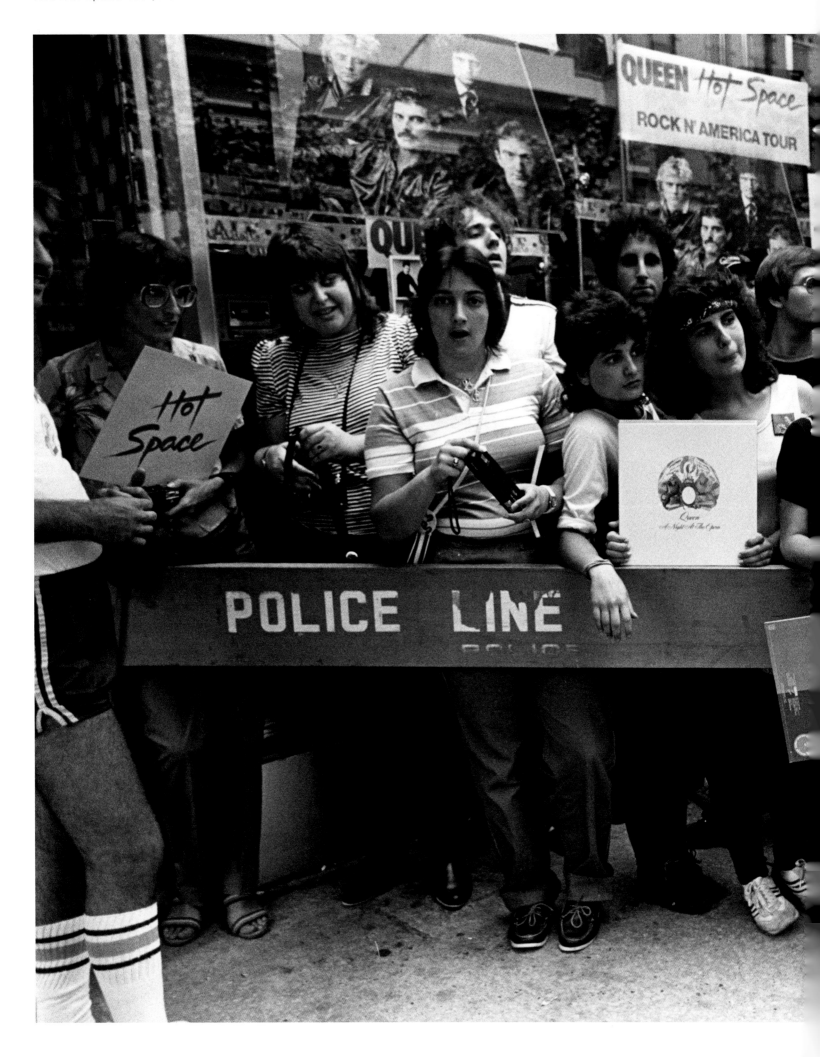

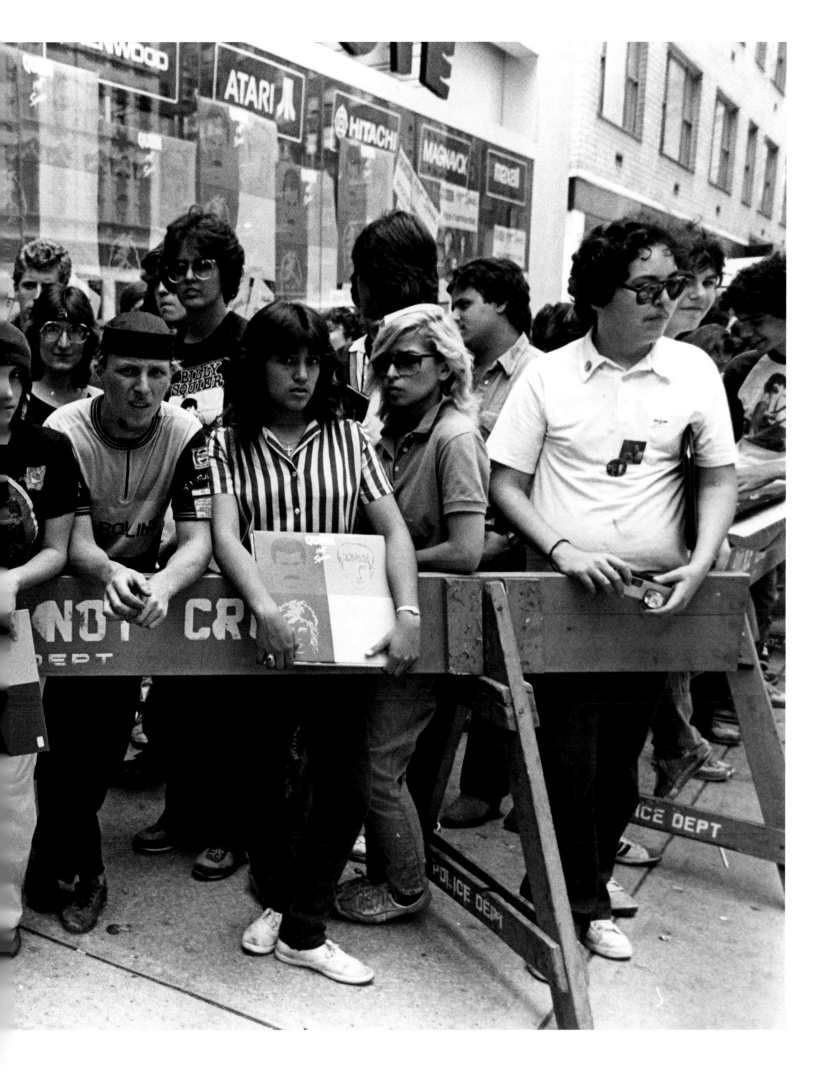

246

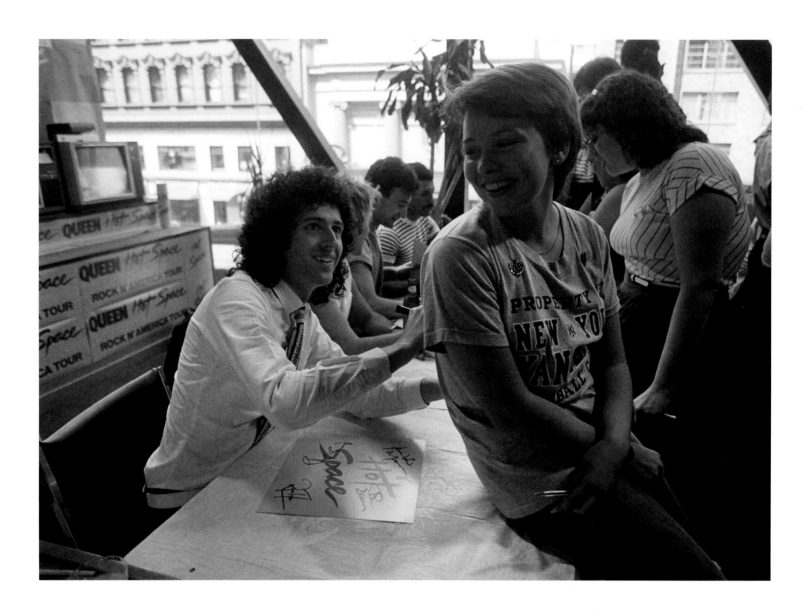

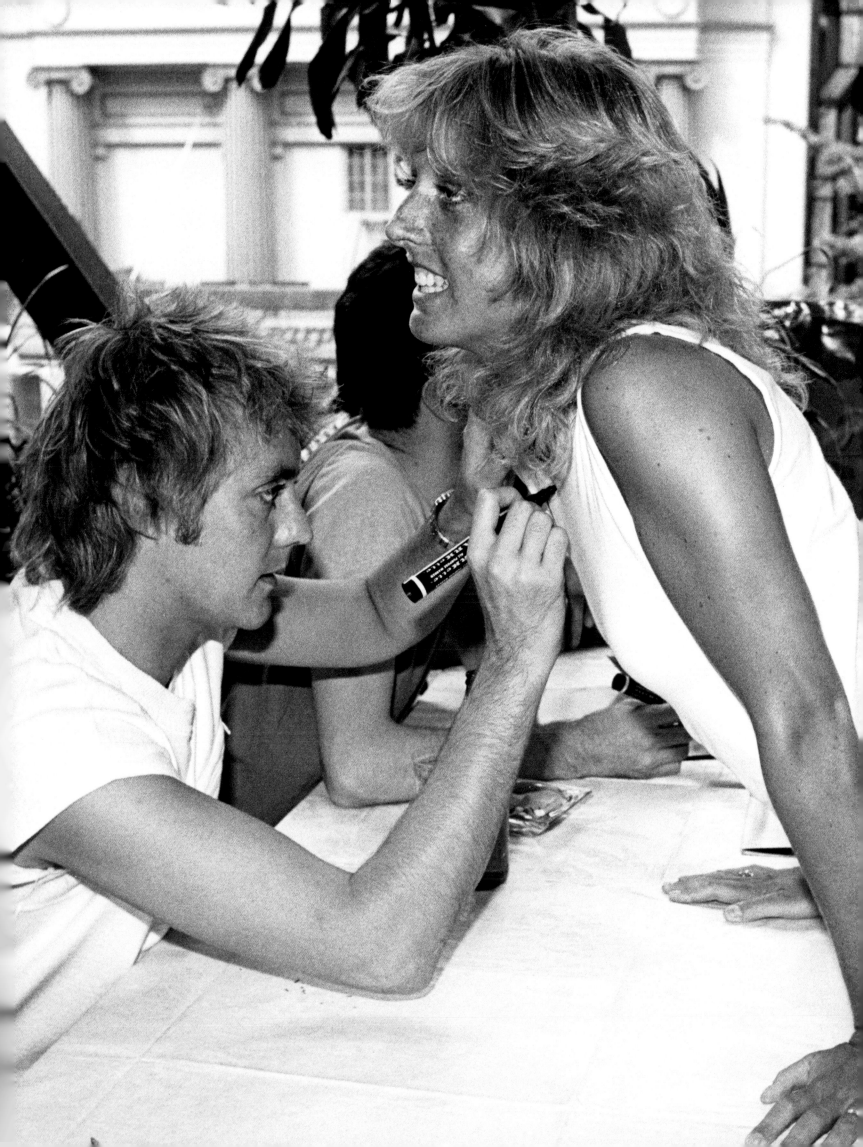

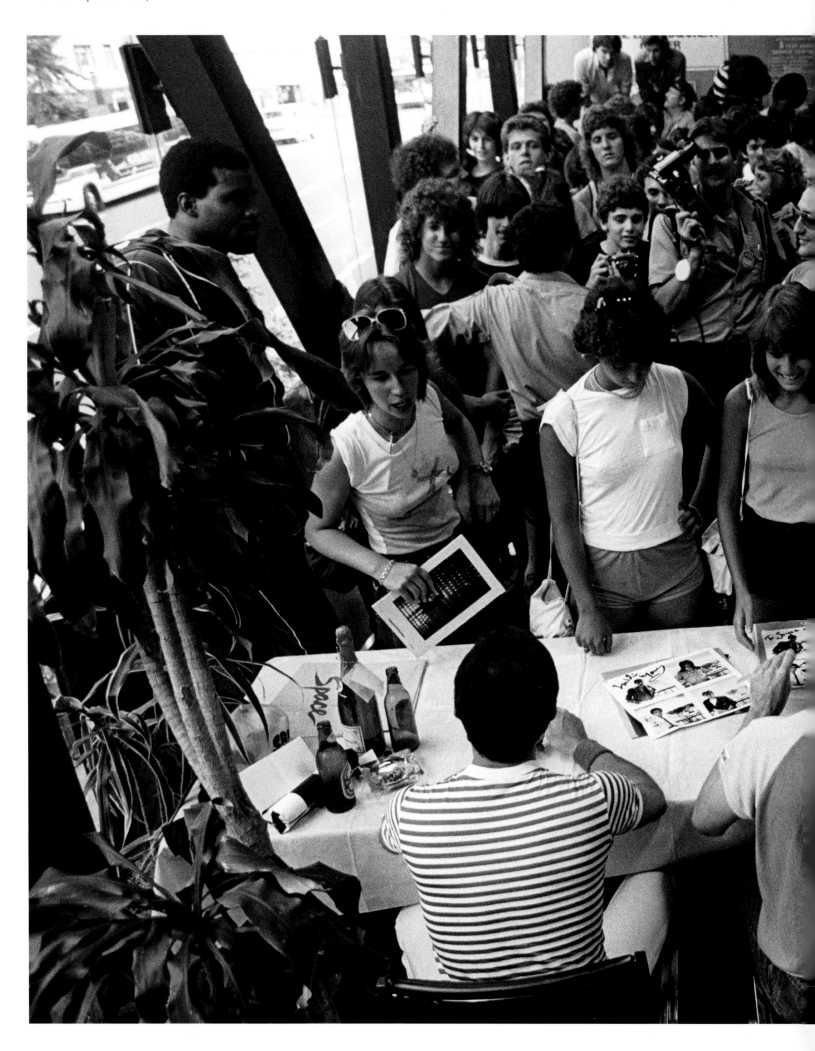

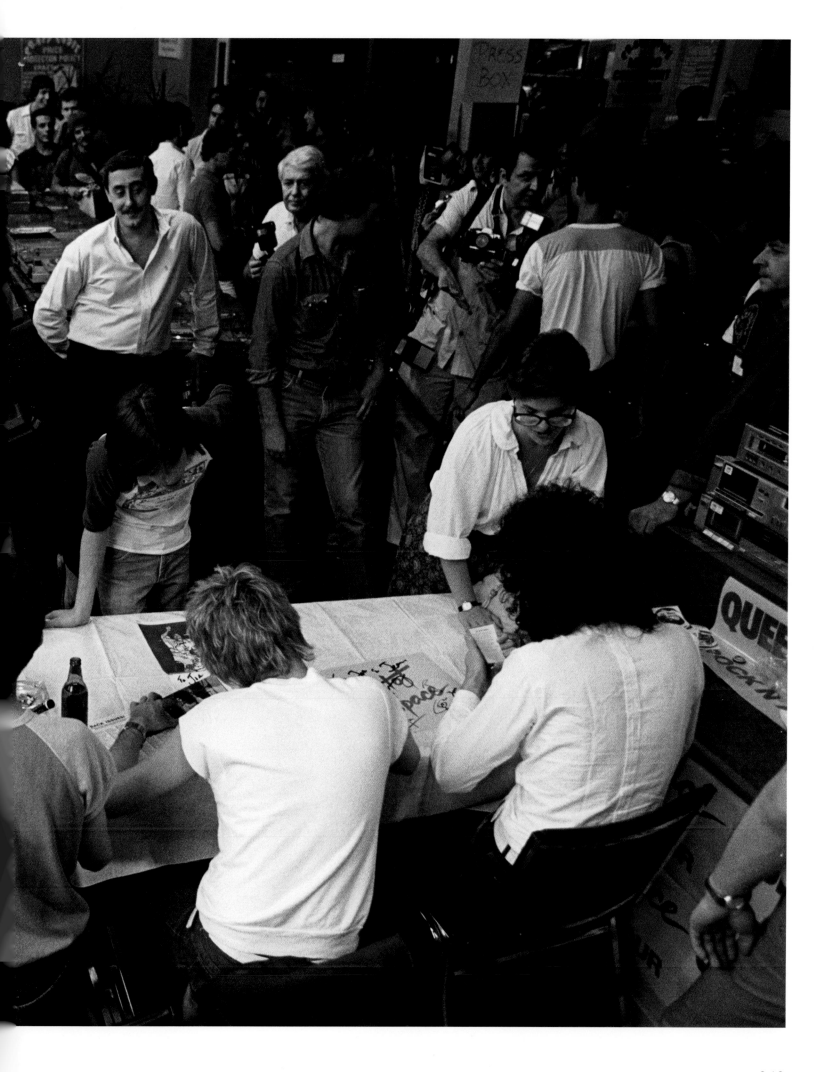

Live Aid, 1985

13 July – Wembley Stadium, London, UK

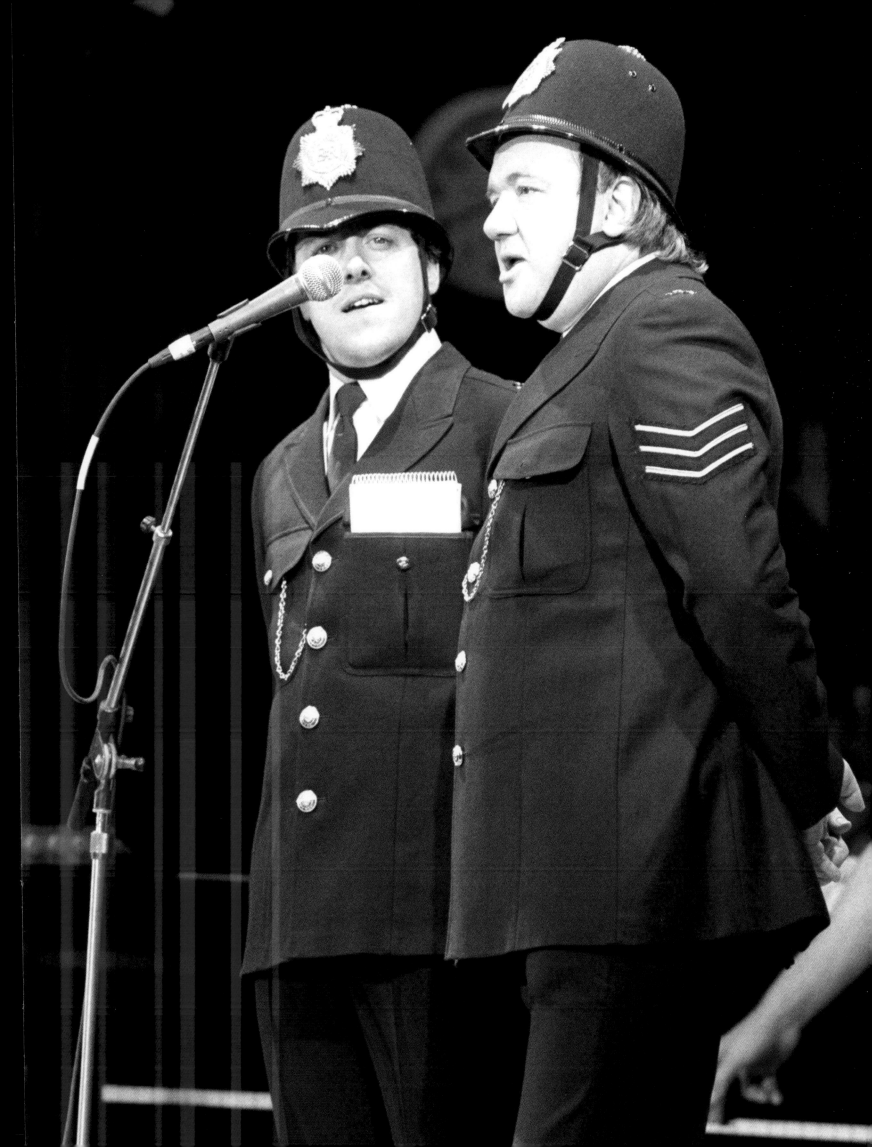

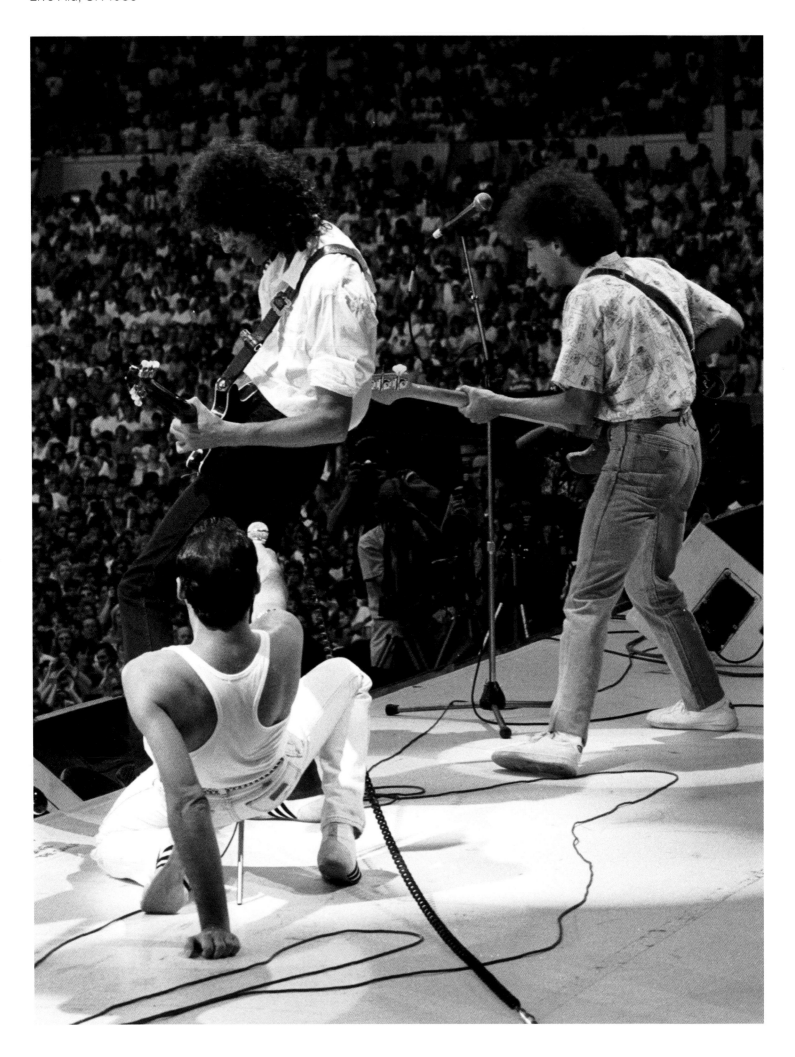

I had been in England for a couple of weeks working on Bruce Springsteen's *Born in the USA* tour when the Live Aid shows were announced. Since I was already holed up at the Mayfair Hotel in London, I was able to secure the gig (thanks to Harvey Goldsmith) as the official American photographer at the British Live Aid show. Now keep in mind, these big stadium gigs with multiple artists that are put together to benefit a particular charity are not in any way, shape or form a real rock show. They are TV shows, plain and simple. The TV producers run the show. Get the talent on, get 'em off, five songs each, blah, blah, blah. They're just huge televised rock gangbangs.

Shooting one of these shows presents a certain kind of problem. After a while all you're doing is running film through the camera, with no real thought as to what you're shooting. If it's on stage, shoot it. If it's backstage, shoot it, if it's a topless girl in the audience, shoot it, if it's some guitarist tuning up in the wings, shoot it. You're constantly chasing the next photograph, when ideally it should come to you. You can amass an extremely large bag of exposed film that way. When I got back to the hotel I counted 95 rolls.

From the moment the show began I was trying to be in two places at once. When I was shooting whoever was onstage I'd run a couple of rolls through my cameras and then tear ass backstage. Most of the first few bands sounded like canned polka music to me. Honestly, it sounded like one big snoozeathon. U2 took the stage and at least there was finally some excitement . . . then Dire Straights followed them and I decided to take a bit of a break and snuck under the stage for a few minutes to just sit and catch my breath. As luck would have it, I ran into Gerry Stickells, who had just taken the Queen boys up the stairs on the other side of the stage from where I had been sitting. He literally picked me up, dragged me up the stairs and put me right in the back of Brian's amps. "Do what you want—and watch out for the blokes holding the TV cables," he hollered to me.

Suddenly it no longer seemed like a big TV show. It felt like I was home. My band, my crew, home sweet home. I didn't realize until their set was over that I was the only photographer on stage with them.

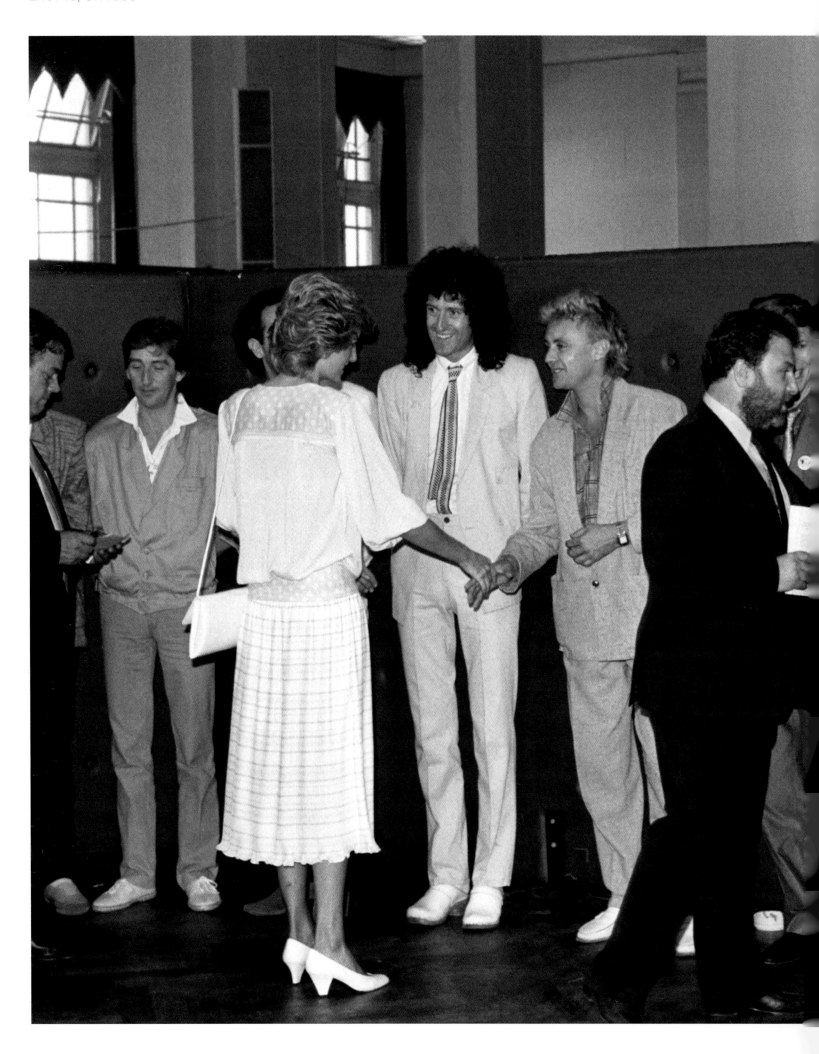

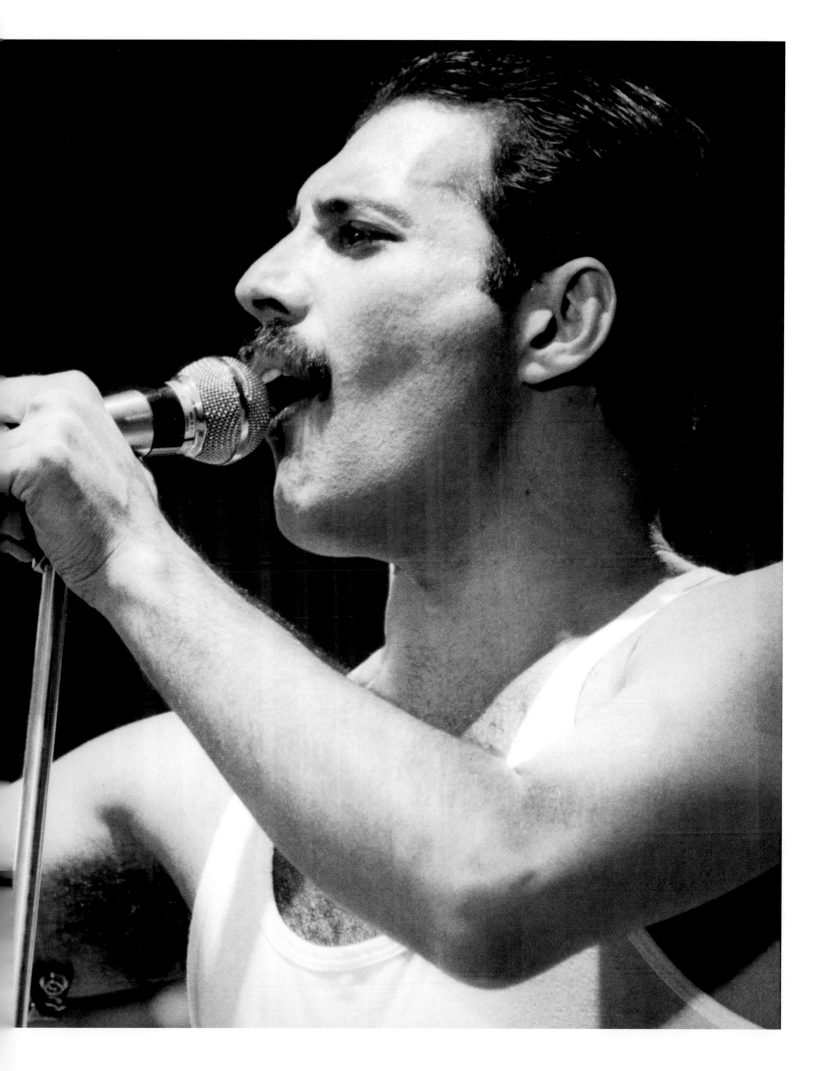

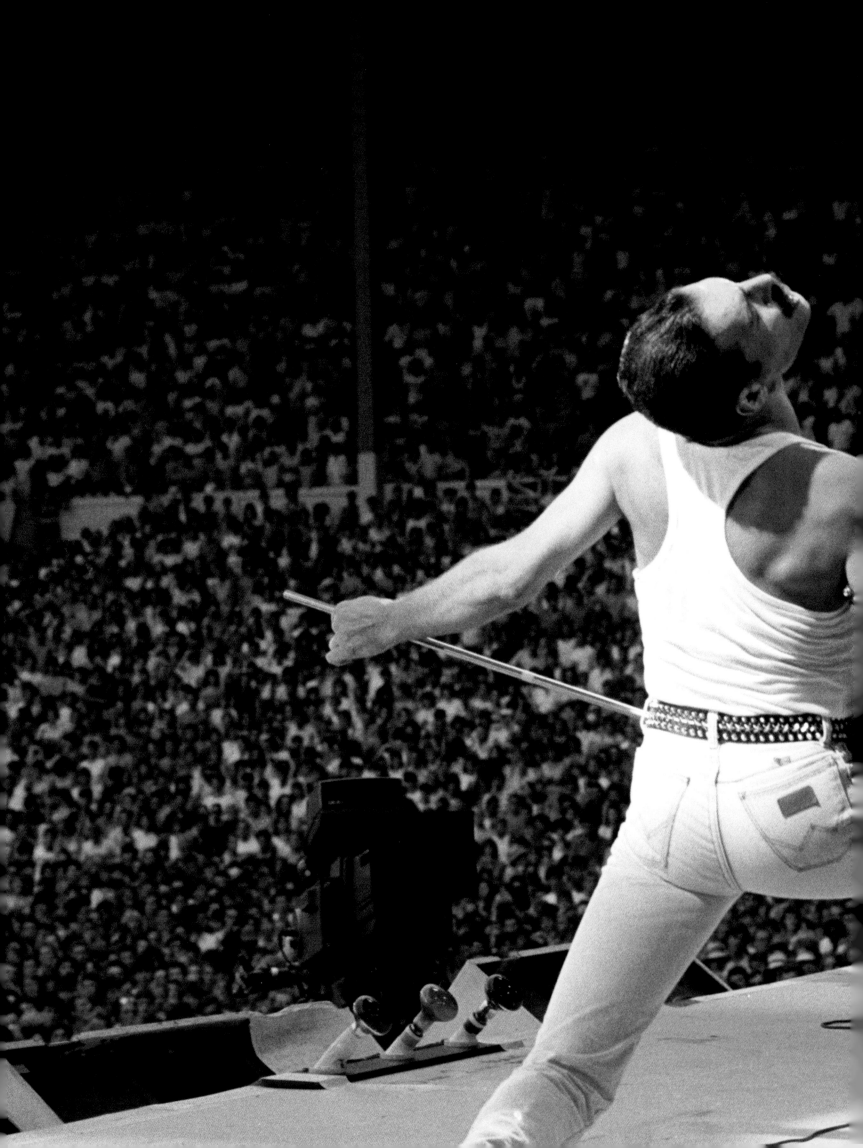

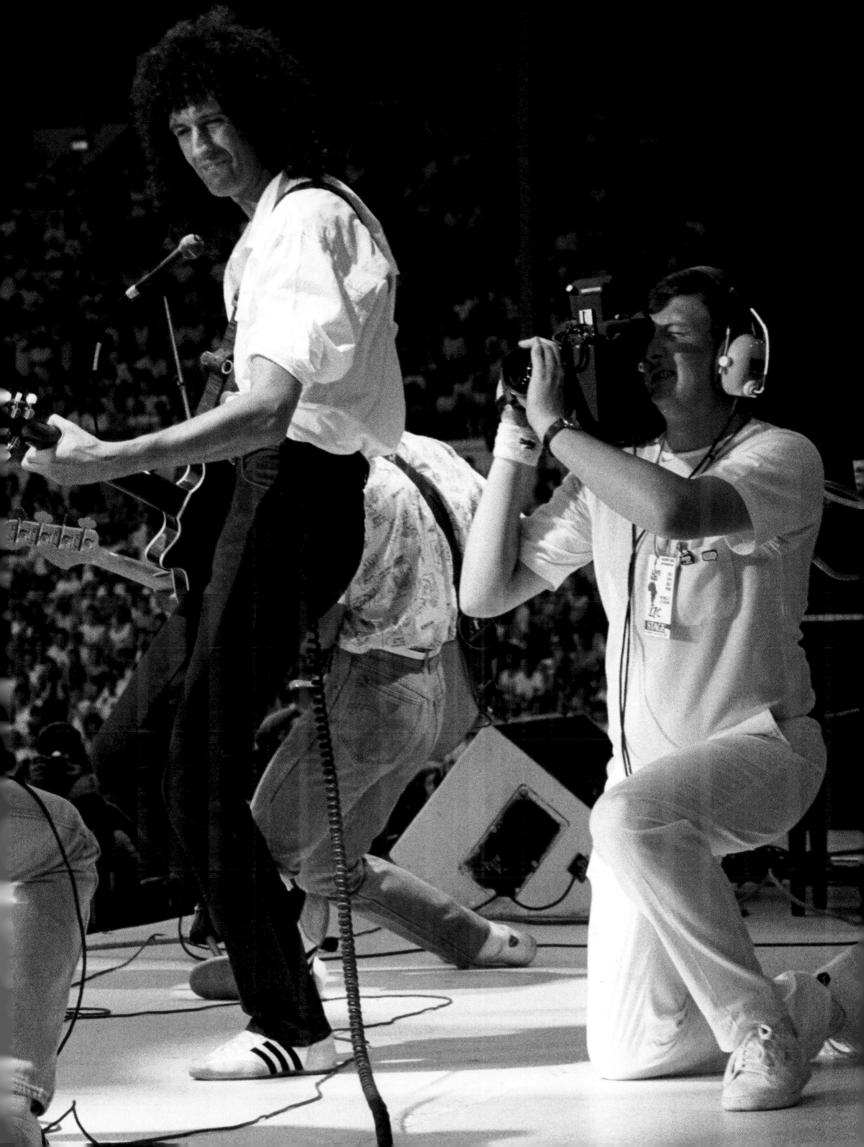

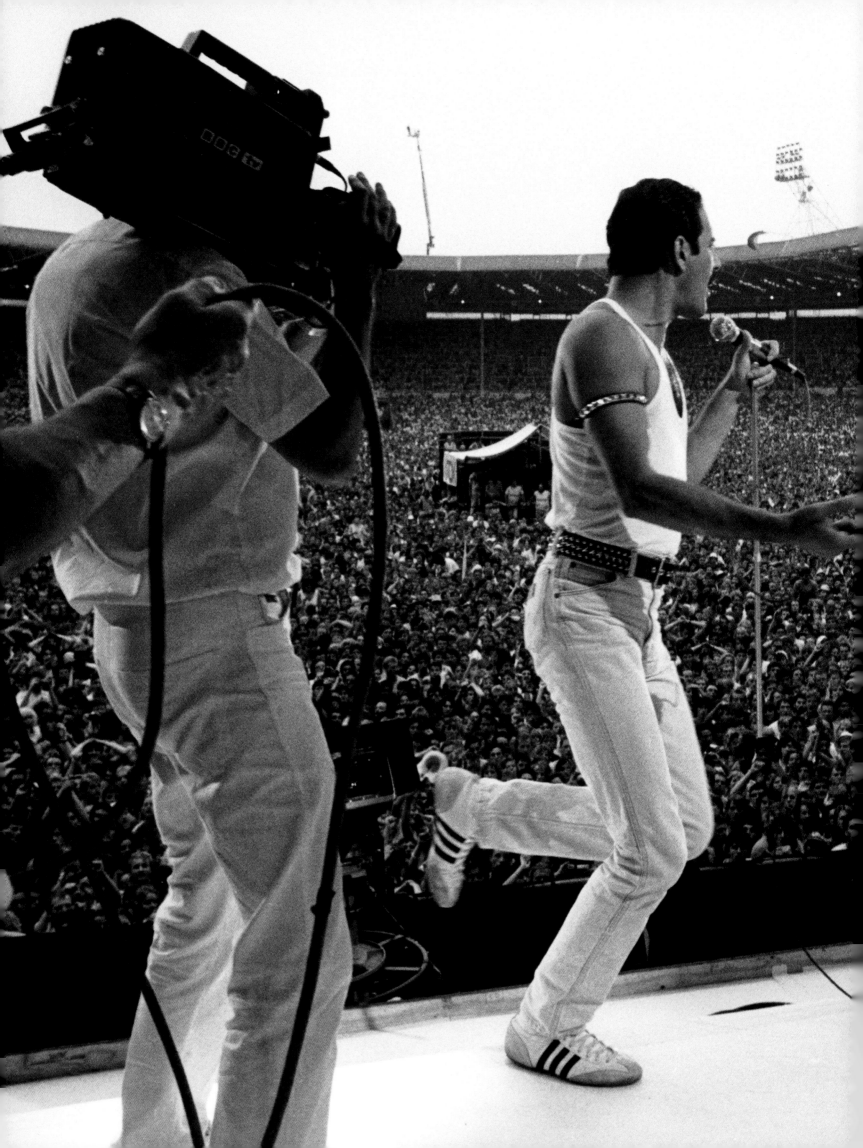

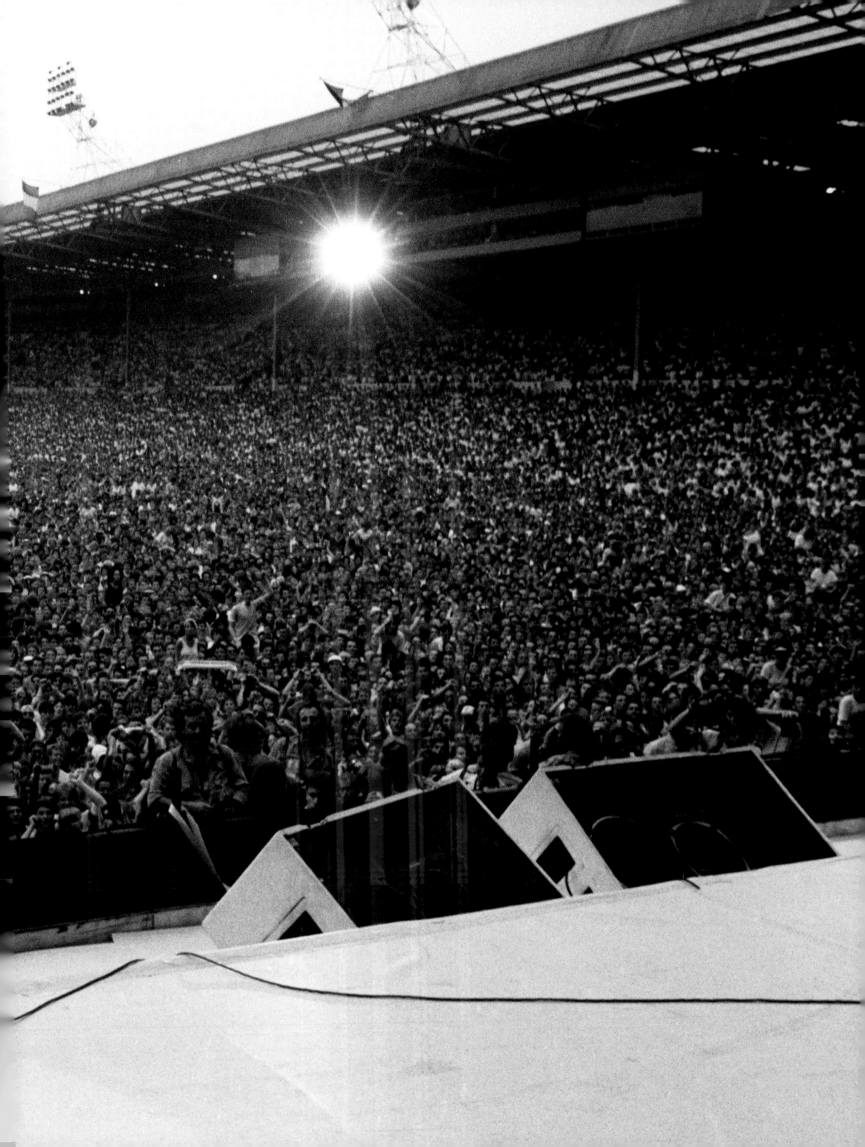

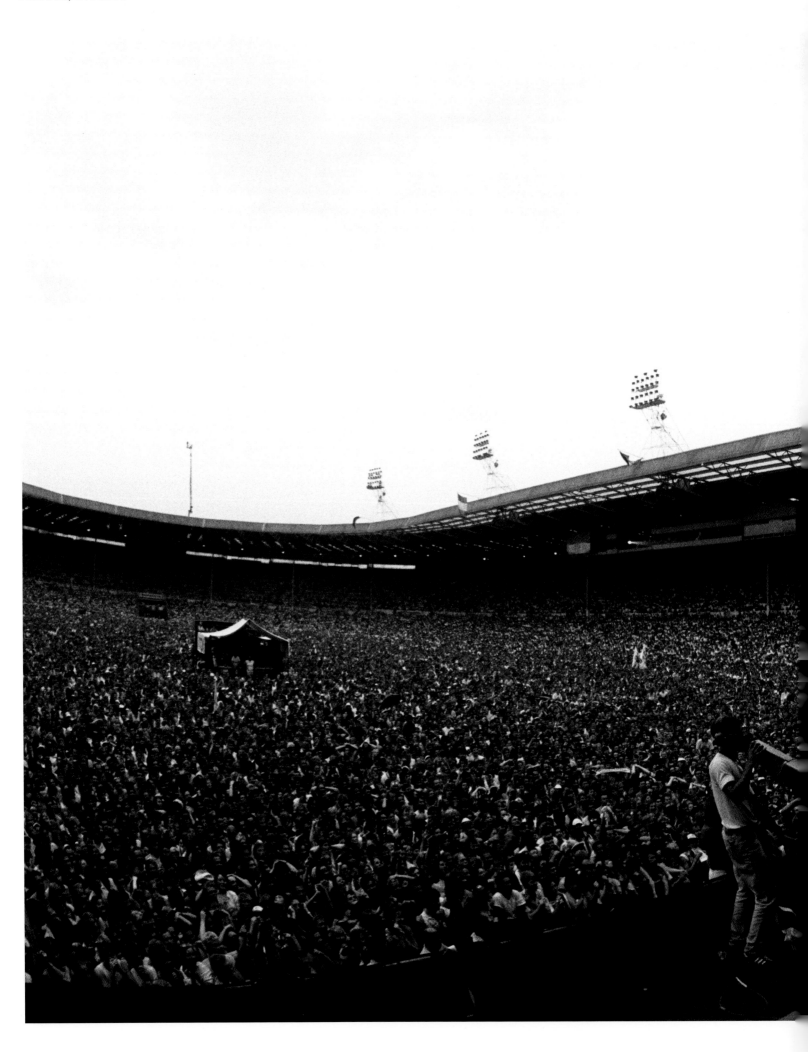

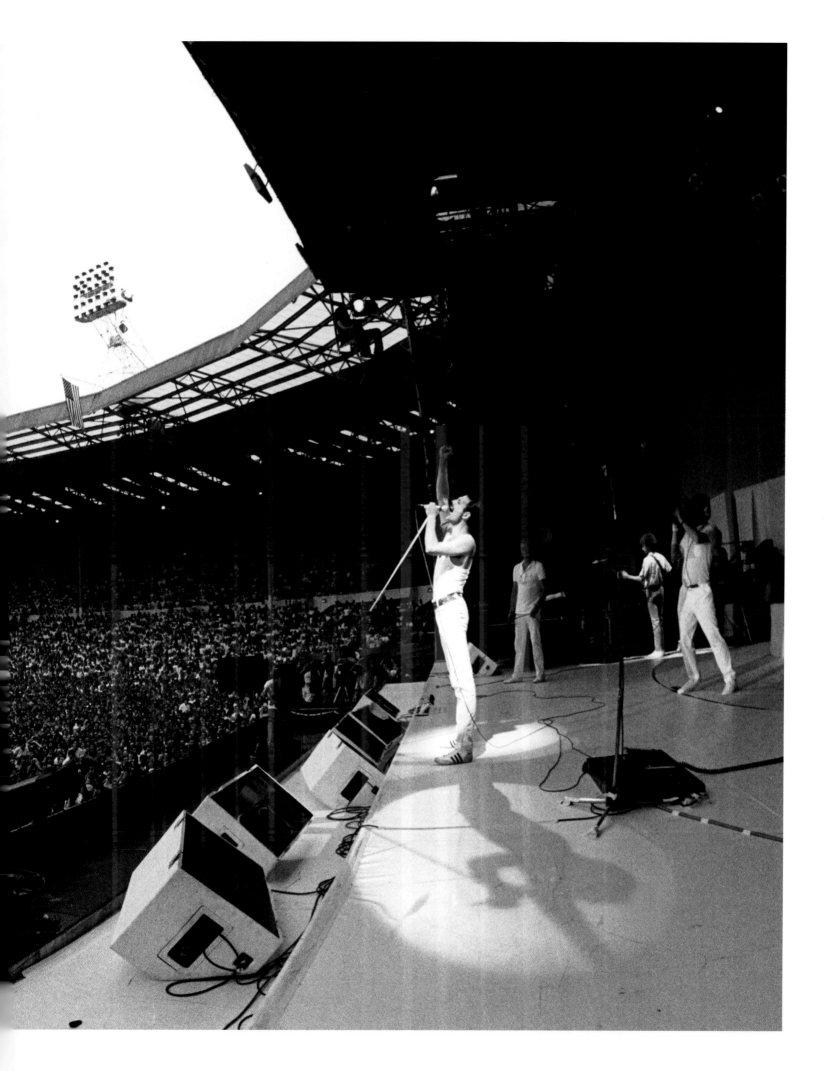

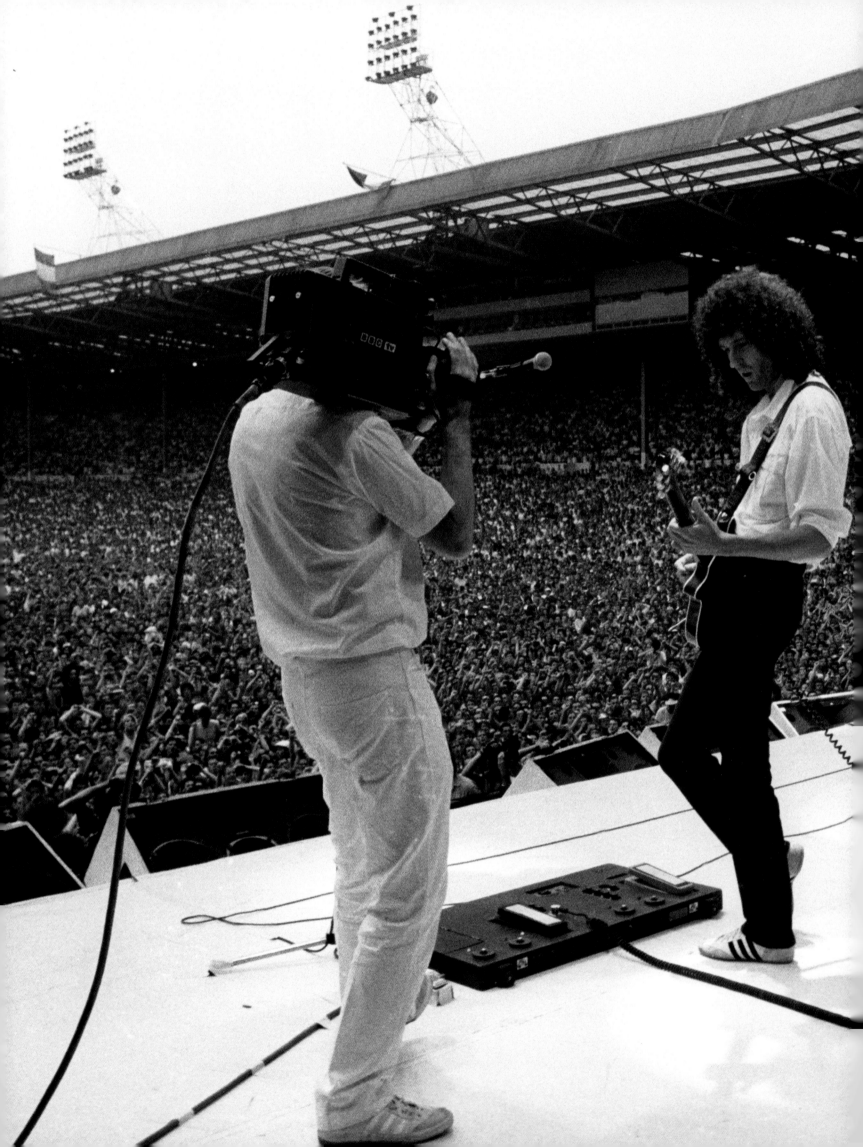

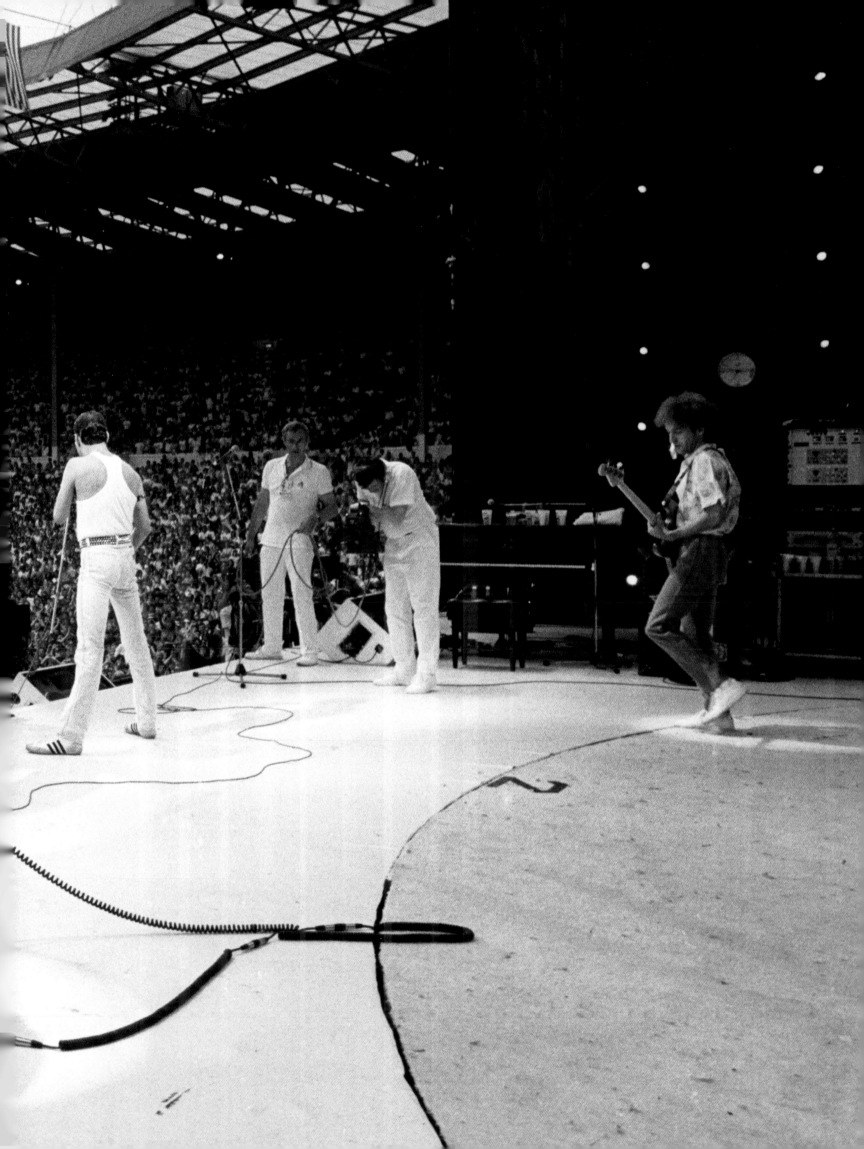

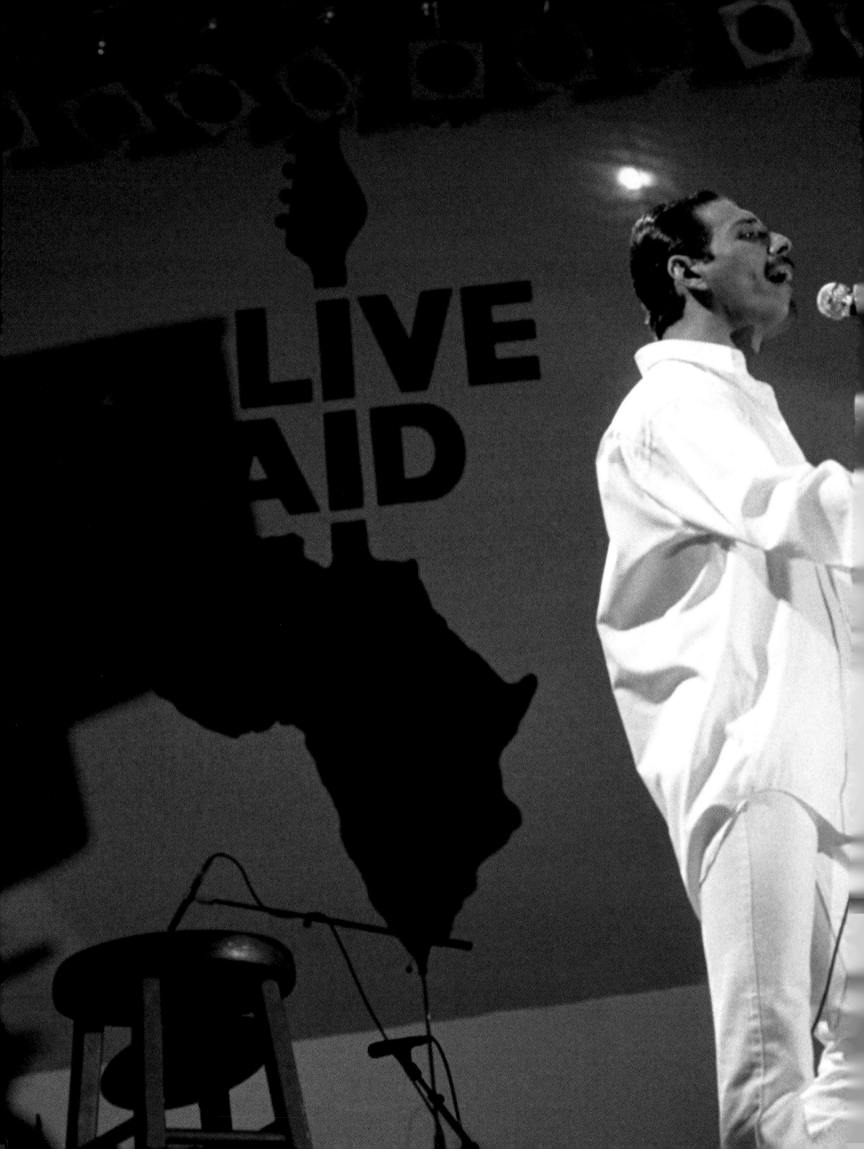

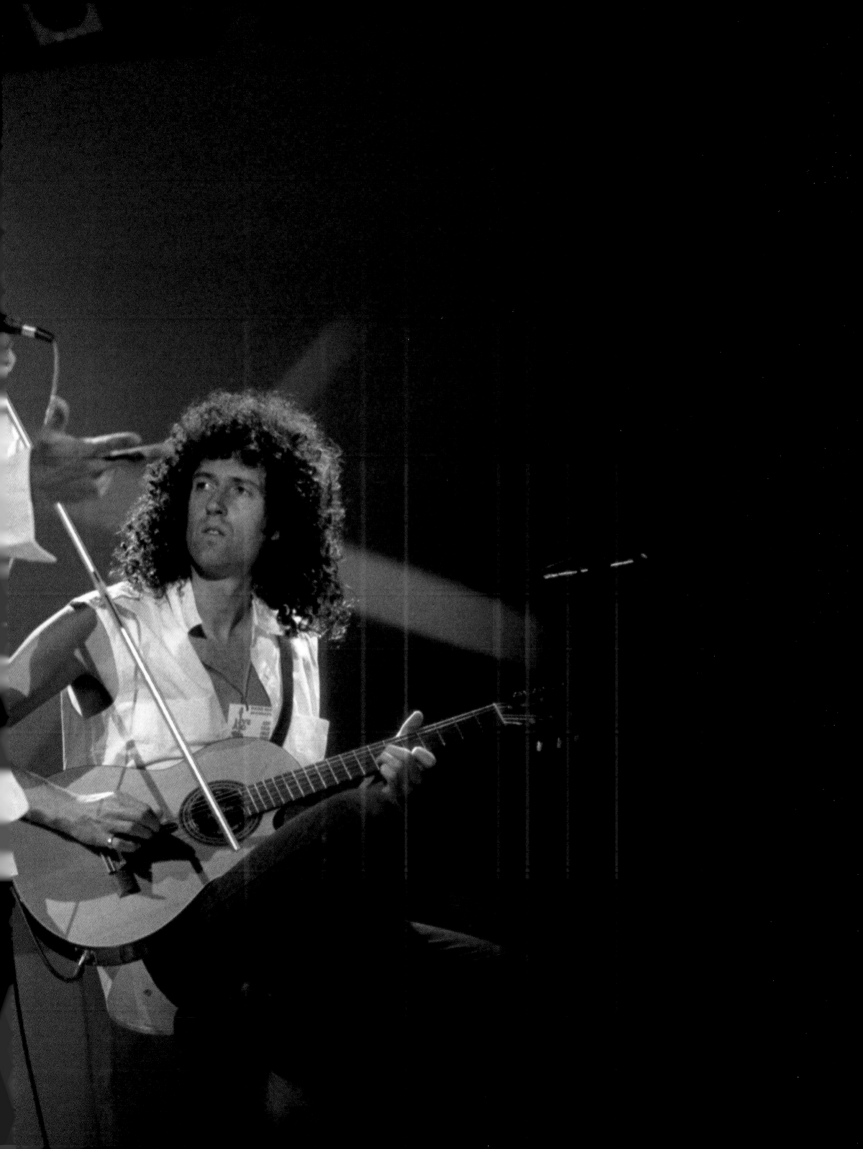

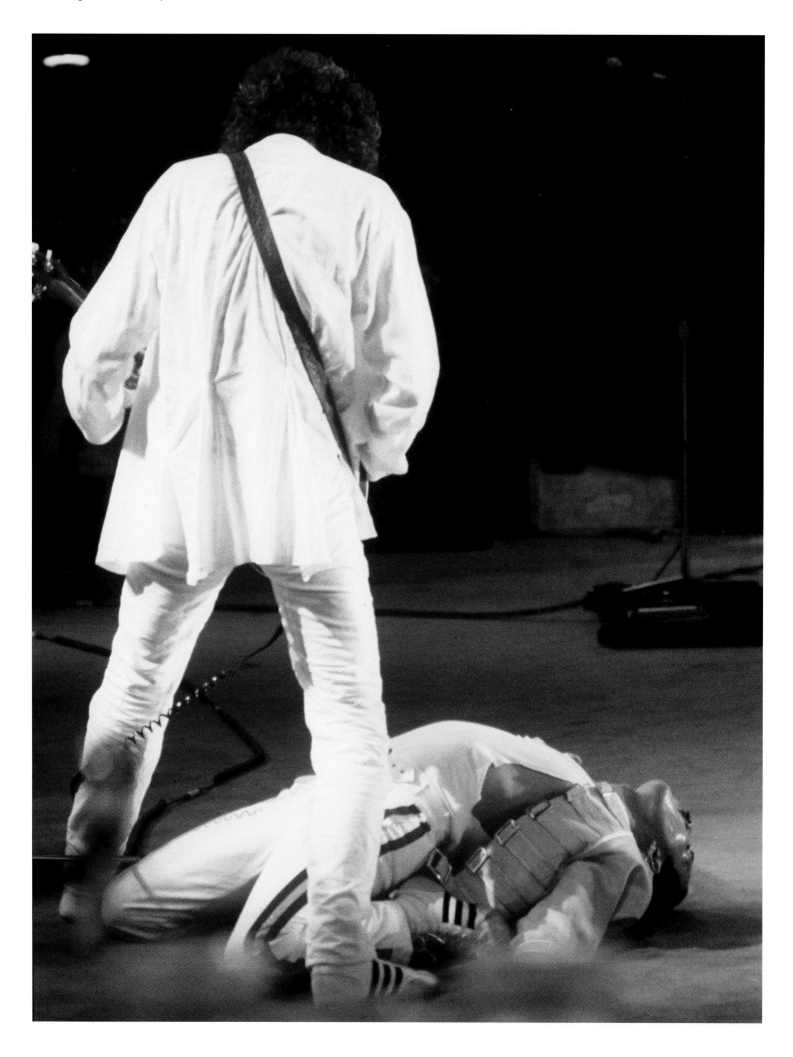

The Magic Tour, Europe 1986

07 June – Råsunda Fotbollsstadion, Stockholm, Sweden
11 June – Groenoordhallen, Leiden, The Netherlands
12 June – Groenoordhallen, Leiden, The Netherlands
14 June – Hippodrome de Vincennes, Paris, France
17 June – Forest National, Brussels, Belgium
19 June – Groenoordhallen, Leiden, The Netherlands
21 June – Maimarktgelände, Mannheim, Germany
26 June – Waldbühne, Berlin, Germany
28 June – Olympiahalle, Munich, Germany
29 June – Olympiahalle, Munich, Germany
01 July – Hallenstadion, Zürich, Switzerland
02 July – Hallenstadion, Zürich, Switzerland
05 July – Slane Castle, Slane, County Meath, Ireland
09 July – St. James Park, Newcastle, UK
11 July – Wembley Stadium, London, UK
12 July – Wembley Stadium, London, UK
16 July – Maine Road, Manchester, UK
19 July – Müngersdorfer Stadion, Cologne, Germany
21 July – Stadthalle, Vienna, Austria
22 July – Stadthalle, Vienna, Austria
27 July – Népstadion, Budapest, Hungary
30 July – Amphithéâtre, Fréjus, France
01 August – Mini Estadi, Barcelona, Spain
03 August – Rayo Vallecano, Madrid, Spain
05 August – Estadio Municipal, Marbella, Spain
09 August – Knebworth Park, Stevenage, UK

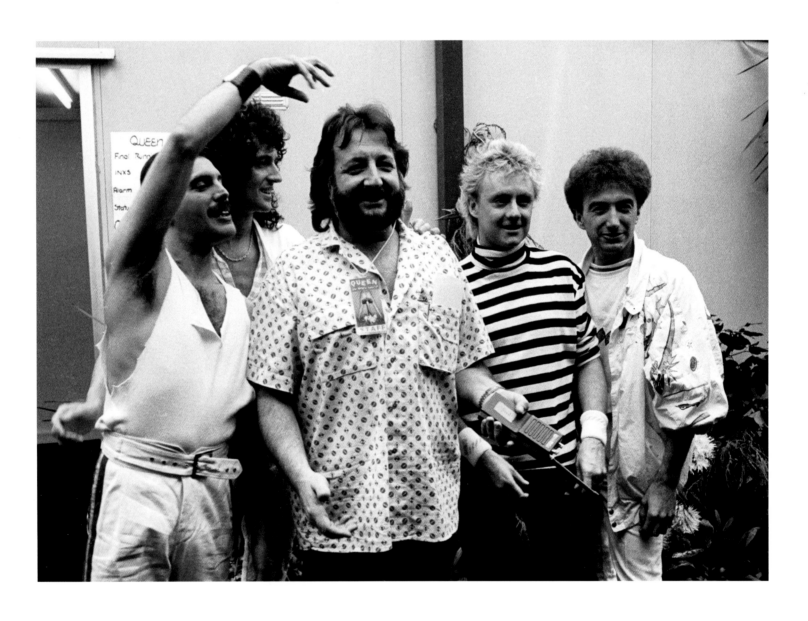

Queen's brief performance at Live Aid had captivated the entire world and the following year Freddie, Roger, John and Brian set out to prove that Live Aid was not an anomaly. In 1986 Queen roared back with a vengeance.

I'd always felt that musically the band had been way ahead of its time, and I think I was right . . . it just took until 1986 for the world to catch up.

The UK dates were going to be beyond memorable; they were going to be their best ever. I had never seen the band fail to rise to an occasion. The bigger the show, the better they were. I flew over to photograph the biggest shows—Slane Castle and Wembley.

I had been to Slane the year before with Bruce Springsteen so I was familiar with the lay of the land there. And just like the year before, there were some of the most drunken rock fans I'd ever seen in my life at any show. Those people were world-class drinkers. They put the Russian fans at Billy Joel's USSR shows to shame.

The Slane gig was great but the first Wembley show was the crown jewel. It really hit me that this was not the band I'd shot in 1976 in Santa Monica. This band was another animal altogether. They were mammoth.

Before the first show I went up in a chopper to take some aerial shots and from 4,000 feet up it looked like a million fans had packed the place. There was always something about Wembley Stadium that felt larger than life. It looked and felt completely different from any stadium in the States or anywhere else.

Wembley was also one of my favorite places to shoot. I used to call it one of my three or four "good luck" venues (the others being, in no particular order, the Forum, Madison Square Garden, and the Omni in Atlanta). I knew I was gonna have a good day—and I did. The fourth frame I shot during that show has become one of the most well-known rock photos in history—Freddie Mercury bending as far back as possible in the center of the frame with the entire Wembley crowd as his backdrop. It's a photograph I'm very proud of . . . and, like all great photographs, it will live forever.

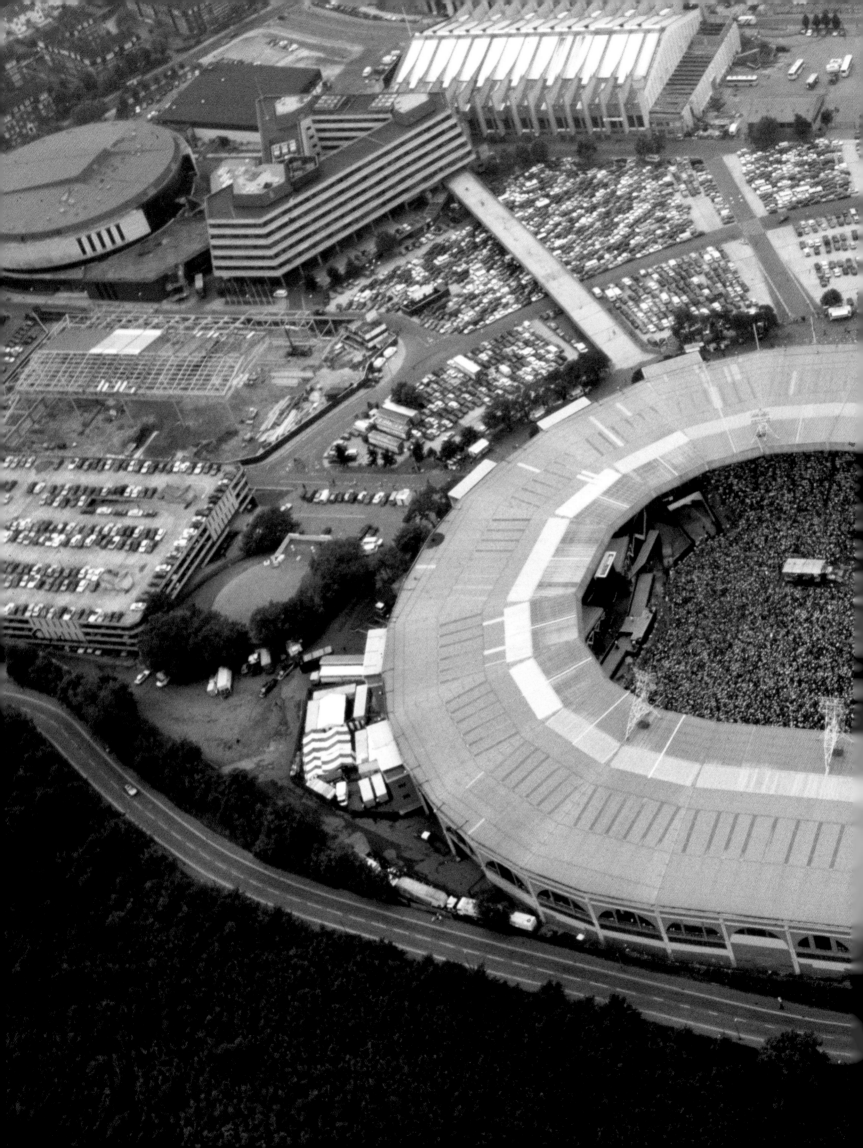

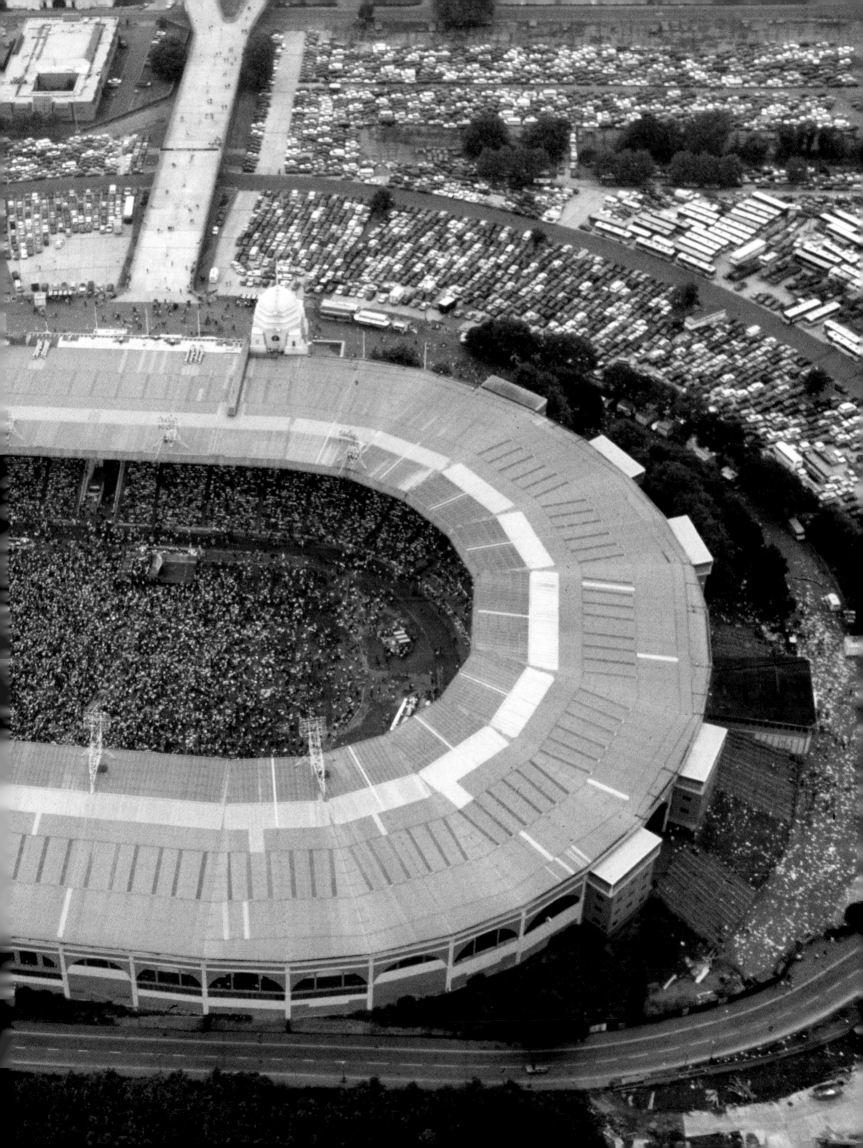

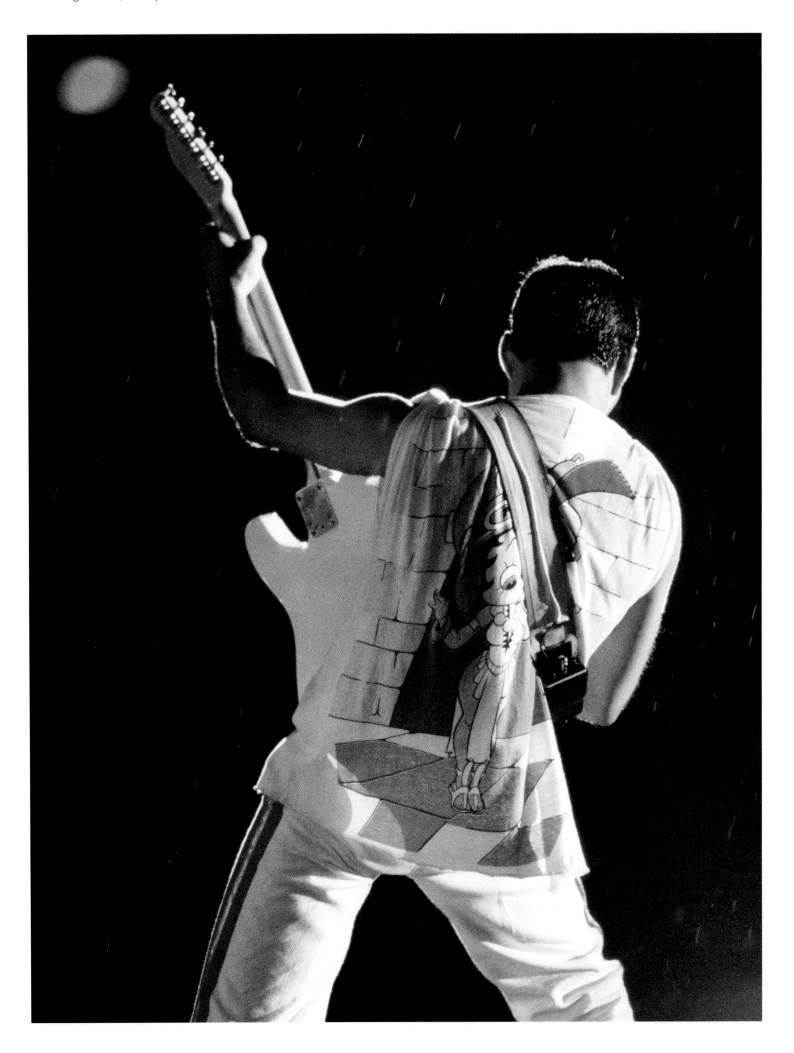

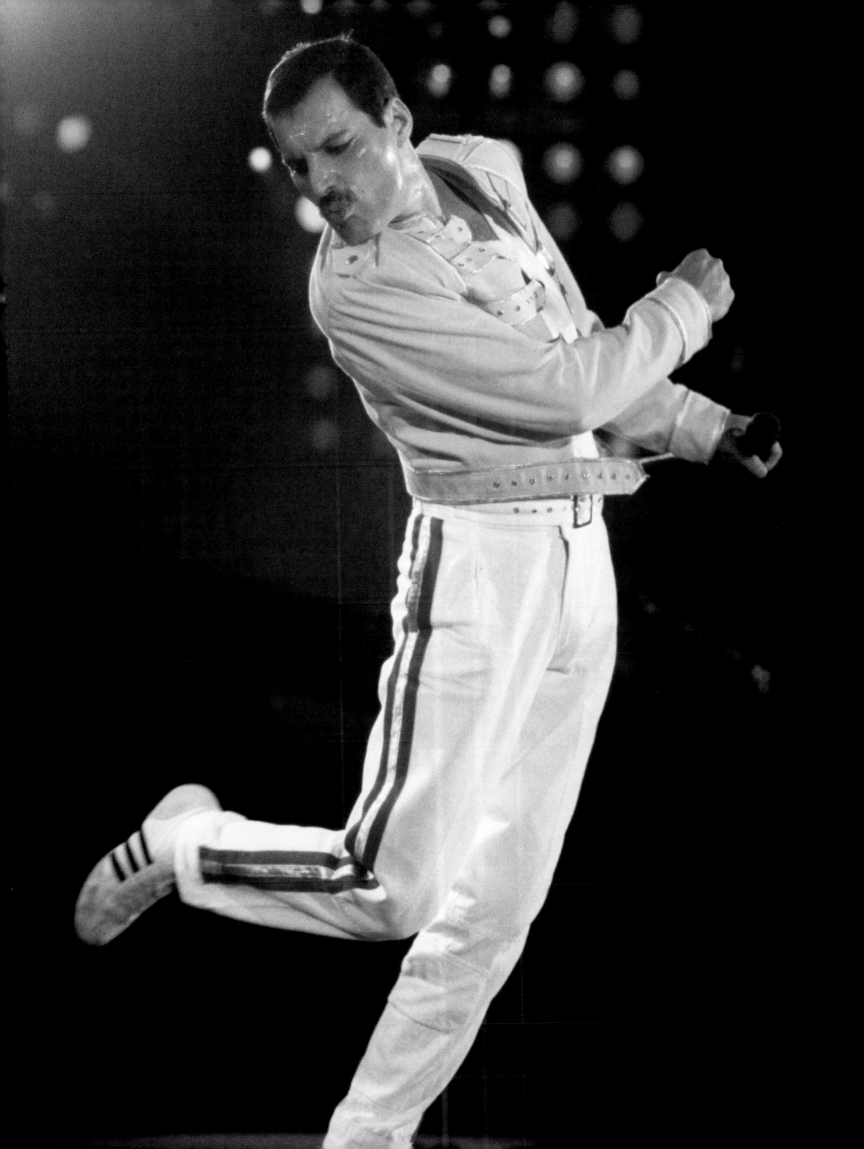

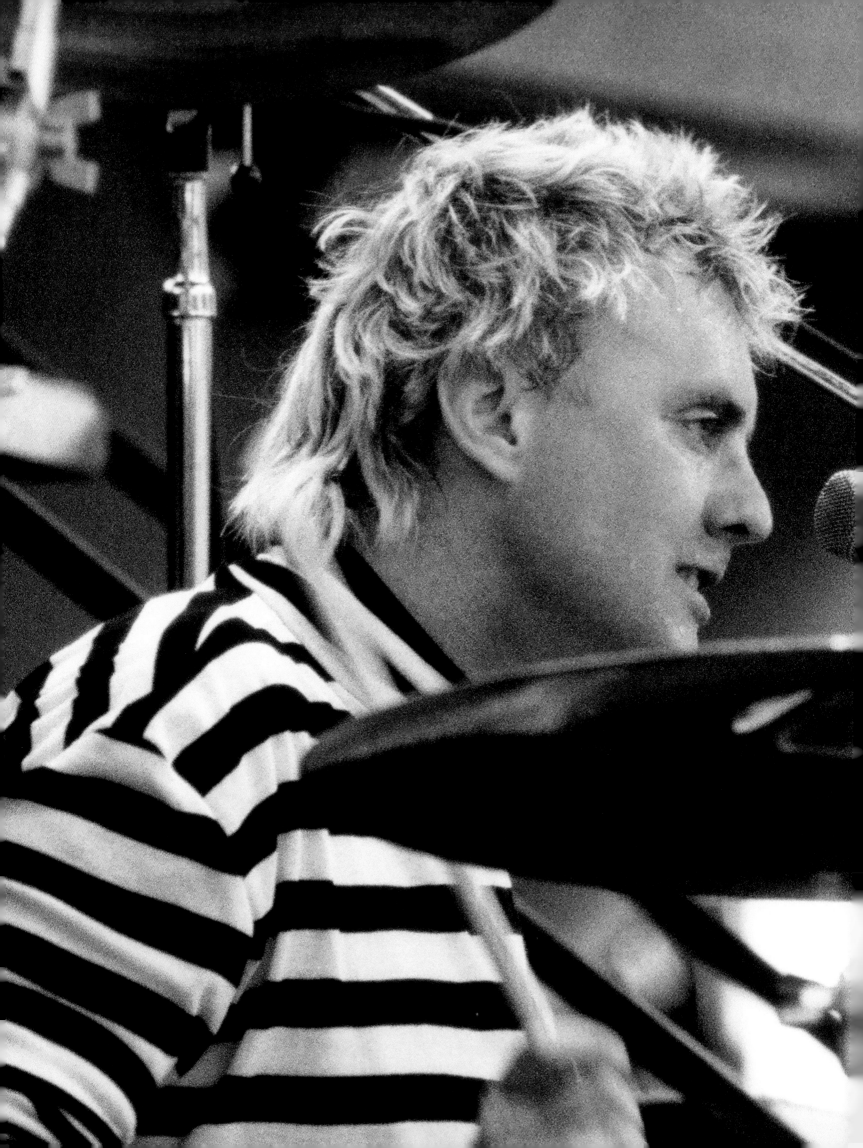

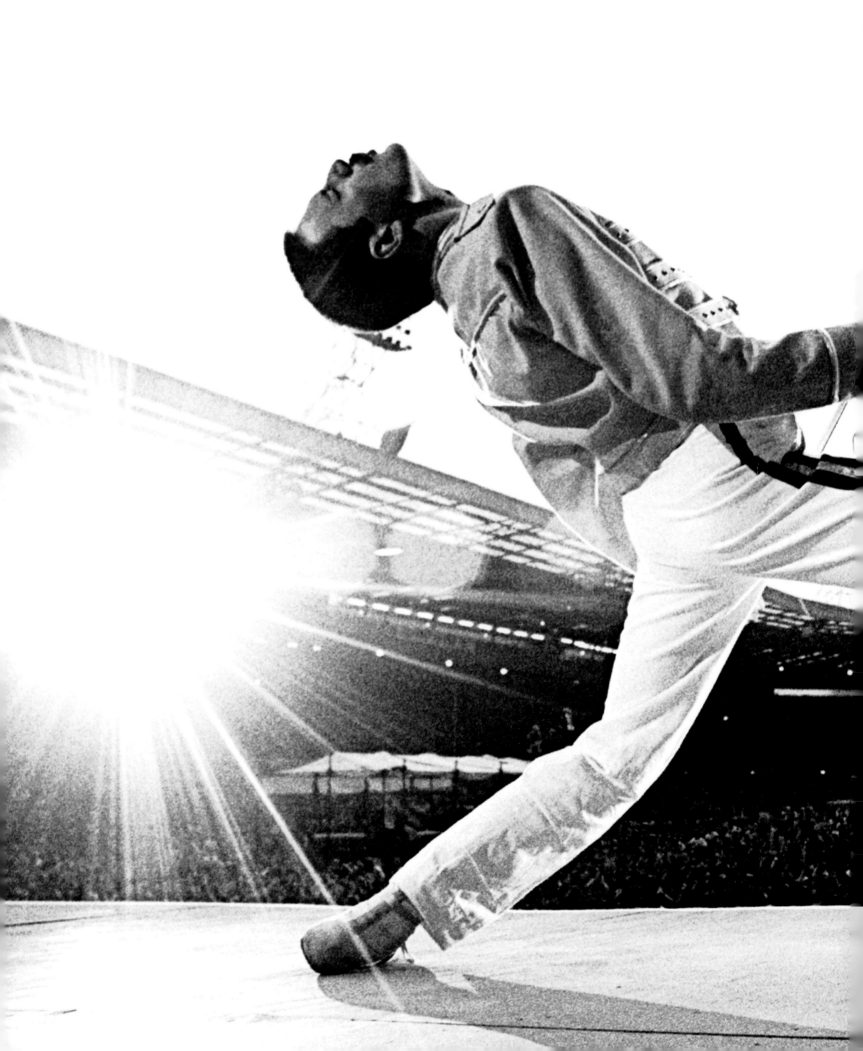

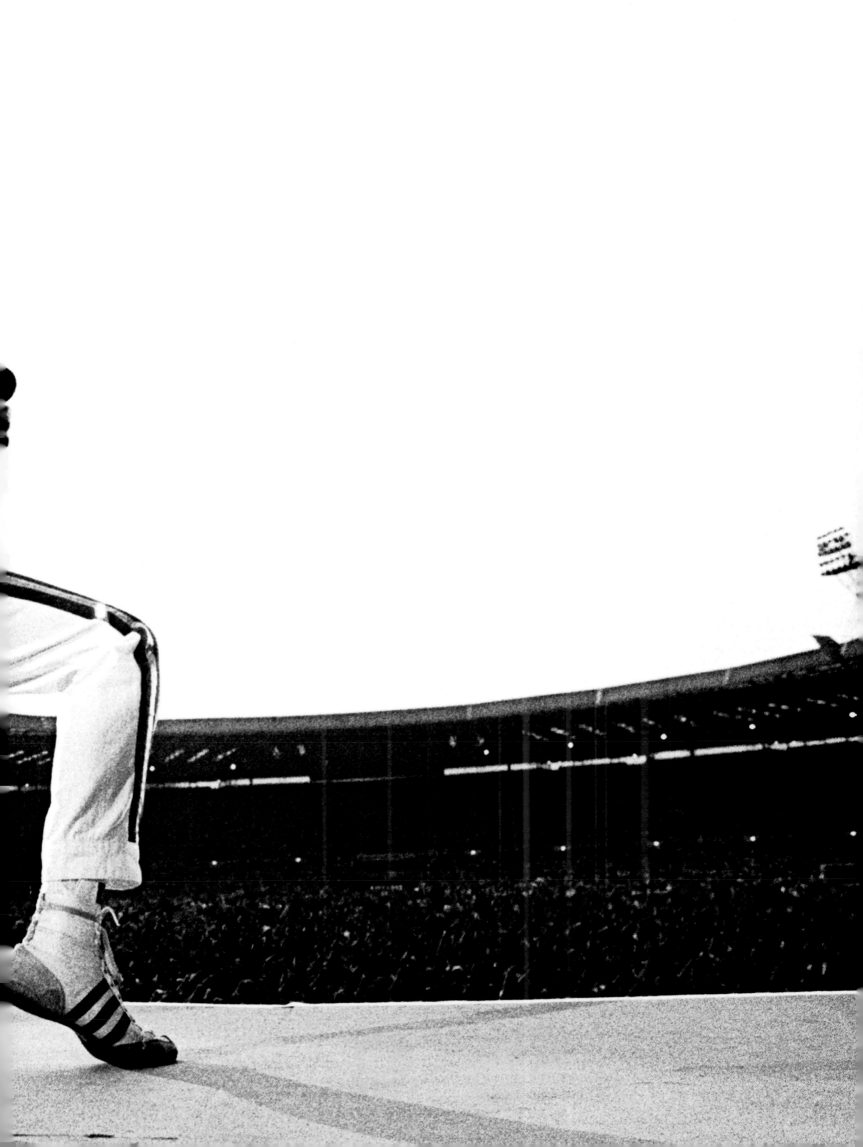

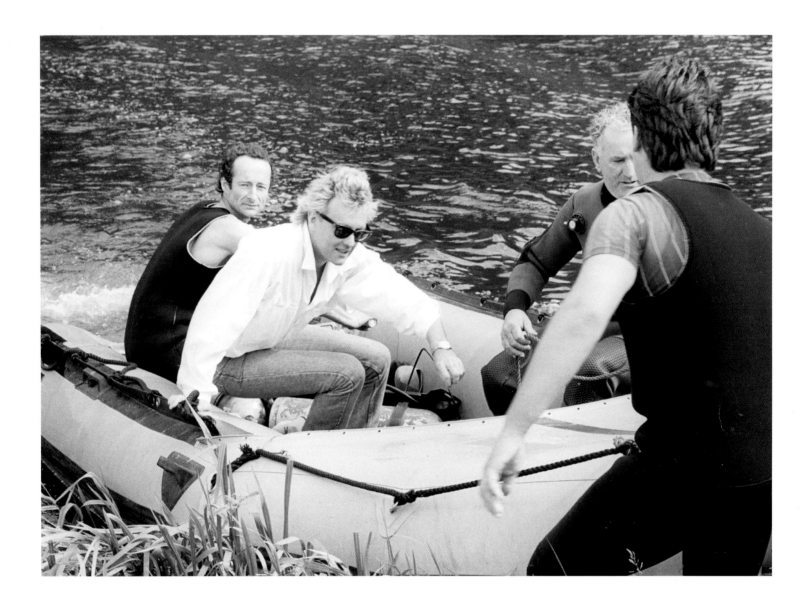

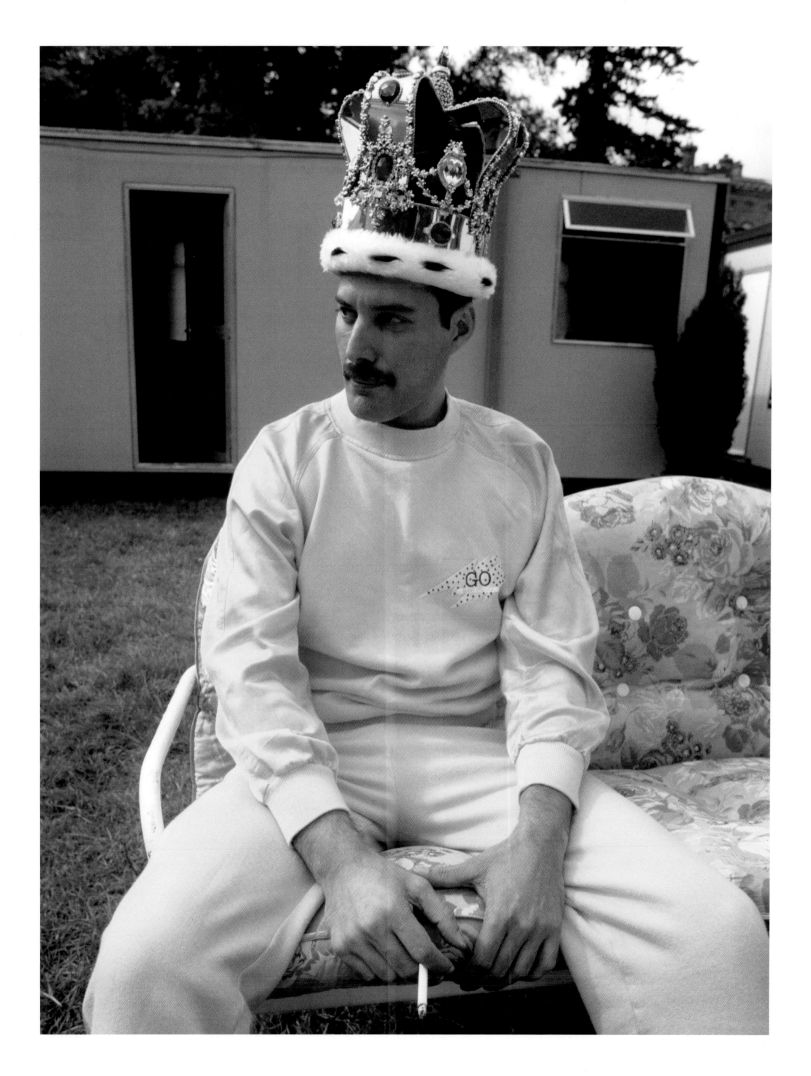

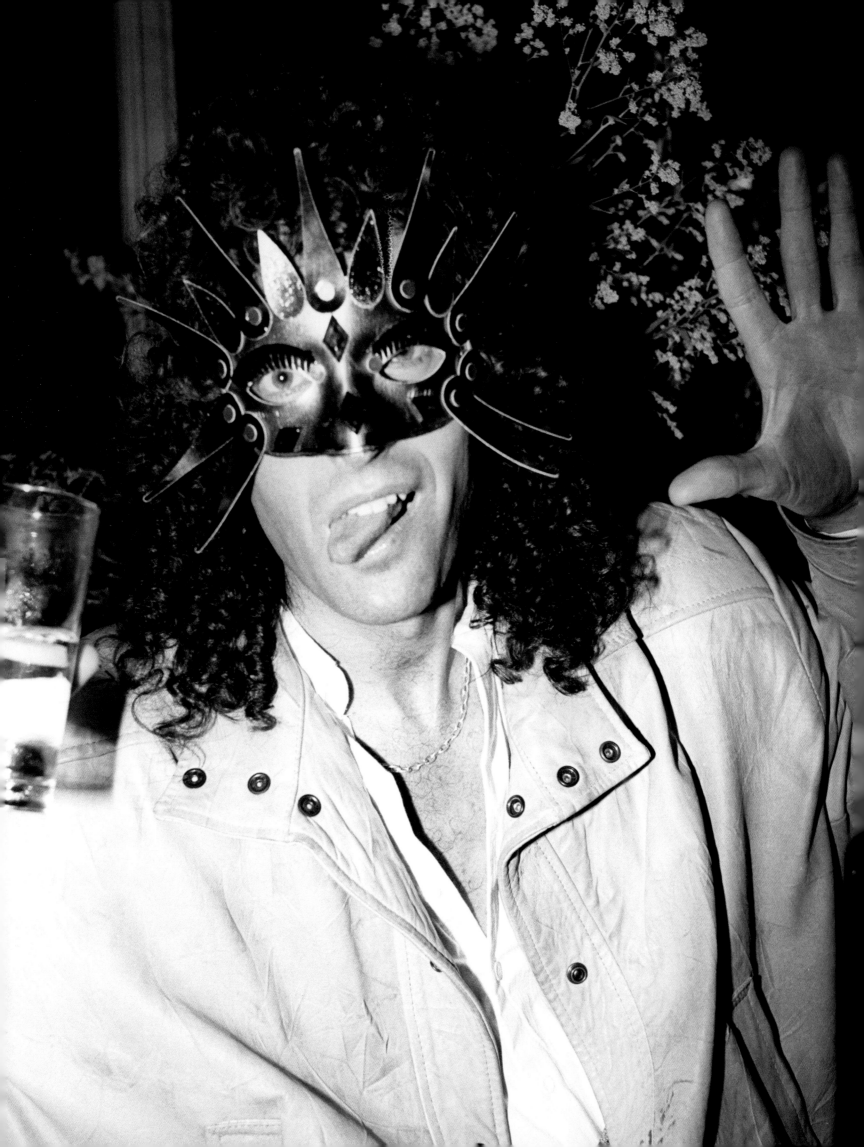

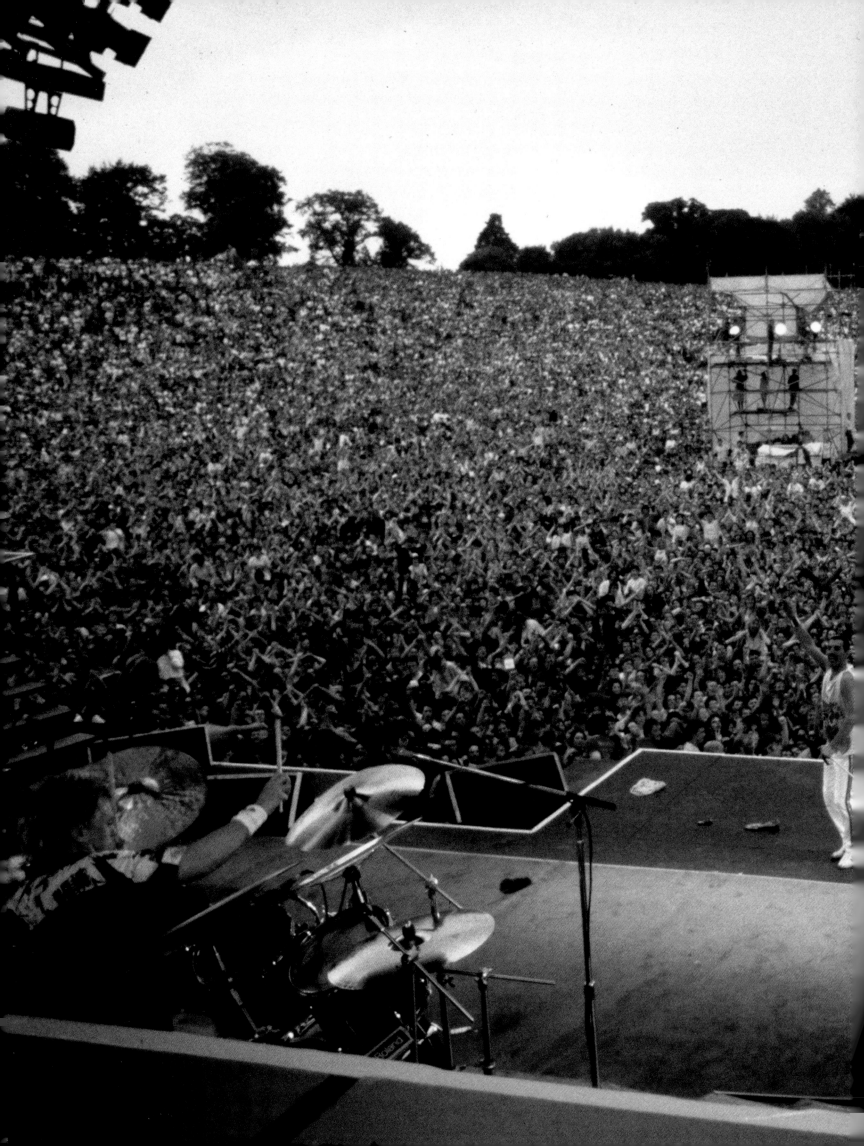

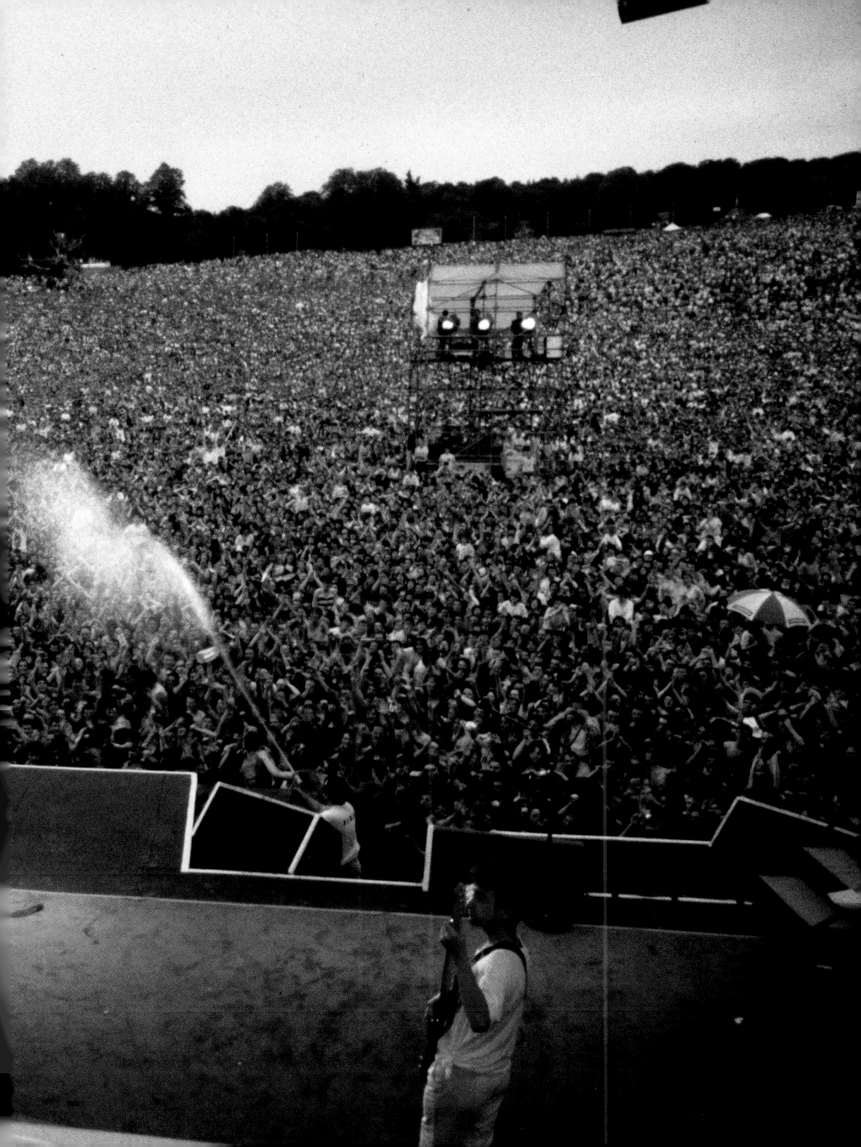

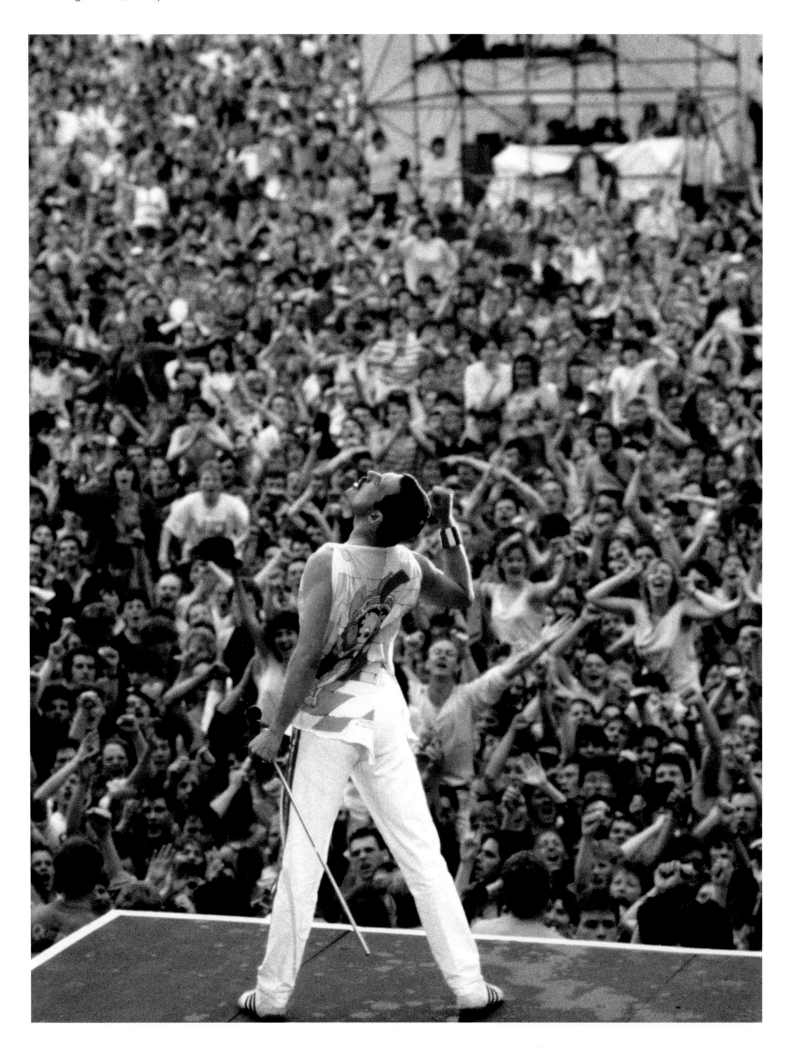

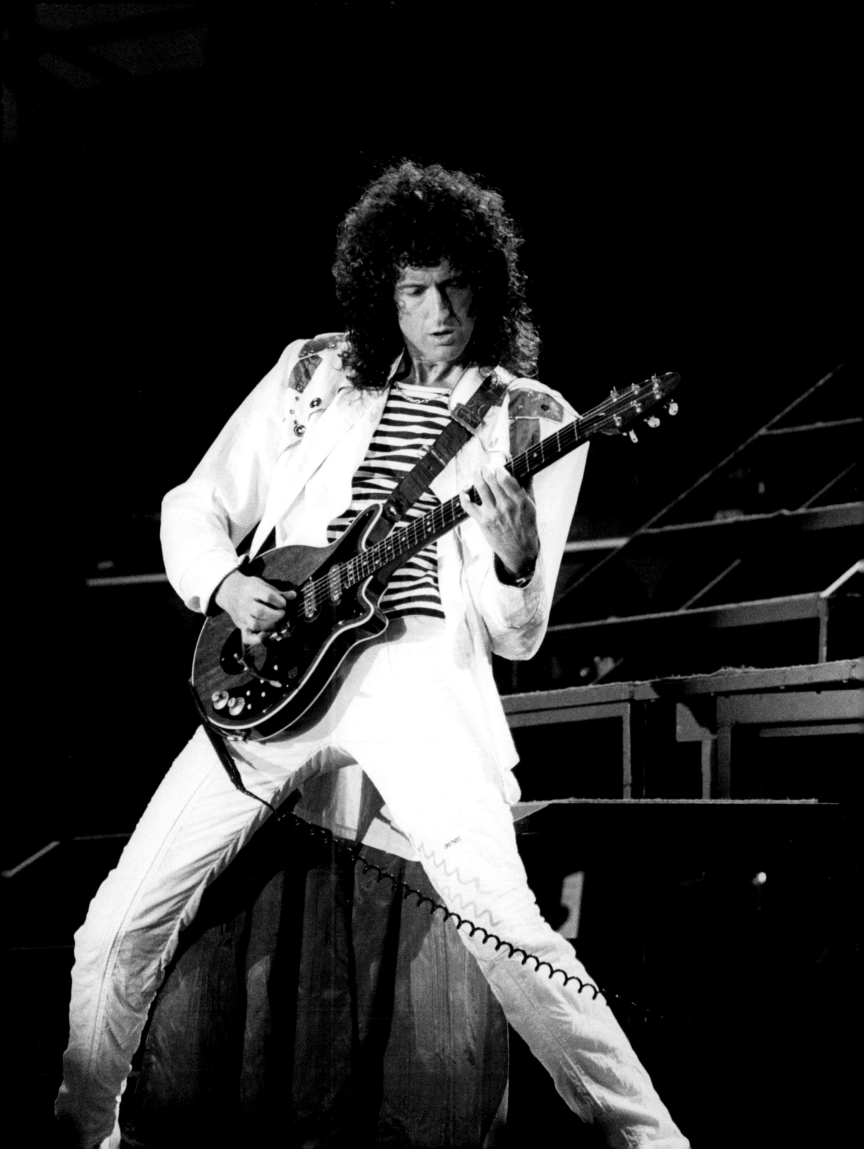

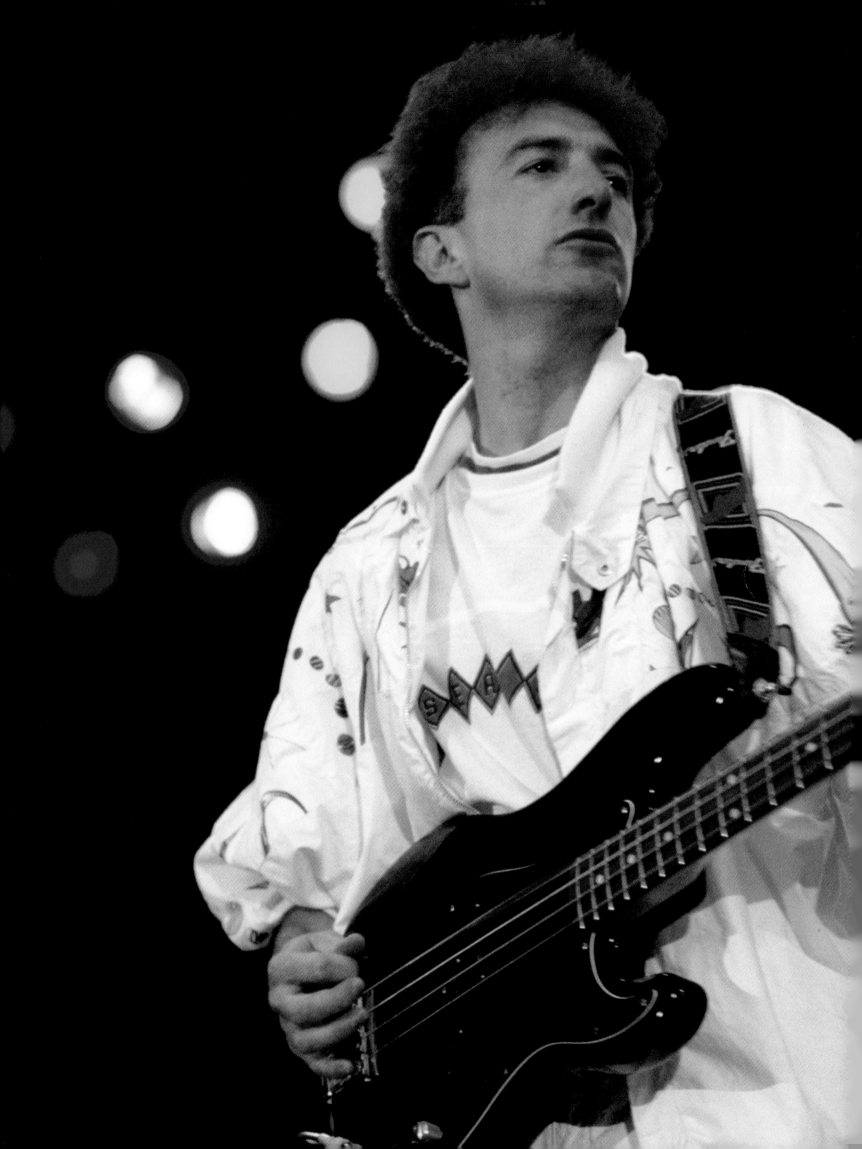

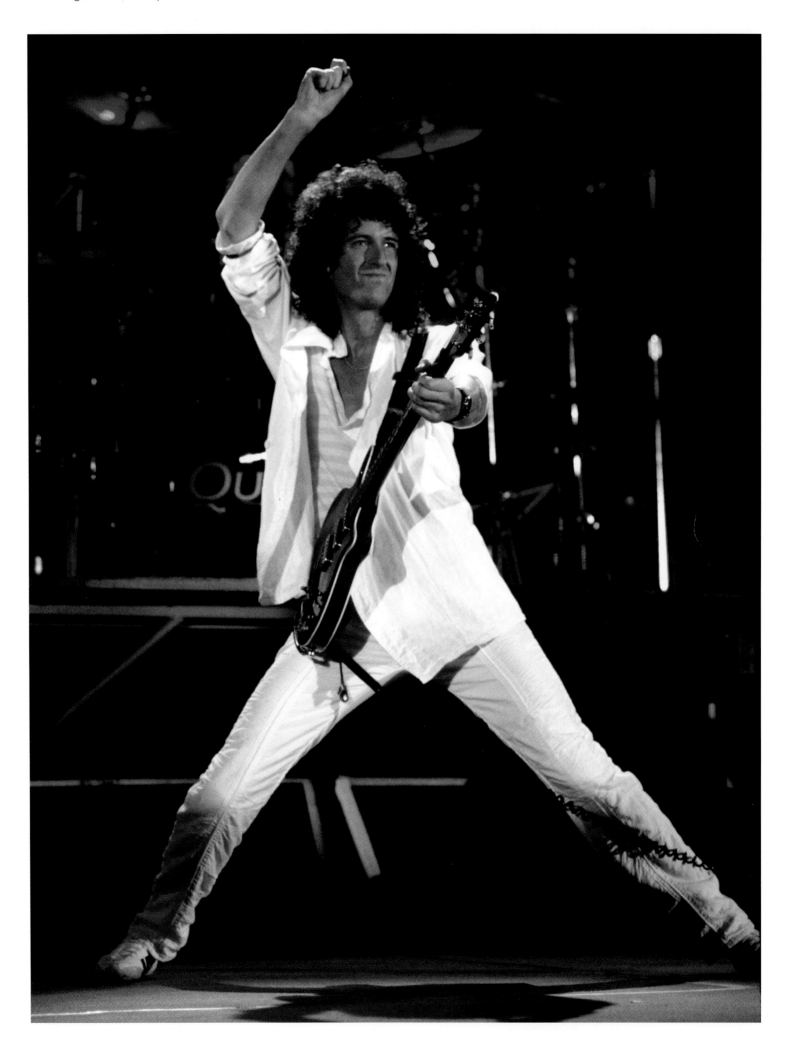

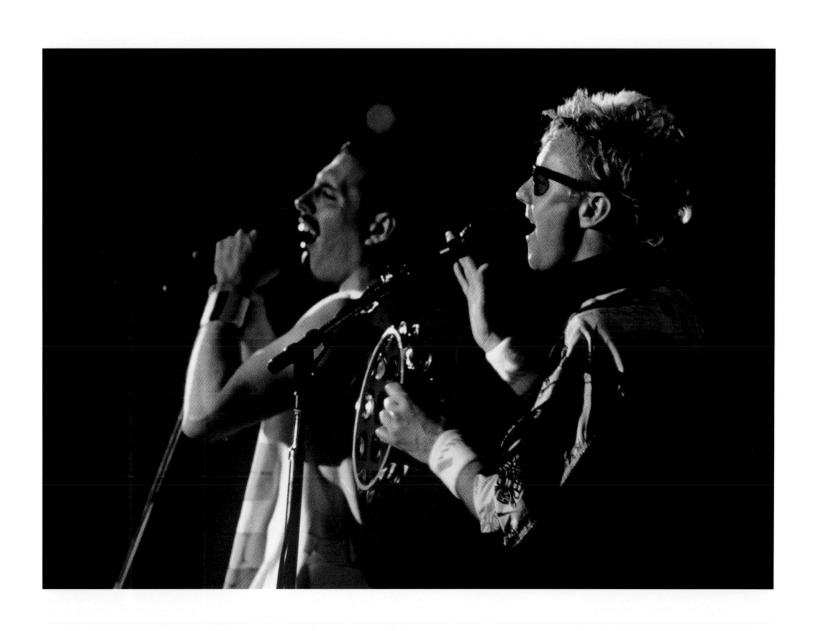

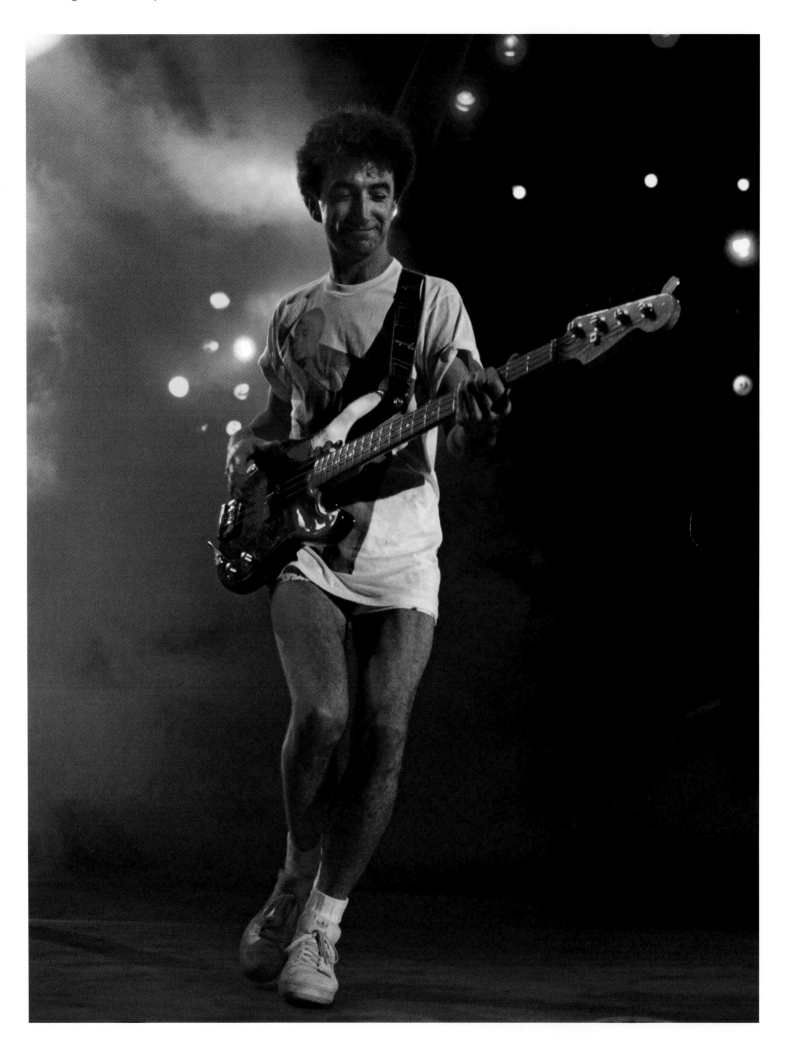

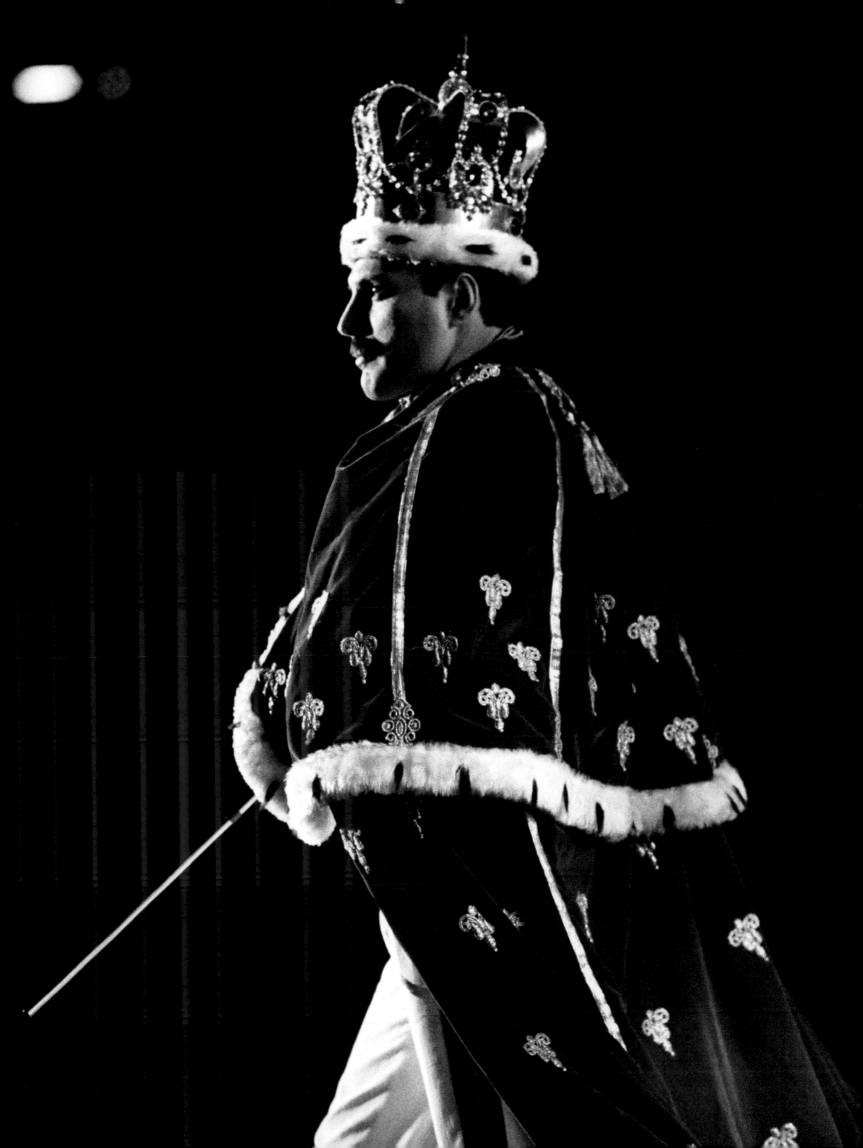

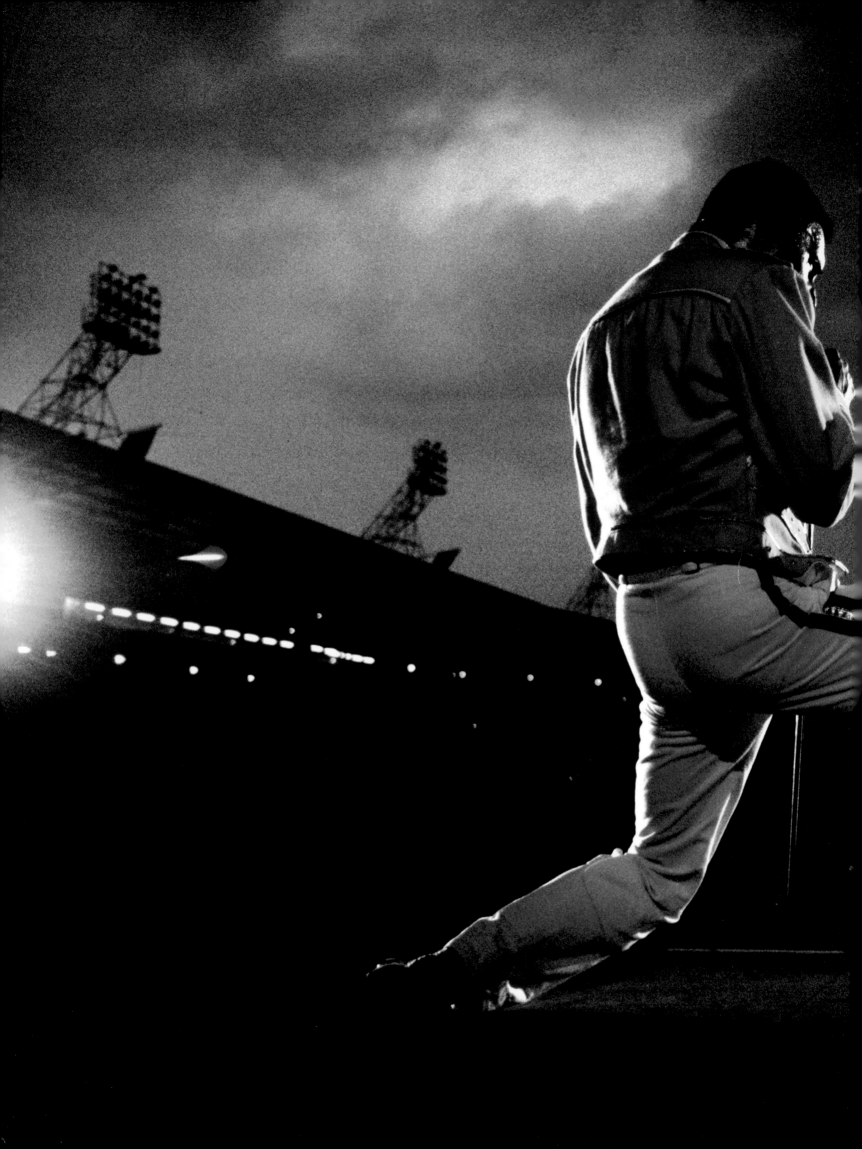

Afterword

As a fan of Queen, I loved the music, but as the band's photographer, I loved the productions. The theatrics, the lighting, the pyrotechnics, the staging—I'd never seen anything like it. From day one, every single Queen concert I've ever shot can only be described as a massive assault on my left frontal lobe (the part of the brain that governs creativity). The minute I'd walk into the venue something strange would happen. It was as if some futuristic artificial intelligence had taken hold of me and my Nikons suddenly had minds of their own.

I don't recall any Queen gig that was not fun to shoot. They were all fun. Big fun. I'm not a critic but I am saying right now that the band brought it every night. Visually, it was a feast beyond words. There was never a bad angle or camera position. These were big-time, world-class level musicians at the top of their game and I couldn't have asked for more. It's as good as it gets. I would just let my camera bodies take me where they wanted to go. I'd burn through film faster than my dog inhaling a piece of roast beef.

Each tour, from 1977 on, got bigger and bigger. They had become known for their bombast, and the fans came fully prepared for anything the band dished out. At some point (don't ask me when) the bombast seemed to turn into bomb blasts. I recall a night that I was particularly focused on getting a specific photograph and didn't realize I was standing about three feet from a fully loaded pyro casing tube that was set to ignite during "Bohemian Rhapsody". I was in another zone and had forgotten all about where I was standing and what was about to happen . . . but one of the crew members pulled me away from it with not more than seven or eight seconds to spare. (I think it may have been Parnelli, since the other crew would have barely noticed me, if at all.) A major bullet was dodged.

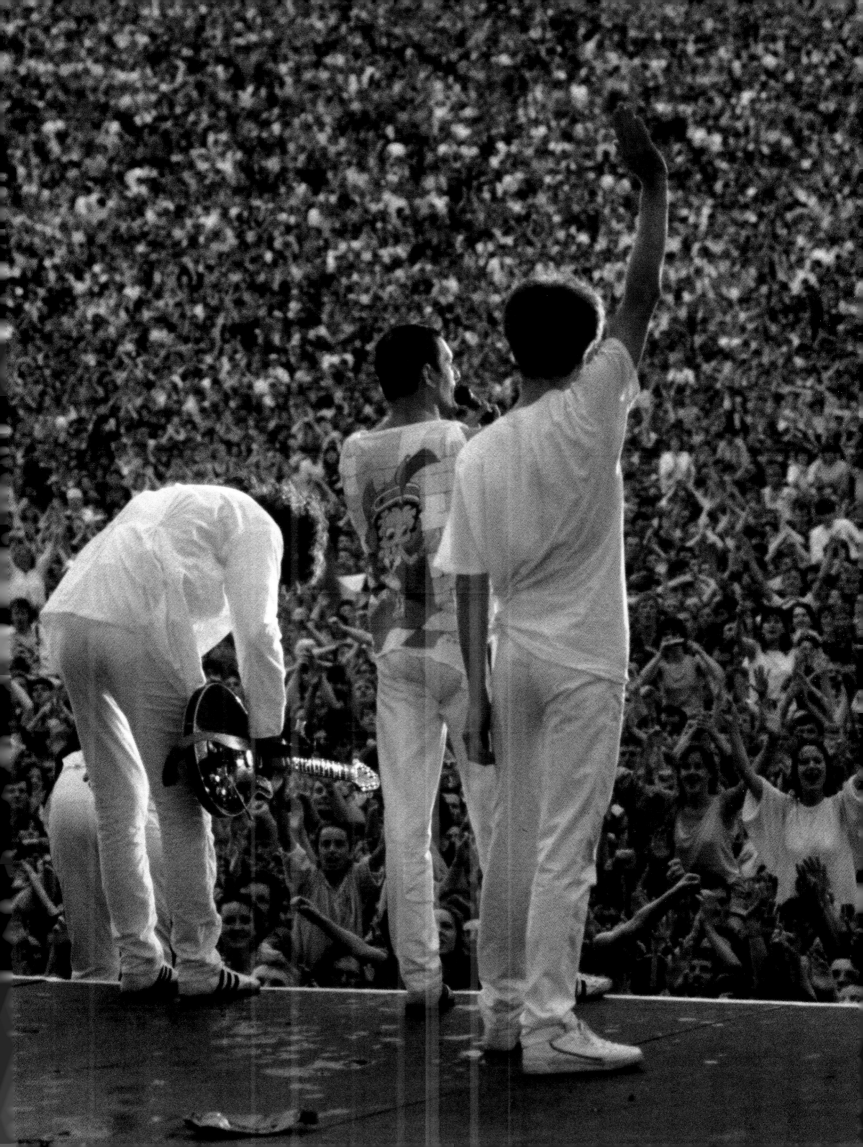

Freddie would certainly be the most animated and least predictable of anyone else in the world while on stage. I always had to be on my game with Freddie, and in fact all of Queen. These were four intelligent, headstrong, opinionated, and brilliantly talented Alpha males. They were the hardest workers I've ever seen on tour, perfectionists on every level imaginable. Playing, rehearsing, soundchecking, not to mention attending band meetings (sometimes during soundcheck, and that's all I'll say . . .), press interviews, planes, trains, and trying to get away from a certain pain-in-the-ass photographer named Neal. To me it felt like a World Series game, two or three times a week.

Many of the pictures in this book have never been seen, and as a fan, I was amazed at the treasure trove of unseen gold I uncovered in the files. It is some of the best work I have ever done. Taking these photographs allowed me to get to know Freddie, Roger, John and Brian in a different way than other people because I watched through a camera, which does not lie. It doesn't have to. It's invisible.

I think Freddie would be proud of this book. I can picture myself walking down the airplane aisle and he's looking at it very intensely. I ask him if he likes it and he looks right at me and says, "It's beautiful darling, it just needs to be bigger." . . . I can literally hear him saying that as I write this.

Neal Preston
Los Angeles, March 2020

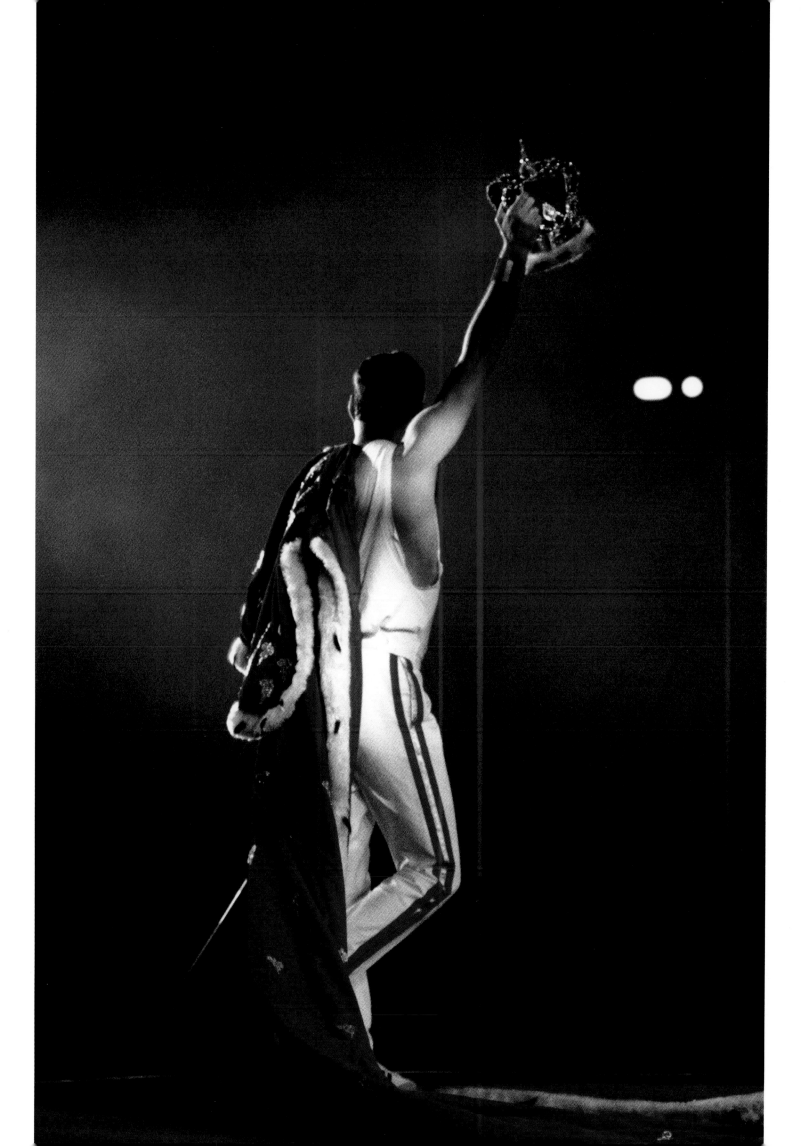

Additional Captions

Front Cover El Gigante de Arroyito (Estadio Rosario Central), Rosario, Argentina, 6 March 1981 (NP)

p.2-3 Our trusty Brittania 4-engined tour plane (RT)

p.10-11 Morumbi Stadium, São Paolo, second largest in the world, 130,000 approximately (RT)

p.16-17 Brian and his strobe tuners in his practice/tune-up room (RT)

p.19 RT with his Nikon SLR camera bought in Japan (RT)

p.20-21 The author catching zzzs (RT)

p.38 Looking at fan art (NP)

p.40-41 Our Crown light rig—"take off" at show start (RT)

p.60 Relaxing on the plane (RT)

p.61 Mary Austin with Freddie (NP)

p.74-75 Brian's parents, Ruth and Harold, backstage at Madison Square Garden (NP)

p.100-101 Stripped down drum kit on our revolutionary lowering stage (RT)

p.102-103 "That" stage descending to the front of the main stage (RT)

p.104-105 On "that" stage (RT)

p.76 RT with Pete Brown, our dear departed assistant manager (RT)

p.76-79 At Disney (NP)

p.108 Bicycle riders at Madison Square Garden (RT)

p.118-119 RT backstage at Forum LA with Freddie and Paul Prenter (RT)

p.138-139 RT in his LA deco bathroom (RT)

p.146-149 Michael Jackson and Olivia Newton-John in our Forum backstage (RT)

p.150 The Great Gerry Stickells with Freddie (RT)

p.156-157 Our incredible road crew. Bless 'em all! (RT)

p.158-159 RT at home in LA (RT)

p.167 JD with the "Angel of Death," our scary "bodyguard and anti-bandit chief"! (RT)

p.170-171 At Morumbi (RT)

p.180-181 Argentina madness! (RT)

p.194-195 Our Master of Ceremonies—Diego Maradona (The Hand of God) (RT)

p.196-197 With manager Jim Beach, meeting Argentine President Viola (right) (NP)

p.208-209 Freddie and RT half time in Pueblo, Mexico City (RT)

p.237 With Andy Warhol at Madison Square Garden (RT)

p.244-249 "Crazy Eddie's" Record Store in New York City, 27 July 1982 (NP)

p.251 Mel Smith and Griff Rhys Jones introduce Queen at Live Aid (NP)

p.254-255 Morning of Live Aid—Diana, Brian, RT, Harvey Goldsmith, Bowie, Prince Charles, Kenney Jones, Elton, etc. (RT)

p.266-267 Freddie and Brian performing "Is This The World We Created?" (NP)

p.272-273 Wembley Stadium (NP)

p.280-281 Backstage at Slane Castle (NP)

p.282-285 "The Magic Party" at The Roof Gardens in Kensington, 12 July 1986 (NP)

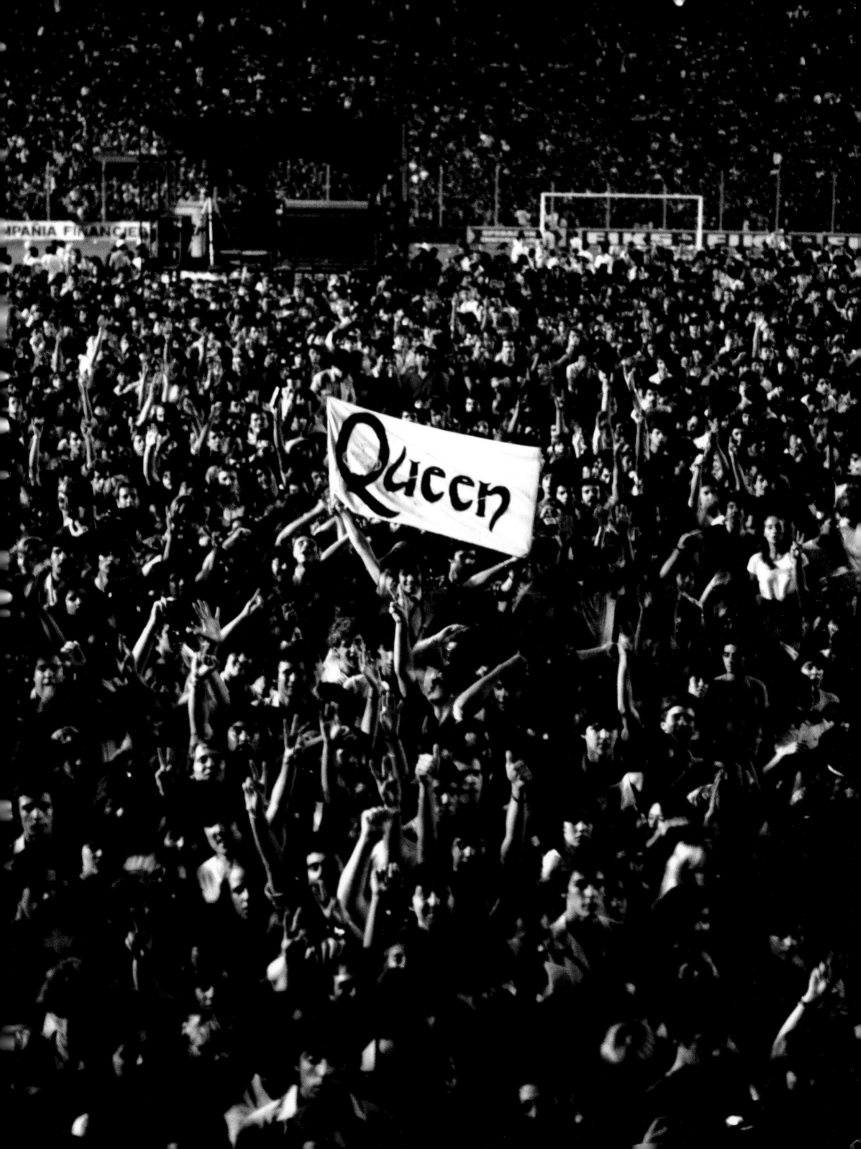

Editor: Dave Brolan
Art Direction and Design: Richard Gray

Cover Design: Joakim Olsson and Richard Gray
Text Editor: Alison Elangasinghe
Editorial Associate: Rory Bruton
Pre-Press: James Cowen

First published 2020 by Reel Art Press,
an imprint of Rare Art Press Ltd., London, UK

reelartpress.com
queenonline.com

First Edition
10 9 8 7 6 5 4 3 2 1

ISBN: 978-1-909526-71-6

Queen Management: Jim Beach

All photographs: © Queen Productions Ltd. 2020
Queen logo and crest: © Queen Productions Ltd. 2020
Copyright © (forewords) text: Queen Productions Ltd. 2020
Copyright © (main body) text: Neal Preston 2020
All maps by Harold May: © Brian May 2020

Thanks to Greg Brooks, Adam Unger and Jim Jenkins

This book is printed on paper Condat matt Périgord, ECF, acid free and age
resistant. The Lecta Group uses only celluloses from certified or well managed
forests and plantations.

Printed by Graphius, Gent

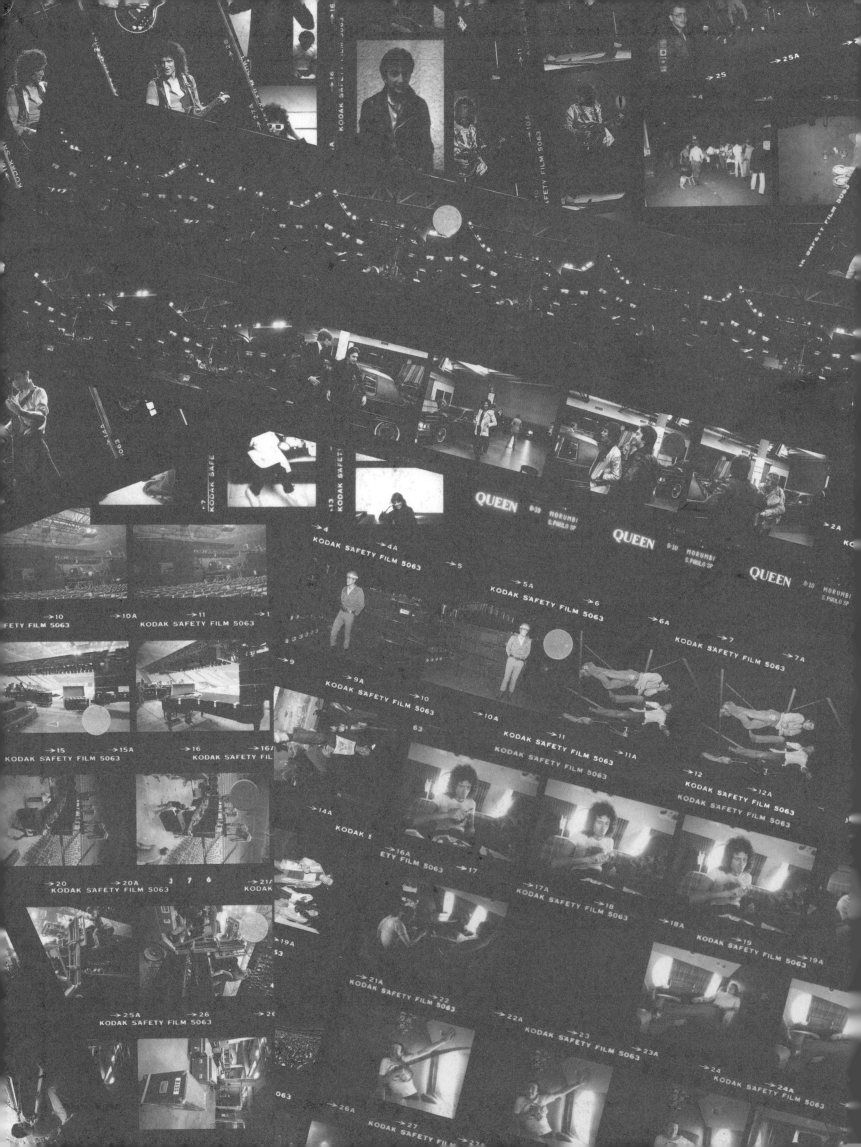